intensely dutch

**image, abstraction and the word
post-war and beyond**

intensely dutch

image, abstraction and the word
post-war and beyond

constant karel appel corneille lucebert

gerrit benner jaap nanninga

bram van velde willem de kooning wim oepts edgar fernhout

jaap wagemaker jan j schoonhoven bram bogart

jan riske theo kuijpers

hendrik kolenberg

assisted by Anne Gérard

with contributions from Ludo van Halem, Lies Netel and Cornelis Vleeskens

translation of poems by Cornelis Vleeskens

Published to accompany an exhibition at the
Art Gallery of New South Wales, Sydney
5 June – 23 August 2009

First published 2009
Art Gallery of New South Wales
Art Gallery Road, The Domain
Sydney 2000, Australia
www.artgallery.nsw.gov.au

Art Gallery of New South Wales
Cataloguing-in-publication data

Kolenberg, Hendrik.
Intensely Dutch: image, abstraction and the word post-war
and beyond / Hendrik Kolenberg assisted by Anne Gérard with
contributions from Ludo van Halem, Lies Netel and Cornelis
Vleeskens; translation of poems by Cornelis Vleeskens.

Includes bibliographic references.
ISBN 9781741740417

1. Sandberg, Willem Jacob Henri Berend, 1897-1984 –
Influence – Exhibitions. 2. Cobra (Association) – Exhibitions.
3. Art, Dutch – 20th century – Exhibitions. 4. Poetry, Dutch –
20th century – Exhibitions. 5. Abstract expressionism –
Netherlands – Exhibitions. 6. Art and literature – Netherlands –
Exhibitions. 7. Art informel – Netherlands – Exhibitions.
I. Gérard, Anne. II. Art Gallery of New South Wales. III. T.
ISBN 978-1-74174-041-7

Editing Margaret Malone
Design Mark Boxshall
Production Cara Hickman
Rights & permissions Michelle Andringa
Index Jo Rudd
Pre-press Spitting Image
Printing Everbest Printing, China

The Art Gallery of New South Wales is a statutory body
of the NSW State Government.

cover: Karel Appel, *Ontmoeting* (Encounter) 1951
Netherlands Institute for Cultural Heritage (on loan to
Centraal Museum, Utrecht)

endpapers: Jan J Schoonhoven, *Gerythmeerd quadratenreliëf*
(Rythmical grid relief) 1968 Gemeentemuseum, The Hague

opposite title page: Bram Bogart, *Daybreak* 1997 (detail)
Private collection

this page: Last woodcut by Constant for *Het uitzicht
van de duif* (The prospect of the dove) 1952
Gemeentemuseum, The Hague

Dedicated to Gijsbertus Anthonius Kolenberg (1915–2006) and
Maria Wilhelmina Kolenberg née Schellaars (1920–2008)

contents

acknowledgements

The idea for staging an exhibition of modern Dutch art started with a prompt from Anne Flanagan, Deputy Director and General Manager of Exhibitions at the Gallery, made before I visited the Netherlands in September/October 2006. It began to take shape on another visit there a year later when I met with museum directors and curators to look at collections with potential loans in mind; a visit sponsored by the Netherlands Consul-General in Australia, Margarita Bot, and the Dutch Museumvereniging / Stichting Internationale Culturale Activiteiten (Service Centre for International Cultural Activities) in Amsterdam. Directors and curators of various museums, selected artists and collectors in the Netherlands responded positively and graciously to the exhibition proposal. The former Netherlands Ambassador to Australia, Niek van Zutphen, gave the project his full support and assisted with an introduction to the youngest daughter of CoBrA artist Lucebert. The search for and purchase of books and exhibition catalogues was undertaken in earnest from the start, particularly given the relative paucity of such material in Australian libraries.

This publication and accompanying exhibition would not have been possible without the generous sponsorship of ING in Australia. From the start, Eric Drok, CEO of ING Direct in Sydney, gave enthusiastic support. The involvement of ING has been essential to the project's success. In the Netherlands, the Head of ING Arts Management, Annabelle Birnie, readily agreed to important loans and offered her assistance.

The majority of loans are from ten important Dutch public collections. Sincere thanks to the directors, curators and registrars of each for their generosity and willingness to lend to faraway Australia – Sjarel Ex, Director, Margreet Wafelbakker, Jacqueline Rapmund and Sandra Tatsakis of the Boijmans van Beuningen Museum, Rotterdam; Wim van Krimpen, former Director, Hans Janssen, Vivien Entius and Frans Peterse of the Gemeentemuseum, The Hague; Kees van Twist, Director, Caspar Martens, Marieke van Loenhout and Jenny Kloostra of the Groningermuseum, Groningen; Charles Esche, Director, Christiane Berndes and Marcia Vissers of the Van Abbemuseum, Eindhoven; Pauline Terreehorst, Director, Meta Knol, Len van den Berg and Cecile Ogink of Centraal Museum, Utrecht; Peter Schoon, Director, Moniek Peters, Suzanne Harleman and Alicja Rakuzyn of the Dordrechtsmuseum, Dordrecht; Diana Wind, Director, Ludo van Halem and Christel Kordes of the Stedelijk Museum, Schiedam; Rick Vercauteren, Director, and Ingrid Kentgens of Museum van Bommel van Dam, Venlo; Tiana Wilhelm, Director, and Lies Netel of Museum Henriette Polak, Zutphen; Henriëtte van der Linden, Director, Evert Rodrigo, Simone Vermaat and Sylvia van Schaik of the Netherlands Institute for Cultural Heritage, Amsterdam and Rijswijk.

Sincere thanks to Alfred Pacquement, Director, and Isabelle Monod-Fontaine for a critical loan from the Centre Georges Pompidou, Musée national d'art moderne in Paris, and to the Directors of Australian galleries for their support – Ron Radford, Director, Anna Gray, Miriam Kelly, Elena Taylor and Lucina Ward of the National Gallery of Australia; Gerard Vaughan, Director, and Ted Gott of the National Gallery of Victoria; Tony Ellwood, Director, and David Barnett, Queensland Art Gallery; Jason Smith, Director, Lesley Harding and Katarina Paseta, Museum of Modern Art at Heide; Ron Ramsey, Director, and Donna Robson of the Newcastle Region Art Gallery.

Heartfelt thanks to private lenders in the Netherlands, Belgium and Australia, including artists Bram Bogart, Theo Kuijpers and Jan Riske, the lithographic printer Fred Genis, and collectors Jan Nieuwenhuizen Segaar, Aimé and Jacqueline Proost and Robert Ypes.

Thanks also to Thomas Möhlmann of the Foundation for the production and translation of Dutch Literature, Amsterdam and Sjoerd van Faassen of the Letterkundig Museum, The Hague for their assistance and advice.

Particular thanks to Cornelis Vleeskens for his translations of post-war Dutch poetry and of Lies Netel's essay; to George Hall for translating Ludo van Halem's essay; to Susan Holgate, Akky van Ogtrop, Fred Genis, Tineke Schuur-Kaspers, Siem Bakker, Maia and Tony Swaanswijk, Ton Geerts, Edmond Bergsma, Toby Clarke, Anna Green, Rosanna Cameron, Raymond Arnold and Margaret Weatherall.

Special thanks to AGNSW Director Edmund Capon for his support throughout and for securing the important loan of a painting by Constant while on long-service leave in Paris in 2008; to colleagues in Business Development, Marketing,

Publicity, Exhibitions, Design, Photography, Public Programs, Library, Conservation and Installation, most especially Leith Brooke, Brian Ladd, Erica Drew, Charlotte Cox, Diarne Wiercinski, Mark Boxshall, Carley Wright, Kaye Truelove, Vivian Huang, Eric Riddler, Stefanie Tarvey and Nik Reith; to Helen Campbell who attended to the daily demands of Australian Prints, Drawings and Watercolours whenever I was occupied with *Intensely Dutch*; and Patricia James, trusted long-serving volunteer, for her help in research, reading, typing and checking, as she has provided on all my publications.

The assistance of my wife, Julianna, was essential. She accompanied me to the Netherlands in 2006 and 2007, took hundreds of photographs in various museum store-rooms, offices and artist studios, loaded them onto a computer, re-sized and re-ordered them and printed them off on demand. Her photos provided essential daily reference material. Critical, too, was the assistance of Anne Gérard, a PhD student at the Sorbonne (Paris) and Sydney University, studying 19th and 20th century Australian artists active in Paris. She assisted with research, the preparation of artist biographies, the bibliography and was involved in all aspects of this publication. Klawa Koppenol in the Netherlands also contributed with bibliographical research on works included in the exhibition.

The support of Weert-based Dutch artist Rob Kars, a life-long friend, was invaluable. Heartfelt thanks for his hospitality, willingness to drive me to out-of-the-way destinations, his extensive library, gifts of many books and for our discussions about Dutch art and literature over many years, including, most recently, this project. Thanks also to my cousin in Rotterdam, Henk Schellaars, and friends Hélène and Leen van den Heuvel, Brouwershaven, for their encouragement on visits 'home'.

HENDRIK KOLENBERG

Modern Dutch art and artists have for a long time been an almost invisible part of the Australian cultural landscape. It has taken almost half a century, and a very dedicated and inspired man, Hendrik Kolenberg, himself of Dutch origin, before a major Australian museum, the Art Gallery of New South Wales, decided to organize a substantial exhibition of Dutch art from after the Second World War.

One wonders why modern Dutch art is so little known in Australia, when past Dutch masters such as Rembrandt, Van Gogh and Mondriaan have been household names for so long. Maybe it reflects the nature of the first Dutch immigrants, who adapted so well to their new home-country, as to become virtually invisible?

Times are changing, however. When in 2007 Hendrik Kolenberg first came to us with his long cherished dream to show another side of the Dutch – the vibrant and lively CoBrA-connected art which had developed in the Netherlands after the Second World War, involving both painting and poetry – it seemed the right thing at the right time and very much in line with the increasingly warm relationship between the Netherlands and Australia. The former Netherlands Ambassador to Australia, Mr Niek van Zutphen, gave his wholehearted and much appreciated support to the project from the start.

We are proud to have been involved in realizing a dream: to bring Dutch post-war artists to the general Australian public in this wonderful exhibition. We wish to extend our special appreciation to Edmund Capon and Anne Flanagan for having understood the significance of these modern Dutch artists and for having made it possible to show a hitherto almost unknown aspect of Dutch cultural heritage in such a prestigious venue.

WILLEM ANDREAE
Netherlands Ambassador to Australia

MARGARITA BOT
Netherlands Consul-General to Australia

ING is pleased to partner with the Art Gallery of New South Wales to bring to the public this major Australian exhibition of modern Dutch art, *Intensely Dutch*, which focuses on the wave of Dutch modernism post World War II. These works express uncompromising optimism through their vibrant colour, technique and experimentation.

Our Dutch origin means this exhibition holds a special meaning for ING Group. Here in Australia, as the fourth largest retail fund manager and fifth largest savings and mortgages bank, our local profile continues to grow making us one of this country's most respected financial services brands.

ING is delighted to link its core business of banking, investments, life insurance and retirement services to the visual world of art. ING regularly provides its customers with many opportunities to enjoy fine art and culture through the sponsorship of various events and exhibitions. The aim is to help our customers meet their financial needs while promoting art and culture within the financial industry.

ING is pleased to support this exhibition enabling the public to experience these inspirational post-war Dutch artists first-hand. We hope it provides an insight into modern Dutch culture and inspires local artistic expression.

HARRY N STOUT
CEO
ING Australia Ltd

ERIC D DROK
CEO
ING DIRECT Australia

wim oepts
village 1972 (detail)
ING, Amsterdam

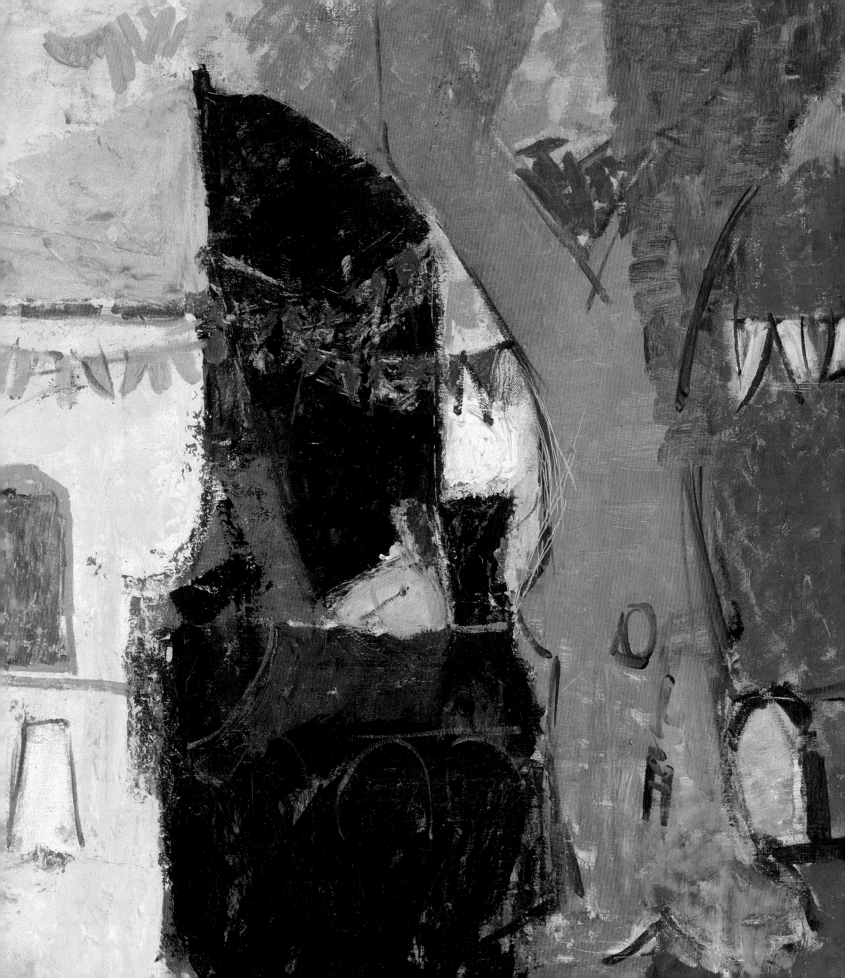

foreword

In Australia, awareness of Dutch culture is too often limited to clichés – windmills, clogs and raw herrings – or it may extend to the names of some of its most famous past artist heroes – Rembrandt, Vermeer, Van Gogh and Mondriaan. Knowledge may nowadays even include a popular violinist or soccer coach or two, or Dutch place names in Australia – Arnhem Land, Tasmania (Van Diemens Land), Rottnest Island – but despite having played an important part in the early discovery of Australia, and with substantial post-war immigration and important Dutch business interests here, the Dutch and their culture have remained largely invisible to most Australians.

Nevertheless, Dutch art, science and business have been at the centre of European culture since at least the 17th century. Despite its relatively small population and landmass, Dutch influence and enterprise extends worldwide and we on this continent can feel the historical presence of Dutch commercial endeavours in the islands of our Indonesian neighbours. In that context of global aspiration, we are fortunate to have ING, a major international Dutch company with vigorous business interests in Australia, as our principal sponsor for the project.

In 1961–62 a seemingly modest exhibition *Trends in Dutch painting since Van Gogh* was shown in Australia. Organized by the Gemeentemuseum in The Hague, its tour began in Melbourne at the National Gallery of Victoria and was shown at the Art Gallery of New South Wales. Several remarkable paintings by Vincent van Gogh, George Hendrik Breitner and Piet Mondriaan were featured, as well as paintings by post-war Dutch artists Karel Appel, Corneille, Gerrit Benner, Jaap Nanninga and Jaap Wagemaker, who are included in *Intensely Dutch*. It is now almost fifty years since, certainly beyond the memory of most visitors.

This publication and accompanying exhibition are an initiative of Hendrik Kolenberg, Senior Curator of Australian Prints, Drawings and Watercolours at the Gallery. Dutch-born, he has remained seriously interested in the land of his birth, its art and literature since arriving here in 1952. The richly varied selection of works of art he has chosen will be unfamiliar to most of our visitors, but clearly not for long. He has been mindful of the need to highlight connections between Dutch and Australian art and for this reason has included the work of the Dutch born and trained Australian artist, Jan Riske, whose work, like that of other artists of Dutch birth or heritage in Australia, has already contributed greatly to the enrichment of Australian culture since the early 1950s.

This publication and accompanying exhibition would not have been possible without the generous sponsorship of ING in Australia. Particular thanks to Eric Drok CEO of ING Direct in Sydney and his staff. He has steadfastly supported this project from the start. ING's support is absolutely integral to the project's success.

On behalf of the Gallery and its trustees, our grateful thanks to the representatives of the Netherlands government, former Ambassador Niek van Zutphen, current Ambassador Willem Andreae and Consul-General Margarita Bot, for their interest in and support of this project, and most sincerely, all lenders both public and private in the Netherlands, France, Belgium and Australia. My thanks to Hendrik Kolenberg, and all staff and volunteers who assisted in making this exhibition and publication a reality.

EDMUND CAPON
Director, Art Gallery of New South Wales

corneille
le port en tête (the port overhead)
1949 (detail)
Stedelijk Museum, Schiedam

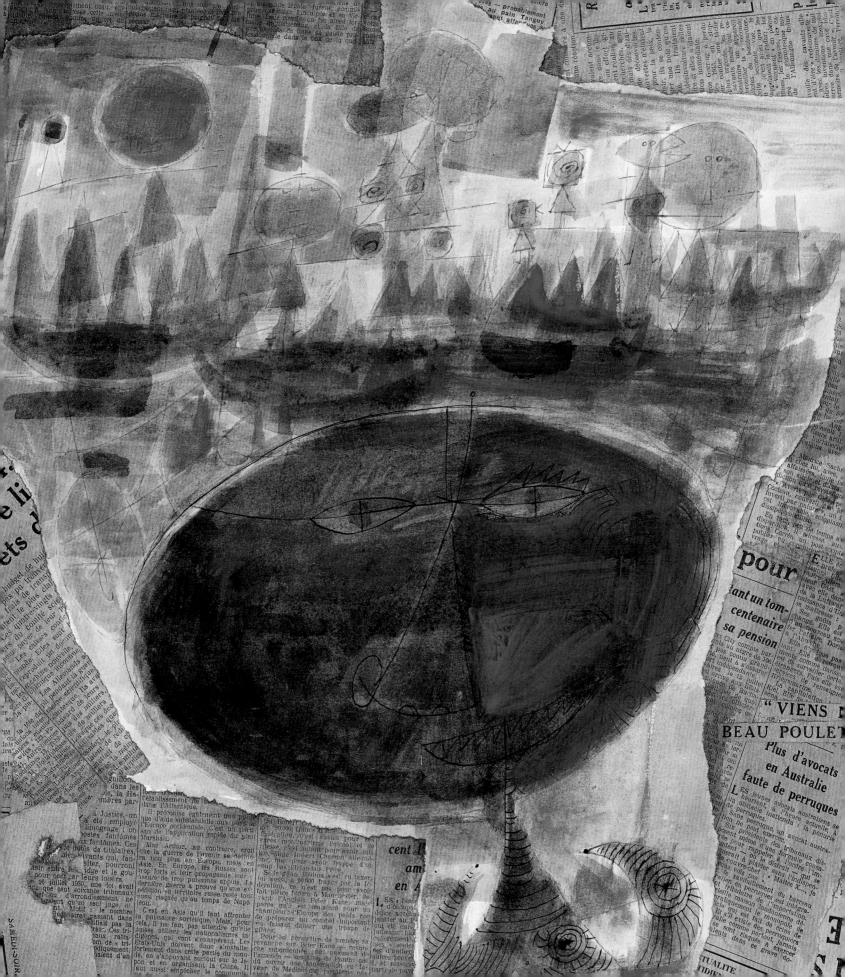

introduction

HENDRIK KOLENBERG

Uncompromising, confronting, optimistic – after the Second World War a new generation of Dutch artists, writers and architects took to modernity as never before. For them it was a time of renewal. Born in the 1920s, they were in their twenties after the War, and as youthful survivors of the violations and hardships of German occupation, past successes, apart from the most revolutionary, just didn't interest many of them. Some of the most gifted banded together to form the Dutch Experimentele Groep (Experimental Group) in Amsterdam in 1948[1] and forged close associations with like-minded artists from Denmark and Belgium, which quickly led to the formation of a rebellious new art movement they called CoBrA.[2]

Dutch CoBrA artists weren't the only artists working in post-war Netherlands, but CoBrA was very much at the fiery hub of contemporary art in Europe in the late 1940s and early 1950s. With its irreverent dada-like disregard for convention, CoBrA shook conservative taste, and in the process dramatically re-cast the character of Dutch art. It was an ambitious, raw and vibrant new international art movement from three of the smallest European nations, up-staging, if only briefly, the dominance of the French avant-garde, which CoBrA artists felt was given to tedious theorizing.

This new art movement suited the 'northern' Dutch temperament, emphasizing individuality, bold expressive imagery and strong colour, though it didn't seem so to many at the time. Part of its freshness and power was because its artists admired and emulated child art, folk art, the art of the untutored and mentally unstable, as well as art from Africa, New Guinea and Alaska. The work of Pablo Picasso, Paul Klee and Joan Miró were formative influences too, as was the emerging art of Jean Dubuffet. CoBrA artists met and occasionally worked collectively in Denmark, Belgium and the Netherlands, but felt most unhindered in Paris. Almost all of the artists included in *Intensely Dutch* lived and/or worked in Paris at some time – Bram van Velde, Edgar Fernhout, Wim Oepts, Karel Appel, Constant, Corneille, Lucebert, Jaap Nanninga, Jaap Wagemaker, Bram Bogart.

The Dane Asger Jorn, Netherlanders Karel Appel, Corneille and Constant, and the Belgian Pierre Alechinsky are the best known CoBrA artists internationally, but CoBrA had many adherents and followers in Denmark, Belgium and the Netherlands, as well as in Germany, England and France, and well beyond its short existence from 1949–51.[3]

1. In 1946, shortly after the end of the Second World War, the Dutch artist Constant met the Danish artist Asger Jorn in Paris. Jorn enthused Constant about the activities of the Danish experimental group *Höst* and its periodical *Helhesten*. Jorn invited Constant to Denmark and urged him to generate a similar group of like-minded artists in the Netherlands. In 1947 Constant met Appel and Corneille and the following year they and some other artists and writers formed the Experimentele Groep. Amongst those who took part were Anton Rooskens, Theo Wolvecamp, Constant's brother Jan Nieuwenhuys, Eugène Brands and poets Gerrit Kouwenaar, Jan G Elburg and Lucebert.

2. After a gathering of avant-garde artists, the 'Revolutionary surrealists', in Paris from 5–7 November 1948, Belgian poets Christian Dotremont and Joseph Noiret, Danish artist Asger Jorn and three Dutch artists, Karel Appel, Corneille and Constant, met at the café Notre-Dame and decided to start a new group they named CoBrA. CoBrA was an inspired acronym invented by Dotremont, made up of the first letters of the capital cities from which its main participants came: Copenhagen, Brussels, Amsterdam. It took the place of various avant-garde groups in Copenhagen, Brussels and Amsterdam with which each was involved. Their action was in part a rejection of the theorizing that they believed beleaguered the participants at the Paris conference that they had just attended.

3. Karl Otto Gotz in Germany, Stephen Gilbert and William Gear in England, Jean-Michel Atlan and Jacques Doucet in France are perhaps the best known. Refer to Willemijn Stokvis, *Cobra*, De Bezige Bij, Amsterdam 1974.

Heading of page 3 to periodical *Cobra* no 4, 1949, the Dutch issue

So cobra is no longer only a word for a venomous snake, at least not to those interested in the development of modern European art. Although the name derives from the cities Copenhagen, Brussels and Amsterdam, references to 'snake' appealed to CoBrA artists, who, from the beginning, produced images of snakes for use in their various activities and publications. Animals, real and imaginary, were generally important in CoBrA iconography, birds particularly, but also cats, dogs, horses and fish. Associations of freedom, independence and sheer enjoyment in the otherness of animals, rather than any suggestion of anthropomorphism, prompted the attraction to animal imagery.

Constant, the group's secretary and self-appointed spokesman, wrote a stirring Manifesto published by the Experimentele Groep in their periodical *Reflex 1* 1948 and again in 1949 in the 4th issue of the periodical *Cobra*, which was devoted to the Dutch artists. It reads like a call to arms:

Our art is the art of a revolutionary period … and the herald of a new era … it is the expression of a life force that is all the stronger for being resisted, and of considerable psychological significance in the struggle to establish a new society. … a painting is not a composition of colour and line but an animal, a night, a scream, a human being, or all of these things together.[4]

Each artist included here was prominent in the first major exhibition of CoBrA art and artists held in November 1949 at the Stedelijk Museum, Amsterdam,[5] under its new Director Willem Sandberg.[6] Four of CoBrA's principal Dutch members – Constant, Appel, Corneille and Lucebert – are at the heart of this publication and exhibition.

CoBrA didn't only comprise painters. Equally important in the Netherlands were writers, especially poets. Poets Gerrit Kouwenaar, Jan G Elburg and Bert Schierbeek were actively involved in the Dutch Experimentele Groep/CoBrA movement, prompting various collaborations with artists: Appel with the Belgian writer Hugo Claus and with Schierbeek, Constant with Kouwenaar and with Elburg, for example. Particularly outstanding is *Het uitzicht van de duif* (The prospect of the dove) 1952, the result of a collaboration between Constant and Elburg. Not only are Constant's reductive red, black and blue woodcuts forcefully dramatic, but Elburg's poem is equally stirring and memorable. Set in Gill Sans typeface and printed in ten parts, nine with woodcuts, it asks to be read aloud. Though in time Elburg may have harboured doubts about the youthful marxism of his poem (it was not included in his collected poems in 1975), in word-play, imagery and directness, it remains one of the most powerful expressions of post-war Dutch literature.

Constant was highly articulate and throughout his life wrote various texts associated with his work, especially in the post-CoBrA period, when he became involved in the international situationist movement and began to develop his own ideas concerning urban life, making sculptural models for an idealized urban future which he called *New Babylon*.[7] Many of the painters associated with the Experimentele Groep wrote, and several of the poets drew and painted.

Lucebert was an exceptional poet and artist. He illustrated his own work and that of fellow writers with his drawings. Part of CoBrA from the start (initially as a poet), he was aptly dubbed a double-talent, and by the mid 1950s, post-CoBrA, he was painting with daring gusto, inspired by Picasso and Dubuffet, as well as his artist friends. The period 1959–61 were red letter years for him as he established himself as a major Dutch painter. The titles for his paintings underscore his humour and inventiveness with words (as in *I can't dance, I've got ants in my pants* 1984, included here); and he skipped naturally from Dutch to French, German, Spanish and English. There was also mutual respect between Lucebert and Appel which remained throughout their lives. Lucebert's poems for Appel are clear evidence of regard and affection:

4. From the English translation of Constant's 'Manifesto' by Leonard Bright in *Cobra, an international movement in art after the Second World War*, Willemijn Stokvis, Polígrafa, Barcelona 1987, pp 29–31

5. The exhibition was designed and installed by the modern Dutch architect Aldo van Eyck and ran from 3–28 November 1949. Both Constant and Appel painted large canvases especially for the exhibition. Constant's *Barricade* 1949 remains one of the most stirring and important paintings of the CoBrA movement. The Dutch 4th issue of the periodical *Cobra*, of which Corneille was editor, was its catalogue. The exhibition attracted considerable attention in Dutch newspapers, especially following the public row that occurred on Saturday 5 November in response to Christian Dotremont's address given at the poetry readings and other speeches associated with the exhibition.

6. Sandberg was arguably the most influential Dutch museum director of the post-war years, and under his guidance Amsterdam's Stedelijk Museum became one of the most important and innovative museums of modern art in the world. His name and legacy, concerning exhibitions, publications and acquisitions at the Stedelijk Museum during his directorship (1945–62), are still held in very high regard in the Netherlands. Immediately after the War, exhibitions of contemporary Dutch artists were staged, as were major exhibitions of Braque, Matisse and Picasso (including his *Guernica*), for example. Sandberg modelled the Stedelijk somewhat on New York's Museum of Modern Art in the time of its first Director, Alfred H Barr jnr. For an overview of his life and thoughts refer to Ank Leeuw-Marcar, *Willem Sandberg, portret van een kunstenaar*, Meulenhoff, Amsterdam 1981.

7. Refer to Mark Wigley, *Constant's New Babylon, the hyper-architecture of desire*, Witte de With center for contemporary art, 010, Rotterdam 1998 for a relatively recent and comprehensive reference in English to Constant and his *New Babylon* project. This book also has a number of Constant's best known writings translated into English. For the most up-to-date exhibition list and bibliography, including a list of Constant's writings, refer to Trudy van der Horst (the artist's widow), *Constant: de late periode, tegen de stroom in naar essentie*, BnM, Nijmegen 2008.

you are the dearest, you are the dearest
a thousandfold told to wood, metal, paint, cork
did the image make falling shafts everywhere
from gratitude he placed the sun inside it [8]

One of the most interesting aspects of post-war Dutch art is the connection between art and literature, especially poetry. Apart from various collaborations between artists and poets, a number of literary periodicals like *Blurb* and *Braak* began to appear that promoted the writings of the new post-war generation, which were often illustrated by artists. They were modest productions but influential nonetheless, as were various publications by members of the Experimentele Groep and CoBrA. Apart from Lucebert, Karel Appel and Corneille also wrote poetry (though Appel did so at first only in private). Jaap Nanninga, too, was a poet, his poems published under the *nom de plume* Cor Stutvoet.[9] In the 1920s and 1930s Bram van Velde wrote moving letters (published in 2006) to his first patron and former employer Eduard Kramers which, together with the publication of transcriptions of his conversations with French writer Charles Juliet from the 1960s to '70s, provide us with a vivid picture of a singular creative life, and are an important contribution to the literature of art.[10] The titles of Bram Bogart's paintings also reveal a love of word play that is very like concrete poetry. The poet Gerrit Kouwenaar (whose elder brother, David Kouwenaar, was a painter) was briefly an art critic as a young writer, as were other writers, including the influential Dutch novelist W F Hermans. Unfortunately, there just aren't enough translations of Dutch literature into English for there to be more than a limited awareness in the English-speaking world of twentieth-century Dutch literature, which is rich territory for those able to read Dutch.[11]

WAR, POST-WAR

The Second World War had a debilitating effect on Netherlanders, quite apart from its brutality. The country capitulated quickly to Germany following devastating air raids in May 1940, especially on Rotterdam, its principal port. Neutral during the First World War, this was an unexpected assault on Dutch soil by a close neighbour. Nazi Germany aimed to absorb the Netherlands into its Third Reich, based on the mistaken assumption that Netherlanders were essentially German. Artists were also required to subject themselves to the insidious scrutiny and censorship of the Nazi *Kultuurkamer* (Chamber of Culture), set up by the occupiers in order to control and direct creative activity in the Netherlands. Artists required the sanction of the *Kultuurkamer* to buy art materials, sell or exhibit during the War years. Many Dutch artists refused to comply and went into hiding, emerging only after the entry of Canadian forces and the retreat of the German army, in May 1945. The last year of the War was particularly difficult and the winter one of the coldest on record in Europe. Food was only available on the black market. Dubbed the *hongerwinter* (hunger-winter), many people died from starvation and/or the cold. The young artist Corneille was just one who faced starvation, weighing barely forty kilos at the end of the War.[12]

Soon, the new generation of artists to which Corneille belonged feared another enemy – cultural stagnation or a return to how things were before the War. As Constant expressed it in his Manifesto:

The cultural vacuum has never been so strong or so widespread as after the last war, when the continuity of centuries of cultural evolution was broken by a single jerk of the string.

For many artists, particularly those involved in CoBrA, post-war Netherlands was stiflingly conservative. The close-knit homogeneity of the population and its established social and cultural values was firmly set

8. Translated by Cornelis Vleeskens from: *Jij ben de liefste, jij ben de liefste/ Duizendmaal tegen hout, metaal, verf, kurk gezegd/ Maakte het beeld vallende schacht overal/ Uit dankbaarheid heeft hij de zon er in gelegd* part V of a nine-part poem *Dagwerk van Dionysos* (Daily work of Dionysus) written early in 1948, shortly after Lucebert met Appel. The two best known poems by Lucebert for Appel are from the 1960s: *Drift op zolder en Vragende kinderen, voor Karel Appel* [English translation p 197] and *Vrijheid, voor Karel Appel*. After Lucebert's death, Appel wrote affectionately about him in one of the major Dutch newspapers (*NRC Handelsblad* 20 May 1994): 'Aan mijn dierbare vriend Lucebert' (To my beloved friend Lucebert), recounting how alike he felt they were in looks, type of person, way of speaking, creative drive etc.

9. Cor Stutvoet, *Gedichten*, De Windroos, Amsterdam 1955

10. Anita Hopmans & Erik Slagter, 'Het ritmus van de kunst': brieven van Bram van Velde aan zijn mecenas 1922–1935, Thoth, Bussum 2006; Charles Juliet, *Conversations with Samuel Beckett and Bram van Velde*, Academic Press, Leiden 1995

11. Two of the most recent anthologies of post-war Dutch poetry translated into English are: Peter Glassgold, *Living space, poems of the Dutch fifties* (PIP anthology of world poetry of the 20th century, volume 6), Green Integer, Los Angeles 2005; and J M Coetzee, *Landscape with rowers, poetry from the Netherlands*, Princeton University Press, Princeton 2004. Dutch-born Australian poet Cornelis Vleeskens was responsible for *Naked dreams, Dutch poetry in translation*, Post Neo publications, Melbourne 1988 and *Simon Vinkenoog, and the eye became a rainbow*, Fling Poetry, Melbourne 1990. He is also responsible for translations of poems from Dutch to English in this publication.

12. Cathérine van Houts, *Karel Appel, de biografie*, Contact, Amsterdam 2000, p 69

against change. The general Dutch population wanted nothing more than a return to pre-war conditions, free from conflict and occupying forces, re-establishing their lives and homes and looking forward to a return to relative prosperity.

There is often cultural resurgence following war, associated with the inevitable reconstruction of towns and cities. Rotterdam was rebuilt into a modern city and its extensive harbour (the biggest in Europe) modernized. Improvements were made in public housing across the Netherlands, as well as to social services, in keeping with the needs of a modern state. Artists and intellectuals, many of whom were politically radicalized by their experiences in the Depression and War years, were highly critical of cautious and conservative post-war governments. This eventually led to the aggressive activism of the Dutch PROVO movement of the 1960s. There was also a growing desire amongst many, including artists and writers, to leave the Netherlands, to be as far as possible from where War had been waged. Post-war emigration from the Netherlands was actively encouraged by the Dutch government, which was fearful of accommodating a growing population in a relatively small country, short on resources. The governments of preferred destinations for potential migrants – America, Canada, South Africa, Australia and New Zealand – anxious for labour from culturally-desirable Europe, were willing participants.[13]

Substantial numbers of assisted Dutch migrants came to Australia after the Second World War, including artists and writers. Jan Riske, freshly graduated from art school in Rotterdam, and the highly regarded poet/editor Koos Schuur were among them. Schuur stayed the best part of twelve years before returning to the Netherlands;[14] Riske remained and established himself as a significant abstract painter, first in Hobart, then in Melbourne and Sydney. He also continued to exhibit in the Netherlands and in time, in the United States and London. The lithographic printer Fred Genis first came to Australia in 1959.[15] He stayed until 1964 working as a PMG linesman. Genis was an admirer of Schuur's poetry even before he came to Australia and made contact with him once in Sydney. Their friendship, forged in Australia, lasted until Schuur's death in 1995. Genis returned to Australia in 1979 after establishing his reputation as a major lithographic printer in America in the 1960s and early '70s, printing for Robert Rauschenberg, James Rosenquist and Willem de Kooning, amongst others, as well as for artists in the Netherlands when he was there in the 1970s, including Lucebert, Gerrit Benner and Theo Kuijpers.

For many other artists, leaving the Netherlands permanently, or intending to, was not on their minds, but general dissatisfaction with the status quo was. Many artists hoped for change and sought to facilitate it. Dutch architecture benefitted from post-war renewal; the evidence is clearly visible almost everywhere in the Netherlands. Modern architecture is a natural part of the built environment, experimentation and innovation are encouraged, and the old and new are generally convincingly complementary or effectively in contrast. Modern literature, music and art flourished and received (still receive) serious government support. Post-war schemes for public sculpture,[16] paying artists for their work, including art in new buildings, and supporting artists through art rental schemes, have influenced governments in other parts of the world (including Australia) in formulating ways to support and encourage art and artists.

THE ARTISTS

More than any other Dutch artist of the past, Vincent van Gogh was the guiding star for post-war artists – as much for his stubborn purposeful determination and intensity, as for the expressive power and originality of his art. Bram van Velde admired Vincent van Gogh above almost anyone else,[17] as did Jaap Nanninga, Wim Oepts, Karel Appel and Corneille. Bram Bogart has held Van Gogh in the highest regard from the very beginning, so have Jan Riske and Theo Kuijpers. The art of the Dutch graphic artist Hendrik Nicolaas Werkman (1882–1945)[18] was also influential, greatly facilitated by a major exhibition of his work

13. For an overview of Dutch migration to Australia, refer to Nonja Peters, *The Dutch down under, 1606–2006*, Wolters Kluwer, Sydney 2006

14. Schuur continued writing while he was in Australia, though with difficulty, a situation exacerbated by his wife leaving him and their two sons soon after their arrival. Schuur's colourful letters to friends in the Netherlands (including Jan G Elburg and Bert Schierbeek) were published as a book, *De kookaburra lacht* (The kookaburra laughs) in Amsterdam in 1953. It was popular in the Netherlands and re-printed in an expanded edition upon Schuur's return ten years later, but unfortunately has never been translated into English for Australian readers. His extended poem *Fata morgana voor Nederlanders* (Mirage for Netherlanders) gives a far more considered (and lyrical) expression of his migrant experience [English translation of last part p 197].

15. Refer to Sonia Dean, *The artist and the printer: lithographs 1966–1981, a collection of printer's proofs* (exh cat), National Gallery of Victoria, Melbourne 1982; Hendrik Kolenberg, *From the lithographer's workshop* (exh cat), Art Gallery of New South Wales, Sydney 1993; and Julianna Kolenberg, *From the studio of master lithographer Fred Genis* (exh cat), Victorian Arts Centre, Melbourne 1997

16. Unfortunately, sculpture is not included in *Intensely Dutch*, in spite of the quality of post-war Dutch sculpture by Charlotte van Pallandt, Wessel Couzijn, Lotti van der Gaag, Shinkichi Tajiri, Carel Visser, André Volten and Auke de Vries, to name just a few. Karel Appel produced inventive sculptural works from the very start, and there are also some compelling monumental bronzes by Willem de Kooning (one at the National Gallery of Victoria). Since the Second World War contemporary public sculpture has proliferated throughout the Netherlands. With post-war reconstruction of Rotterdam, major works by internationally renowned sculptors Ossip Zadkine, Marino Marini, Fritz Wotruba, Pablo Picasso and Henry Moore and many other Dutch and European sculptors were placed in various parts of the city. The Kröller-Müller Museum near Arnhem has specialized in modern sculpture, establishing an extensive outdoor sculpture park that has attracted visitors internationally and influenced public museums around the world.

17. Bram van Velde said of Van Gogh, 'He was a beacon. Not like me. I just feel my way in the dark' (Juliet 1995, p 79).

18. Refer to Alston W Purvis, *H N Werkman*, Yale University Press, New Haven 2004; and Dieuwertje Dekkers, Jikke van der Spek & Anneke de Vries, *H N Werkman: het complete oeuvre*, NAi, Rotterdam 2008

at the Stedelijk Museum, Amsterdam, held immediately after the War. Tragically, Werkman was killed by German soldiers in the last days of the Second World War. In the first few years after the War, Piet Mondriaan's art and that of De Stijl were considered too detached from daily reality, but that gradually changed and the effect of Mondriaan's work is discernible in a number of important post-war artists, including Constant (briefly, post-CoBrA), Edgar Fernhout, Jan J Schoonhoven and Bram Bogart.

The work of two Dutch luminaries of twentieth-century abstraction, Bram van Velde and Willem de Kooning, foreshadowed the generation that grew to prominence after 1945. Van Velde lived and worked for much of his life in France, having left the Netherlands in 1922 for Germany, then moving to Paris in 1924. De Kooning spent most of his life in America after jumping ship in 1926. Both artists worked at their art instinctively, developing slowly but deliberately until both won acceptance as major abstract painters in the years immediately after the Second World War. Van Velde was associated with French post-war École de Paris abstraction; De Kooning was a key figure in North American abstract expressionism. Among Dutch artists the work of each is revered, though the Dutch public and its museums (apart from Amsterdam's Stedelijk Museum) were slow to react.

Bram van Velde's abstraction was far from formal. Its enigmatic power came from his struggle with poverty and isolation. His is an internalized private language of haunting dream-like forms, long reflected upon prior to the act of painting. For him, painting was a process of transcending painfully deep emotional experiences. The French writer Charles Juliet, who visited and interviewed Van Velde and Irish writer Samuel Beckett in the 1960s and '70s, transcribed the essence of his conversations with each of these solitary men. Van Velde's words are amongst the most memorable, bleak and inspiring records of a creative individual ever published. Typical are:

Life is a struggle. So is painting.

Pictures don't come from your head but from life.

When I am working, everything I've done comes back and goes into my hand. Instead of being behind me, it's suddenly in front.

A painting is an instant of time that has escaped oblivion.[19]

The extraordinary friendship that existed between Bram van Velde and Samuel Beckett highlights the existential impact of his paintings. Van Velde was first introduced to Beckett in 1937 (the year Beckett settled in Paris) by his younger brother Geer van Velde, also an abstract painter in Paris, but the close association between Van Velde and Beckett did not begin until 1940, when, at a particularly bleak time, Van Velde wrote to Beckett. Their friendship ultimately proved to be important to each of them, though neither was known to be a conversationalist; both frequently remaining silent in company. Beckett purchased a painting and contributed through his writings to the appreciation of Van Velde in the post-war years. He wrote poetically and with understanding about the paintings:

An endless unveiling, veil behind veil, plane after plane of imperfect transparencies, light and space themselves veils, an unveiling towards the unveilable, the nothing, the thing again.[20]

As a young man in The Hague, Van Velde was influenced by George Hendrik Breitner's vigorous tonal paintings of Amsterdam, its streets and inhabitants.[21] But when Van Velde moved in 1922 to Worpswede near Bremen, northern Germany (attracted by a small group of expressionist German painters), he too turned to expressionism. The earlier influential artists' colony, of which Paula Modersohn-Becker was a key member, had long disbanded before Van Velde arrived. He met his future wife, the painter

19. Charles Juliet, *Conversations with Samuel Beckett and Bram van Velde*, Academic Press, Leiden 1995, pp 75, 43, 113, 74

20. Samuel Beckett in *Bram van Velde*, Harry N Abrams, New York 1962. Beckett wrote tellingly about both Van Velde brothers, Bram and Geer – see bibliography. The painting by Bram van Velde that he bought, *Untitled* 1937, is now in the Centre Georges Pompidou, Musée national d'art moderne, Paris.

21. George Hendrik Breitner (1857–1923) was one of the most important Dutch painters of the late 19th and early 20th centuries, occupying a similar place in Dutch art to that of Walter Richard Sickert in British art. There are numerous books and exhibition catalogues; the standard reference is: Adriaan H Venema, *G H Breitner 1857–1923*, Het Wereldvenster, Bussum 1981.

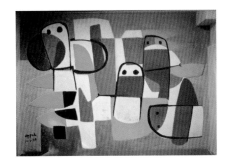

Karel Appel *Vragende kinderen* 1949
Mural in café of Town Hall, Amsterdam

Lilian Klöker, in Worpswede and struggled to survive financially, despite a modest allowance from his former employer Eduard Kramers. His letters to Kramers reveal a life deeply committed to art whatever the sacrifices. In Worpswede, sharply accented colour began to occupy Van Velde more and more, drawing him to Paris where Matisse and the *fauves* had earlier pioneered the use of intense colour.

After the War, Van Velde's work became increasingly abstract. He painted in thin veils of diluted oil paint or in gouache and, with the encouragement of his dealer, Jacques Putman, produced over 400 lithographs. Although he was not prolific as a painter, his lithographs have effectively distributed the essential characteristics of his work to collections internationally.[22]

Willem de Kooning's reputation as a major painter was made in America. Like Van Velde, he initially trained as a painter/decorator. His first drawings were immaculately realist, but in New York, especially after meeting the expatriate Jewish-Armenian artist Arshile Gorky, he was increasingly attracted to a surrealist form of abstraction. The agitated expressive painterliness of De Kooning's work after the War is akin to Chaïm Soutine's and reveals an emotionally charged northern European temperament, most obvious in *Woman I* to *Woman V* 1950–53.[23] This was not lost on Karel Appel when he saw De Kooning's paintings for the first time in New York in 1957. Appel's painterly brutality is very like De Kooning's. De Kooning's excoriating images may hark back to his troubled childhood relationship with his mother, just as they reflect the depiction of women in American popular culture.

 Appel was the most physically dynamic of the Dutch CoBrA artists and, following the public outcry over his mural *Vragende kinderen* (Enquiring children) for the café in Amsterdam's Town Hall in 1949, he acquired a notoriety that quickly led to international fame. Almost from the start he painted and sculpted with vigorous abandon – first as a young artist in an unlit, unheated attic studio in the old centre of Amsterdam, and later, in the 1950s in Paris. Doors, buckets, soap-holders, odd pieces of sawn wood and detritus found on the street or in rubbish bins, crudely or summarily painted, found their way into his early post-war work, adding to a reputation which many considered deliberately provocative.

Much quoted is his 'I paint, I mess about a bit … I put it on particularly thick just now, I smack the paint on with brushes and spatulas, and my bare hands, I sometimes throw on whole pots…' It was a somewhat cavalier or offhand response to a straightforward question from the Dutch journalist Jan Vrijman for an article which appeared in a Dutch weekly magazine in 1955 – *What are you doing at the moment, Karel?* [24] Appel's answer confirmed the worst fears of his critics: that he didn't take art seriously. As Appel explained later, 'That's painter's talk. Messing about a bit, everything is in that … That means it's going well. People missed it completely'. Vrijman went on to produce a brilliant film about Appel at work, in which he is shown literally attacking his canvas with palette knives and squeezing paint directly onto the surface from big tubes of paint, set to music by Dizzy Gillespie and Appel's own *Musique barbare*.[25]

Appel was and remained an uncompromisingly figurative painter, though his energetic painterly attack was essentially *tachist* or abstract expressionist. He believed that pictorial solutions had to be found and resolved in the manipulation of his chosen material – paint, which he mixed with seventeenth-century stand oil, damar varnish and raw eggs[26] – and not from any pre-conceived image or formula. He produced some of his toughest and best work in Paris in the 1950s and '60s (such as *Paysage à la tête noire* 1959, included here), though he was actually happiest living and working in New York, after he began showing there, initially with the Martha Jackson Gallery in 1954–55. He continued to paint and sculpt with vigour, often on a monumental scale, until the end of his life. *Horizon of Tuscany #36* 1995 is a particularly joyful example of this last phase of his painting life.

22. Refer to Rainer Michael Mason & Jacques Putman, *Les lithographies 1923–1973*, *Les lithographies II 1974–1978* and *Les lithographies III 1979–1981*, Yves Rivière, Paris 1973, 1979 and 1984 respectively.

23. The last in the series, *Woman V* 1953, in the collection of the National Gallery of Australia, was not, unfortunately, available for loan.

24. Jan Vrijman 'Appel rolt ver van de stam', *Vrij Nederland*, 29 January 1955. Also refer to Van Houts 2000, pp 214–215

25. Vrijman began making the film, *De werkelijkheid van Karel Appel* (The reality of Karel Appel) in 1961. Dizzy Gillespie composed *Lyrics for Appel* especially for the film. The film won the Golden Bear for the best short film at the Berlin Film Festival in 1962. A gramophone record was made of Appel's *Musique barbare*.

26. Van Houts 2000, pp 167–168

Appel and Corneille formed a close friendship from the moment they met at the Rijksakademie van Beeldende Kunsten in Amsterdam during the War, but became competitive as their reputations grew. Their friendship was one of opposites. Corneille is the most French in sensibility of the Dutch CoBrA artists. His drawing was exceptional from very early in his development and he demonstrated a sophistication in colour orchestration and composition that set him apart as painter and draughtsman, especially in the 1950s and '60s. When Corneille turned to printmaking, his draughtsmanship and skills as a designer became even more apparent. His prints, books and portfolios are amongst the most accomplished of any post-war artist's. Successful collaborations with writers and poets are a significant part of his work, none more so than with Jean-Clarence Lambert and the Senegalese poet and statesman Léopold Sédar Senghor.

After the War Appel and Corneille tried, unsuccessfully, to attract two idiosyncratic Dutch artists from an older generation to their experimental group – Gerrit Benner and Jaap Nanninga. Benner and Nanninga were from conservative rural northern Netherlands. Benner had struggled in isolation in Leeuwarden and Groningen for years, partly influenced by the work of various Dutch, German and Belgian expressionists as well as Hendrik Werkman. While in hiding from the German occupiers during the Second World War, Benner created an extremely simplified, brightly coloured and expressive vocabulary of shapes or forms for clouds and sky, landscape and cows, which can be described as unmistakeably Dutch. Nanninga, who moved to The Hague in 1940, gradually established himself as a major painter for his equally reductive, tonally restrained and melancholic abstracts. Both Benner and Nanninga admired the work of the new CoBrA artists but were happier working by themselves. Benner moved to Amsterdam and occupied Appel's abandoned studio after Appel left for Paris in 1950. Nanninga's friendship with Hague modernist artists Piet Ouborg and Wim Hussem[27] suited him better than the brash young Appel – who probably realized as much when he made a lightning visit to Nanninga's studio in 1949. The work of both Benner and Nanninga underscores the power and originality of individual sensibilities amongst artists in post-war Netherlands.

Constant was as gifted musically as he was visually, and equally able to express himself effectively in words (written and spoken) across several languages. In just a few years he moved effortlessly from passionate engagement with CoBrA imagery to abstraction,[28] sculpture and architectural theory and practice, almost abandoning painting altogether in the early 1950s. In 1969, after an intense seventeen-year engagement with his architectural *New Babylon* project, painting re-emerged as his dominant occupation. In the next thirty-five years he was responsible for a remarkable and varied body of paintings, drawings, watercolours and prints, the quality of which alone would ensure his reputation as a major twentieth-century European master.[29]

Although CoBrA disbanded in 1951, its influence continued, but it wasn't the only new art movement of consequence to artists in the Netherlands. Significantly, there were manifestations of *art informel* by various artists, just as there were in France, Germany, Italy and Spain. The best known and most successful of these artists in the Netherlands were Jaap Wagemaker, Jan J Schoonhoven and Bram Bogart.

Wagemaker was from Haarlem near Amsterdam and initially, in the 1930s, he painted expressionist works in the vein of the Dutch expressionist Herman Kruyder and the Belgian Constant Permeke, but after the War and his move to Amsterdam (into one of the modern purpose-built artists' studios on the Zomerdijkstraat),[30] his work began to change, especially when he became aware of CoBrA art and artists. Schoonhoven and Bogart came from the small historic town of Delft (between Rotterdam and

27. Piet Ouborg (1893–1956); refer to Leonie ten Duis & Annelies Haase, *Ouborg schilder/painter*, Openbaar Kunstbezit, Amsterdam/SDU, The Hague 1990; Wim Hussem (1900–74), painter and poet.

28. As Constant explored abstraction post-CoBrA, during a short stay in London in 1951–52 he had a decided influence on the modern British artist Roger Hilton. See Adrian Lewis, *Roger Hilton*, Ashgate, Aldershot 2003.

29. Refer to Jean-Clarence Lambert, *Constant, les trois espaces*; *Constant, les aquarelles* and *Constant, l'atelier d'Amsterdam*, Cercle d'Art, Paris 1992, 1994 and 2000 respectively; and Trudy van der Horst 2008.

30. These studios were designed and built specifically for the use of artists between 1932 and 1934. The architectural firm responsible, Zanstra, Giessen and Sijmons, was strongly influenced by Le Corbusier. Comprising four levels, ground floor studios were the biggest and intended for sculptors. They are still in use. Apart from Wagemaker, Herman Kruyder, Charlotte van Pallandt and Jan Wolkers have lived and worked there. Refer to Simon den Heijer & Marike van der Knaap, *Jaap Wagemaker, schilder van het elementaire*, Waanders, Zwolle 1995, pp 40, 41.

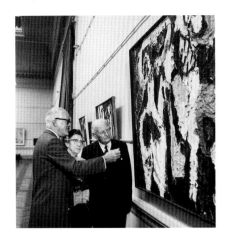

Hal Missingham, Director, with visitors to exhibition *Trends in Dutch painting since Van Gogh* at the Art Gallery of New South Wales, December 1961

The Hague). At first glance their art could not be further from the seventeenth-century artist with which Delft is usually associated, though the cool detachment of Schoonhoven's white reliefs share a fundamental stillness and geometry with Vermeer's paintings.

With most critical and public attention on the artists of the CoBrA movement in Amsterdam, artists like Schoonhoven and Bogart initially struggled to gain recognition, although Wagemaker won through relatively quickly. Schoonhoven did so in time, though he worked for a living as a postal clerk in Delft and The Hague for over thirty years. Bogart left for Paris in 1951 and, at Dutch sculptor Lotti van der Gaag's suggestion (his girlfriend at the time), moved into a studio on rue Santeuil – the same ex-leatherworks warehouse Appel, Corneille and Constant used, though they had little interest in Bogart, or he in them.[31] Eventually Bogart settled in Belgium where he took Belgian nationality. In Belgium, Bogart's work received immediate acclaim and he remains a major figure there, as well as internationally. His extravagant, brilliantly pigmented layers of paint set him apart from his contemporaries. There is a joyous masculine sensuality in his monumental reliefs of paint, heightened by the use of bright saturated colour. Occasionally there is a complete absence of colour in surprisingly spare and contemplative works in white or black. The dramatic simplicity of *Daybreak* 1997 recalls Van Gogh painting the sun – an ecstatic exclamation of white light across a field of incandescent yellow, the equivalent of sharp Australian summer sun at midday!

The gridded ascetic minimalism of Schoonhoven's work evokes the facades of modern skyscrapers in today's cities, whereas Wagemaker's organic, earth-like surfaces made using burlap, bones, odd pieces of worn wood, slate or rusted machinery, bring crumbling walls, our cave-dwelling pre-historic past, or even the effect of industrial pollution to mind. It is heartening that there are evocative works by such artists in Australia, and hence included here – Bogart's *Dansante larmoyante*, in the collection of the National Gallery of Victoria, and Wagemaker's *Verdigris*, at the Newcastle Region Art Gallery, both from 1958. An icy wind seems to blow across the paint impastoed terrain of Melbourne's Bogart, while a foul chemical odour is suggested by Newcastle's Wagemaker. Interestingly, Newcastle purchased its Wagemaker in 1962, from the only other Australian exhibition apart from this one to include post-war Dutch art. On tour in Australia 1961–62, *Trends in Dutch painting since Van Gogh*, was organized by the Gemeentemuseum, The Hague.[32]

Two other artists from an older generation than the key figures in the CoBrA movement, and whose art matured after the War, were Wim Oepts and Edgar Fernhout. In the 1930s, Oepts painted brooding realist figure compositions under the influence of Charley Toorop, Fernhout's mother. Oepts also produced some exciting woodcuts, but after discovering the south of France in the late 1930s, he turned to high-key Mediterranean light with fauvist panache throughout the 1950s, '60s, '70s and '80s, simplifying, re-configuring and abstracting his subjects in his studio from the simple notational drawings he made 'on the spot'. Modest in size, his canvases recreate the ideal summer's day, as he must often have experienced it in the small towns and fishing villages of the France he loved. Briefly one of Othon Friesz's students in Paris, he rarely exhibited his work. He was poor and worked largely in isolation, almost forgotten except for a few artist friends and enthusiastic collectors. It wasn't until the opening of the Museum Henriette Polak in Zutphen in the late 1970s, that his work began to receive its due. A book about his life and work appeared shortly after his death in 1988.[33]

Fernhout was similarly attracted to light – there is a particular, clear transparency of light in his still lifes and studio window paintings from the 1930s that recalls the Italian *quattrocento* of Piero della Francesca and Antonello da Messina – but after the War the refined magic realism of his work began to change.

31. *Halle-aux-cuirs* (Leather Halls) 20 rue Santeuil, 5th arrondissement, near the Jardin des Plantes.

32. The exhibition was first shown at the National Gallery of Victoria in Melbourne, before touring to Launceston, Sydney, Adelaide and Newcastle between October 1961 and February 1962. In Sydney it was held at the Art Gallery of NSW attracting reviews by James Gleeson, 'Fitting climax', *Sun*, Sydney, 14 December 1961; John Henshaw, 'Forceful contribution', *Bulletin*, Sydney, 23 December 1961; and Robert Hughes, 'Van Gogh among us', *Nation*, Sydney, 13 January 1962.

33. Dolf Welling, *Wim Oepts, schilder van het zonnige Zuiden*, Waanders, Zwolle 1991. The most recent publication is Lies Netel, *Wim Oepts 'peinture, c'est le principal' 1904–1988*, Museum Henriette Polak, Zutphen 2006

He emphasized flat brush-strokes in his portraits, still life compositions and seascapes, simplifying and abstracting his subjects until he arrived at an ordered pattern of brush-strokes suggestive of vibrations of light. In an inspired passage about Fernhout's *Autumn* 1962 in *Studio International* in 1973, Rudi Fuchs wrote:

How slowly and painstakingly this painting must have been painted. Stroke has been laid over stroke, adjustment after adjustment; there is no area which has not been retouched several times over. … The strokes of the brush are discretely in evidence; their difference in direction is only slight though just enough to articulate each individual position; hence they are at no point countering each other. In fact their relative positions seem to be calculated so as to let them slip into and *receive* each other, like people embracing.[34]

As a boy, Fernhout knew Piet Mondriaan, a friend of both his grandfather, the artist Jan Toorop, and his mother, Charley Toorop. Mondriaan's influence is present in Fernhout's earliest paintings, but most clearly discernible in his late post-war paintings, though he eschewed the extreme formal logic of Mondriaan for a tempered painterly lyricism.

Also included here are two artists born in the 1930s, Jan Riske and Theo Kuijpers, whose work grew out of the hard-won freedoms of the immediate post-war generation. Their inclusion extends the scope of this publication and associated exhibition beyond the post-war period. They also highlight particular connections between Dutch and Australian art. Jan Riske's earliest abstract paintings were made in Australia in the mid 1950s though they betray a distinctly European sensibility. He and his family experienced the dangers and hardships of German occupation in Dordrecht during the War. Near Rotterdam, Dordrecht is the biggest junction of canals for inland shipping in the Netherlands and was therefore of strategic importance to the German occupiers. After the War, Riske was encouraged by the Director of the Dordrechtsmuseum, Dr Laurens J Bol, who helped him to secure a scholarship to attend the Academie van Beeldende Kunsten in Rotterdam. In 1952, aged 21, Riske left for Australia, following in the footsteps of his elder brother. Initially he settled in Tasmania, working for a time on the west coast, before travelling around rural Queensland. Shortly after, he set up a studio in Hobart and began to exhibit his paintings.

In the early 1960s Riske developed a dramatic and monumental form of abstract expressionism, painting in grand gestures with heavy impasto. The sheer size and power of these early canvases are quite breathtaking. *Apocalypse* is fifteen metres long and consists of twelve vertical adjoining panels each of which is two and a half metres in height. It was painted and exhibited in Amsterdam in 1962, in an old warehouse studio he shared with another painter and a sculptor.[35] *Apocalypse* is clearly his masterwork from this early phase, but unfortunately its current whereabouts is unknown. By the 1970s Riske had evolved into an intensely formal painter and draughtsman, his work structured geometrically, with fastidious surfaces in paint or black ink patiently layered to create spatial complexity and the sensation of infinity. Riske regards *Yellow command* 1988–89 (one of three major paintings by him at the National Gallery of Australia, Canberra) to be one of his very best. Reminiscent of a wheatfield by Van Gogh, its impasto is as ordered as if it were finely woven on a loom. There is an inherent tension in his work however, giving the impression that if any attempt were made to alter any part, the whole would instantly re-configure into another equally ordered arrangement.

As a young artist in the 1960s, Theo Kuijpers responded with precocious enthusiasm to the CoBrA artists and to *art informel*. A bold abstract painter from the start, he turned to collage and assemblage in the late 1960s and '70s, but returned to full-bodied painting after visiting Australia in 1979 and the USA in 1981. His mature work is a fusion of painting and collage, on dense discarded sail-cloth, exploiting the textural qualities of uneven, overlapping or frayed edges, seams, selvages, loose threads, stitching and all manner of other imperfections.

34. *Studio International*, May 1973, p 222. Rudi Fuchs, as Director, was responsible for an important memorial exhibition of Fernhout's work at the Van Abbemuseum, Eindhoven in 1976.

35. Riske shared the studio with the painter Hans Nahuijs and sculptor Jan de Baat. Refer to their catalogue *Barokke abstractie/ideeën*, self published, Amsterdam [1963]

While initially under the spell of CoBrA, Kuijpers soon established a distinctly personal, gestural paint handling. His collage phase owed much to Wagemaker and Tàpies (and he in turn influenced the Australian artist Tim Storrier, when they met in Australia in 1979 via the lithographic printer Fred Genis in Sydney).[36] Kuijpers was using sticks, pig's bladders, lead, wax, string and other ephemeral materials in his collages at the time. While here, he found traditional Australian Aboriginal art and the Australian bush and landscape seductive, and admired the work of Australian artists John Olsen, John Firth-Smith and Brett Whiteley, introduced to him by Fred Genis. The work that followed owes a great deal to his contact with Aboriginal art and culture. Kuijpers made a second trip to Australia in 1985. Upon returning to the Netherlands and a new studio in Eindhoven, he worked his way through his Australian experiences in drawings and paintings of remarkable bravura. As he told Bert Schierbeek, 'I think that anything you see freshly – each image, every form – needs time to fall in with what you'd seen earlier on. Then you can do something with it'.[37]

A decade of work that brought him back to his beginnings ensued, in which paint and gesture evoke memory of places seen and deeply felt. Greater formal authority characterizes his work in maturity. In its robust masculinity there is an undeniable poetry that is the result of experience and sheer love of painting.

Apart from two visits to Australia, Kuijpers has travelled widely, attracted by exotic cultures, landscapes and architecture, including South America, Egypt and Morocco. He is, however, wedded to the region he is from – in temper, speech and appearance he is 'Brabants', that is, from the southern Dutch province of Brabant. Both his studio and his home are in Brabant – the former in Eindhoven, the city in which he studied art, and the latter in Nuenen, where Vincent van Gogh (also from Brabant) lived between 1883 and 1885, working prolifically and painting his now famous *Aardappeleters* (Potato eaters) 1885.

MODERN DUTCH ART AND AUSTRALIA

Australian artists are inevitably overlooked for inclusion in ambitious surveys of nineteenth- and twentieth-century western art in Europe, such as those on impressionism, post-impressionism, surrealism, abstraction etc. Usually these focus on the art and artists of those places nearest the centres of greatest innovation. Nevertheless, Australian artists often travel to major cities attracted to forces of change and the intensity of activity in big cities, absorbing and/or re-interpreting what they find there and as a result, produce works of art that could find a place in international surveys.

Although there may be few direct connections between post-war Dutch and Australian art, there are immediately discernible similarities that are well worth exploring.

Just as Dutch CoBrA artists were inspired by child art and the art of Africa, the Australian artist John Olsen, for example, was attracted to Australian Aboriginal art. He also greatly admired the early twentieth-century moderns Picasso, Klee and Miró, and nearer in time, Dubuffet. He met Asger Jorn, Lucebert and Corneille in Paris in the 1950s and travelled with Corneille to Spain, where Olsen felt more at home than in Paris.[38] There is a clear similarity between the work of Olsen and some CoBrA artists, especially Corneille, though it is naïve to suggest that this is simply a matter of direct influence. Nevertheless, Olsen shares a great deal with CoBrA artists and it is certainly interesting to consider his work in the light of his Dutch, Belgian and Danish contemporaries.

Arthur Boyd's potent expressionist paintings of cripples and eccentrics from the War years (*Lovers on a bench* 1943 and *The gargoyles* 1944) are very like Constant's fiercest CoBrA images, or those inspired by the War, such as *De brand* and *Gevallen fietser*, painted in 1950, though Boyd and Constant never met and were unlikely to have known of one another's work. Indeed Constant's imagery (and that of other

36. Refer to Linda van Nunen, *Point to point, the art of Tim Storrier*, Craftsman House, Sydney 1987, p 73; and for images of collages by Kuijpers prior to his visit to Australia, Rick Vercauteren, *Theo Kuijpers, terugblik op twintig jaar kunstenaarschap*, Noordbrabants Museum, 's-Hertogenbosch 1988, pp 18–33

37. Bert Schierbeek & Reyer Kras, *IJmuider kring*, Reflex, Utrecht 1984, p 22

38. Refer to Deborah Hart, *John Olsen*, Craftsman House, Sydney 1991, p 37

CoBrA artists) brings to mind the early work of a number of the Melbourne Antipodeans apart from Arthur Boyd – Sidney Nolan, John Perceval and Albert Tucker. Edgar Fernhout's late paintings may remind some of the late phase of Ralph Balson's work; to others Karel Appel's *Paysage à la tête noire* 1959 may seem akin to recent paintings by Kevin Connor. Similarly, it is interesting to consider Elwyn Lynn's work with Jaap Wagemaker's in mind or the works of Ian Fairweather and Tony Tuckson with Bram van Velde's. Viewers to this exhibition may notice other similarities between Dutch and Australian artists.

Too often it is the activity of artists working in London, Paris and New York that takes precedence in Australia. When faced with the familiar attractions of nations with bigger populations, smaller countries like the Netherlands tend to be overlooked here. However, what at first appears to be unknown or foreign, need not be so. Australians often have to rely on secondary sources – the written word (books, art magazines), film/video – to access European art. Language may also be a barrier to those who rely on the English language alone in seeking answers to their enquiries.

Therefore, this publication and associated exhibition, brought together for an Australian audience, provide a rare first-hand introduction to the work of fifteen important post-war Dutch artists. Furthermore, it provides a pathway between Dutch and Australian experience and encourages a re-consideration of our connection with European art and culture. Each of the fifteen artists is perceived by this author to have sensibilities that are particularly Dutch and representative of the most telling features of new Dutch art after the Second World War and beyond. A closer look at the art of the Netherlands from a time when Australian art was also compelling, will not just help us to arrive at a fuller appreciation of a rich culture with a substantial post-war migrant population in Australia, but also cast fresh light on our own.

jan riske
the structure of joy 1967 (detail)
Art Gallery of New South Wales, Sydney

constant karel appel corneille lucebert

gerrit benner jaap nanninga

bram van velde willem de kooning wim oepts edgar fernhout

jaap wagemaker jan j schoonhoven bram bogart

jan riske theo kuijpers

constant

Constant Anton Nieuwenhuys was born in Amsterdam on 21 July 1920. As a boy he was interested in all the arts, especially poetry and music. He played the guitar and sang in a choir. As an adolescent he completed a mural painting for the refectory of his Jesuit school, though he left the school as an atheist. Unlike his mother, his father, an office manager, discouraged his son's interest in art. He spent 1938 at the Kunstnijverheidsschool (School for Arts and Crafts) in Amsterdam, where he learned techniques which would prove useful to him later, especially for his *New Babylon* project. From 1939 to 1941 he attended anatomy classes at the Rijksakademie van Beeldende Kunsten (National Academy of Fine Arts).

Germany occupied the Netherlands 1940–45 and bombed Dutch cities. Constant was deeply affected by the destruction, and particularly by the occupation of his native city. Like many other Dutch artists he went into hiding in 1943 after refusing to subscribe to the Nazi *Kultuurkamer* (Chamber of Culture) and, during the following years, suffered hardship, hunger and lack of art materials. Enforced isolation enabled him to read the works of the great philosophers, including Plato, Descartes, Hegel and, especially, Marx, whose ideas left an indelible mark on his thinking about art, architecture and urbanism. He devoted himself to his art, even re-using his canvases by boiling them to remove layers of paint. He was already an expressive painter with a colourful palette. His early portraits and still lifes were soon replaced by subjects that reflected a private child-like world full of imaginary and playful creatures. Animals remained important throughout Constant's life – he invariably had a pet dog or monkey.

24 l'animal sorcier (the animal sorcerer) 1949

Centre Georges Pompidou, Musée national d'art moderne, Paris

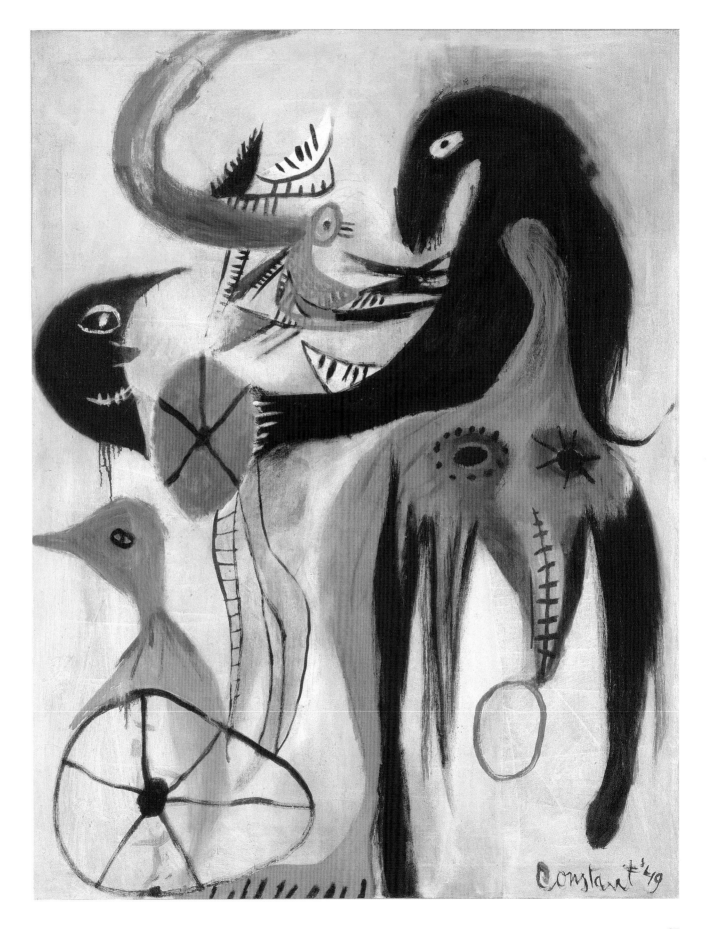

After the War, Constant lived briefly in Bergen, before returning to Amsterdam and an apartment opposite the zoo where he stayed for thirty years. He first visited Paris in the autumn of 1946, which proved to be a turning point for him. He admired the work of Paul Cézanne, Pablo Picasso, Henri Matisse, Alberto Giacometti, and discovered Joan Miró whose oneiric universe became a major inspiration. In Paris, the Dutch architect Aldo van Eyck introduced Constant to the Danish artist Asger Jorn and the two quickly developed a close relationship. Constant visited Jorn in Denmark and they began discussing the establishment of a new art movement, which eventually became CoBrA. In Amsterdam in July 1948, Constant, Karel Appel, Corneille and others, including poets Gerrit Kouwenaar and Jan G Elburg, founded the Dutch Experimentele Groep (Experimental Group). Constant was the group's spokesperson and theorist. His Manifesto, published in the first issue of the Experimental Group's review *Reflex*, proclaimed the necessity of 'experimental art', stating that:

The creative act is more important than that which it creates.[1]

In November 1948, CoBrA was founded in Paris by Danish, Belgian and Dutch artists including Karel Appel, Corneille and Constant. Constant remained at the centre of all CoBrA's activities until it disbanded in 1951. His private life was thrown into turmoil when his wife left him for Asger Jorn in 1949. Of their three children, Viktor, the eldest (born in 1944), remained with him. Viktor later became a film-maker and close collaborator on his father's models for *New Babylon*. Many of Constant's paintings were characterized by a brutal painterliness and anguished subject matter, as in *L'animal sorcier* 1949 and *De brand* 1950, inspired by his memories of the War.

During the CoBrA years and after, Constant travelled extensively in Europe and lived briefly in Frankfurt and Paris. In late 1952, at the invitation of the British Arts Council, Constant spent three months in London, where he met many artists including Henry Moore, Victor Pasmore and Roger Hilton. Back in Amsterdam in 1953, Constant became intensely interested in architecture and began to study its principles. Encouraged by Aldo van Eyck, he sought to articulate a new art, with utopian ideals aimed at a better life. He devoted more and more time to questions of architecture and urbanism, gradually forsaking painting, though not abandoning it entirely. After attending the conference of the Mouvement International pour un Bauhaus Imaginiste with Jorn in Alba, Italy, Constant grew ever closer to the thinking of the intellectuals of the avant-garde, especially the Lettrists and Situationists, and the concept of 'unitary urbanism'. In 1960, only two years after joining the International Situationist movement (founded by the French theorist Guy Debord), Constant left to devote himself exclusively to an architecturally inspired project of his own, *New Babylon*. It occupied him until 1969. During that time he produced a remarkable number of models, sculptures, drawings and paintings that gave imaginative shape to his unique vision.

He envisaged a new and ever-changing world in which current social structures were broken and leisure was more important. He believed, like the Dutch philosopher Johan Huizinga and his book *Homo Ludens*, that every individual should be free to modify his living space organically for the good of the community. Constant's ideas and his *New Babylon* project aroused international interest: his writings were published widely between 1959 and 1968; his models, maps, collages and constructions were exhibited frequently; and he contributed to numerous international conferences. When he abandoned his project in 1969, Constant believed he had achieved all he could. The French poet Jean-Clarence Lambert, who has written extensively about Constant, noted that it marked his 'return to the studio'.

Having taken part in several collective and innovative art movements over twenty years, Constant retreated to his studio to devote himself to painting, drawing, watercolour and etching. He said that it was impossible for him to ignore any plastic art form. His admiration for the old masters – Titian, Eugène Delacroix and Paul Cézanne in particular, became more obvious. He considered his work to be within the same tradition of western European painting, with colour as his central concern and the human figure as his primary focus. For him every new work of art represented a new adventure. At the end of his life he stated that:

A great work is one that offers maximum expression with the greatest simplicity.[2]

Throughout his long life Constant remained an independent, combative and compassionate individual. His paintings were often inspired by current events or the consequences of war and disaster. As the French art historian and critic Philippe Dagen has written:

In the second half of the 20th century, [Constant is] one of the artists who, constantly, stubbornly, refused to separate the condition of the artist from his situation as a human being.[3]

Constant died, aged 85, on 1 August 2005 in Utrecht.

1. Constant, 'Manifesto', *Reflex 1,* Amsterdam 1948. English translation in *Cobra*, Willemijn Stokvis, Ediciones Polígrafa, Barcelona 1987, p 30

2. Constant in documentary by Maarten Schmidt/Thomas Doebele, *Constant, avant le départ,* VPRO 2005, DVD 82 minutes (first played on Dutch television, Nederland 3, 21 December 2005)

3. Philippe Dagen, *Constant graveur,* Cercle d'Art, Paris 2004, p 45

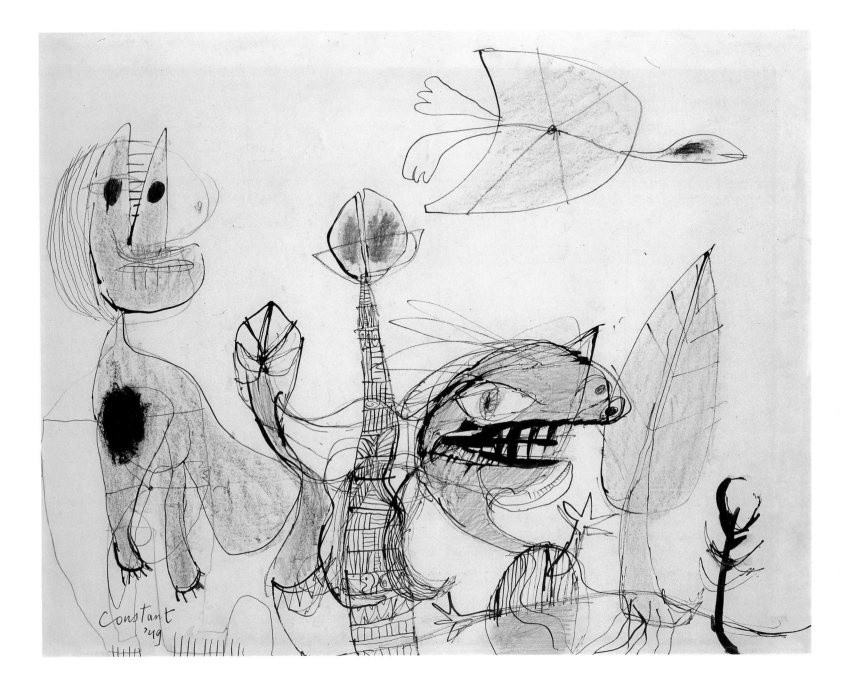

constant
27 tekening II (drawing II) 1949
Netherlands Institute for Cultural Heritage (on loan to Stedelijk Museum, Schiedam)

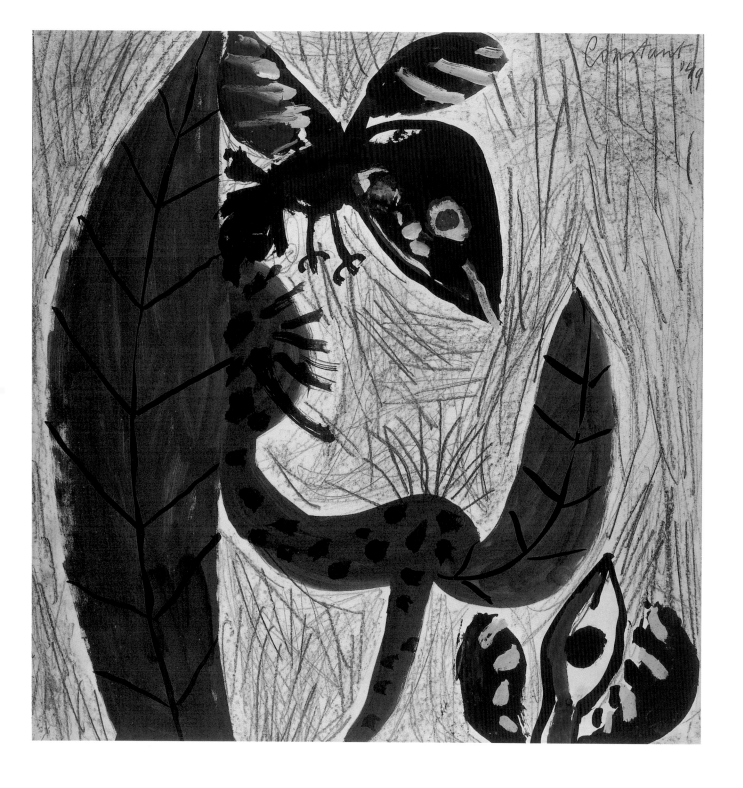

constant
28 vogels (birds) 1949
Stedelijk Museum, Schiedam

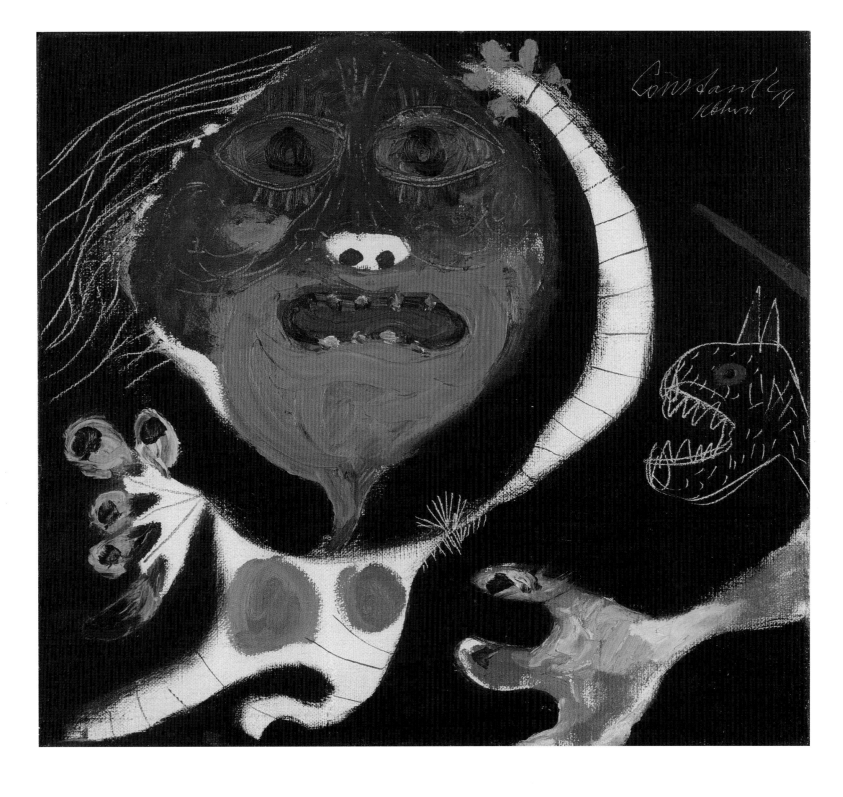

23 untitled, copenhagen 1949

Jan and Ellen Nieuwenhuizen Segaar

HET UITZICHT VAN DE DUIF

JAN ELBURG en CONSTANT

Koud als de vis, als het kijken van kruipende dieren,
als onderkoeld zonlicht onder ijs;
planten zijn stom en de dieren zwijgen.
Ik heb mijn eigen ontreddderd leven
om te weten hoe het met anderen is
in dit opgepompt en geverfd paradijs.

Wat de arbeiders met de rug van hun kinderen
en met het vel van hun handen betalen,
betaal ik mee: een losgeld van onrecht
met de gehavende taal van mijn blinde
ontevredenheid, maar altijd betaal ik te weinig:
slechts met de tijdlijke tik van mijn hart;
niet met de koekoeksklok van mijn bloed.

Maar de ogen gezouten door zweet en tranen,
maar het tergende ruien van de kalenders:
dat doen de dagen hem, wat doen de dagen?
Wat doen wij? Wij schuren de muren dun
met schampere krassen van kinderkrijt,
met een mes en een vijl van gewone wensen,
om eenmaal bewust de lamlendigheid
van het bukken, omkeren en bezwijken
aan de veiligheid van het onrecht en leed
van het arbeiderskind en de ongelijke
bevoorrechting ver om ons dood te weten.
Voorwaarts, en niet vergeten.

Wie biedt? Wat baat mij de stapelplaats
janmaats en machinegeweren? Wie biedt meer,
biedt mij een plaats zonder praatjes
van maan, mooie mogol of moloch of mammon,
een gewone plek zon, zonder gouden verleden?
Magnaat, magistraat, advocaat van de duivel,
wie biedt? En ik vraag geen afbraak.

Zij hebben octrooi op instortende huizen
en kleerscheuren, alleenvertoningsrecht
van mijn regen, op de rechte weg
de tol, om mijn geld te geven, te heffen,
het vruchtgebruik van gewassen:
koolzaad en graan en de zoete peen.

Van oudsher zien de ogen liever dons dan bloed
dat dons groeit op de duiven van Picasso:
daar steken de scherven als messen naar,
daar steken de fosforbommen de brand in,
daar steken die naar ons spugen de draak mee,
daar steekt het verleden de loftrompetten
van dode verdrukkers.

Vleselijk is onze vrede, gewone begeerte
naar een veilige wieg met een kleine stem,
een vriendelijk woord en een snee kruimig brood:
daar knaagt de dood aan, daar slaat een gele haan
de vlam van zijn vleugels aan,
daar komt men aan met een hand als brand.

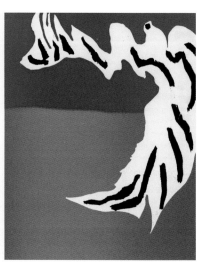

constant & jan g elburg
29 het uitzicht van de duif (the prospect of the dove) 1952
Gemeentemuseum, The Hague

English translation p 193

Met het beschadigd protest om een vrijheid
van veilig te zijn tegen zonbrand en regen
en honger en hoon van de windbuilen,
betaal ik mee aan een nooit te voldoene
hypotheek die de voorouders voor is gelogen
met de prenten van helden en stadhouders,
met de rekensommen van a naar b
en de doodgewone hooghollandse taalles.

Uitsluitend aan de gedachten als kamerplanten,
bestoft in het avondlicht, gaan steden dood;
uitsluitend aan de terrassen met krokante vrouwen,
uitsluitend aan de wanhoop thuis en de gregoriaanse
schooldeun achter de geeuwende ramen
slijten fabrieken en handelshuizen.
Uitsluitend aan haat sluit het hart zich, de wenk
van de handen met lettertekens als rook;
uitsluitend aan leugens sterft het woord,
aan leuzen en lessen het goed vertrouwen
van wind en water en oevervogels.

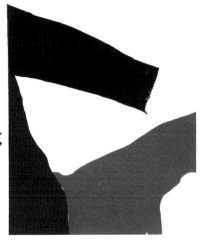

Wij, die die wereld bekijken met een vers
op de tong als een fluittoon van hoon,
wij dragen in wangen opgeborgen
een koperen doodshoofd dat boos is:
door hamers van binnenuit nors gebeukt;
in het zoeklicht van buiten verstard tot een grijns:
de lach van het cynische incasseren.

Zo kunnen de straten en kamers ons opleveren.
Wij zijn, want de straat kan ons opleveren,
met een voet en een voet en een hand
en een handtastelijk duidelijk gelijk,
grof en verongelijkt, omdat wij zijn die wij zijn:
met handen en voeten en monden ontkomen
aan deze onmenselijke mentaliteit:
lipstick te zijn van de klassenstaat.

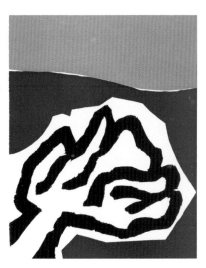

Ik moet: zoet zijn, soldaten betalen,
betaalde moed, overgoed bloed en pijn
eisen en goedkeuren, leugens bewijzen
en leuren met jabroers en harlekijnen,
bonen van broodroof eten.

Ik moest beter weten, Marx niet lezen,
kieskeurig wezen, niet de kant kiezen
van de blauwkielen onder het kolengruis,
uit het achterhuis, de armzalige achter-
en arbeidersbuurten, neen, fijn van alure
zijn en mij spijzen met het overschone,
ten hemel wijzen en God vertonen
(dat is: op een werf van bederf werken).
En de H-bommen doen de deur dicht.
Wie biedt een simpel uitzicht,
zonder aalmoezen angst, zonder pleinen van angst?

Dit is de keuze: onheuse leuzen,
delicaat gepraat van vingertoppen
op een toetsenbord met alfabet der kaballa,
of staan en weer vallen in het wisselvallig
gevecht om brood en recht en een nieuwe wereld,
met de veeltallig-veeltalige menigten:
kinderen, huismoeders, hardknuistige kerels:
een eenstemmig veemgericht van vrede.

Kameraden, wie een eerlijk besluit
in een lied uit en bij zijn klasse staan gaat,
zal door hofmeiers, honden en verstokte kohorten
gezocht en gejaagd worden, gehaat worden
als veepest. Maar het zal lang laat worden
eer hij van zijn vermaningen aflaat.

Persoonlijk willen wij een vaderland,
door de koeien betreden en gegeten,
met koren en zonnige wegen, zelfs in de regen:
dat egt men met prikkeldraad,
daar legt men vulkanen aan,
daar vecht zich een waanzin van wagenraderen
door dat zware broodgraan, dat laaien zal.

Werkelijk zijn wij met velen,
een werkelijkheid met blote handen:
daar zet men de tanden in,
daar duwt men geweren in van gewin,
daar neemt men de koperen centen uit,
daar wil men de lijnen in lezen,
hoe het zal wezen.

Het is bewezen dat hun rijk heeft uitgeluid:
wij zijn tot moed gedoemd, grauw van vertrouwen,
dat wij varen zullen, dit land bebouwen,
als vrijen in de fabrieken staan.
Daar helpt geen lievemoederen aan,
geen god in een heilig huis aan,
geen wichelroede, geen maan,
geen muizenval die op niets slaat,
geen huilen, geen politiestaat:
de toekomst ligt in de vuisten
van het proletariaat.

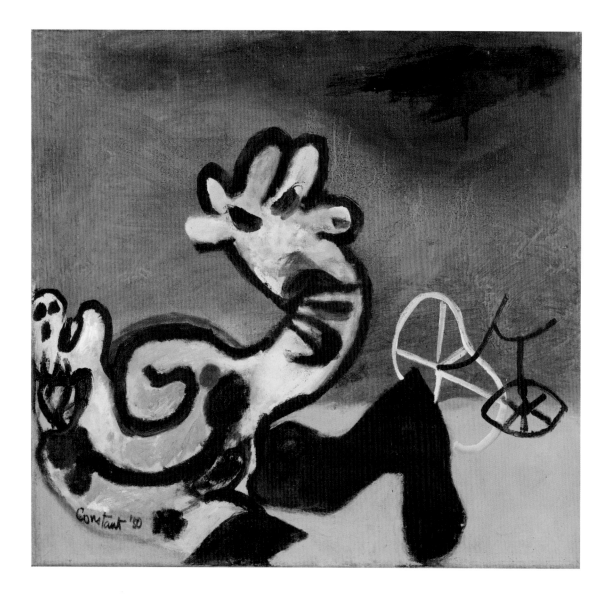

constant
25 gevallen fietser (fallen cyclist) 1950
Groninger Museum, Groningen

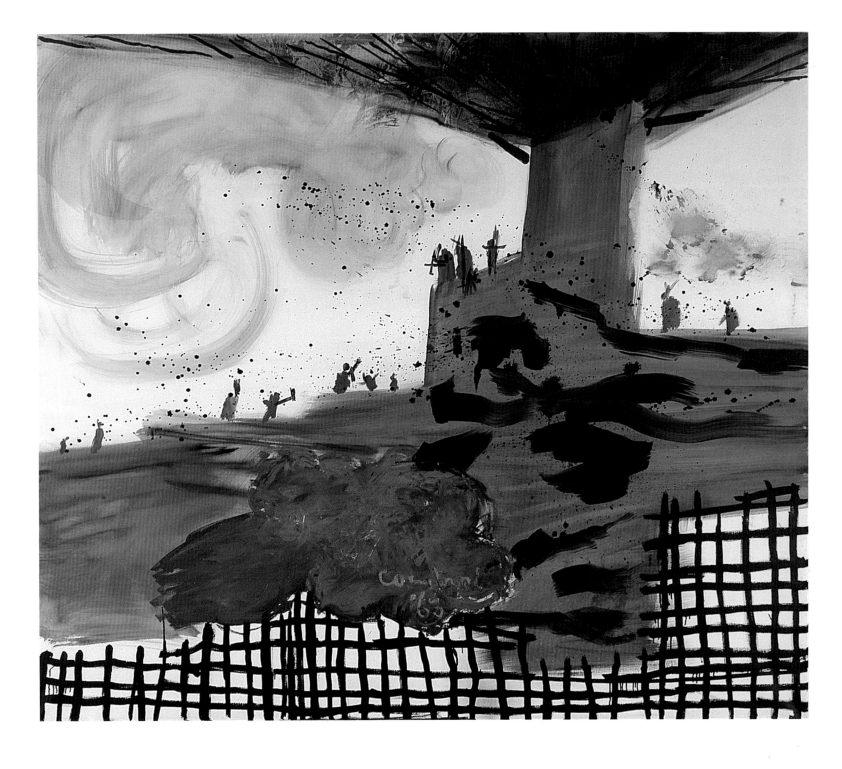

26 groeten uit new babylon (greetings from new babylon) 1963

Netherlands Institute for Cultural Heritage (on loan to Stedelijk Museum, Schiedam)

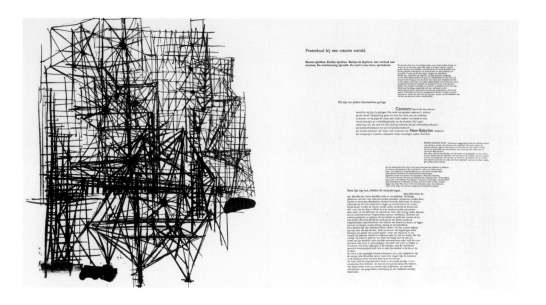

Preambuul bij een nieuwe wereld.

Stenen spreken. Steden spreken. Ruïnes en skylines: een verhaal van mensen. De overlevering spreekt. De stad is een steen, spreekbaal.

Wij zijn van andere bouwwerken getuige.

Constant toont een nieuwe wereld en wij zijn de getuigen. Het recht om spreken: ontroert ik ontroer op zijn ritueel. Ideografing geen wij hem het recht, we zijn raddelfisp te komen, aan zij grije die rede, aan bode bedden, een bedbestel aan hem, van de bisgeja en verbeeldingsleelde van de bisyden. Hij is glan genderling, een die wijk een Sen eeniky uiteraard, die zin verhwelling ontroerkt van duidende weboort het serit en getudu beikende wil wordt eenkunse, wor heilig, mehr onkeoroer het **New-Babylon** ontoneet. Een schipping in waarden, nisyootse, free, tribriggen, spilen, thieerinde.

Naus ligt nog vast, behalve de veranderingen.

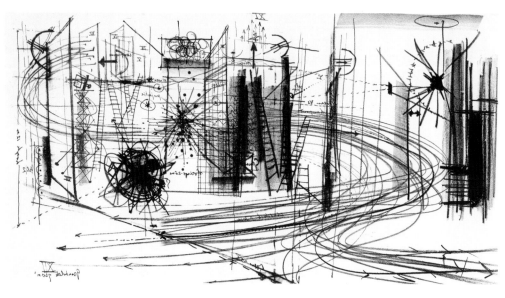

constant & simon vinkenoog
30 new babylon 1963
Boijmans van Beuningen Museum, Rotterdam

Full text, English translation p 194

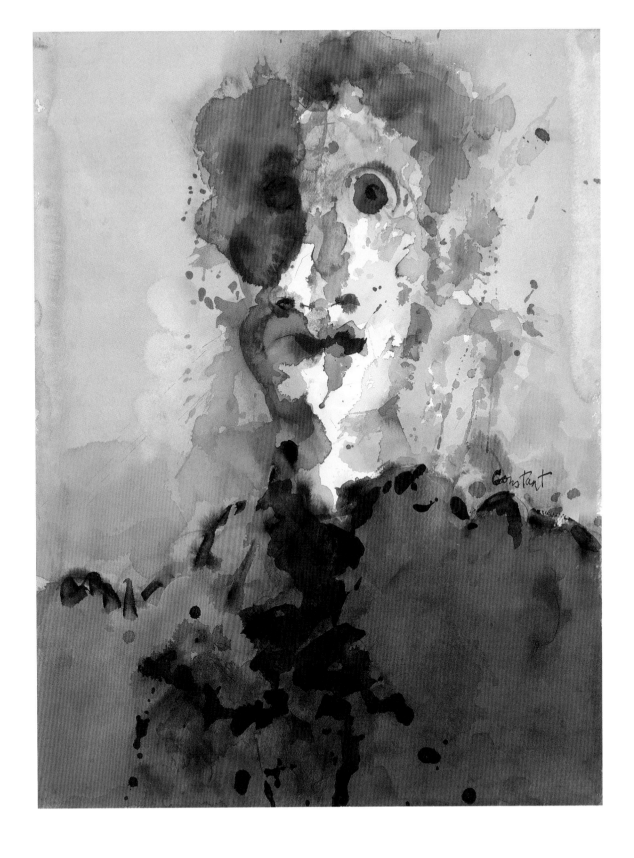

constant
31 mathilde visser 1985
Museum Henriette Polak, Zutphen

karel appel

Christiaan Karel Appel was born on 25 April 1921 in the Dapperstraat, Amsterdam, to Jan Appel, a barber, and his wife Johanna Chevalier of French Huguenot background. Karel was the second of four sons. In 1928 the family moved to a house opposite the Tropenmuseum (Ethnographic Museum) in Amsterdam. As a boy, Appel enjoyed drawing and painting, and his uncle, Karel Chevalier, a talented amateur painter, gave him an easel and paint-box when he was fifteen. They painted together and both went to the realist painter Jozef Verheijen for tuition. In 1936 Karel left school to work in his father's barber shop, but left home at eighteen determined to be an artist.

During the German occupation of the Netherlands in the Second World War, Appel lived in an attic room that served as his studio on the Ouderzijds Voorburgwal, in the old centre of Amsterdam. He admired Vincent van Gogh most of all. In emulation of Van Gogh, he drew and painted quickly – portraits, landscapes, the city and harbour. He attended the Rijksakademie van Beeldende Kunsten (National Academy of Fine Arts), Amsterdam, between 1942 and 1944. He met Corneille at the academy and they formed a close bond, attracted to the work of Pablo Picasso, Henri Matisse, Chaïm Soutine and Max Beckmann. Corneille wrote poetry; as did Appel, in private at first (his favourite poet was Walt Whitman). In the final year of the War, to avoid being sent to Germany, Appel went into hiding, only returning to Amsterdam after the armistice.

Appel had his first solo exhibition in 1946 in Groningen. He and Corneille visited Gerrit Benner in Groningen and greatly admired his brightly coloured, severely abstracted Frisian landscapes and cows. In the same year Appel's work was included in *Jonge schilders* (Young painters) at the Stedelijk Museum, Amsterdam. He and Corneille visited Liège in Belgium, Corneille's birthplace, where they sold works to a Belgian collector, travelled to Antwerp and Brussels and met numerous Belgian artists.

Appel was influenced by the work of Paul Klee and the African masks he knew from the Tropenmuseum. He also experimented with collage, assemblage and sculpture using found objects from rubbish bins and the street. In 1948 he met artists Lucebert and Constant, also Tonie Sluyter, the daughter of an artist, who became his partner. In June 1948 Appel was one of the founding members of the Dutch Experimentele Groep (Experimental Group) with Corneille, Constant and other artists, including poets Lucebert, Gerrit Kouwenaar and Jan G Elburg. In November 1948 they joined with Danish and Belgian artists in Paris to form CoBrA. That year, Appel sought and received a commission to paint a mural in the café of Amsterdam's Town Hall. When completed early in 1949, *Vragende kinderen* (Enquiring children) attracted a storm of protest, gaining him instant notoriety. The mural was covered with wallpaper until restored in 1959.

In November 1949, a major exhibition of CoBrA artists and poets *Internationale tentoonstelling experimentele kunst* (International exhibition of experimental art), designed and installed by Dutch architect Aldo van Eyck, was held at Amsterdam's Stedelijk Museum. There were public protests, including those of disaffected artists. The negative over-reaction to Appel's work and that of his friends contributed to his growing discontent with the Netherlands. After producing a major sculpture for Rotterdam's *Ahoy* entertainment centre, he left for Paris in 1950. He briefly returned to Amsterdam for a solo exhibition at Kunstzaal van Lier in 1951 and to paint a mural in the café of the Stedelijk Museum. It was commissioned by the Director, Willem Sandberg, who had vigorously supported the earlier mural.

Appel, Corneille and Constant found studio space in a former leatherworks warehouse on rue Santeuil near the Jardin des Plantes in Paris, which they shared with several other artists. He met the Belgian writer Hugo Claus in Paris and they collaborated on a booklet *De blijde en onvoorziene week* (The happy and unexpected week) and over time, other projects, including the first book of Appel's work *Karel Appel schilder* (Karel Appel painter), published in 1962. He and the Dutch poet Simon Vinkenoog became friends in Paris (where Vinkenoog worked for Unesco). Thereafter, Vinkenoog also championed Appel's work in publications, at exhibition openings and poetry readings. Drawings by Appel and Corneille illustrated Vinkenoog's influential book of poems by contemporary Dutch poets, *Atoonal*, published in 1951. In Paris, Appel visited an exhibition of 'psychopathological' art and made drawings over the pages of a copy of the accompanying catalogue, arguably some of the most compelling of his life.

In the 1950s, while Appel lived and worked in Paris, support for him increased considerably. Authorities on contemporary art, Michel Tapié, Herbert Read and Guggenheim Gallery Director, James Johnson Sweeney, befriended him and wrote about his work. Willem Sandberg in Amsterdam also remained supportive. Appel exhibited at the São Paolo Bienal in 1953, represented the Netherlands at the Biennale di Venezia in 1954 (with Jan Wiegers, Charley Toorop, Wessel Couzijn and Corneille), exhibited in Brussels, London and New York, travelled frequently (including a trip to Italy where he made and decorated ceramics with Asger Jorn) and had his first solo exhibition in Paris at Studio Facchetti in 1954. He remained controversial in the Netherlands, especially after an interview with the Dutch journalist Jan Vrijman in January 1955:

I paint, I mess about a bit … I lay it on thickly now, I hit the paint on with brushes and palette-knives and my bare hands.[1]

Internationally, he was the best known living Dutch painter.

Appel bought a house in Paris in 1955, and after his relationship with Tonie Sluyter ended, he met the Dutch-born model Machteld van der Groen. Their relationship lasted until her premature death in 1970. In 1957 he travelled to New York, where he was happier than anywhere else and subsequently spent part of each year working in a variety of studios in New York. He met Dutch-born abstract expressionist Willem de Kooning, with whom he felt a close affinity, and the American artist Franz Kline. He was awarded the Guggenheim International Award in 1960. In 1961 Jan Vrijman made a remarkable film about Appel, with music by Dizzy Gillespie.

In 1964 Appel left Paris for the French countryside and a chateau near Auxerre. He undertook a major series of polychrome sculptures cut from plywood and assembled in layers, marking an increasing involvement in sculpture that led to his first monumental aluminium sculptures in 1971. In 1976 he collaborated with the Belgian artist Pierre Alechinsky on a series of large drawings, published in a book accompanied by Hugo Claus' poems. Appel's own poetry was also published in book form for the first time, including *Océan blessé* (Wounded ocean) 1982 and *Ode aan het rood, gedichten* (Ode to red, poems) 1996. He was commissioned to produce designs for ballets and operas in Paris and Amsterdam. He had studios in New York, Rome, Monaco and Tuscany, continued to exhibit internationally, and travelled extensively – to South America, India, Indonesia, China and Japan.

Karel Appel died aged 85 on 3 May 2006 in Zürich.

1. Karel Appel in an interview with Jan Vrijman, *Vrij Nederland*, 29 January 1955 in *Karel Appel, de biografie*, Cathérine van Houts, Contact, Amsterdam 2000, p 215

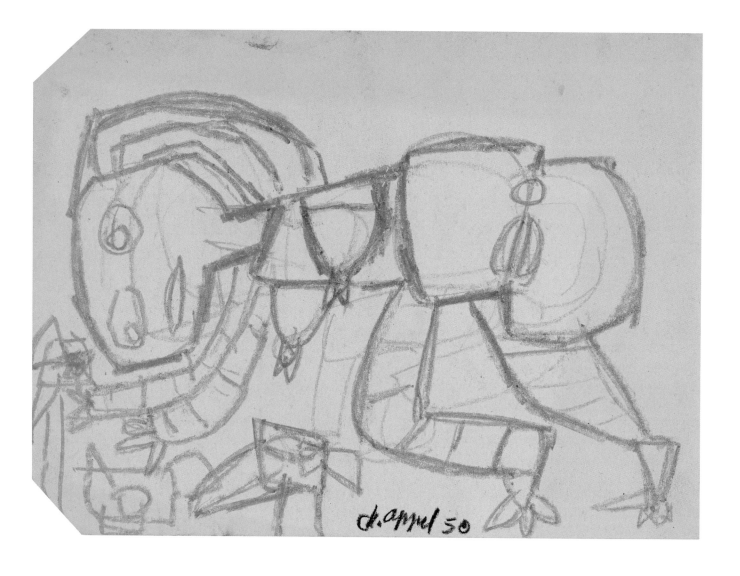

karel appel

6 untitled 1950

Gemeentemuseum, The Hague

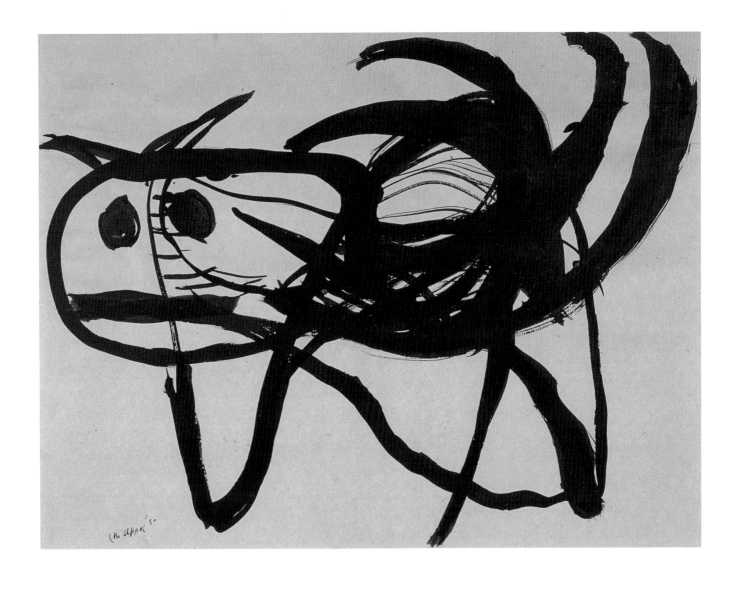

5 dier (animal) 1950
Boijmans van Beuningen Museum, Rotterdam

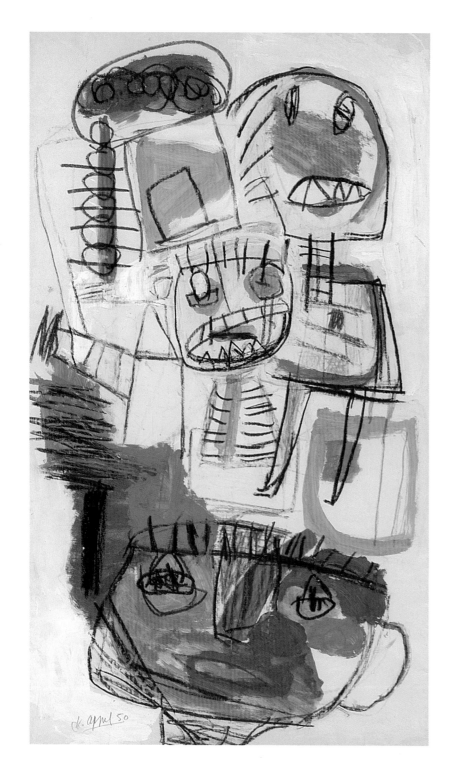

Hongerwinter

Ik wou dat ik een vogel was
en ze vlogen over de akkers
waar de boer niet zaaide
het ploegende paard niet was
de mensen zuchtend in kampen zaten
maar de vogels vlogen vrij

Ik wou dat ik een vogel was
niet het konijn dat ik aansprak
om de honger te stillen

Toen de mensen uniformen aantrokken
en geen mensen meer waren
en geen gezichten meer hadden
vlogen de vogels vrij
de kraai (niet het konijn) de merel
ik wou dat ik een vogel was.

Karel Appel 1945

The Hunger Winter

I wish I were a bird
and flew with them above the fields
where no farmers sowed
and no horses ploughed
and the people sighed in the camps
while the birds flew free

I wish I were a bird
and not the rabbit I waylaid
to ease my hunger

when the people put on their uniforms
they were no longer people
they no longer had faces
but the birds flew free
the crow and the blackbird
(but not the rabbit)
I wish I were a bird

karel appel
7 optocht (procession) 1950
Netherlands Institute for Cultural Heritage (on loan to Stedelijk Museum, Schiedam)

1 ontmoeting (encounter) 1951
Netherlands Institute for Cultural Heritage
(on loan to Centraal Museum, Utrecht)

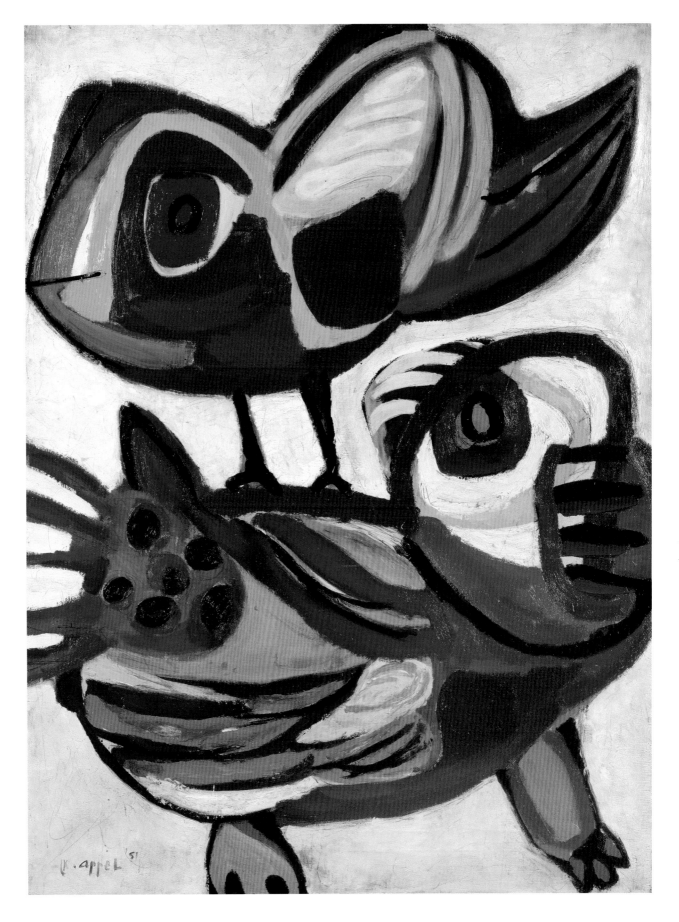

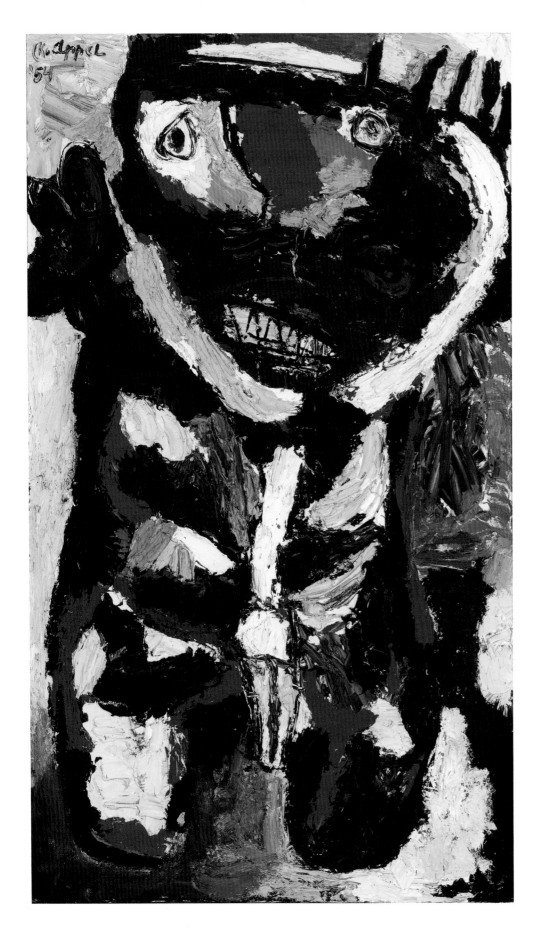

karel appel
2 de wilde jongen (the wild boy) 1954
Stedelijk Museum, Schiedam

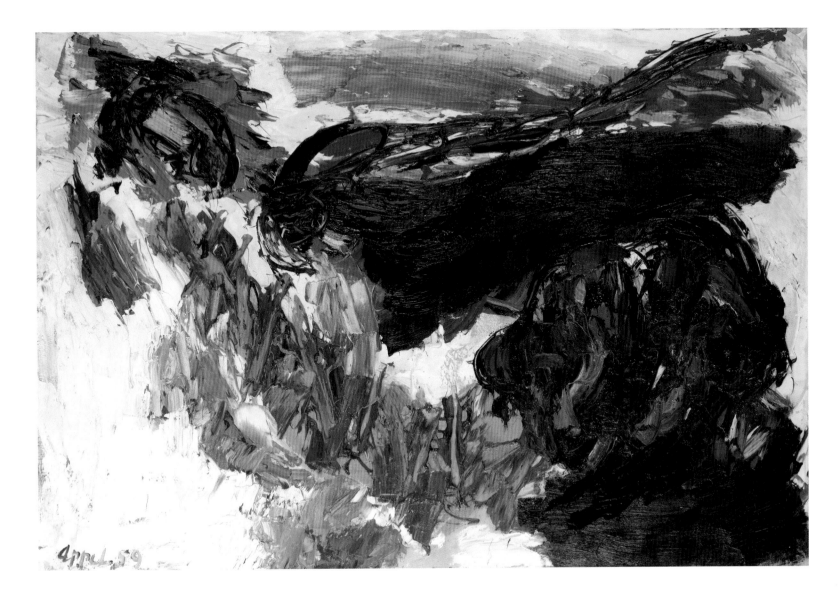

3 paysage à la tête noire (landscape with a black head) 1959
Jan and Ellen Nieuwenhuizen Segaar

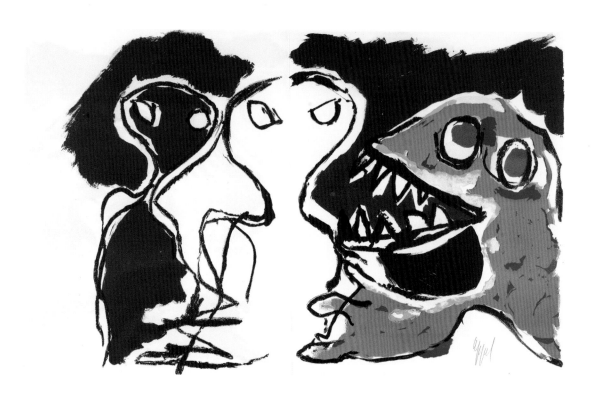

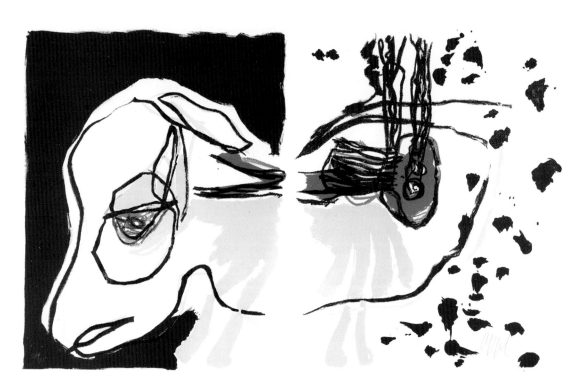

karel appel & bert schierbeek

8 a beast drawn man / het dier heeft een mens getekend 1963

Boijmans van Beuningen Museum, Rotterdam

Full text, English translation p 195

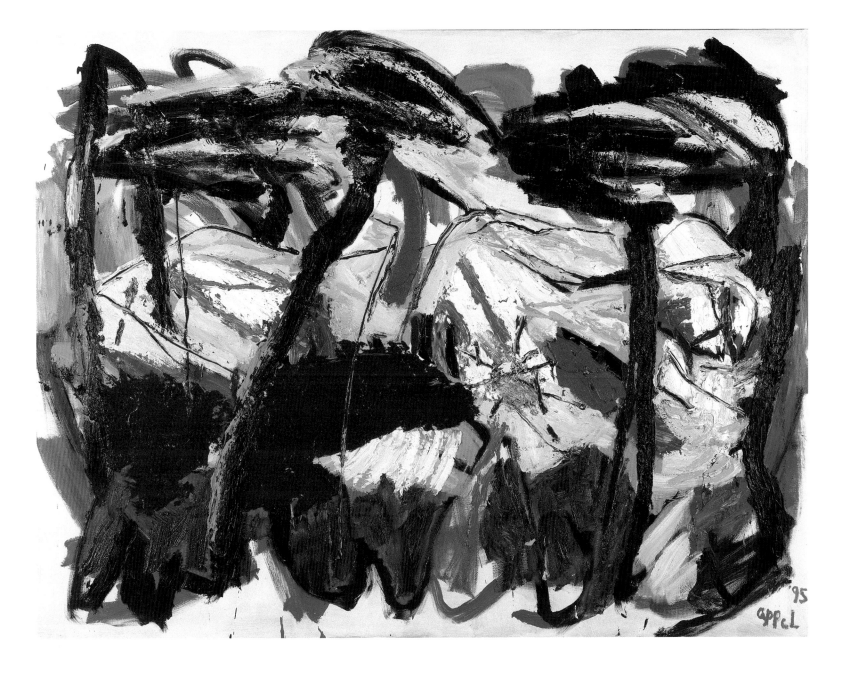

karel appel
4 horizon of tuscany #36 1995
ING, Amsterdam

corneille

Corneille Guillaume Beverloo was born on 4 July 1922 in Liège, Belgium, to Dutch parents. Despite an unsatisfactory relationship with his taciturn father, Corneille had a happy childhood. In 1937 his family moved to the Netherlands and settled in Haarlem.

Corneille visited Amsterdam in 1939, moving there after the outbreak of War. Between 1940 and 1943, he intermittently studied drawing and printmaking at the Rijksakademie van Beeldende Kunsten (National Academy of Fine Arts), where he met Karel Appel. They quickly entered into a close and fulfilling friendship, brought together by dissatisfaction with the conservative teaching of the Academy. Although he admired the Dutch old masters Rembrandt and Frans Hals, Corneille was even more attracted by the moderns Vincent van Gogh, Henri Matisse and Pablo Picasso. Immediately after the War, he discovered the younger artists of the 'École de Paris' including Jean Bazaine and Maurice Estève and confirmed his interest in earlier moderns such as Pierre Bonnard, Raoul Dufy and Amedeo Modigliani. Corneille and Appel felt compelled to leave the Netherlands, first visiting Belgium where Belgian artists had direct contact with Parisian art circles.

Corneille's first solo exhibition was in Groningen in northern Netherlands in April 1946. A few months later he was included in the exhibition *Jonge schilders* (Young painters) at the Stedelijk Museum in Amsterdam, and in January 1947 he exhibited with Appel in the Gildehuys, Amsterdam. At the invitation of Margit Eppinger-Weiss, a Hungarian enthusiastic about the paintings and gouaches he exhibited, Corneille travelled to Budapest a few weeks later and stayed for four months. This was his first long distance journey and it instilled in him an enduring passion for travel. The contrast between the war-damaged city and the natural vitality of the Hungarian countryside fascinated him. In Budapest he met the poet and librarian Imre Pán who introduced him to the poetry of Arthur Rimbaud and the surrealists, especially André Breton, Paul Éluard and Louis Aragon. He discovered the art of Paul Klee, which inspired him to create a personal universe. These influences are revealed in the titles of his early paintings, which are like poetic commentaries.

Later he published his poems in the periodicals *Reflex* and *Cobra,* wrote travel notes and collaborated on numerous prints and illustrated books with poets and writers, including Christian Dotremont, Lucebert, Hugo Claus, Simon Vinkenoog, Federico García Lorca and Octavio Paz.

Corneille met the painter Constant in Amsterdam in 1947. Appel, Constant and Corneille exhibited together several times the following year. With other Dutch artists and poets, they founded the Dutch Experimentele Groep (Experimental Group) in July 1948. He also met his future wife Henny Riemens at this time. Her photographs are an invaluable record of Corneille's beginnings as an artist, as well as of his contemporaries. In November, they joined Belgian and Danish artists in initiating the new CoBrA art movement in Paris. Corneille participated actively in all aspects of the movement, exhibiting and travelling with CoBrA members. He was also editor of the 4th issue of their periodical *Cobra*, which was devoted to the Dutch CoBrA artists. Stimulated by the group's spirit and inspired by children's drawings, he established a painting and drawing style characterized by strong lines and a rich interplay of colours.

In May 1949 Corneille travelled to Tunisia, following in the footsteps of Paul Klee. There he was affected by the vivid Tunisian light and colour. Africa and its art fascinated him and influenced his art. He has returned there frequently. His second African trip in 1951 was across the Hoggar Mountains in southern Algeria with the architect Aldo van Eyck. This had an even more radical impact on his development as an artist. The harshness of the African desert led him to eliminate the human figure from his work, concentrating on abstracting the landscape into organic concentric forms with strong outlines suggesting stones and mineral formations.

Corneille settled permanently in Paris in 1950 and henceforth the city became an important theme in his work. He continued experimenting, studying etching with S W Hayter in Paris in 1953 and creating his first ceramics with Asger Jorn in Albisola Mare near Genoa in 1954–55, where he also met Wifredo Lam, Roberto Matta, Enrico Baj and Lucio Fontana.

Other countries have been important to Corneille, including Spain, where he spent five summers in the fishing village of Cadaqués, and Mexico. On an extensive visit to Africa in 1957, he travelled from Dakar in Senegal to Nairobi, Kenya, through Nigeria, Sudan and Ethiopia. This was followed by trips to South America, the Dutch Antilles and the United States. In the 1960s he travelled to Brazil, Cuba, Mexico and Yugoslavia; in the 1970s to San Francisco, China, Japan and Indonesia. Each of these trips was important to him and his art. As a northern European, Corneille was inevitably attracted to the sun, as revealed in *Le voyage du grand soleil rouge* 1963.

In 1961 he abandoned his easel and began painting his canvases on the studio floor. He further simplified his forms, his touch became more rapid and confident, and primary colours predominated, accentuating contrasts and emphasizing the details in idealized gardens, animals, imaginary creatures or plants. The human figure re-appeared in his paintings at the beginning of the 1970s. Primarily his attention was on the archetypal or eternal woman, both symbolic and erotic, with masculine desire embodied as a bird. After 1973, the autonomous nature of his shapes and colours became simpler, more decorative and jubilant.

Driven by his hunger for new creative experiences, Corneille continued to travel widely, returning to Africa and Cuba and to other destinations like Saint Petersburg in Russia and Jaffa in Israel. He often stayed for months at a time to work, while still maintaining studios in Paris, Italy and Belgium. In 1982, his son, Dimitri, was born to one of his favourite models, Natacha Pavel, a Russian dancer born in Paris. Dimitri wrote an affectionate text for a retrospective of his father's work in Villiers-Adam, *Corneille, mon père*, in 2002.

Since the 1950s Corneille has known great international success. He has exhibited frequently throughout Europe, North and South America. His first solo exhibition in Paris was at Galerie Colette Allendy in 1954. He participated in the São Paulo Bienal in 1953, the Biennale di Venezia in 1954 (in his own pavilion) and in the following year at the Carnegie International in Pittsburgh. He has received many prizes and honours including the Guggenheim International Award in 1956 and the Ibiza Graphic Prize in 1972.

One of the major Dutch artists of his time, Corneille's work is not restricted to painting – he has produced a considerable oeuvre of prints, books, sculptures, ceramics and photographs. A number of publications and exhibitions have explored his passion for Africa and his collection of African art. Most recently there have been exhibitions of his work at the Cobra Museum of Modern Art in Amstelveen (2007) and in Auvers-sur-Oise, France (2008).

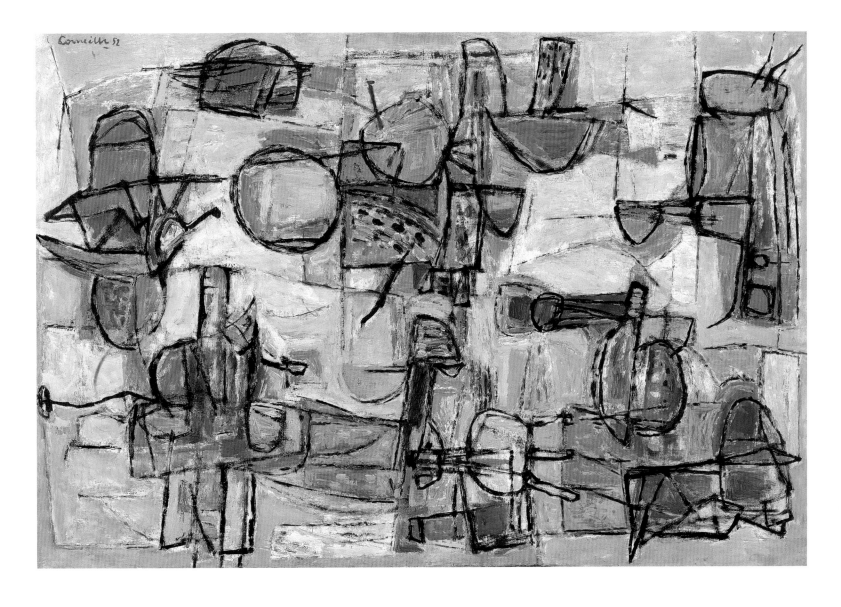

corneille

36 le port en tête (the port overhead) 1949

Stedelijk Museum, Schiedam

32 espace animé (animated space) 1952

Stedelijk Museum, Schiedam

corneille
37 zon (sun) 1953
Stedelijk Museum, Schiedam

33 après la tempête (after the storm) 1954

Van Abbemuseum, Eindhoven

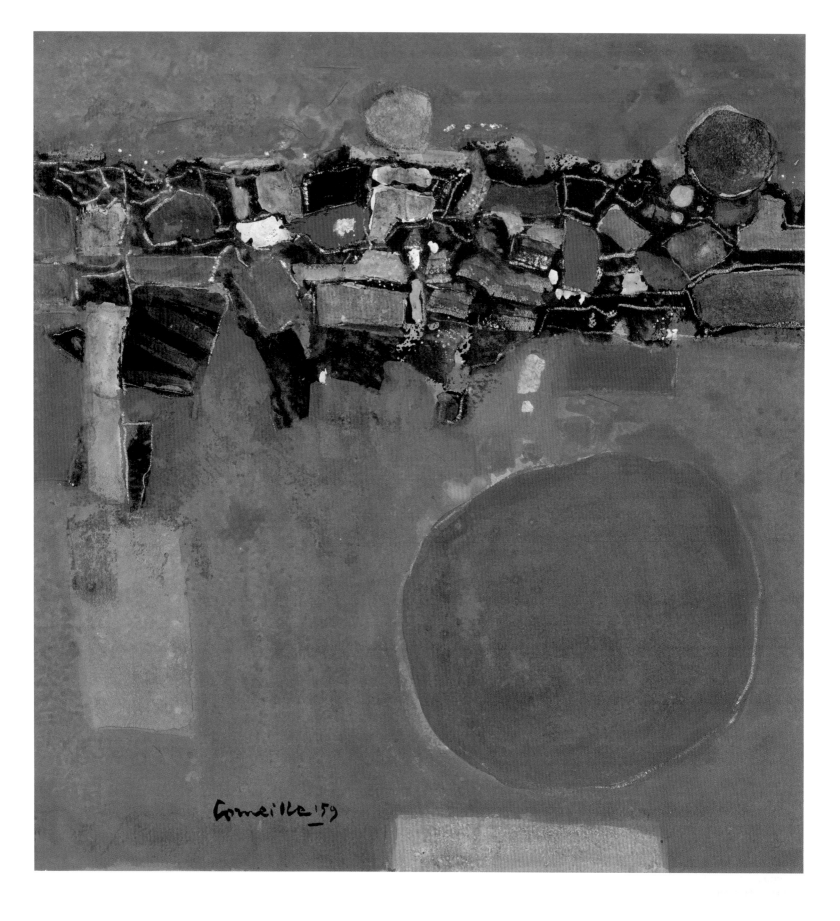

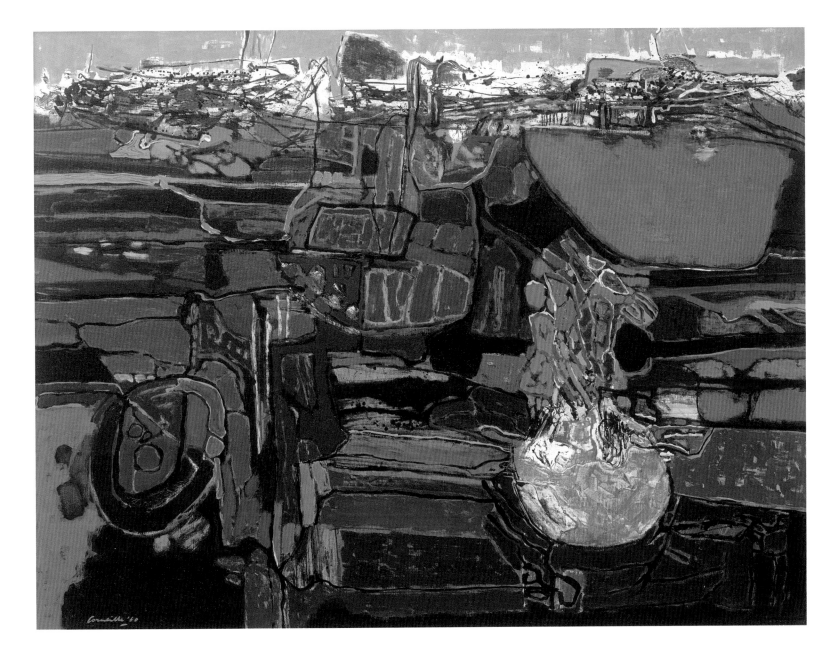

corneille

38 compositie/paysage du sud
(composition/southern landscape) 1959

Boijmans van Beuningen Museum, Rotterdam

34 aux abords de la grande cité
(on the outskirts of the big city) 1960

Van Abbemuseum, Eindhoven

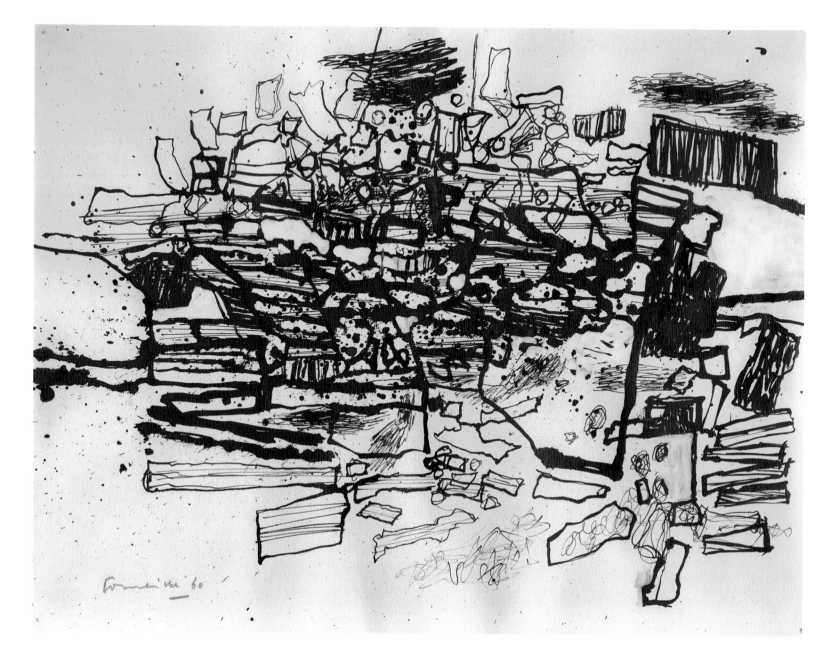

corneille
39 bretagne ii (brittany ii) 1960
Gemeentemuseum, The Hague

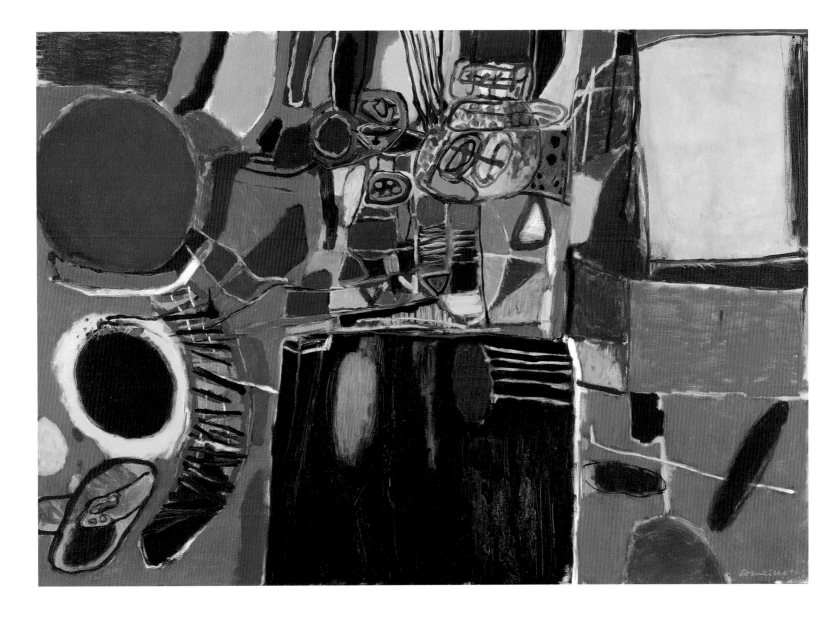

35 le voyage du grand soleil rouge (the big red sun's voyage) 1963
Netherlands Institute for Cultural Heritage (on loan to Stedelijk Museum, Schiedam)

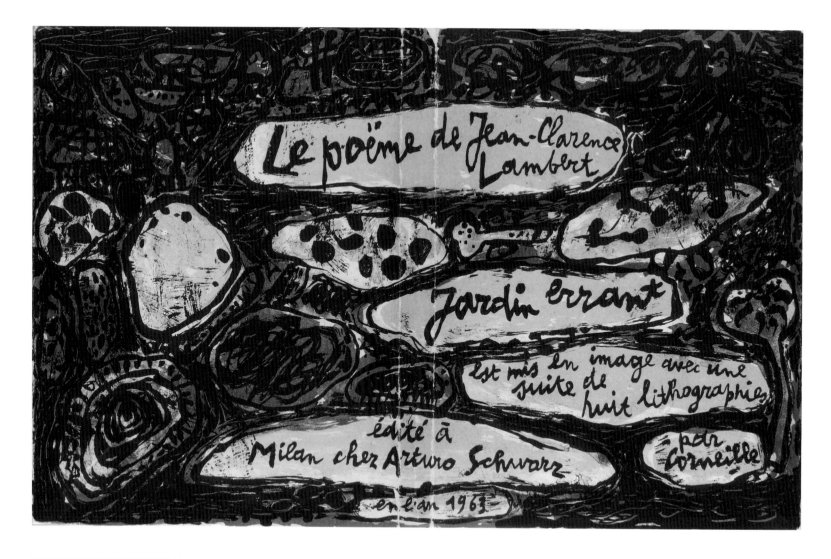

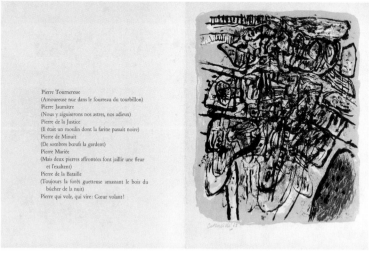

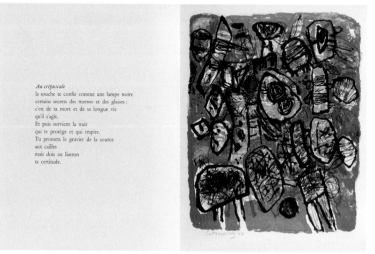

corneille & jean-clarence lambert
40 jardin errant (meandering garden) 1963
Private collection

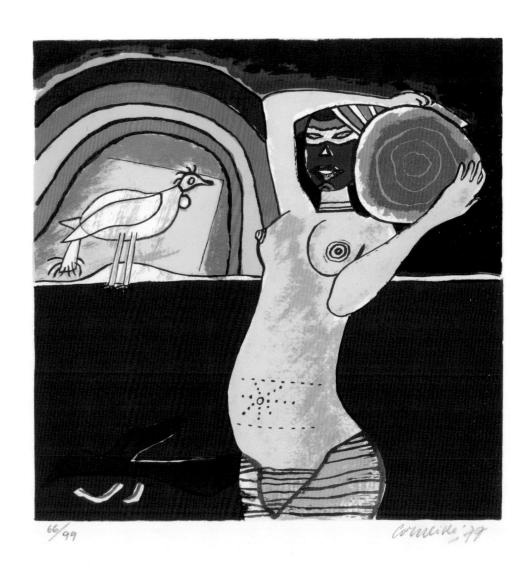

66/99 corneille '77

corneille
41 omaggio a leopold sedar sengor (in homage to léopold sédar senghor) 1977
Private collection

lucebert

Lubertus Jacobus Swaanswijk was born on 15 September 1924 in Amsterdam and was given the same name as his father, a house-painter and signwriter. Lucebert's mother left her husband and three sons in 1926; his father subsequently married a domestic worker from Brabant, southern Holland. Until he was thirteen, Lucebert and his family lived in the poor but colourful Jordaan district of Amsterdam, where, in 1934, he witnessed a rowdy demonstration against the reduction of the unemployment benefit that left a strong impression on him. When his family moved to another part of Amsterdam, he continued to play in the Jordaan with friends, including Johan van der Zant (later the poet Hans Andreas). Lucebert was introduced to poetry at school by his German language teacher and to drawing by the artist and musician, Johan van Hell.

In 1939 Lucebert left school to help his father with painting and wall-papering. Lucebert's love of spontaneously drawing on walls was soon noticed and he was encouraged to attend the Kunstnijverheidschool (School for Arts and Crafts) in Amsterdam. The new Director, Mart Stam, architect/furniture designer and former teacher at the Bauhaus, greatly impressed him and opened his eyes to dada and surrealism. But, after only four months, his father needed him to work in order to contribute to the family's living costs. Lucebert subsequently worked at a variety of jobs, but remained close to his schoolfriends, with whom he shared an interest in art, poetry and philosophy.

In 1943, as part of the German occupation of the Netherlands, he was sent to Apollensdorf near Wittenberg, Germany, to work in a spring-making factory. He wrote poetry and letters to his friends, and visited nearby Wittenberg and Dessau. Naturally outspoken, he was accused of causing trouble, given dangerous work that made him ill and was sent home, where he immediately went into hiding.

After the War, Lucebert led a nomadic life, staying with friends or with his stepmother's family in Brabant. He drew and wrote constantly from this time, often leaving the results of his efforts behind as tokens of payment for hospitality. Occasional sales of drawings or modest payments for murals in churches provided his only real income. He met and became friends with the artist Karel Appel and the poet/journalist Gerrit Kouwenaar and began using the name Lucebert.

In 1948 he travelled to Paris with a friend, the artist Anton Martineau. They painted a mural in the stairwell of a school in Les Pavillons-sous-Bois near Paris and he began to write experimental poetry:

I permit myself much freedom, in choice of words and grammar.[1]

In Amsterdam he exhibited his drawings. Kouwenaar introduced him to the poet Jan G Elburg. He also met the writer Bert Schierbeek and his wife, a ceramicist, and lived with them for a time. Kouwenaar and Elburg recognized the originality of Lucebert's poems and encouraged him to join the newly created Dutch Experimentele Groep (Experimental Group). Later that year, they joined with Danish and Belgian artists to form CoBrA.

Lucebert's controversial early poem *Minnebrief aan onze gemartelde bruid Indonesia* (Love letter to our tormented bride Indonesia) was highly critical of the Dutch army's politically motivated action in Indonesia in December 1948. It appeared in the second of the two issues of the Experimentele Groep's review *Reflex*. This poem, about a highly emotive issue, established his name as a poet. In the first major CoBrA exhibition at the Stedelijk Museum, Amsterdam, in November 1949, his inclusion, together with Kouwenaar, Elburg and Schierbeek, was as a poet. Lucebert's exposition *Verdediging van de 50-ers* (Defence of the Fifties) appeared in the 4th issue of the periodical *CoBrA*, which was devoted to Dutch artists, though he had difficulties in finding a publisher for his poetry and did not receive any particular recognition for his art. However, soon after, the new literary magazine *Braak* (started by poets Remco Campert and Rudy Kousbroek) did support and publish his work, and the writer Simon Vinkenoog included him in his magazine *Blurb* and in his book of poetry by modern Dutch poets, *Atoonal* (1951). A number of books of Lucebert's poetry followed and he was soon dubbed the *Koning der vijftigers* (King of the Fifties) and awarded the Amsterdam Poetry Prize in 1953 (and again in 1956, '60 and '62).

In 1952 Lucebert met his life partner Tony Koek; they married soon after and moved to Bergen, North Holland. In 1954 he joined Bertolt Brecht's theatre group in East Berlin, as a master student, staying six months and taking his wife and children with him. He also visited Bulgaria where he drew, wrote and began taking photographs. Back in Bergen, with a new big studio, he started painting and printmaking seriously. His first solo exhibition was at Galerie Espace, Haarlem, in 1958.

In 1959 he exhibited at the Stedelijk Museum, Amsterdam, and at the Stedelijk Museum, Schiedam, was awarded a prize at the Première Biennale de la jeunesse, Paris, and included in Documenta II, Kassel, Germany. He exhibited widely throughout the Netherlands and internationally. Lucebert evolved an idiosyncratic iconography and was highly regarded as being equally talented in both art and poetry. He won further important prizes for his art including the Premio Marzotto in Milan 1962, Premio Carlo Cardazzo, Venice 1964, Jacobus van Looyprijs, Haarlem 1990, and for his poetry, the Constantijn Huygensprijs 1965, P C Hoofdprijs 1967 and Prijs der Nederlandse letteren (Netherlands Literature Prize) 1983.

From 1965 Lucebert spent part of each year in Alicante, Spain. He produced murals, ceramics and artist books, and continued to write and give readings of his poems. He exhibited widely across Europe, where serious interest in his work has remained since his death. In 1986 a major private collection of his work was given to the Stedelijk Museum, Amsterdam, and in 2006 his family presented the Netherlands Institute for Cultural Heritage with the majority of works remaining in his estate, some 200 paintings and 2,000 works on paper.

Lucebert became seriously ill in 1991 but continued to work until his death aged 69 in Bergen on 10 May 1994.

His monumental *Verzamelde gedichten* (Collected poems) was published posthumously in 2002. It is considered one of the most important books of modern Dutch literature. As the literary scholar Ton den Boon noted recently, 'no other modern Dutch poet has exercised as great an influence upon the use of our language'.[2]

1. Lucebert in Peter Hofman, *De jonge Lucebert*, De Bezige Bij, Amsterdam 2004, p 157
2. Ton den Boon, *'Wie wil stralen die moet branden': citaten en aforismen van Lucebert*, BnM, Nijmegen 2007, p 5

ik draai een kleine revolutie af
ik draai een kleine mooie revolutie af
ik ben niet langer van land
ik ben weer water
ik draag schuimende koppen op mijn hoofd
ik draag schietende schimmen in mijn hoofd
op mijn rug rust een zeemeermin
op mijn rug rust de wind
de wind en de zeemeermin zingen
de schuimende koppen ruisen
de schietende schimmen vallen

ik draai een kleine mooie ritselende revolutie af
en ik val en ik ruis en ik zing

Lucebert

i spin a little revolution round
i spin a little pretty revolution round
i am no longer of the land
i am water again
i carry foaming breakers on my head
i carry shooting shadows in my head
on my back rests a mermaid
on my back rests the wind
the wind and the mermaid sing
the foaming breakers rustle
the shooting shadows fall

i spin a little pretty rustling revolution round
and i fall and i rustle and i sing

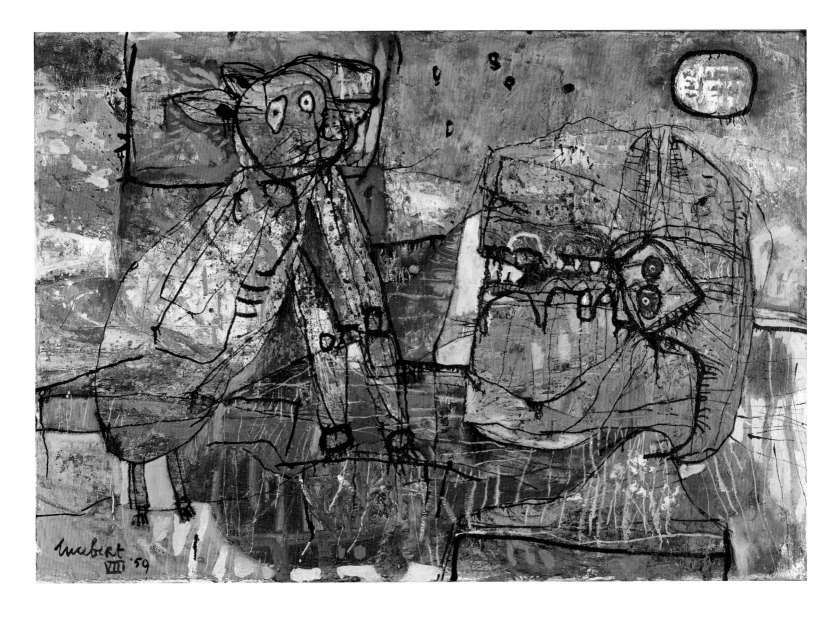

lucebert

60 dierentemmer (animal tamer) 1959

Stedelijk Museum, Schiedam

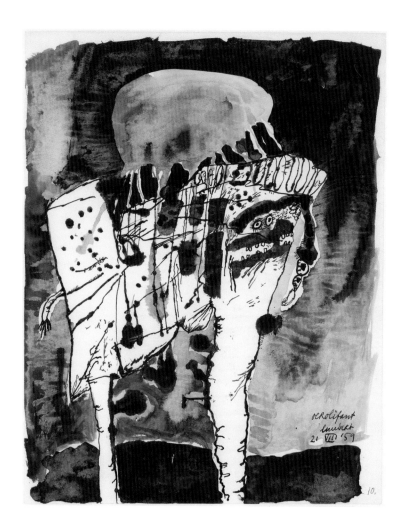

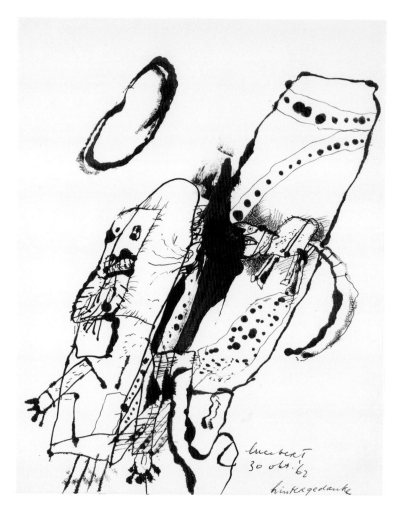

lucebert

64 oerolifant (ancient elephant) 1959

Boijmans van Beuningen Museum, Rotterdam

66 hintergedanke (ulterior motive) 1962

Boijmans van Beuningen Museum, Rotterdam

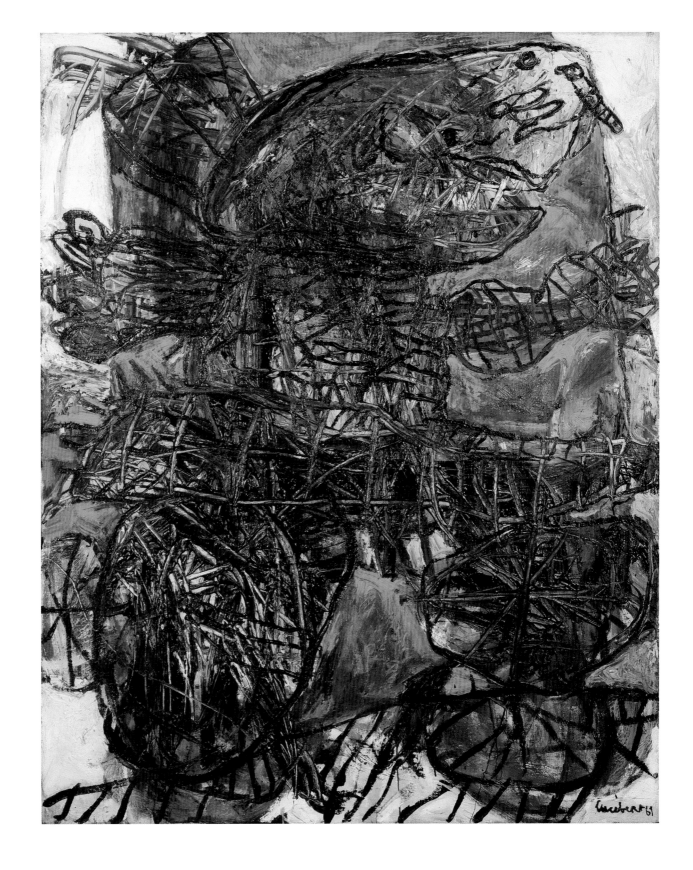

61 schilderij/compositie (painting/composition) 1961
Gemeentemuseum, The Hague

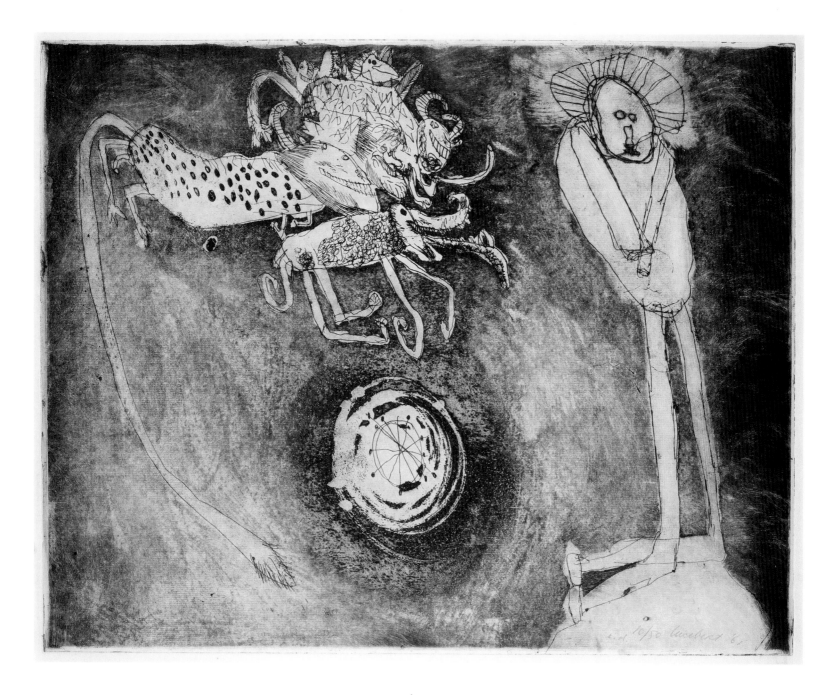

lucebert

65 de verzoeking van de heilige antonius iii (the temptation of st anthony iii) 1961
Gemeentemuseum, The Hague

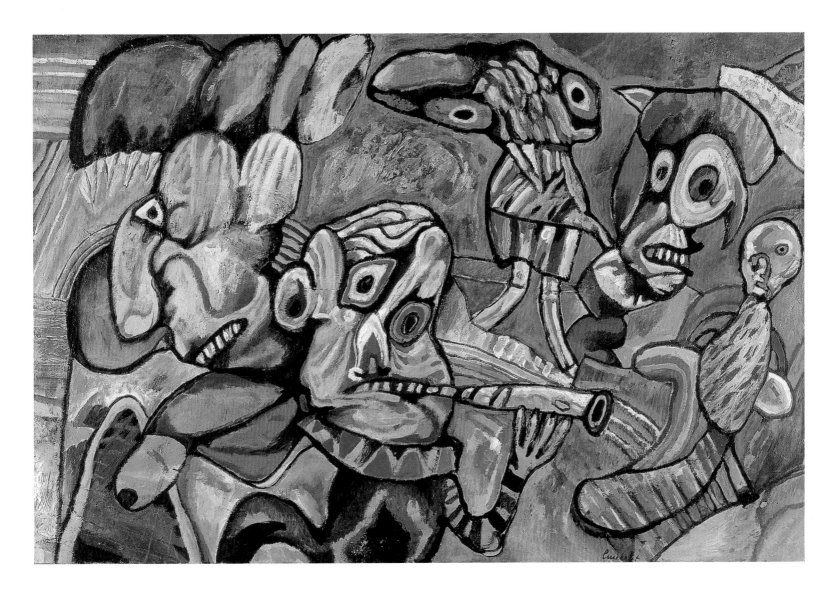

62 het dorpsfeest (the village fair) 1974

Netherlands Institute for Cultural Heritage

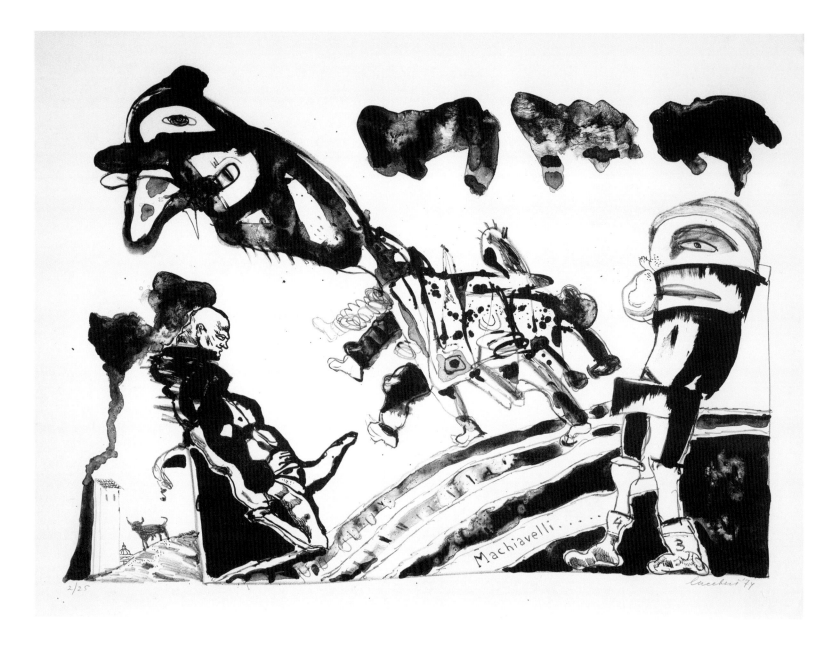

lucebert
67 macchiavelli 1974
Private collection

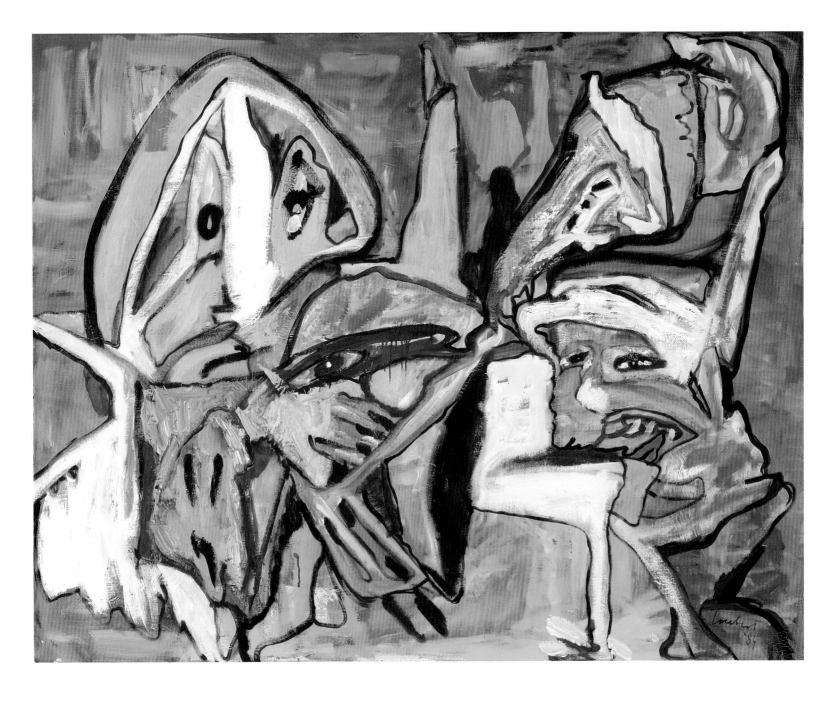

63 i can't dance, i've got ants in my pants 1984
Netherlands Institute for Cultural Heritage

gerrit benner

Gerrit Benner was born on 31 July 1897 in Leeuwarden, Friesland, northern Netherlands, the only child of Hendrikus Benner and his wife Idkse Zijlstra. His father was originally a teacher turned sailor, who later became a craftsman specializing in fine carpentry. Gerrit spent much of his childhood drawing and reading. After finishing primary school, he was sent to trade school to train as a house-painter. Subsequently, he worked as a painter for the Leeuwarden municipality. He married Geesje Schaap in 1918 and they had two sons.

Benner and his wife opened a shop selling jewellery, perfume and leather goods in Leeuwarden, which was initially very successful. He often visited Amsterdam as buyer for their shop, occasionally visiting the Stedelijk Museum. Benner painted in his spare time and enjoyed a comfortable, happy family life, which included sailing on the Frisian lakes on weekends. He did not exhibit or seek recognition for his work, but was briefly a member of a Fries artists' group De Horizon in Leeuwarden. The worldwide Depression of 1929–30, together with an attempt at moving their shop to another location in the city, seriously affected their business and it was eventually bankrupted in 1937. The family moved to a more affordable working class part of Leeuwarden until at least the end of the Second World War. During this time he destroyed almost all of his early work.

When the Netherlands surrendered to Germany in May 1940, Benner refused to comply with the Nazi *Kultuurkamer* (Chamber of Culture) and was therefore not officially permitted to work as an artist or to buy art materials. As a result, he and his family spent part of the War in hiding. During this time, he continued to draw and paint. When the artist Wim Kersten (later a curator at the Stedelijk Museum in Amsterdam) met Benner, he saw and admired his work. Benner also met Oskar Gubitz, an advertising artist, who had lived in Bremen for many years and was enthusiastic about German expressionism and the work of Paula Modersohn-Becker. Gubitz's wife, her sister and children lived in Benner's Leeuwarden house during his absence so, when the Netherlands was liberated in May 1945, Gubitz returned the favour and provided Benner with a studio in his building in Groningen, in north-east Netherlands. He also introduced Benner to the daughter of the influential graphic artist Hendrik Werkman and her husband, Siep van der Berg, Gubitz's partner in their advertising art business. Werkman's work was a revelation to Benner who had worked largely in isolation up to that time. A remarkably inventive artist and printmaker, Werkman was tragically killed by German soldiers just three days before the end of the War. His work has continued to inspire and influence Dutch artists to the present day.

Constant Permeke's work also exerted a strong influence on Benner, as did the German expressionist-inspired Dutch artists of De Ploeg (The Plough). Essentially, however, Benner created his own starkly simplified landscapes and animal forms, often set against brilliantly coloured skies.

Benner had his first solo exhibition at the house of a collector in Groningen in 1946. It was favourably reviewed in the local newspaper and later that year he exhibited again in the newly established Mangelgang Gallery in Groningen. Karel Appel and Corneille, who also had their first exhibitions in Groningen in 1946, visited Benner because they were attracted by the originality of his work.

In 1947 Benner exhibited at the Princessehof Museum in Leeuwarden, at Kunstzaal van Lier in Amsterdam and was included in several group exhibitions. A surgeon and collector, Dr H L Straat, began to collect his work and gave him a monthly allowance. As Benner's work became better known, his eldest son Henk, a schoolteacher, began to represent his father's interests in Amsterdam.

Benner visited Chamonix in the French Alps in 1950 and Paris the following year, but ill health prevented further travel. He rented Karel Appel's recently vacated studio after Appel left Amsterdam for Paris. Attracted by the sea and dunes, Benner visited the Dutch islands of Terschelling in 1952. In 1953 his work was included at the São Paulo Bienal, in major exhibitions of modern Dutch art at the Stedelijk Museum, Amsterdam, and in the United States of America. In 1955 there was a retrospective exhibition at the Van Abbemuseum, Eindhoven.

Benner and his wife moved permanently to Amsterdam in 1956. In 1957 Benner visited Scotland with his youngest son Pieter. At this time he exhibited drawings and gouaches in Italy and Germany. In 1958 he won the Guggenheim International Award for the Netherlands, visited New York and, with Jaap Nanninga, represented the Netherlands at the Biennale di Venezia. His work was shown in London, Paris and Belgrade and in 1959 he moved into his own house in Amsterdam with enough space so that he could relinquish Appel's former studio. That year there was a major exhibition of his work at the Stedelijk Museum, followed by important exhibitions in the Kunstgalerie in Bochum, Germany, and the Rijksmuseum Twenthe in Enschede, the Netherlands.

He continued to exhibit frequently in the Netherlands and internationally, as well as fulfilling public commissions in Rijswijk, Leeuwarden, Maassluis and Amsterdam, but in 1967 he was hospitalized for a time. In 1970 he returned to Friesland and thereafter spent less time in Amsterdam. Benner's health gradually deteriorated and he was again hospitalised in 1978. Gerrit Benner died aged 84 on 15 November 1981.

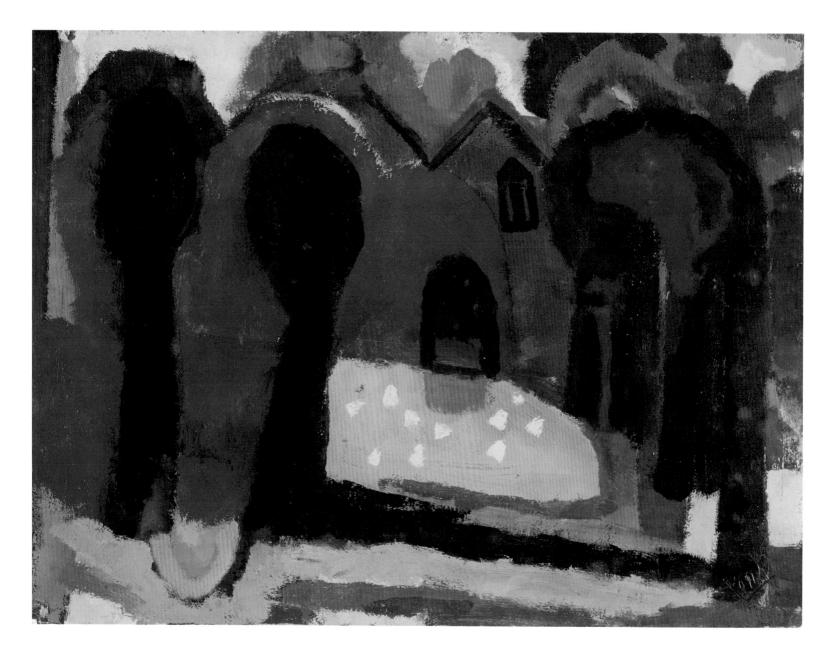

gerrit benner

12 plantsoen (park) 1952
Groninger Museum, Groningen

10 bomen (trees) 1955
Groninger Museum, Groningen

72

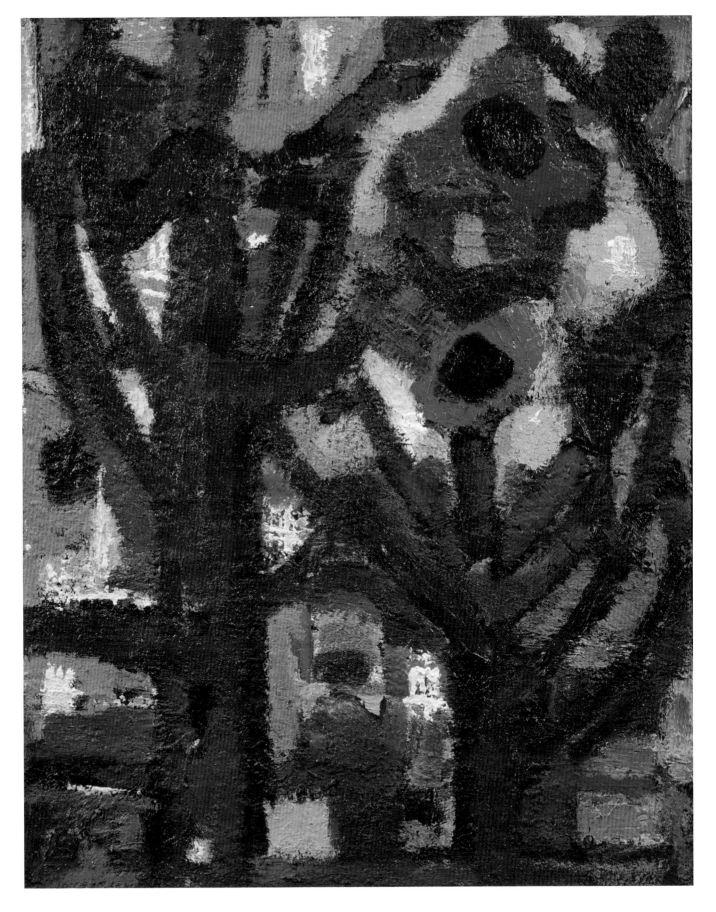

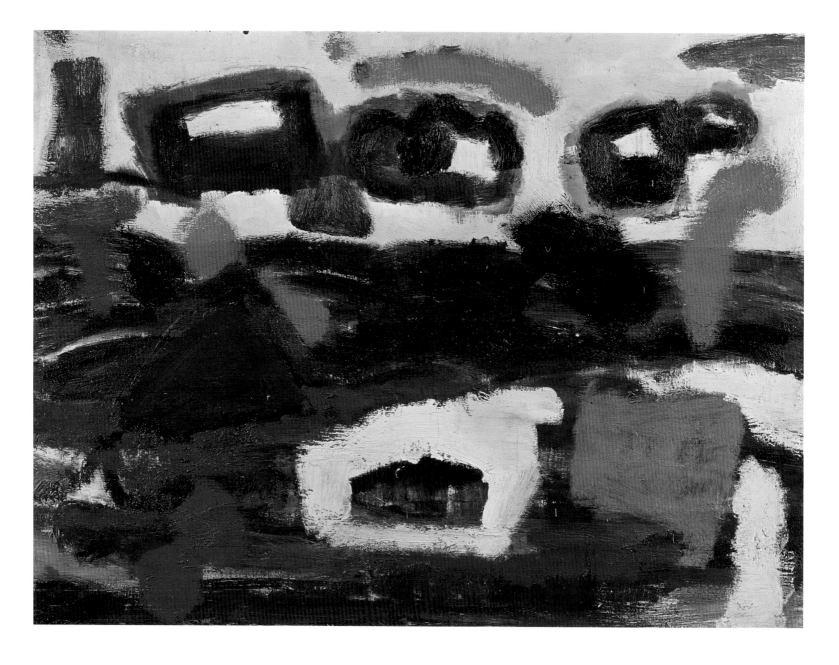

gerrit benner
9 wind, water, wolken (wind, water, clouds) 1954
Van Abbemuseum, Eindhoven

15 untitled 1977
Private collection

13 koeien (cows) 1956/57
Boijmans van Beuningen Museum, Rotterdam

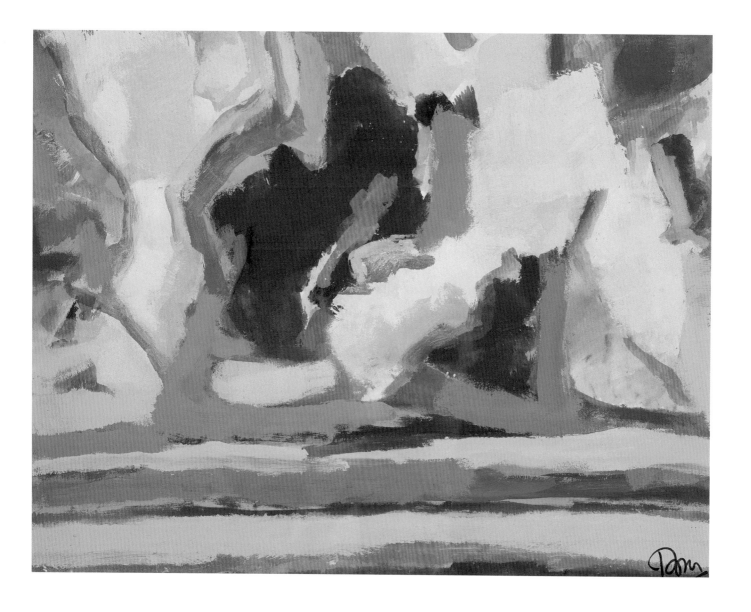

gerrit benner
14 zomer (summer) 1970
Museum Henriette Polak, Zutphen

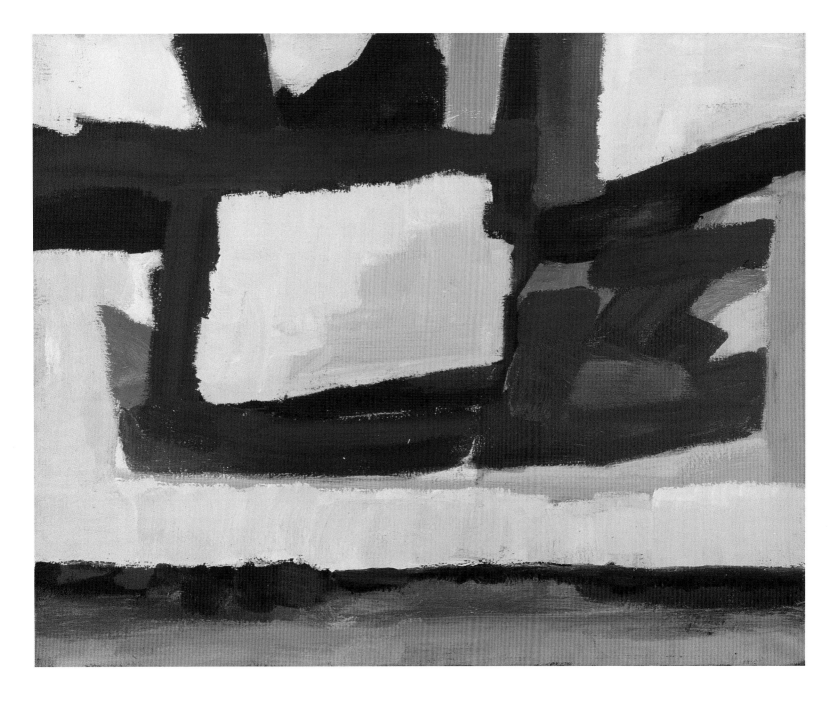

11 fries landschap (frisian landscape) 1970
Groninger Museum, Groningen

jaap nanninga

Jacob (Jaap) Nanninga was born on 19 November 1904 in Winschoten, northern Netherlands, where his father was a postman. He was the first of ten children.

Music was important to Nanninga. He played the violin as a boy, and later, his favourite instrument was an accordion. In adolescence he also drew and painted. There was a serious art community in Winschoten where the underground resistance group Blauwe Schuit (Blue Barge) operated during the Second World War. The graphic artist Hendrik Werkman, an early influence on Nanninga, printed clandestinely for this group.

Working for a living, or as an artist during the Depression years, was extremely difficult, so Nanninga tried various occupations – shop assistant, signwriter, travelling salesman. He spent six months in Amsterdam in 1928 in order to attend the Olympic Games and took some of his drawings and paintings with him in the hope of showing them. In Amsterdam he found temporary work painting lampshades and attended evening classes at the Rijksakademie van Beeldende Kunsten (National Academy of Fine Arts).

In 1929, after returning to Groningen, he married and the first of three daughters was born. He enrolled at the Vrije Academie (Free Academy) in Groningen, where he came in contact with Werkman and artists associated with the influential group De Ploeg (The Plough), including its leading practitioner, the Kirchner-inspired Dutch expressionist Jan Wiegers.

68 koning (king) 1953
Stedelijk Museum, Schiedam

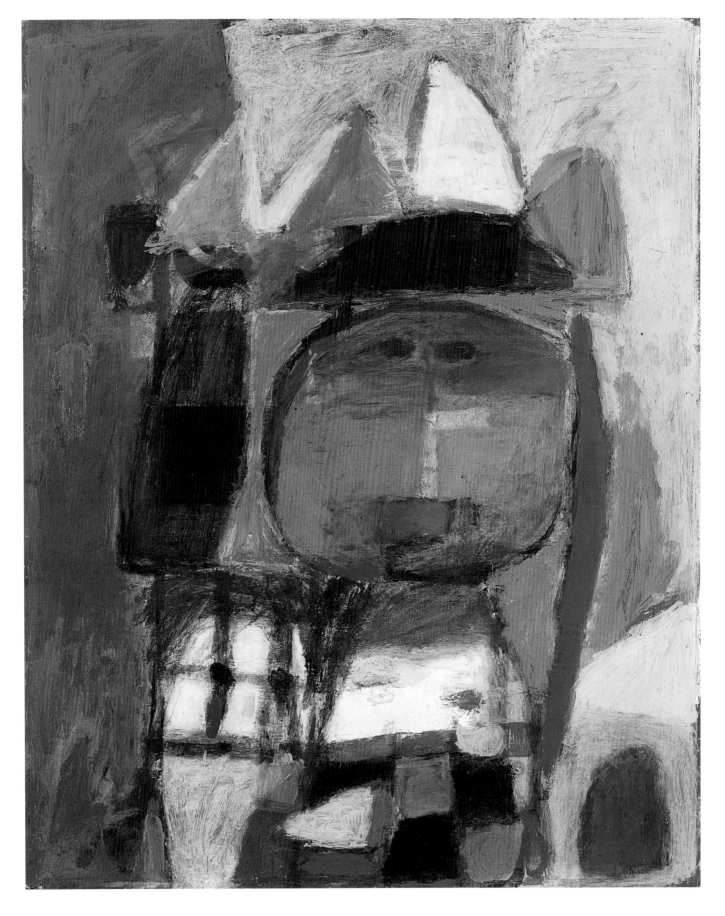

Nanninga continued to practise his art, made drawings in public in tobacconist shops and painted advertising hoardings. He left his wife in 1936, bought a caravan and travelled through Germany and Poland. When he returned, he moved to The Hague and in 1940, married a Polish-German woman he had met on his travels and they lived in his caravan in The Hague.

Nanninga worked briefly for a painter/decorator in The Hague, enrolled at the Academie van Beeldende Kunsten (Academy of Fine Arts) and, between 1939 and 1944, attended drawing and painting classes. The painter Hermanus Berserik described him as, 'a big, somewhat slow-moving man with an unmistakable Groningen accent and melancholy eyes'.[1]

Nanninga also received tuition from the painter Lydia Duif. She knew the work of Paul Klee and Wassily Kandinsky, painted brightly coloured still lifes and travelled extensively. He made contact with the occupants of a well-known artists' house in The Hague and moved into its attic with only his painting materials, effectively ending his second marriage.

French modern masters such as Édouard Vuillard, Pierre Bonnard, Henri Matisse, Raoul Dufy, Georges Braque and Georges Rouault were the most admired at the artists' house. He stayed there alone throughout the War and during much of the bombardment of The Hague in 1944–45. He escaped briefly, moved from place to place but continued to paint. Nanninga returned for an exhibition of his work shortly after the end of the War.

In 1946 Nanninga travelled to the south of France, stayed in the holiday house of a friend at Cagnes-sur-Mer and, for a time, set up a studio on the French Riviera. He saw the work of Henri Matisse, Marc Chagall and Georges Braque, and came to a better understanding of the work that Vincent van Gogh painted in the south of France. Thereafter Van Gogh's work was a sustaining inspiration for Nanninga. He spent some time in Paris and attended the Académie de la Grande Chaumière. He met the Dutch abstract painter Geer van Velde (younger brother of Bram van Velde) in France and was encouraged by his example to paint abstractly.

Nanninga returned to The Hague in 1948, found a studio space in the semi-rural environment of Clingendael on the outskirts of The Hague and remained working there until his death. This studio was later described as 'a dark hole full of rats like small dogs'.[2]

He married for the third time in 1948. They had a son and a daughter, but divorced in 1951. Karel Appel visited Nanninga in 1949 hoping to recruit him for the newly formed CoBrA group, but quickly realized that they had little in common.

Nanninga won several major prizes for painting, including the Jacob Maris Prize twice (1951 and 1953), and was part of the Posthoorn artists group in The Hague. There were close friendships with the painter/poet Willem Hussem and surrealist Piet Ouborg. However, Nanninga remained a reserved, melancholic and private individual, totally absorbed in his work. Secretly he wrote poetry and published it under a pseudonym, Cor Stutvoet.

In 1957 he was included in the exhibition of contemporary painters *Vijf generaties* (Five generations) at the Stedelijk Museum, Amsterdam, which led to a visit from its influential Director Willem Sandberg. Nanninga was undergoing a serious operation in hospital at the time of the visit, so Sandberg visited the studio unaccompanied and was struck by the quality and originality of Nanninga's contemplative abstract art. Exhibitions followed at the Stedelijk Museum, Schiedam, the Stedelijk Museum, Amsterdam, and the Gemeentemuseum, The Hague. This exposure led to international interest in his work.

Nanninga exhibited at the Biennale di Venezia with Gerrit Benner in 1958 and the following year at the São Paulo Bienal with Karel Appel and Corneille. In 1959, with the support of the Maison Jaune fund, he re-visited the south of France.

On 6 January 1962, after attending an exhibition of the work of the revered Dutch poet Jan Jacob Slauerhoff at the Literature Museum in The Hague, Nanninga was killed in a car accident with a tram.[3] He was 57 years old with an enviable reputation as a painter; his work increasingly collected by museums and private collectors in the Netherlands and elsewhere in Europe. A memorial retrospective was held at the Boijmans van Beuningen Museum, Rotterdam, and at the Gemeentemuseum, The Hague, 1962–63.

1. Hermanus Berserik in Erik Slagter, *Nanninga schilder/painter/peintre*, Openbaar Kunstbezit, Amsterdam 1987, p 11

2. Bibeb in Erik Slagter, 1987, p 13

3. On the day of his death in a copy of the Stauerhoff exhibition catalogue he wrote: And now I know, I'll not find peace / Not out at sea, nor on the land / Until the last beam falls on wood / Or on a grain of sand

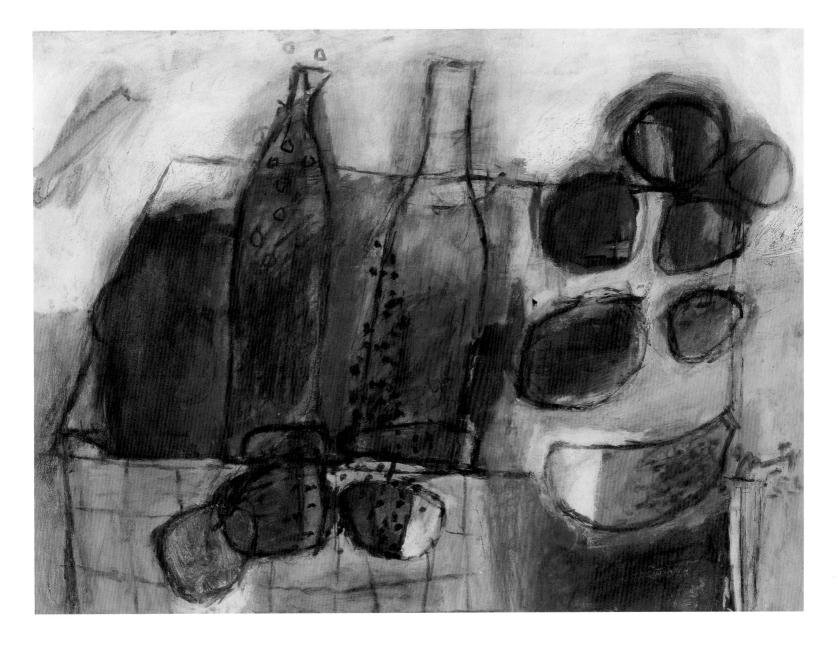

jaap nanninga
72 stilleven (still life) 1953
Van Abbemuseum, Eindhoven

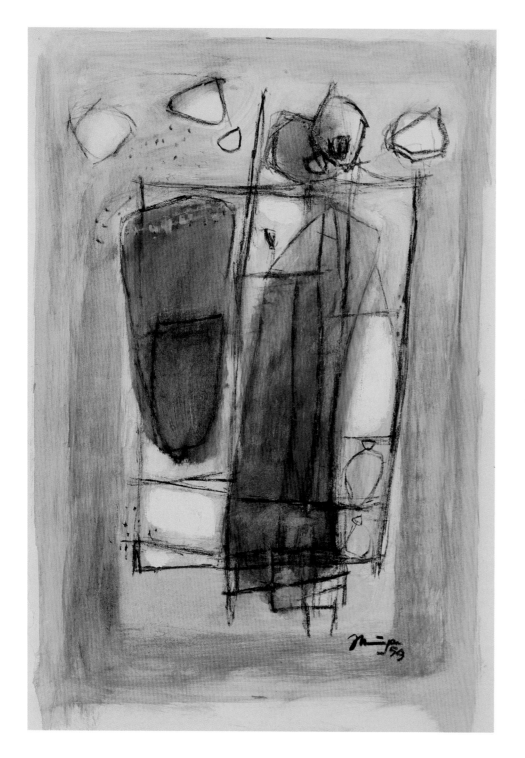

Wolkenhuizen

Wolkenhuizen die wij schiepen
vliegtuigen
bierglazen
kacheltangen
rood voor lippen
 nagels
 wangen,
bed waar wij vannacht op sliepen –
iedere dakpan is verlangen

Cor Stutvoet (Jaap Nanninga)

Aircastles

Those aircastles we created
airplanes
beerglasses
firetongs
red for lips
 nails
 cheeks,
that bed on which we slept tonight –
each rooftile filled with longing

jaap nanninga
73 compositie (composition) 1959
Gemeentemuseum, The Hague

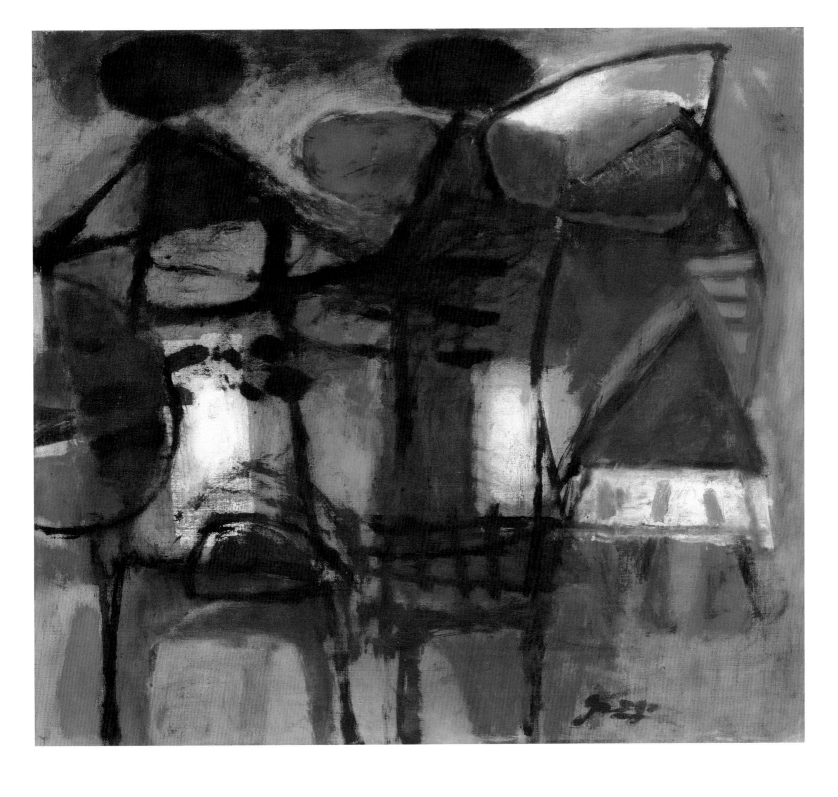

69 uganda 1958
Gemeentemuseum, The Hague

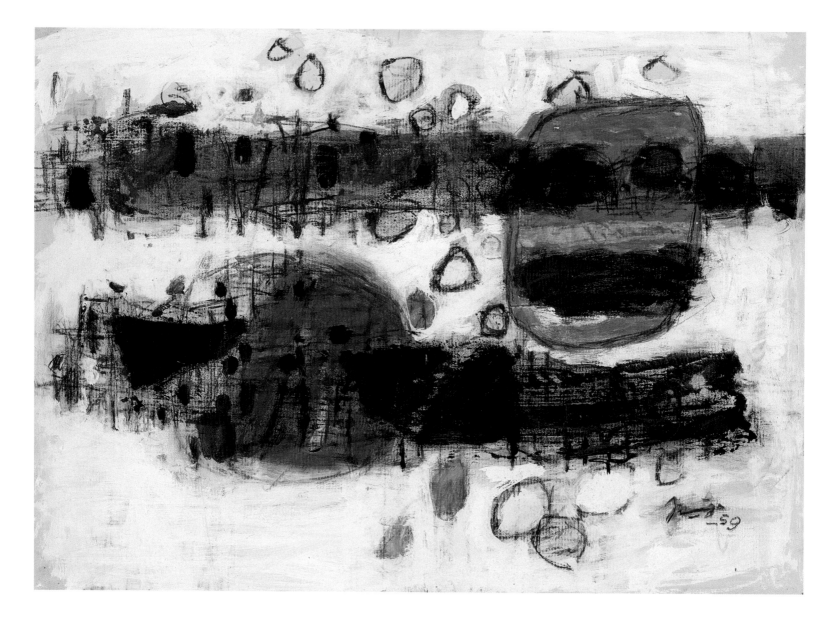

jaap nanninga
74 compositie op wit fond (composition on white background) 1959
Dordrechtsmuseum, Dordrecht

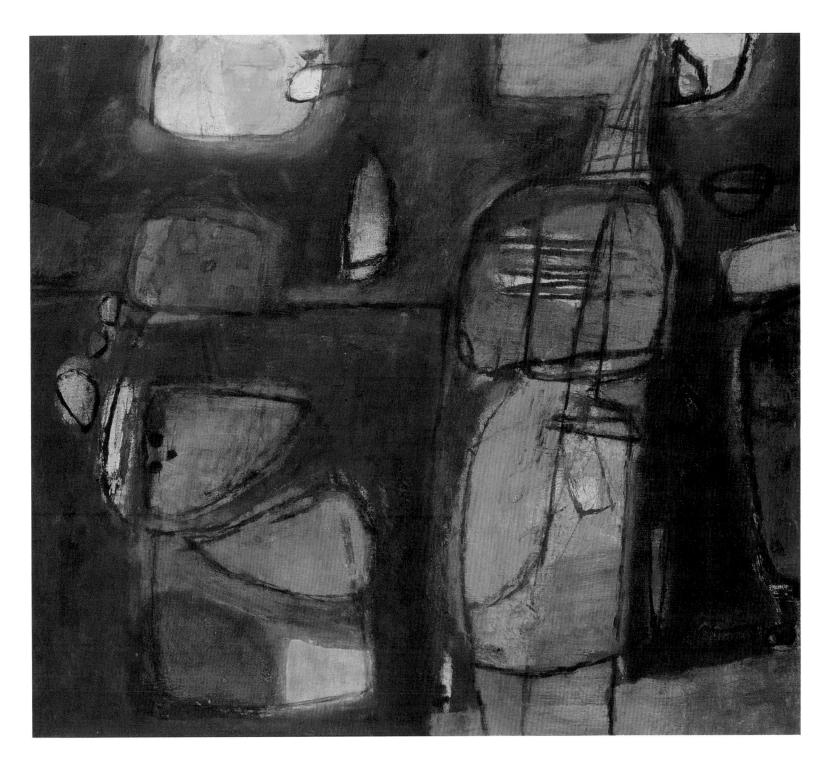

70 figura 1960
Van Abbemuseum, Eindhoven

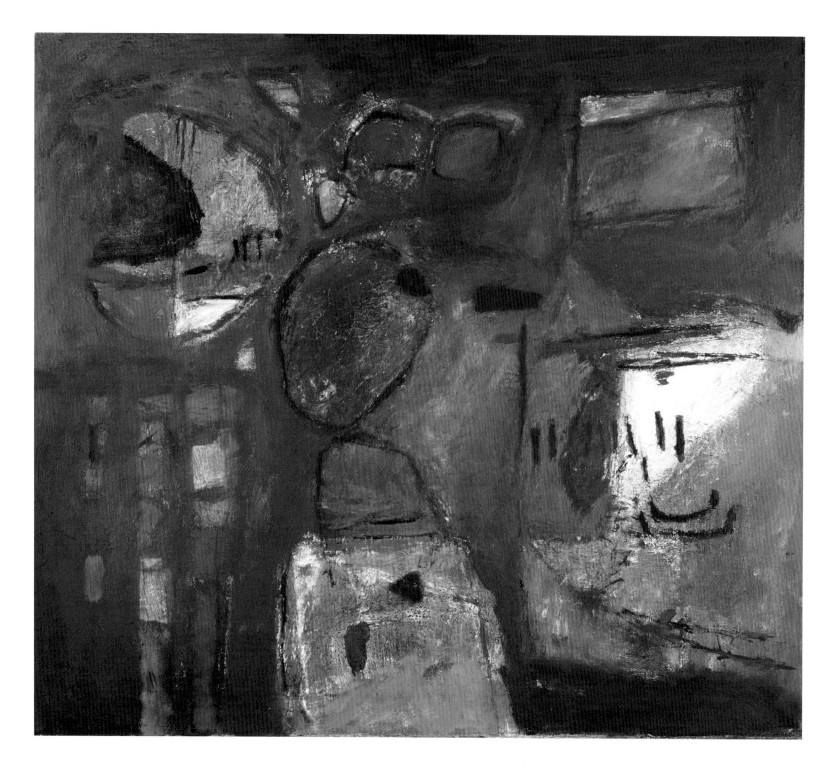

jaap nanninga
71 bagdad 1961
Boijmans van Beuningen Museum, Rotterdam

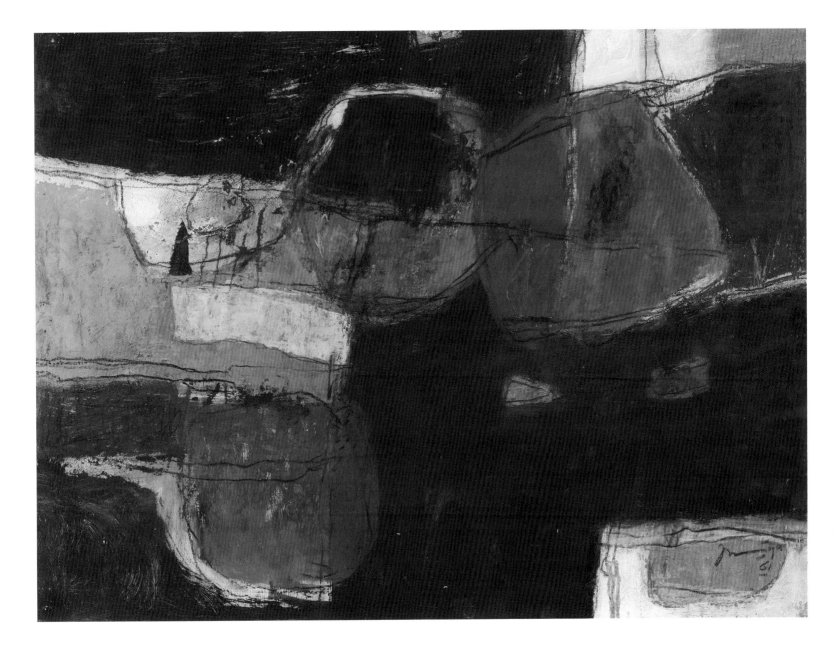

75 compositie in kleuren (composition in colours) 1961
Boijmans van Beuningen Museum, Rotterdam

bram van velde

Bram van Velde was born in Zoeterwoude, near Leiden, on 19 October 1895, the second of four children. His younger brother Geer also became a painter and his sister Jacoba, a writer and translator, including Samuel Beckett's. His father, who owned a small river freight business that fell into serious financial difficulties, abandoned his family when Bram was eight years old. Bram, with his brother and sisters, moved to The Hague with their mother and lived in extreme poverty. His father died alone shortly after in Utrecht. His difficult early years deeply affected Bram and throughout his life he displayed an intense humility and austerity.

In 1907 Bram van Velde started as an apprentice in the painting and interior decoration company Van Schaijk & Co in The Hague. Van Schaijk's partner Eduard H Kramers, a collector and lover of art, encouraged Bram van Velde artistically. In 1922 he provided him with a monthly allowance to pursue art training in Munich. However, Bram van Velde moved to Worpswede near Bremen, attracted by a colony of expressionist artists. There he met his future wife, the painter Lilly Klöker. The experience of painting full time in Worpswede was a turning point in his artistic development. After two years, he moved to Paris with the financial support of Eduard Kramers and Kramers' son, Wijnand.

Geer van Velde joined his brother in 1925, also with the patronage of the Kramers. They shared working and living quarters and were both selected for the Paris Salon des Indépendants in 1927 (and on several occasions until 1941). Whilst in Paris, Bram van Velde was greatly influenced by the work of Henri Matisse. He used Matisseian colours but was already defining a highly personal pictorial language outside any artistic movement of the time.

Having left his native country when he was 27, Bram van Velde rarely returned and became a virtual nomad. Exacerbated by financial insecurity, he was unable to settle anywhere for long. In search of new stimulus, Bram van Velde and Lilly Klöker spent the summer of 1930 in Corsica but returned to Paris before going to Majorca in 1932. Then, from 1933, as a result of the world economic Depression of 1929–30, Eduard Kramers was no longer able to support the brothers. Bram's wife died tragically during the summer of 1936, just as the outbreak of the Spanish Civil War forced his return to Paris.

In 1937 Bram van Velde met the Irish-born writer Samuel Beckett through his brother Geer and Marthe Arnaud-Kunst who later became Bram's partner. In the summer of 1938, he was imprisoned for four weeks in Bayonne in the south of France, because he did not have a valid residence permit. There he completed a poignant series of drawings later known as *Carnet de Bayonne*, using the backs of letters and envelopes that he received from Marthe. Around 1939 Bram van Velde's pictorial language became more complex and increasingly abstract, composed of curves, ovals, lines and circles. He also began to make his first gouaches.

In 1940 in Paris, alone and unable to work, Bram van Velde wrote to Beckett and invited him to visit. Thereafter, they quickly became the closest of friends. It was a rare and vitally important relationship between two otherwise self-absorbed individuals. For Bram van Velde, 'meeting Beckett was a truly miraculous stroke of luck'.[1] Immediately after the Second World War, Beckett wrote tellingly about Bram and Geer van Velde in the journal *Cahiers d'art* (1945–46) in an essay titled, 'La peinture des Van Velde ou le monde et le pantalon' ('Painting by the Van Veldes or the world and a pair of trousers'). Beckett's involvement led to growing interest in and understanding of the work of both brothers.

 Bram van Velde had started painting again at the end of 1945. His first solo exhibition followed a year later at Galerie Mai, Paris. He was 51 years of age. The exhibition was a commercial failure, the first of a string of disappointments to come. He signed a five-year contract with the Galerie Maeght, Paris, which organised an exhibition in New York, that Willem de Kooning saw, and several others in Paris. Unfortunately the gallery lost interest in him because the exhibitions were commercially unsuccessful. Bram van Velde felt more isolated than ever, until he was taken on by the art dealer Jacques Putman in 1952. Public recognition came with the first retrospective of his work, organized by the Kunsthalle, Berne, in 1958, followed by another at the Stedelijk Museum, Amsterdam, in 1959–60. These exhibitions bolstered his reputation, led to greater commercial success and a less uncertain future. Bram van Velde remained faithful to his own painterly abstract language, always seeking greater visual liberty and purity. Drawing had disappeared and space was generated by colour and mass alone.

Bram van Velde's partner Marthe died in a car accident in 1959. Visiting the art dealer and collector Jean Krugier in Geneva that Christmas, he met the young painter Madeleine Spierer. Thereafter he lived in both Paris and Geneva before settling at La Chapelle-sur-Carouge, Switzerland, with Madeleine in 1967. He began travelling in Europe and America for exhibitions of his work and received official recognition in France, the Netherlands and Iceland. He visited New York for the first time in 1962 with Jacques Putman and the Belgian artist Pierre Alechinsky and met Willem de Kooning. Later, Alechinsky reported that, regretfully, the two Dutch artists merely exchanged banalities in their almost forgotten mother-tongue because neither could communicate with one another in their adopted English or French.

At La Chapelle-sur-Carouge, later in Paris and at Putman's house in Grimaud, Provence, Bram van Velde took long walks, a form of meditation that prepared his mind for creative expression.

I am a walker. When I'm not working, I have to walk. I walk so that I can go on working.[2]

From the end of the 1960s he experimented with gouache and black and white inks which naturally led him to re-discover lithography. His first lithograph was made as early as 1923. He painted his last canvas in 1970 and thereafter concentrated exclusively on gouache and lithography. This allowed him to limit his range of colours even further. Lithography made his work far more accessible. In all, he created more than 400 lithographs.

When his relationship with Madeleine ended in 1977, Bram van Velde returned to Paris to his friend Jacques Putman and Putman's partner Catherine Béraud. He spent the last years of his life with them in Paris and in Grimaud where he died aged 86 on 28 December 1981. Bram Van Velde is buried near Arles in the Béraud family vault.

1. Charles Juliet, *Conversations with Samuel Beckett and Bram van Velde,* Academic Press, Leiden 1995, p 60
2. Charles Juliet, 1995, p 77

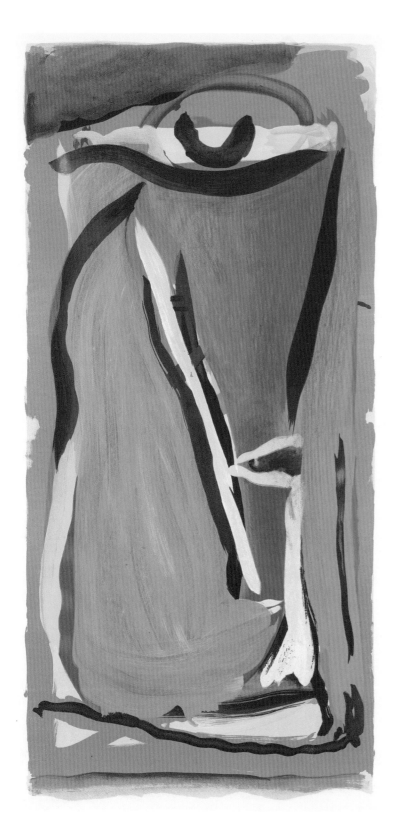

When I approach a canvas, I encounter silence.
This mechanical world is asphyxiating us. Painting is life.
Life is not in the visible.
The canvas allows me to make the invisible visible.

I am well aware that a painting must inevitably be a bizarre, incomprehensible thing.
I start off on the canvas and, little by little, it imposes its own solution.
But that solution is not easy to find.
A painting is not a battle against other people, but against oneself.

A picture is an effort to get at the source, an enquiry into the mystery of life undertaken with one's entire being.

Bram van Velde in Charles Juliet, *Conversations with Samuel Beckett and Bram van Velde,* 1995, pp 63, 70, 89

bram van velde
101 compositie (composition) 1955
Boijmans van Beuningen Museum, Rotterdam

98 compositie (composition) 1950
Gemeentemuseum, The Hague

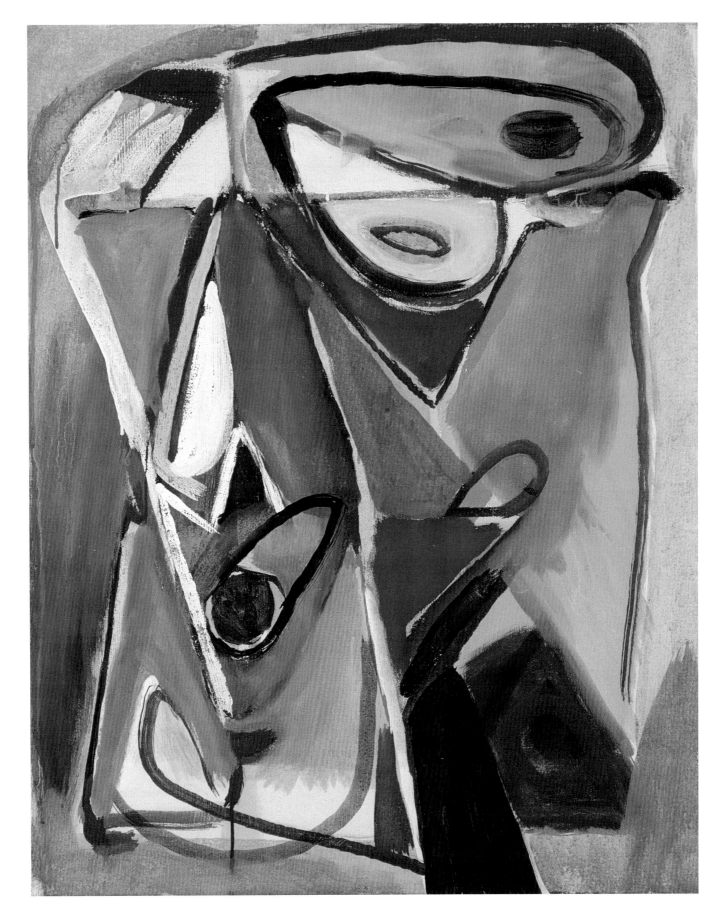

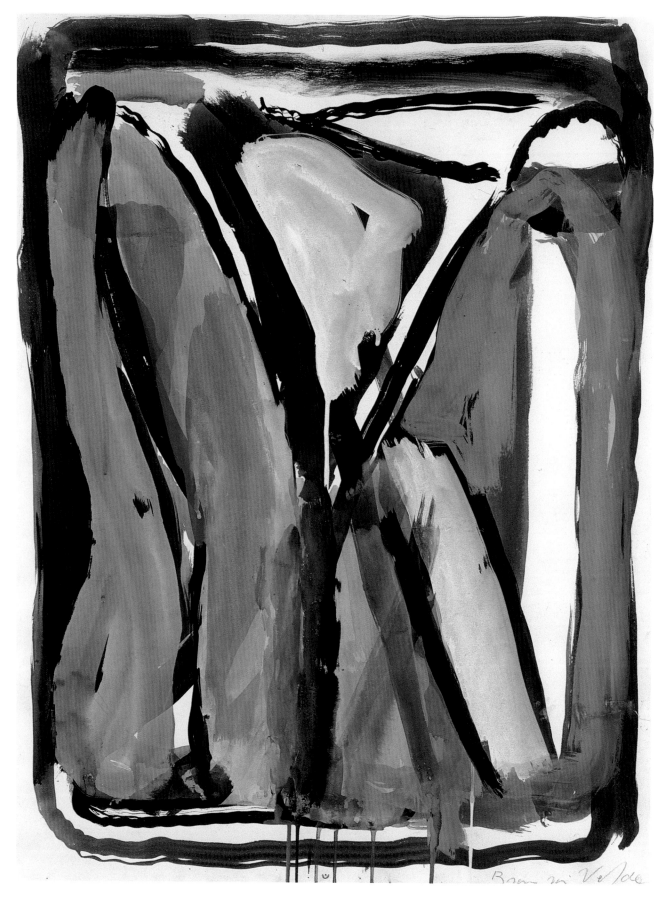

Bram van Velde

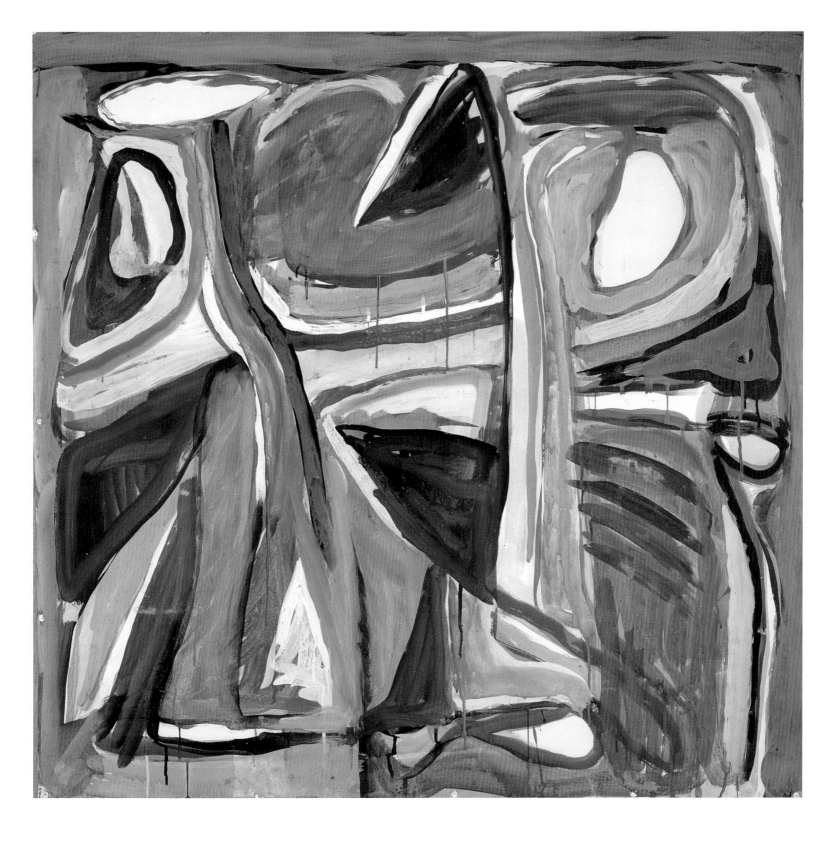

bram van velde

100 compositie (composition) 1971
Netherlands Institute for Cultural Heritage (on loan to Dordrechtsmuseum, Dordrecht)

99 untitled 1961
Van Abbemuseum, Eindhoven

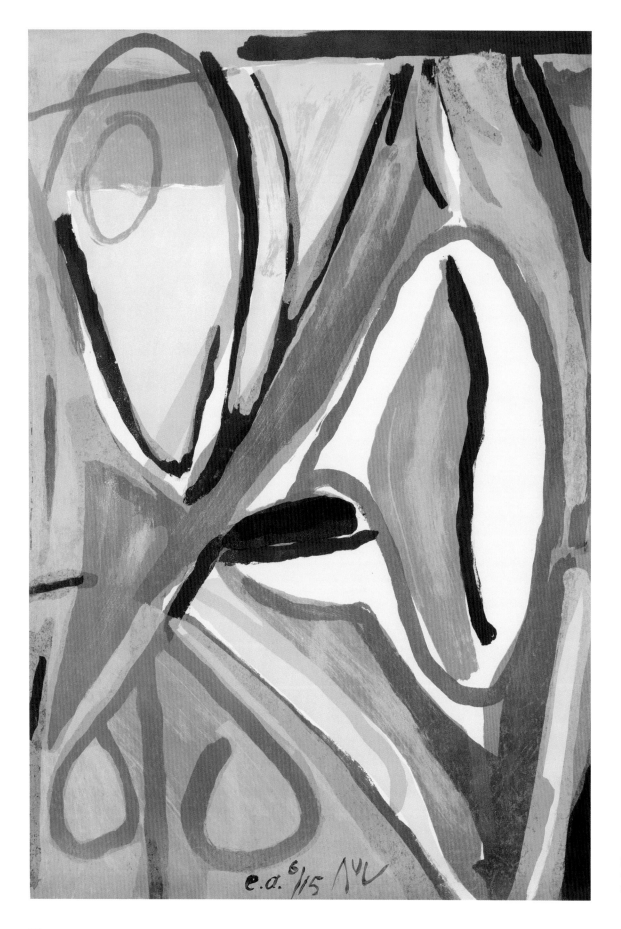

bram van velde
102 untitled 1974
Boijmans van Beuningen Museum, Rotterdam

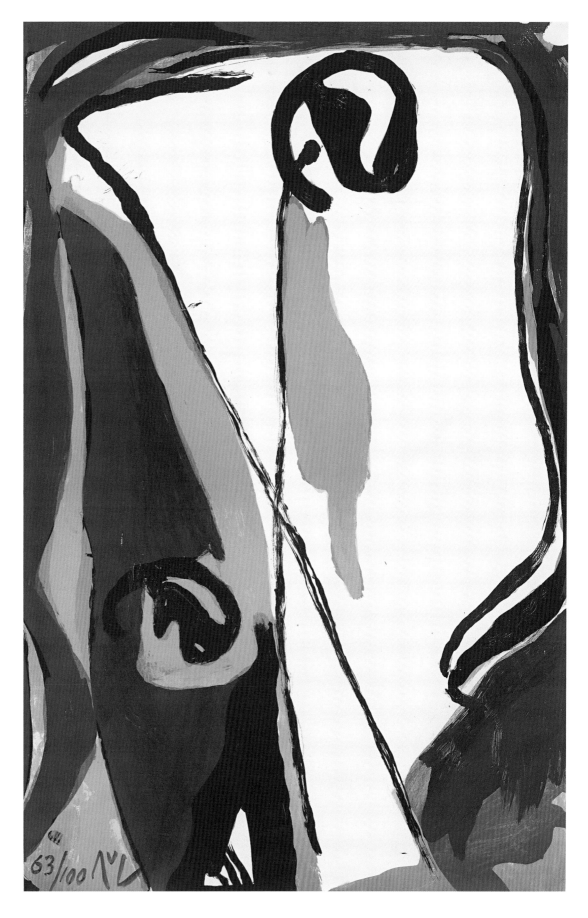

103 untitled 1975
National Gallery of Victoria, Melbourne

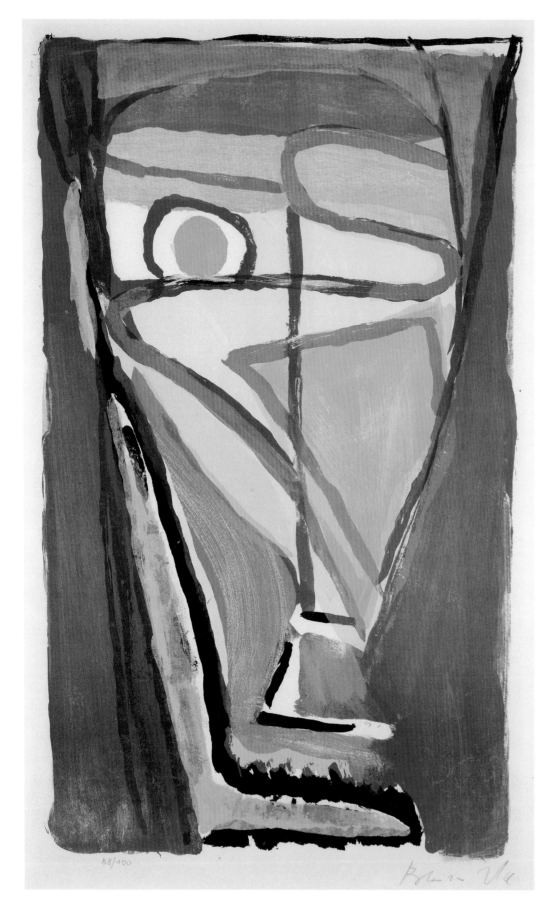

88/100

bram van velde
104 untitled 1975
Stedelijk Museum, Schiedam

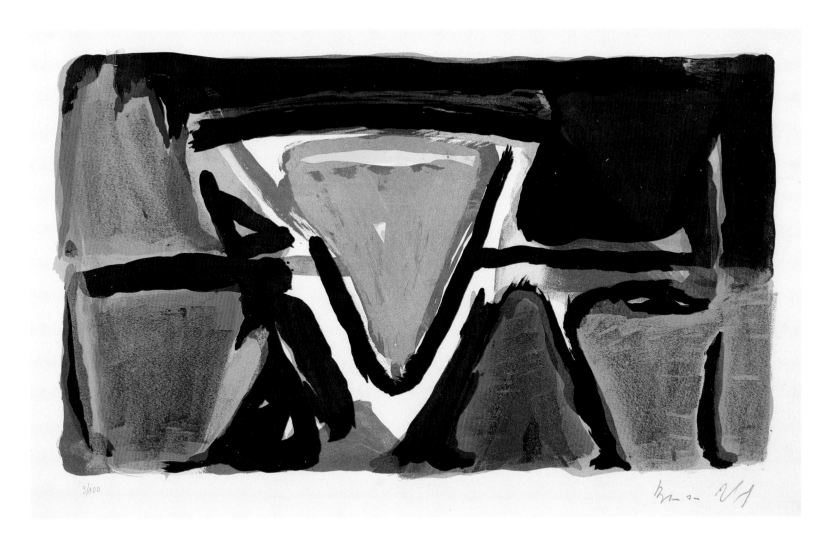

105 untitled 1977
Private collection

willem de kooning

Willem de Kooning was born in North Rotterdam on 4 April 1904. He was three years old when his parents divorced. Both had financial and personal difficulties. His mother Cornelia was violent and tyrannical, and left Willem emotionally scarred. He rarely spoke of his early life in the Netherlands.

In 1916 De Kooning began an apprenticeship in the decorating firm of Giddings & Zonen. From 1917 to 1921 he attended evening drawing classes in the Academie van Beeldende Kunsten en Technische Wetenschappen (Academy of Fine and Applied Arts) in Rotterdam. It is now named after him. From this time on, he began to draw obsessively. This became the creative stimulus for all of his subsequent work. In 1920 he left his mother and shared a studio with two friends. He also left Giddings to work for an art director in a department store, who introduced him to the work of Piet Mondriaan, Jan Toorop and Frank Lloyd Wright, and the art movements De Stijl, Bauhaus and Jugendstil.

 In the following years he explored the Netherlands and Belgium, drawing and supporting himself with commercial art. He re-enrolled in the Academy in 1925 but only attended intermittently. Like many of his contemporaries, De Kooning dreamt about America and its opportunities. In 1926, after several abortive attempts, he succeeded in entering the United States illegally, avoiding the usual entry point of Ellis Island. He left the Netherlands without regret, though he missed his protective elder sister Marie. With the help of Leo Cohan, a Dutch friend, he found work as a house painter at the Holland Seamen's Home in Hoboken, New Jersey, before moving to a studio in Greenwich Village, New York.

De Kooning was determined to become a modern painter and break with the past. He quickly familiarized himself with American art and became part of a lively circle of artists, poets, writers and musicians. In 1929 he was encouraged by the artist and critic John Graham, and artists Stuart Davis and Arshile Gorky. Gorky, an expatriate Armenian, was De Kooning's closest and most influential friend until his suicide in 1948.

In 1935 De Kooning participated in the Federal Arts Project under the Works Progress Administration (WPA), which was launched in order to supply commissions to artists who suffered in the Depression, but left in 1936 because of his foreign status. This was the first time he was able to devote himself fully to art. In the autumn of 1936, the art critic and poet Harold Rosenberg included De Kooning in *New horizons in American art* at the Museum of Modern Art, New York, the first major public exposure of his work. In 1938 he met the art student Elaine Fried. They married in 1943, separated two years later but never divorced. De Kooning had other relationships, but none were as important to him as his art. In 1956 his only daughter Lisa was born to Joan Ward.

In the 1930s De Kooning painted his first abstract compositions and, under the influence of Gorky, a series of male figures. By the end of the decade, his first images of women appeared. During the war years, he was a key member in New York's art world, associated with Barnett Newman, Franz Kline and Jackson Pollock, the most important members of the American abstract expressionist movement. He used biomorphic forms in his paintings, never entirely rejecting the figure but pursuing both abstraction and figuration throughout his life. Around 1946 he painted his now famous series of black and white abstracts, which were shown at his first solo exhibition at Charles Egan Gallery, New York, in April 1948. Despite the admiration of his contemporaries the show was a commercial failure.

During the summers of 1948 and 1950 he taught at Black Mountains College, North Carolina, and the Yale School of Art and Architecture, New Haven, where he was remembered as a conscientious and committed teacher. In 1949 he became a member of the discussion group 'The Club' at 39 East Eighth Street, New York, and delivered a lecture *A desperate view* during one of their Friday night symposia. During the following years he wrote *The Renaissance and order* and *What abstract art means to me*. In each text he justified the choices that he was making in his art. In the late 1940s he met the art critic Thomas Hess who, with Harold Rosenberg, was a strong advocate of his art.

The 1950s was the decade of greatest public recognition for De Kooning. He exhibited more frequently in solo and group shows than previously. He was selected by Alfred H Barr jnr. (Director of the Museum of Modern Art, New York) for the Biennale di Venezia in 1950, was included in the São Paulo Bienal in 1952 and 1953, the Biennale di Venezia again in 1954 and 1956, and won important prizes such as the 60th Annual American Exhibition, Art Institute of Chicago in 1951.

In the summer of 1950 he began the first of his expressive and now famous *Woman* series. The last, *Woman V*, is in the collection of the National Gallery of Australia, Canberra. Three years later, the series was exhibited at the Sidney Janis Gallery in New York and caused a sensation, because most of his contemporaries remained abstract expressionists.

Following the *Woman* series, he entered a new phase of gestural abstraction which became known as 'abstract landscapes'. Pastoral in mood, they were painted during the summers he spent in East Hampton, Long Island.

De Kooning travelled to Rome during the winter of 1959 where he made abstract drawings in black enamel on paper. In 1960 he created his first lithographs, two large black and white prints which coincided with a radical increase in the size of lithographs produced in America in the 1960s. He became an American citizen in 1962, received the Presidential Medal of Freedom and the Guggenheim International Award, but he suffered a serious crisis of doubt concerning his work. In 1964 he had a purpose-built studio erected at The Springs, East Hampton, which was well away from the pressures of New York.

De Kooning returned to the Netherlands in 1968 for the opening of a retrospective at the Stedelijk Museum in Amsterdam organized by the Museum of Modern Art in New York. He travelled to Europe with Thomas Hess and his dealer Xavier Fourcade, visiting Paris to see an Ingres exhibition, and to London where he met Francis Bacon. He spent the summer of 1969 in Rome where he produced 13 small figurative sculptures in clay, which the British sculptor Henry Moore later encouraged him to enlarge and cast in bronze.

In 1970–71 he created two series of lithographs with the Dutch lithographic printer Fred Genis in New York. He continued to devote most of his energy to painting and started employing assistants. In his abstract landscapes, figurative and abstract elements merge in rich colourful compositions, such as *Two trees on Mary Street … Amen!* 1975.

On his seventy-fifth birthday in 1979, De Kooning was honored by the Dutch Queen. In the late 1970s Elaine de Kooning re-entered De Kooning's life and helped him overcome his addiction to alcohol. In the 1980s he painted numerous large abstract canvases that are spare in gesture and colour. At the end of his life he suffered from Alzheimer's disease. De Kooning died aged 93 at his home in East Hampton on 19 October 1997.

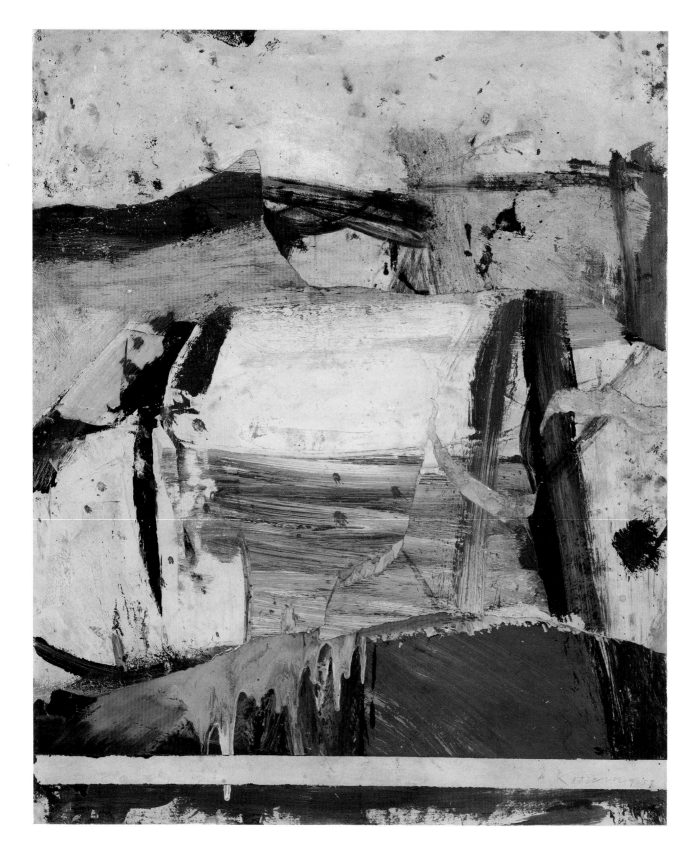

willem de kooning
47 july 4th 1957
National Gallery of Australia, Canberra

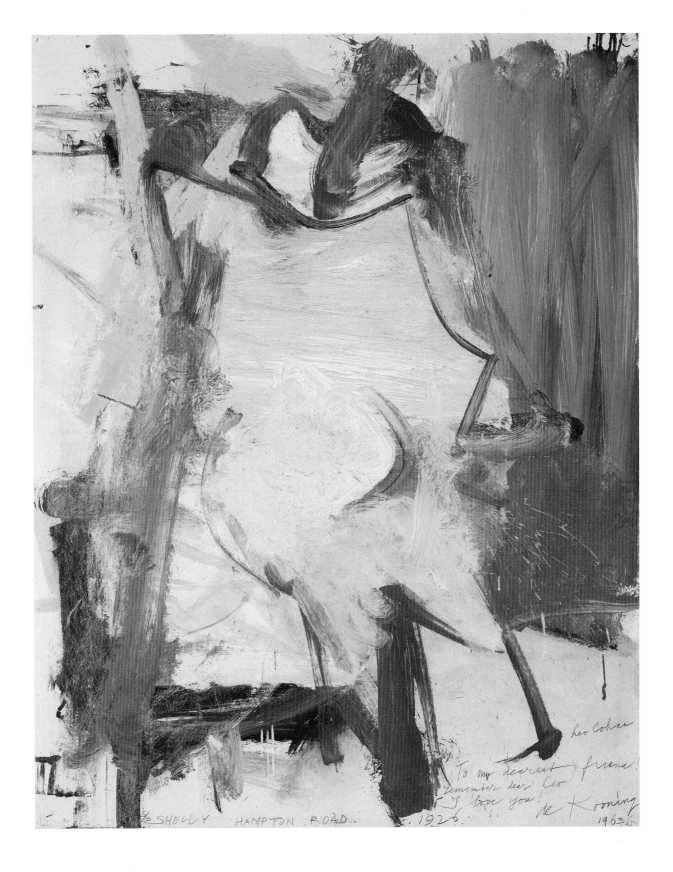

48 the cliff of the palisade with hudson river, weehawken, new jersey 1963

Boijmans van Beuningen Museum, Rotterdam

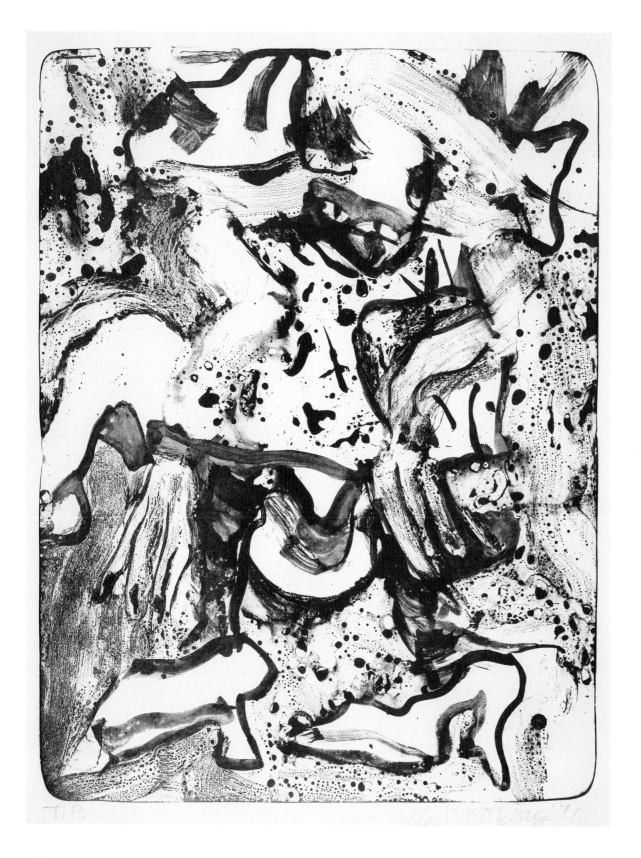

willem de kooning
51 minnie mouse 1971
Art Gallery of New South Wales, Sydney

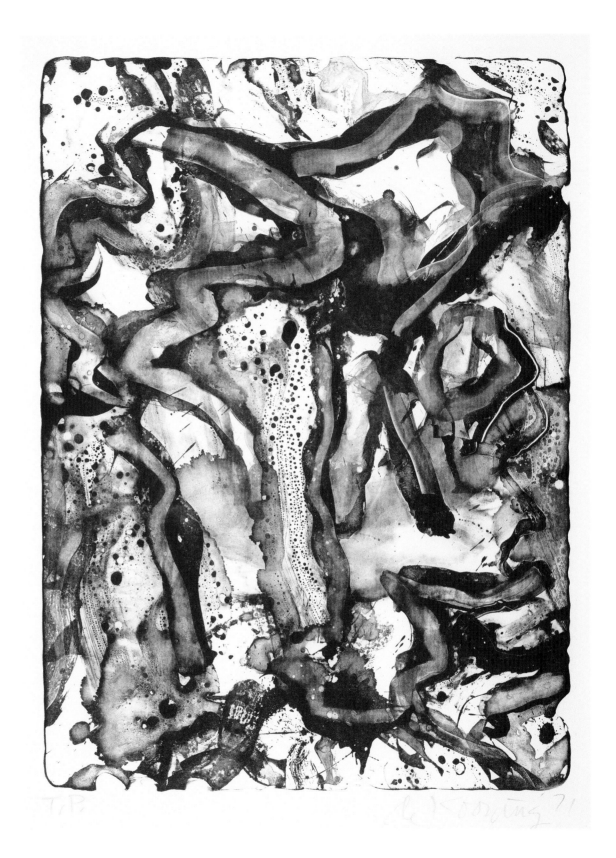

52 landscape at stanton street 1971
Art Gallery of New South Wales, Sydney

willem de kooning
50 untitled figure 1965–80
Art Gallery of New South Wales, Sydney

49 two trees on mary street … amen! 1975
Queensland Art Gallery, Brisbane

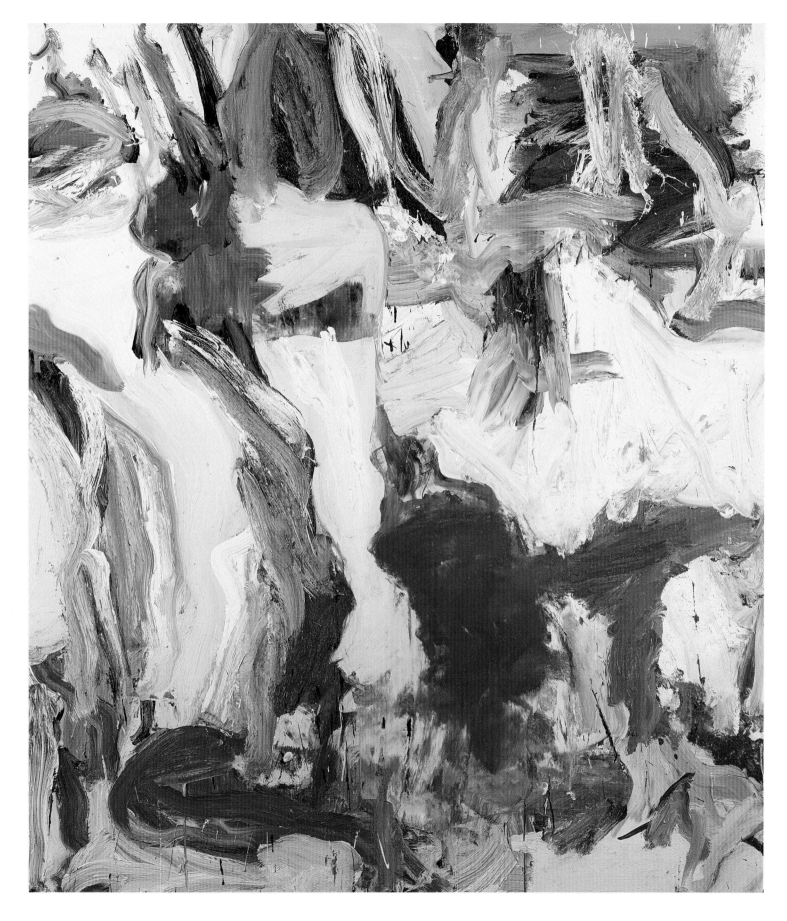

wim oepts

Willem Anthonie Oepts was born on 22 August 1904 in Amsterdam, the youngest of seven children to a working class family. His father was a furniture-maker. They lived in various parts of Amsterdam, stimulating Wim's love of modern city life, which later became the subject matter of his art. Art did not occupy him initially. Instead he was attracted to technical things and attended trade school in order to become a machinist in the maritime industry. He began working at fourteen years of age making drawings of machinery. In his free time he visited the Rijksmuseum where he discovered the paintings and drawings of Vincent van Gogh. Van Gogh became a life-long inspiration as Oepts began to draw his immediate environment.

In search of friends his own age, he joined the newly formed socialist Arbeiders Jeugd Centrale (Young Workers Central) where he discovered the art of the woodcut, a technique much in use in magazine, newspaper and book illustration. This further motivated him to draw, as well as to make woodcuts. Oepts's subjects were mainly popular scenes, cabarets and café interiors depicting the daily life of ordinary people, as well as views of wastelands on the outskirts of the city. In 1925 he met Piet Tiggers (later Director of the Netherlands Opera) who encouraged him and introduced him to the artist Charley Toorop. She was struck by the quality of Oepts' woodcuts and invited him to her house in Bergen. She introduced him to other artists, including the sculptor John Rädecker, designer Gerrit Rietveld and dada-ist Kurt Schwitters.

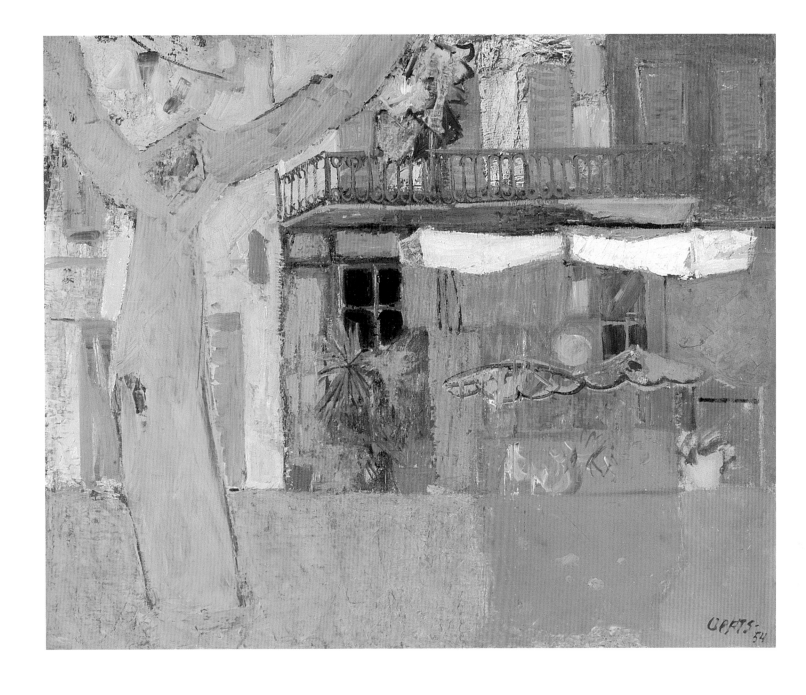

76 dorpscafé (village café) 1954

Netherlands Institute for Cultural Heritage
(on loan to Museum Henriette Polak, Zutphen)

In the second half of the 1920s, due to Charley Toorop's influence, his work was included in group exhibitions at the Stedelijk Museum, Amsterdam, and he made further contacts with artists and critics including Bart van der Leck, H P Bremmer and Joop Sjollema. There was increasing public interest in his work: the municipality of Amsterdam made several purchases. The art historian, Professor J Q van Regteren Altena, also supported Oepts and secured him a scholarship to study at the Rijksakademie van Beeldende Kunsten (National Academy of Fine Arts) in Amsterdam, but that did not suit him for long.

Gradually, Oepts freed himself from the influence of Charley Toorop. He made his first visit to Paris in 1931 and married Nelly Tuenissen. Between 1934 and 1937 he and his wife spent more and more time in France, and he attended Othon Friesz's Académie Scandinave in Paris. Friesz extolled the importance of *orchestration colorée* (orchestration of colour) to his students, which Oepts took as his credo. In 1937 he shared studio space with Sjollema in Amsterdam. Sjollema, who spent most of his time in Paris, introduced Oepts to the French artist's model and painter Marthe Jeanne Caudel. Oepts divorced his first wife and married Caudel in 1939. They moved to Paris, intending to live there in spite of a lack of financial security. When Oepts became seriously ill, they moved to Saint-Tropez to stay with friends, where he was immediately entranced by the light and colour of the south of France, in the area known as the Midi.

The devastating bombardment of Rotterdam by the German airforce in May 1940 and the subsequent occupation of the Netherlands, re-awakened his feelings for his homeland, so he and Marthe moved to London to join the Dutch resistance. He returned to the Netherlands just prior to the German retreat, produced illustrations for the then underground weekly *Vrij Nederland* and the official military magazine *Pen gun.* In 1946 he and Marthe returned to Paris and lived in a studio on rue Lacepède. Poverty curbed his contact with Dutch artist friends, many of whom had returned to the Netherlands at the end of the War.

Each summer, Oepts and his wife left Paris to stay by themselves in a small house and studio, near Saint-Tropez. On the hills of Saint-Tropez and Collioure he made drawings which he developed into paintings in his Paris studio. As he described it:

I must weigh the colours till the colour glows and it begins to acquire significance. A mark must vibrate.[1]

He also painted and repainted layer upon layer in search of the essence of his experiences, rather than depicting any one scene.

I make ten paintings on every painting.[2]

Annually they also visited friends and family in Amsterdam. This became the established pattern of their lives. They devoted themselves to art, in spite of hardship and isolation. He ignored new art movements like CoBrA and the various manifestations of *art informel*, and exhibited with galleries in The Hague and Amsterdam. A financier who supported his work, organized a private showing of his paintings in Vlaardingen in 1952. Following this exhibition, private collectors began visiting him in Paris to purchase his paintings. Thereafter, Oepts spurned commercial galleries and returned to the Netherlands on occasion, his car loaded with paintings for collectors.

With increased sales of his paintings, Oepts and his wife were able to improve their life in Paris and move into a bigger, better apartment and studio space on rue de Navarin. He was also able to have a studio built in a favourite town, Boisseron, near Nîmes. In the late 1970s interest in the work of Oepts and others outside the Dutch mainsteam of modernism (such as Kees Verwey, Otto B de Kat and Sjollema) was re-awakened, aided by the establishment of the Museum Henriette Polak in Zutphen, which specialized in their work.

In the 1980s, as they aged, Oepts and Marthe moved to a Paris apartment on rue de Frochot that was more suited to their needs. In 1984 the Institut Néerlandais in Paris organized a retrospective of his paintings and early woodcuts. Wim Oepts died aged 83 in Paris on 22 March 1988.

1. Lies Netel, *Wim Oepts: 'peinture, c'est le principal' 1904–1988,* Museum Henriette Polak, Zutphen 2006, p 38

2. Lies Netel, 2006 p 40

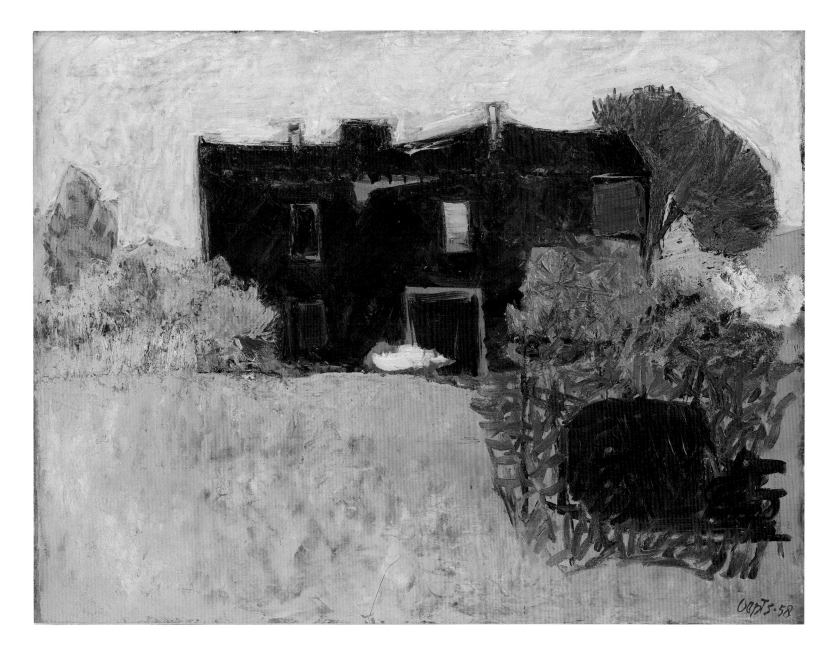

wim oepts
77 het blauwe huis (the blue house) 1958
Museum van Bommel van Dam, Venlo

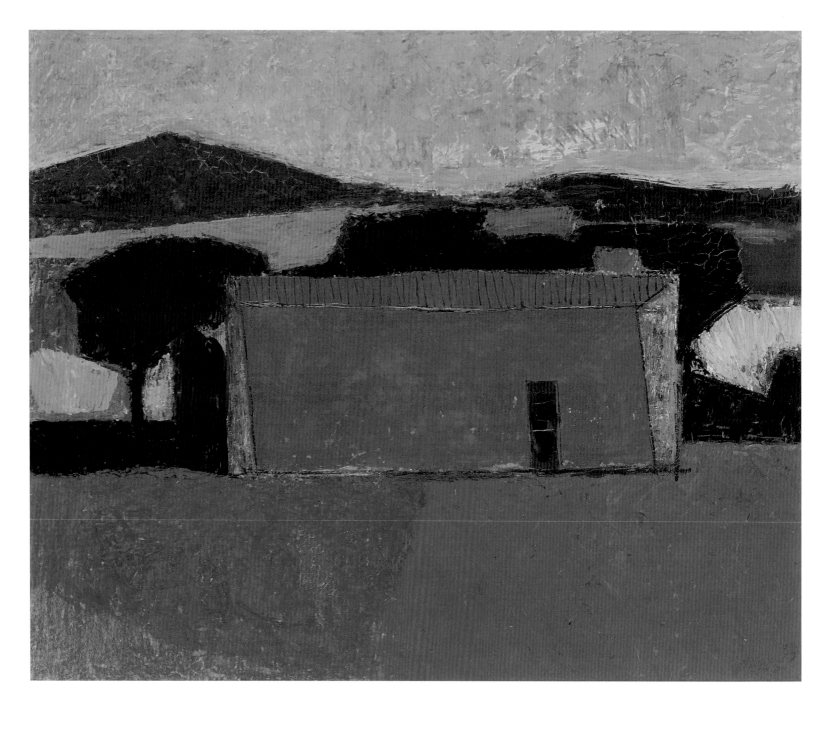

wim oepts
78 het rode huis (the red house) 1959
Museum Henriette Polak, Zutphen

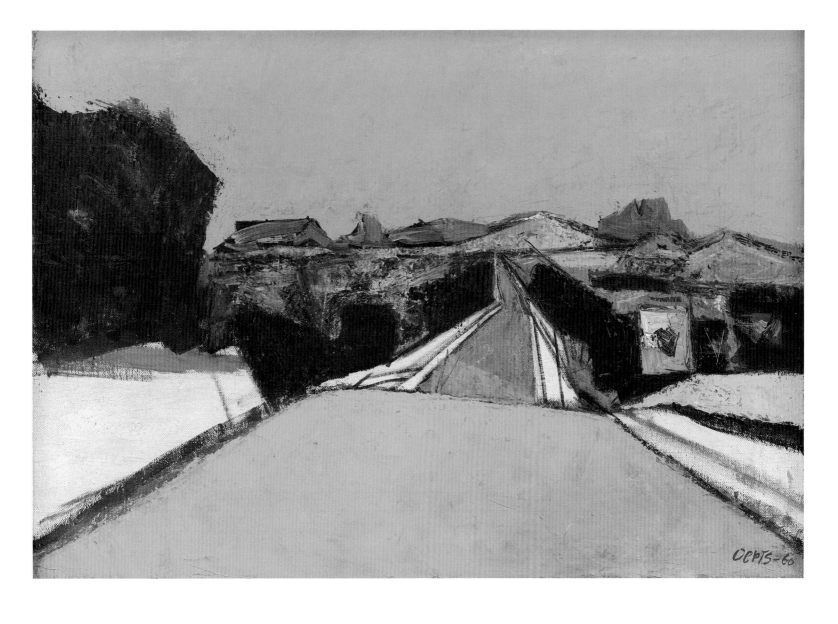

79 route nationale (highway) 1960
Museum van Bommel van Dam, Venlo

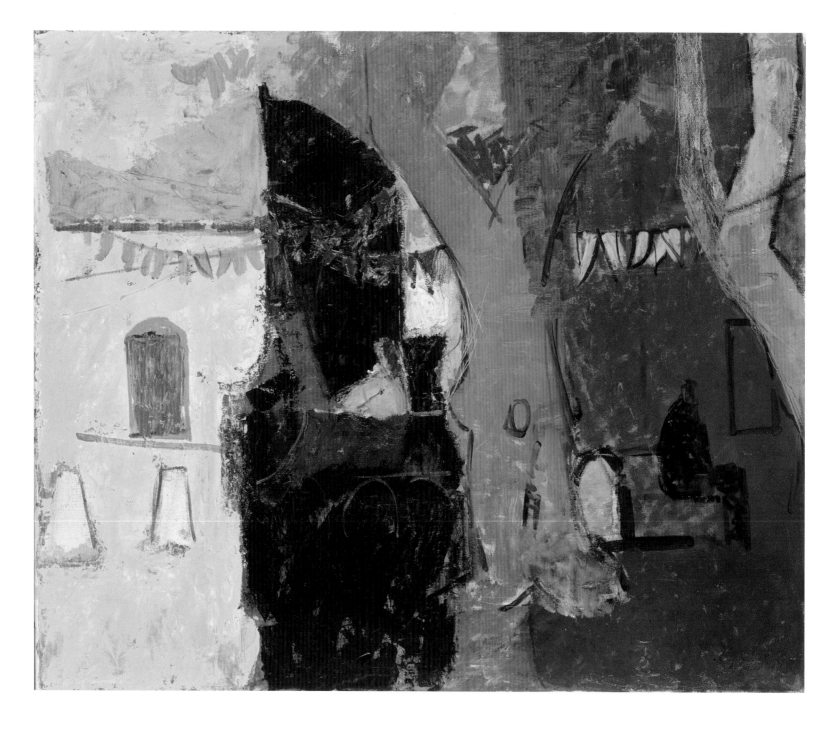

wim oepts
80 village 1972
ING, Amsterdam

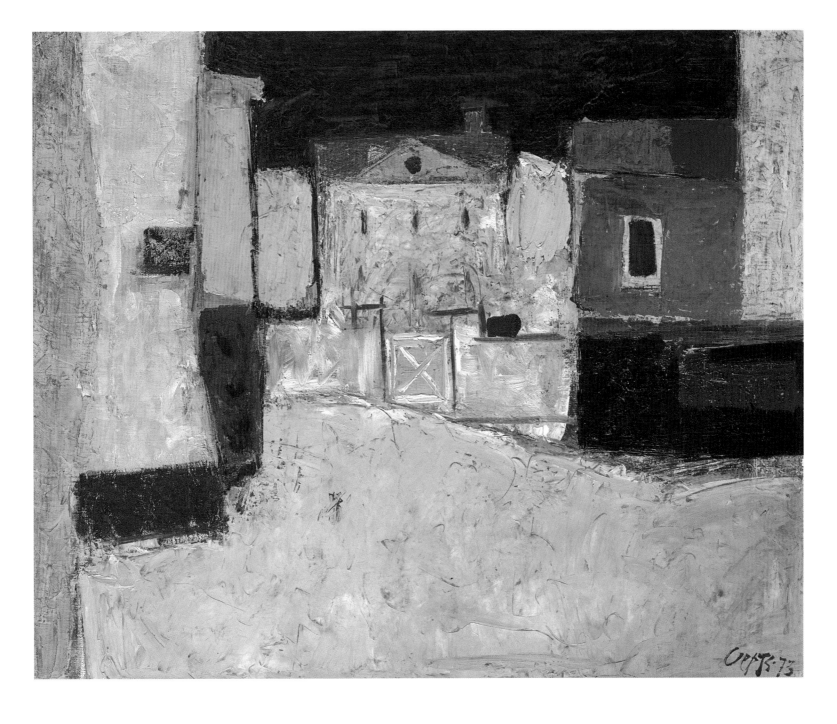

81 provence 1973
ING, Amsterdam

edgar fernhout

Edgar Richard Johannes Fernhout was born in Bergen on 17 August 1912 to a philosopher Hendrik Fernhout and the artist Charley Toorop. He was the first of three children, and his grandfather was the distinguished and influential Dutch artist Jan Toorop.

The young family lived in various places – Bergen, Laren, Schoorl, Utrecht and Zeist. In 1917 Fernhout's parents separated and Jan Toorop supported his daughter and her children financially. Taking her children with her, Charley moved into a house in Amsterdam occupied by various artists, including the painter Conrad Kickert and composer Jakob van Domselaer. The family lived in Schoorl for three years, spending their summers in Walcheren, Domburg and Westkapelle; and the winter of 1920–21 in Paris, where Piet Mondriaan, a family friend who was living and working there at the time, helped them to find suitable accommodation. Mondriaan was to become an enduring influence on Fernhout's future activity as an artist.

In 1921, Jan Toorop paid for a house with studio to be built in Bergen according to Charley Toorop's design. De Vlerken (The Wing) became her much loved home and studio, and after her death in 1955, Fernhout's. Encouraged by his mother and grandfather, Fernhout began painting and drawing in childhood, completing his first painting, a still life, in the summer of 1923, in Saint-Paul de Vence, France. His mother gave him his first lessons in painting and by the age of 16 it was already a serious occupation for him.

His grandfather and his mother were very active in contemporary art, music and literary circles in the Netherlands, to the great benefit of Fernhout and his younger brother John (later a film-maker). The Dutch architect and designer Gerrit Rietveld was a regular visitor of Charley Toorop's, as was the art critic H P Bremmer. Artists as different as Bart van de Leck and Wim Schuhmacher, and a wide range of writers, philosophers and musicians visited De Vlerken. In Paris, Charley was also acquainted with Wassily Kandinsky, Kurt Schwitters, Kasimir Malevitch, Jean Arp, Alexander Calder and Max Ernst. Jan Toorop died in 1928, as Charley's reputation and influence were blossoming and Fernhout's life as an artist was just beginning.

In 1932 Fernhout moved into a place of his own in Amsterdam and he met the artist Rachel Pellekaan. They married in 1934 and lived for a time in his mother's house in Bergen, then in Amsterdam, followed by Alassio on the Italian Riviera, until just before the beginning of the Second World War when they returned to the Netherlands.

In the 1930s Fernhout established himself as a painter of exquisitely realized, austere and poetic still lifes, sensitive portraits, self portraits and interiors with open windows, in magic realist vein. Outstanding amongst them is *Schilderende handen* (Hands painting) 1930 in the Dordrechtsmuseum, Dordrecht. He had his first exhibition in 1932–33 at Kunstzaal van Lier, Amsterdam, one of a number before the War. His mother supported him and assisted with introductions for exhibitions, sales and commissions for portraits until about 1940. In 1936 he met the art historian Hans Jaffé who became a life-long friend. In 1937 the exhibition *Drie generaties* (Three generations), with works by Jan Toorop, Charley Toorop and Edgar Fernhout, was held at the Nieuwenhuizen Segaar Gallery in The Hague.

At the start of the War, Fernhout and his wife lived in Bergen, initially with his mother, but when he and his wife separated in 1940, he left and lived in various places. He survived by painting portraits and returned to Amsterdam after the War. Gradually and subtly, his work began to emphasize painterly abstract qualities, in still life compositions and seascapes suffused with light. His paintings were included in exhibitions outside the Netherlands for the first time, including *Dutch art under occupation* in London in 1946. In 1949 eighteen of his paintings were included in a major exhibition of Dutch and Belgian art at the Gemeentemuseum in The Hague. He was involved in various artists' groups and had a broad range of friends and acquaintances including writers, composers and artists, notable amongst whom were Karel Appel, Gerrit Benner and Jean Bazaine.

In 1948 he met Netje Salomonson and they married in London a year later. A son, Richard (who is also an artist) was born in 1959. By the late 1950s and into the '60s his work was almost wholly abstract, suggestive of the effects of light, the movement of the sea and the

seasons. After his mother's death in 1955, the Fernhouts moved into her house and studio. With the move came an extended period of domestic and artistic stability, conducive to the development of his work, as it reached ever further into abstraction.

Fernhout exhibited more frequently and became increasingly admired by artists, collectors and the cognoscenti. He was a member of the board of the Rijksakademie van Beeldende Kunsten (National Academy of Fine Arts) in Amsterdam, on the selection panel of the Dutch contribution to the Biennale di Venezia and between 1961 and 1968 on a government committee for the purchase of contemporary art. He also taught art in 's-Hertogenbosch.

Many Dutch museums purchased his work and important retrospectives were staged at the Van Abbemuseum, Eindhoven, in 1954 and 1963 (also shown at the Stedelijk Museum, Amsterdam). In 1971, with his close involvement, Leiden's Lakenhal Museum staged an exhibition of his work alongside that of Jan Toorop and Charley Toorop. The Van Abbemuseum staged another retrospective in 1976 after his death.

Edgar Fernhout died suddenly aged 62 at his home in Bergen on 4 November 1974.

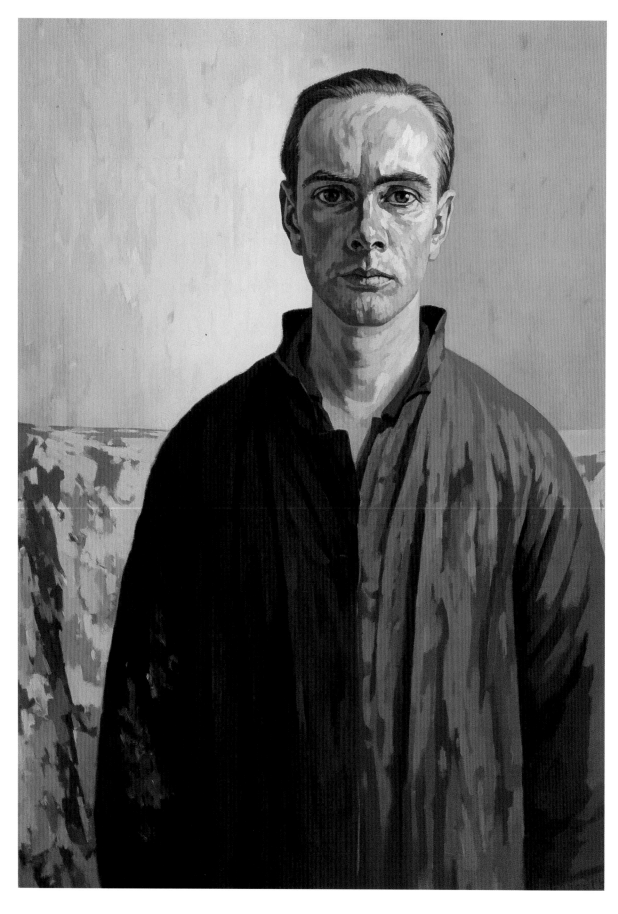

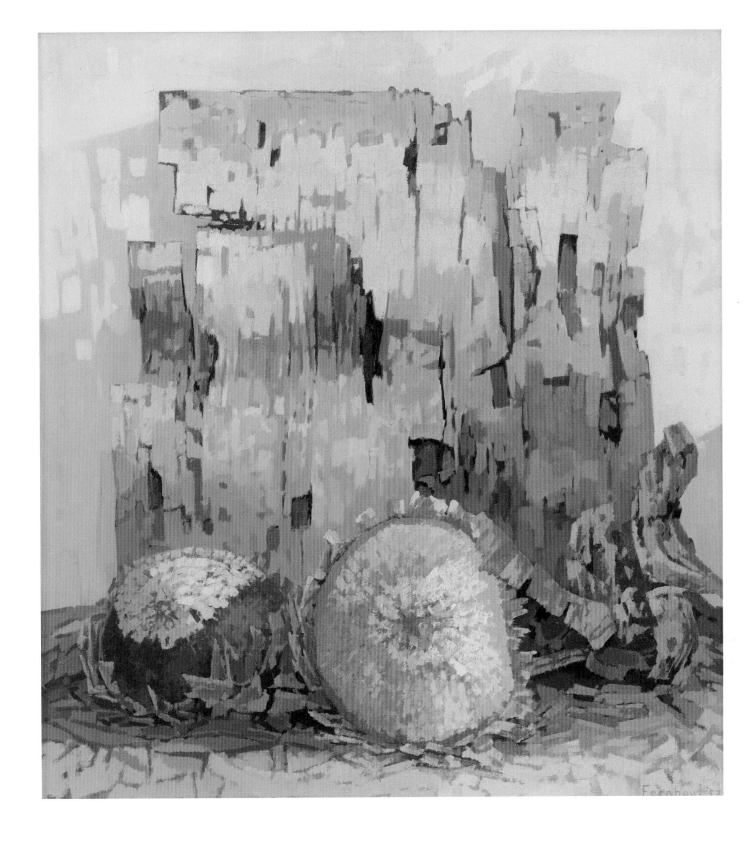

edgar fernhout

42 zelf portret (self portrait) 1953–54

Netherlands Institute for Cultural Heritage (on loan
to Boijmans van Beuningen Museum, Rotterdam)

43 zonnepitten en berkenschors (dried sunflower heads and beech bark) 1957

Museum van Bommel van Dam, Venlo

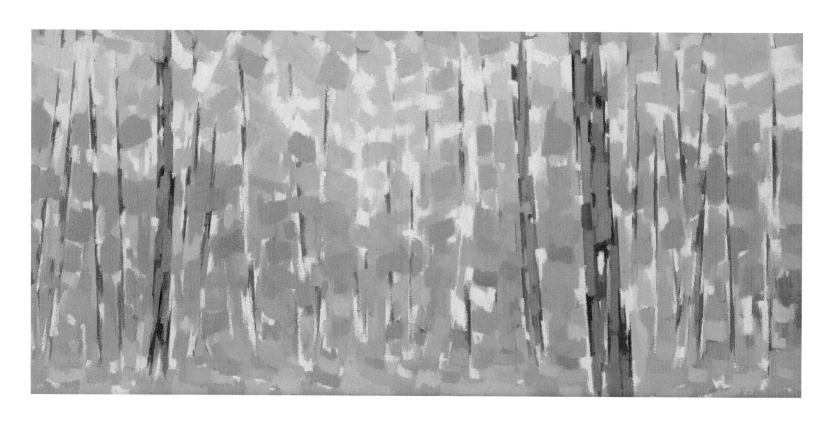

edgar fernhout
44 mistig bos (misty bush) 1959
Museum van Bommel van Dam, Venlo

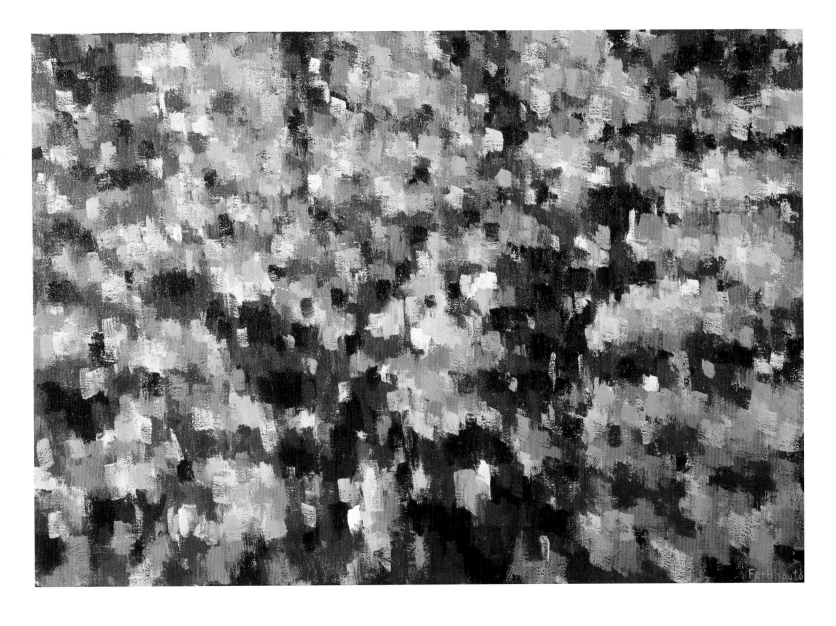

45 herfst (autumn) 1962
Van Abbemuseum, Eindhoven

A painting can, if necessary, be painted with a wooden shoe, as long as it has been lived and doesn't lapse into personal, aesthetic affectation. … All means are okay, so long as the painter doesn't lose touch with his canvas.

I have to wholly become 'sea' or 'thaw' or 'winter' in order to paint sea, thaw or winter. Thus it paints itself through me. Those are lengthy processes; that's why I produce so little, and what I produced doesn't jump out at you either. Perhaps there's something good in this: that which is natural doesn't jump out at you. If my art were to become as natural as the nature which it depicts, that would of course be very good.

Edgar Fernhout in Aloys van den Berk, Jozien Moerbeek, John Steen, *Fernhout schilder/painter*, 1990, pp 58, 68–69

edgar fernhout
46 in voorjaar (spring) 1973
Netherlands Institute for Cultural Heritage

jaap wagemaker

Adriaan Barend (Jaap) Wagemaker was born on 6 January 1906 in Haarlem, the only child of Adrianus Barend and Hubertina Wagemaker. His father was a grocer, saddle-maker and furniture salesman. As a boy, Jaap preferred drawing indoors, to playing outside with friends, because of a hip defect.

In 1919 Wagemaker enrolled at the Kunstnijverheidsschool (School of Arts and Crafts) in Haarlem where he studied decorative arts. Haarlem, near Amsterdam, has always been a relatively lively and historic centre for art with important museums, and during Wagemaker's student years had at least one serious commercial gallery that showed the work of modern masters – Vincent van Gogh, Odilon Redon, James Ensor, Wassily Kandinsky. In the 1920s, the Dutch De Stijl artist Theo van Doesburg and Kurt Schwitters organized a Dada event in Haarlem.

After finishing his studies in 1925, Wagemaker decided to become a painter, joined the Haarlem artists group KZOD and attended their drawing classes. At their meetings he and the artist Piet van Egmond became friends and they visited Paris together at the end of 1927, staying for four months. He visited Paris again on a number of occasions before the Second World War, with his partner at the time, a French teacher.

Wagemaker's early paintings of farm animals, farm life and still lifes were boldly expressionistic, influenced by the Dutch painter Herman Kruyder, the Dutch artists of De Ploeg (The Plough) and the Belgian Constant Permeke. He also admired Henri Matisse and Fernand Léger.

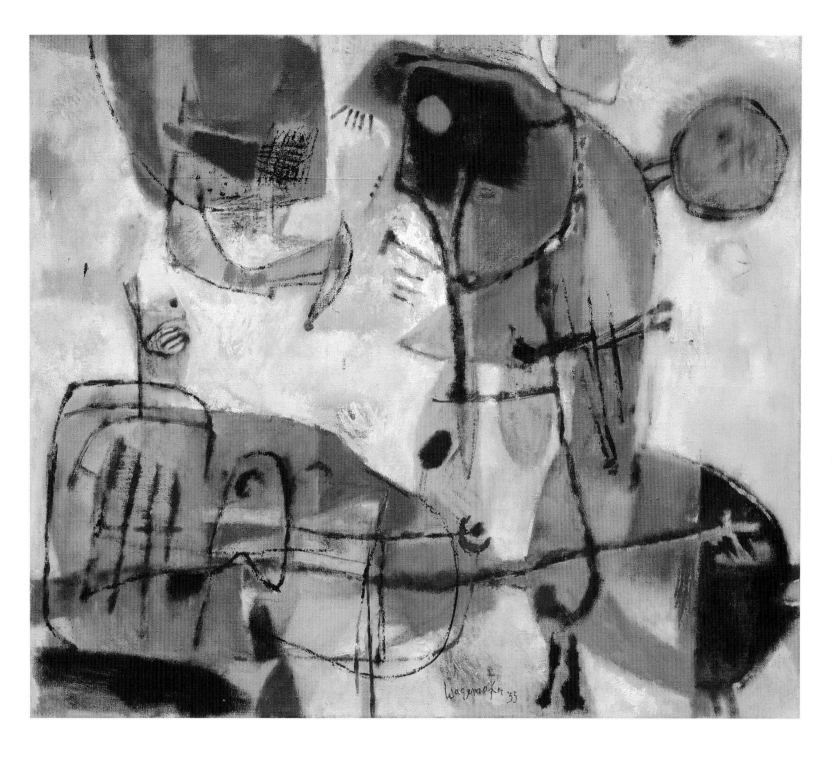

106 verschrikte dieren or het gevecht (frightened animals or the fight) 1955
Centraal Museum, Utrecht

Wagemaker refused to join the Nazi *Kultuurkamer* (Chamber of Culture) during the German occupation of the Netherlands in the Second World War, and hence painted and exhibited rarely. In 1942 he met Maria Louise van Geelkerken. They married the following year and moved to isolated Bilthoven until the end of the War. In 1946 they moved to Amsterdam and lived in one of the modern studio-apartments, purpose-built for artists, on Zomerdijkstraat. Built in 1934, these were designed by Dutch architects influenced by Le Corbusier. Wagemaker remained there until his death. His first marriage ended in 1951 and he married Didi van der Meer in 1952.

Just before the War, Wagemaker's work was included in *Onze kunst van heden* (Our art now) at the Rijksmuseum, Amsterdam, and immediately after the War in *Kunst in vrijheid* (Art in freedom), again at the Rijksmuseum. His landscapes painted in the south of France a year or two later, reveal a distinct change as he came under the influence of Pablo Picasso, Paul Klee and Wassily Kandinsky. After he met the painters and poets of the younger generation associated with the Dutch Experimentele Groep (Experimental Group)/CoBrA and the *Vijftigers* (Fiftiers), his work began to display CoBrA-like characteristics. This was fully revealed in his exhibition at Galerie Le Canard, Amsterdam, in 1955.

Wagemaker, who had taken an interest in ethnographia since the late 1920s, started collecting African and New Guinean art more seriously after the War. In 1955 he visited the caves of prehistoric art in Lascaux, south-western France, and began experimenting with various materials, emphasizing the materiality of his paintings. In 1954–55 he made his first modestly scaled *materieschilderijen* (matter paintings). Wagemaker had seen the work of Jean Fautrier, Jean Dubuffet and Wols on a visit to Paris shortly after marrying Didi van der Meer. He and his wife also spent days at the Stedelijk Museum in Amsterdam, closely studying its contemporary collections. Although Wagemaker did not make his first substantial matter paintings until 1956, he revelled in this new approach, enjoyed working with his hands and was attracted to the tactile qualities of various materials – jute, rope, rotting wood, leather, cork, sand, slate, metal, bones, shells, mechanical bits-and-pieces. He commented:

In my work it is the material that is central, the artwork exists due to its materiality, inwardly, spiritually, so that a connection is made between the material and spirit of the painting, its content.[1]

There was controversy over some of the materials he used – the placement of the head of a vacuum-cleaner brush in a work from 1957, for example.

Wagemaker was one of a select number of Dutch *art informel* artists, including Bram Bogart, Wim de Haan and Jan J Schoonhoven. His new work attracted commercial galleries in the Netherlands, as well as discerning critics and collectors. Museums, such as the Stedelijk,

Amsterdam, and Boijmans van Beuningen, Rotterdam, began to acquire his new work. In 1958 he spent three months in Paris working in a temporarily vacated studio in rue de Santeuil where Karel Appel, Corneille and Bram Bogart had lived and worked earlier.

Wagemaker's work attracted international interest in the late 1950s and '60s. He exhibited in Italy and Germany and took part in various prizes, showing alongside Emil Schumacher, Alberto Burri and Antoni Tàpies. In 1961 he exhibited with Lucebert in New York and was included in the exhibition *The art of assemblage* at the Museum of Modern Art (MOMA purchased one of his works at the time). In 1962 he represented the Netherlands at the Biennale di Venezia, together with Corneille, Shinkichi Tajiri and Co Westerik. There was some persistent opposition to his work in the Netherlands but, with international attention, that receded. He won the important Talens Prize in 1962 and the Prix de la Critique in 1965. In 1966 the Netherlands Government awarded him the Staats Prijs voor Beeldende Kunsten en Architectuur (State Prize for Fine Arts and Architecture) and in 1969 he received a gold medal from the XIX International Biennale in Florence for his oeuvre of gouaches.

He continued to develop and refine his work, using slate more frequently and oyster shells. Photography was important to him, as revealed in one of his best known works, *Hommage à Brassai* 1961 which incorporated camera parts. His work was often inspired by photographs of remote or desert landscapes and he took thousands of colour slides on travels in Spain, Greece, Russia, Africa, Eygpt, Morocco and Mexico.

There was a major retrospective at the Stedelijk Museum, Amsterdam, in 1967, followed by another at the Kunsthalle, Bremen, shortly after his death. Jaap Wagemaker died suddenly aged 66 on 28 January 1972 following an operation on his hip.

1. Simon den Heijer & Marike van der Knaap, *Jaap Wagemaker: schilder van het elementaire,* Waanders, Zwolle 1995, p 59

jaap wagemaker
107 verdigris or oxyde de cuivre (verdigris or copper oxide) 1958
Newcastle Region Art Gallery

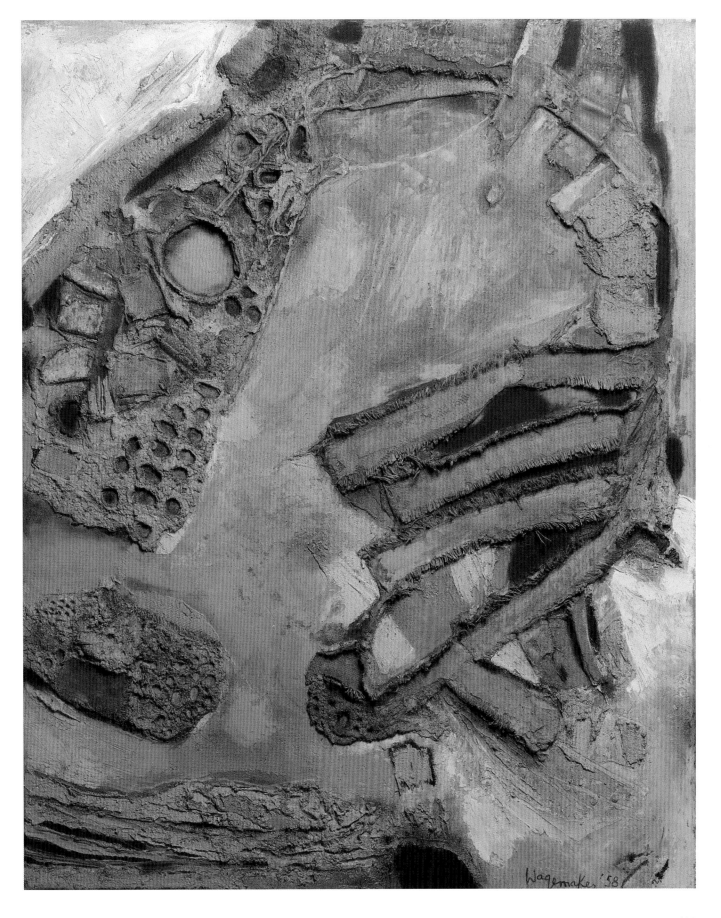

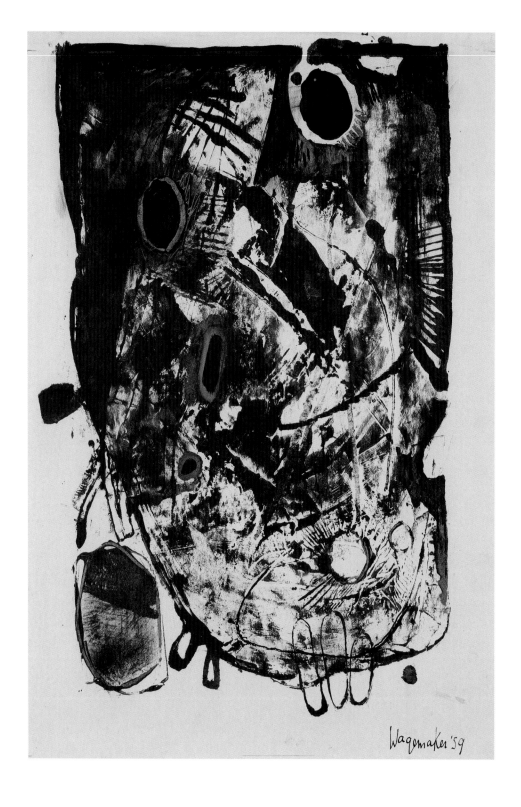

jaap wagemaker
109 compositie (composition) 1959
Groninger Museum, Groningen

110 compositie/geel, zwart met zand
(composition/yellow, black with sand) 1961
Boijmans van Beuningen Museum, Rotterdam

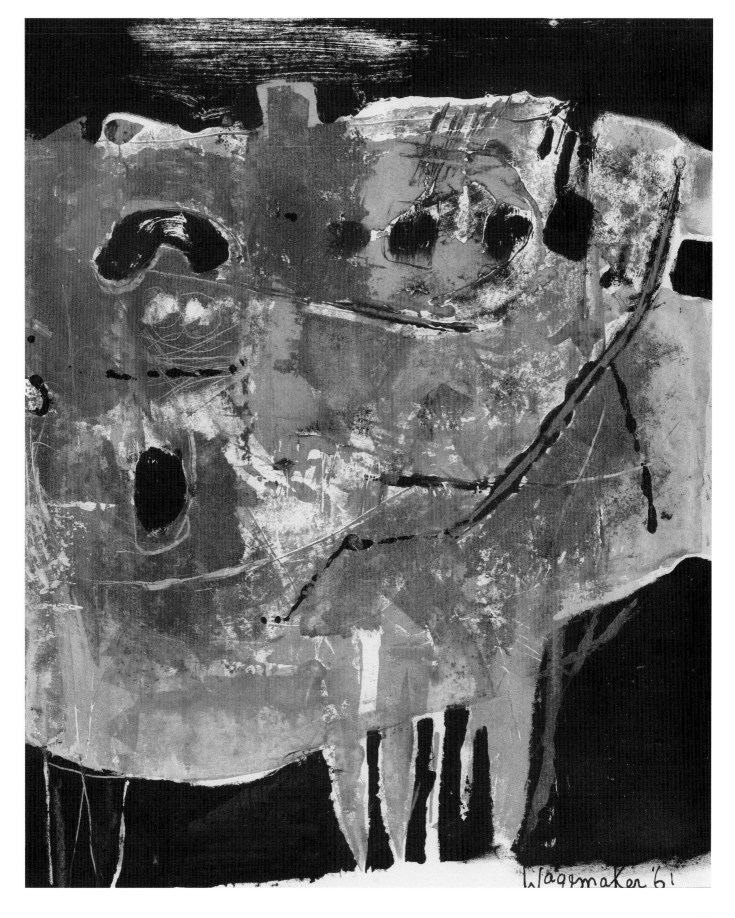

Wagemaker '61

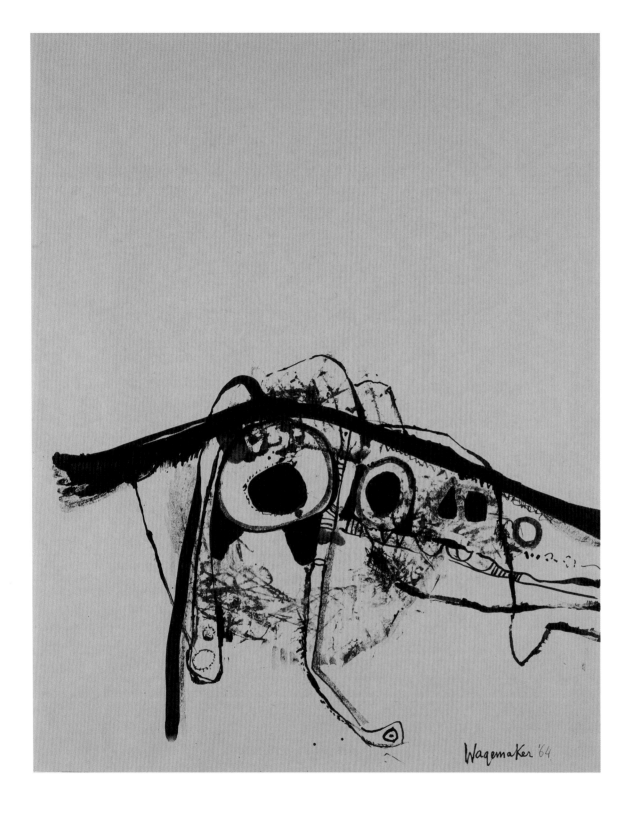

jaap wagemaker

111 compositie (composition) 1964

Groninger Museum, Groningen

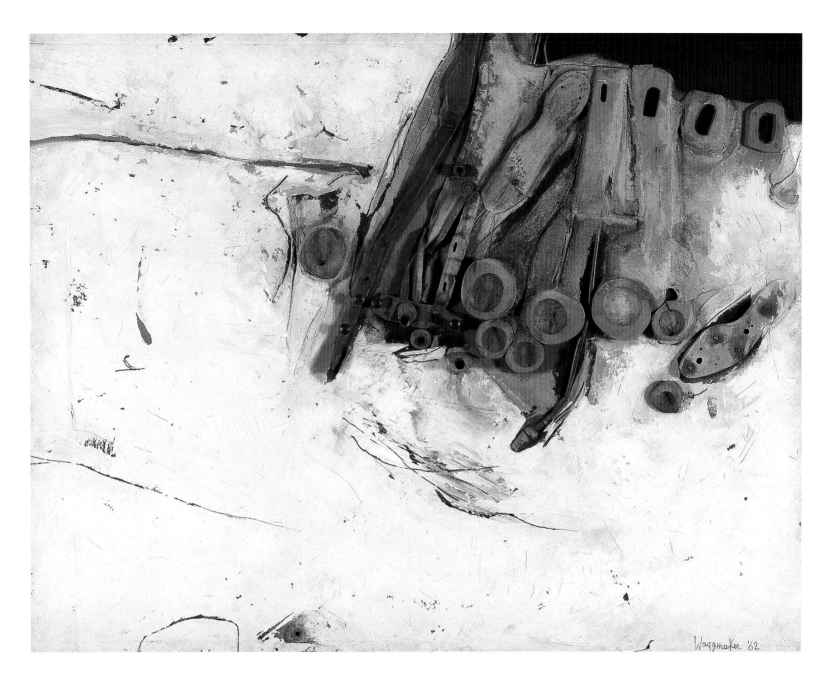

108 les traces (traces) 1962
Netherlands Institute for Cultural Heritage

jan j schoonhoven

Johannes Jacobus Schoonhoven was born in Delft on 27 July 1914 to Heiltje Adriana and Jacob Schoonhoven, the eldest of three children. His father was a painter of Delftware and later a bookkeeper to a wholesale hardware business in Delft who spoke four languages, was interested in philosophy and was a talented watercolourist. The family was strictly Calvinist, but at sixteen, Jan had his name removed from the church register, declaring himself an atheist and joined the Revolutionair Socialistische Arbeiderspartij (Revolutionary Socialist Worker's Party). He remained a committed Marxist for the rest of his life.

From childhood, Schoonhoven was interested in drawing, so his father encouraged him to train as a drawing teacher by enrolling at the Academie van Beeldende Kunsten (Academy of Fine Arts) in The Hague. He studied drawing and painting between 1930 and 1934, and advertising art under Paul Citroen in 1935. Initially he was influenced by German expressionism and later the work of Paul Klee and surrealism. He read voraciously – art, literature, philosophy and politics. His individuality and seriousness were noticeable early on – in temperament, behaviour and dress. He was also fragile in health (one of his kidneys was removed in 1937).

In 1938 Schoonhoven joined the Amsterdam-based contemporary artists' group De Onafhankelijken (The Independents) and exhibited with them until 1940. In 1941, during the German occupation of the Netherlands in the Second World War, he was arrested for his political views and imprisoned. After vigorous protestations from his mother, he was released. In 1942 he was employed by the library in Delft, where he met Anita de Geus, a fellow library worker. They married in 1945 and spent the first twelve years of their married life living with his parents.

After the War, Schoonhoven joined the Netherlands Post Office as a public servant, where he stayed until his retirement in 1979. In 1946 he joined the Haagse Kunstkring (The Hague Art Circle) and briefly, the exhibiting society Pulchri. He had his first solo exhibition at the Kunststudiecentrum (Art Studies Centre), The Hague, in 1949. The influence of Klee's work became less noticeable as Schoonhoven began to develop the cross-hatching technique typical of his drawings from the early 1950s. He suffered from deteriorating health in the mid-1950s, was dissatisfied with his art and received a reprimand from his employer for excessive drinking. Making cardboard constructions for his young son initiated a new beginning, with his first cardboard and papier mâché reliefs.

In 1956 he exhibited in Contour, a biennial exhibition of contemporary Dutch art at the Prinsenhof Museum in Delft, and sold all his 'École de Paris' inspired abstracts, including his gouache *Lonesome lover, hommage à Charlie Parker* 1955. He met Bram Bogart and Jan Henderikse at this time, both of whom experimented with thickly painted, gestural abstract paintings.

Schoonhoven's earliest reliefs were freely constructed from corrugated card and used toilet rolls, covered in papier mâché, deliberately crushed or damaged before he coloured them in dark monochromatic grey or reddish brown house-paint, adopting the title *constructions détruites* (damaged constructions). He believed they were related to action painting. Like bronze or rusted iron in colour, they are reminiscent of eroded walls, the remains of old buildings or even landscapes. In 1959 he wrote:

Let material play itself out to such an extent that, though it remains material, it transcends itself and becomes the agent of the maker's soul.[1]

In 1958 Schoonhoven and his wife moved to a place of their own in Delft. In the same year, he joined with Armando, Jan Henderikse, Henk Peeters and Kees van Bohemen to establish the short-lived Nederlandse Informele Groep (Dutch Informal Group) in reaction to the dominance of CoBrA and American-inspired abstract expressionism. They exhibited throughout the Netherlands and Europe.

In 1960, new tendencies in so-called objective art were practised by various European artists. The influence of the newly formed German Gruppe Zero (Heinz Mack, Günter Uecker and Otto Piene), and similar groups in France and Italy, was felt throughout Europe. Schoonhoven, Armando and Peeters aligned themselves with this new avant-garde as the Dutch Nul Groep (Nil Group). The work of two of the best known Italians, Pietro Manzoni and Lucio Fontana, was particularly important to Schoonhoven's development, as he moved from freely conceived organic forms to formal geometric arrangements using grids painted white. The play of light and shade is an important characteristic of these reliefs. He also resorted to a numerical code for his work rather than titles,

R denoting reliefs and T drawings (*tekeningen*), in keeping with their materiality and the serial nature of his work.

In 1964 he was responsible for an installation (undertaken for him by Peeters) in the Gemeentemuseum, comprising a gallery (or adjacent walls) of stacked folded cardboard. At the same time, he made some reliefs of unpainted cardboard because he liked its natural colour and texture. His reliefs became more complex and sophisticated in arrangement and included circular or saucer shapes. He was much sought after for exhibitions and public collections in the Netherlands and Europe from the mid-1960s, with successful solo exhibitions at Galerie Delta, Rotterdam, in 1964, Klagenfurt, Austria, in 1965 and Galerie Orez, The Hague, in 1966. There was an exhibition of his drawings and reliefs at the Gemeentemuseum, The Hague, in 1967 and in the same year he was awarded second prize at the São Paulo Bienal.

He rarely travelled outside the Netherlands, apart from short visits to Paris with his wife between 1956 and 1960 and two weeks in Russia in 1968. In the early 1960s Anita Schoonhoven painted expressionistic portraits, pursued her passion for jazz and held 'open-house' to jazz musicians in Delft, often until late in the night. A talented singer, she eventually stopped painting, helped set up a jazz club in Delft and organized jazz concerts. She developed a serious lung condition in the 1960s and died in 1978. By then Schoonhoven was one of the most revered artists in the Netherlands, with a growing international reputation. Following his retirement from the Post Office in 1979 he began to lead an ever more reclusive life, wholly devoted to his work, and occasionally employing assistants.

There have been many exhibitions of his work including major retrospectives at the Gemeentemuseum, The Hague, 1984 and the Folkwang Museum, Essen, 1995. His late drawings and reliefs reveal greater freedom and vehemence of expression than ever, recalling the effect of his first bold *constructions détruites* of the 1950s.

Jan J Schoonhoven died aged 80 in Delft, the town he rarely left, on 31 July 1994.

1. Janneke Wesseling, *Schoonhoven, beeldend kunstenaar/visual artist,* Openbaar Kunstbezit, Amsterdam/SDU, The Hague 1990, p 30

jan j schoonhoven

95 lonesome lover, hommage à charlie parker 1955

Museum van Bommel van Dam, Venlo

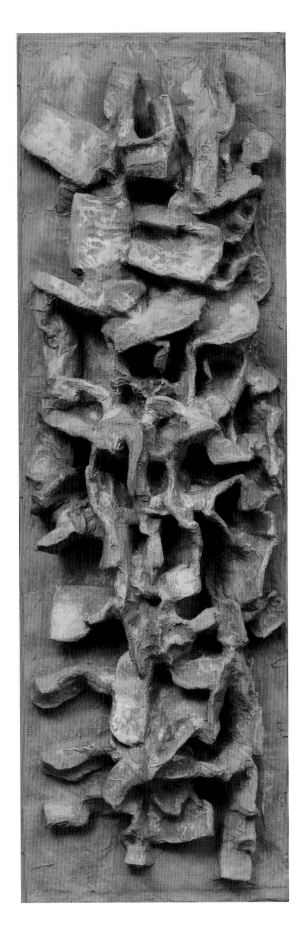

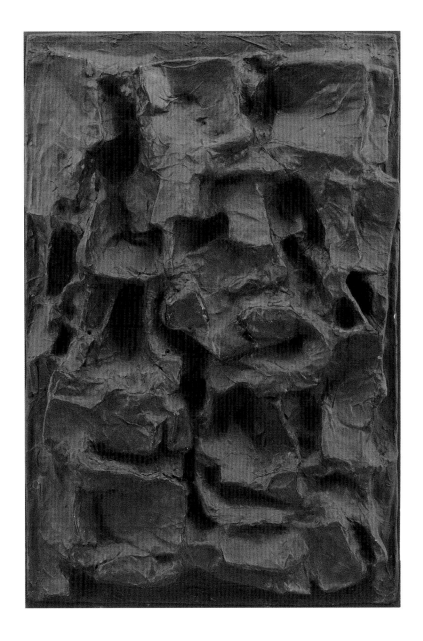

91 vegetation 1959
Museum van Bommel van Dam, Venlo

92 r60-6 1960
Museum van Bommel van Dam, Venlo

133

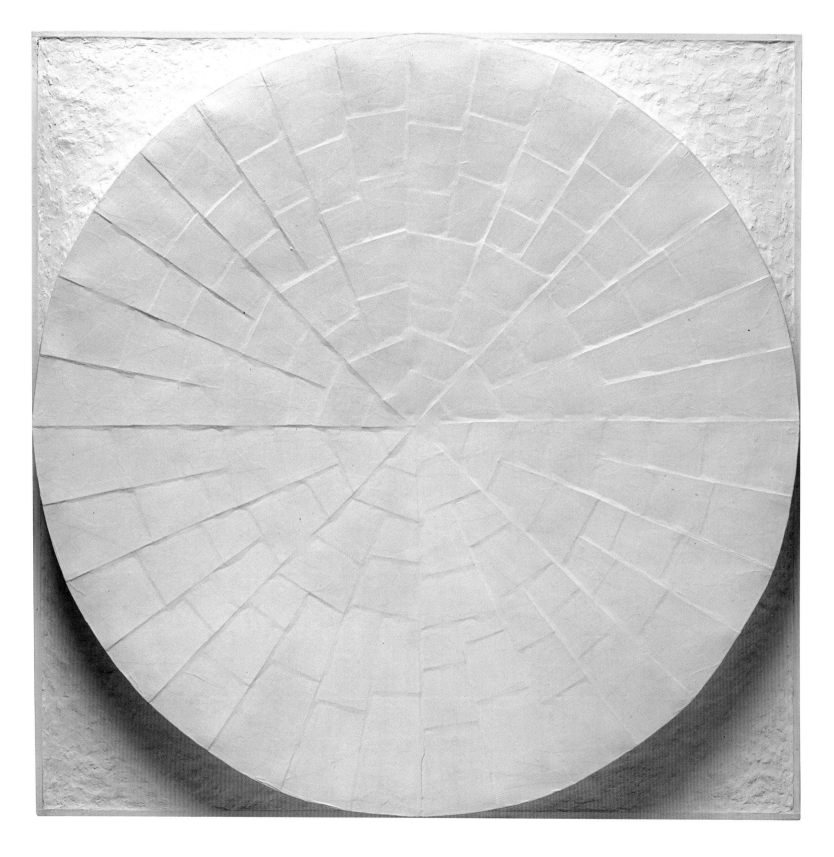

jan j schoonhoven
93 cercle dish relief (circular dish relief) 1966
Gemeentemuseum, The Hague

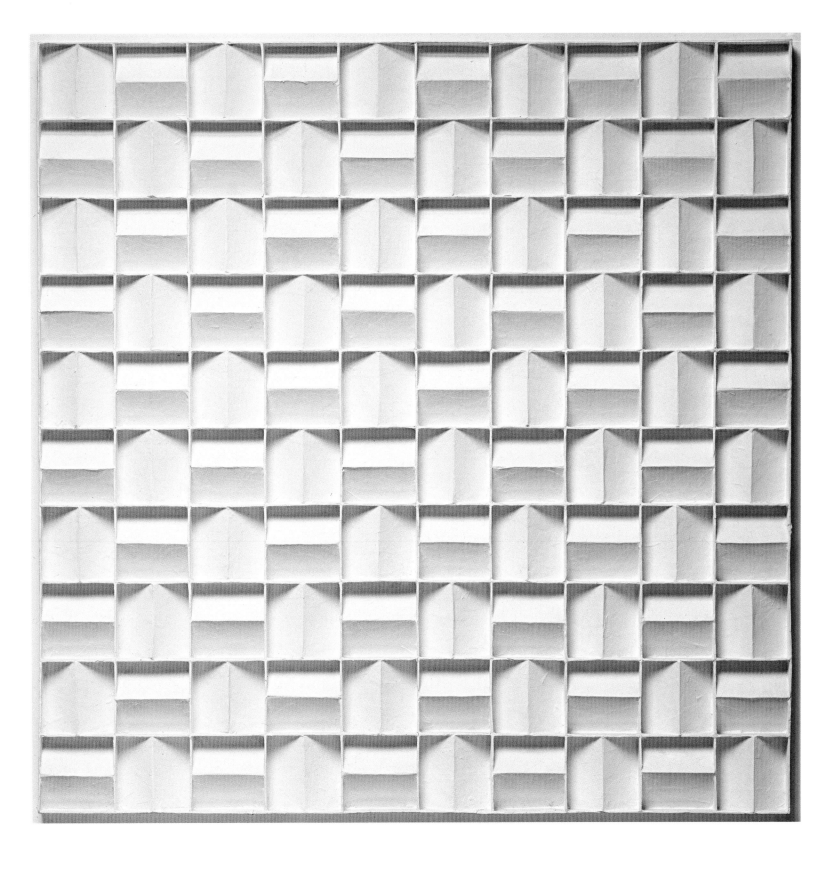

94 gerythmeerd quadratenreliëf (rythmical grid relief) 1968
Gemeentemuseum, The Hague

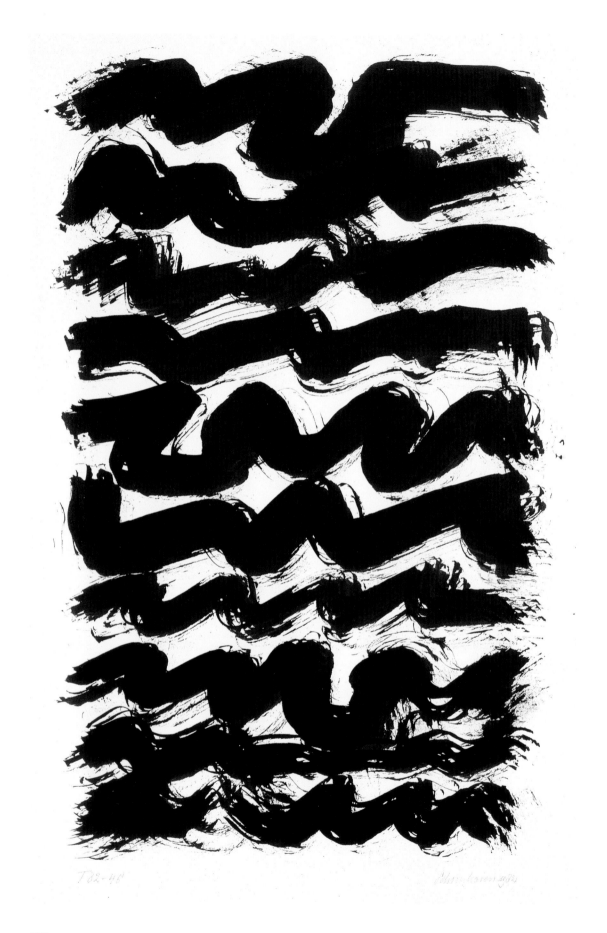

jan j schoonhoven
96 compositie/t82-45
(composition) 1982
Gemeentemuseum, The Hague

97 t88-32 1988
Museum van Bommel van Dam, Venlo

bram bogart

Abraham van den Boogaart was born in Delft on 12 July 1921. His father was a blacksmith and his brother, Geer, a furniture-maker. As a boy, he wanted to become an artist, but in keeping with his father's wishes, he trained as a house painter and decorator. He also undertook a two-year correspondence course in drawing, spending most of his evenings and Sundays studying. He worked as a house painter for only a few months in 1937, before becoming a cinema scene painter for the advertising company Leo Mineur in Rotterdam.

In 1939 Bogart devoted himself to painting and had his first exhibition at Bennewitz Gallery, The Hague, and was beginning to make a living from his painting when the Second World War began and the Netherlands was occupied by Germany. To avoid being forced to work in Germany, Bogart enrolled at the Academie van Beeldende Kunsten (Academy of Fine Arts) in The Hague in 1943, and continued to paint clandestinely in Delft. At this time, his paintings were bold and spontaneous, revealing the simultaneous influence of Vincent van Gogh and the Belgian expressionist, Constant Permeke.

After the War, in 1946, Bogart visited Paris, studied the collections of the Musée du Louvre and attended the free Académie de la Grande Chaumière. He spent the following three years in the south of France, regularly visiting Paris for exhibitions, including those of Bram and Geer van Velde at Galerie Maeght in 1948. Sporadically he also returned to the Netherlands. Painting landscapes 'out-of-doors', he applied undiluted colour directly to his canvases, experimenting with a personal system of autonomous colour. In a cellar that served as his studio in Le Cannet, he painted a few still lifes inspired by the African artefacts stored there, and introduced a vocabulary of symbols comprising crosses, circles and squares into his paintings.

Early in 1951 he moved into the Halle-aux-cuirs (Leather Halls) on rue Santeuil near the Jardin des Plantes in Paris, where other Dutch artists, including Karel Appel and Corneille were living and working, as well as the sculptor Lotti van der Gaag, his girlfriend at the time. Bogart felt little affinity with the CoBrA artists and kept to himself. The signs and symbols he employed became bolder and his colour richer and darker. He began mixing water and oil based paints, and applying paint ever more thickly. Using a simplified version of his name, he started exhibiting at galleries in Paris, Frankfurt, London and Brussels, and from 1956 took part in group exhibitions such as the Salon des Réalités Nouvelles. In the monochromatic works of the late 1950s, such as the tranquil and atmospheric *Dansante larmoyante* 1959, Bogart reveals a poetic sensibility.

In 1958 Bram Bogart met a young Dutch woman Abelina Sjoukje Vos, known as Leni. They travelled to Rome together in 1959 and married in 1962. Bogart returned to Rome several times, attracted by the creative environment. He exhibited at the Galeria L'Attico and met a number of Italian artists, most especially Lucio Fontana with whom he exchanged canvases. Later he also met his compatriot Willem de Kooning in Rome. Both artists were disappointed at the seeming neglect of their work by Dutch museums at the time.

Encouraged by his friend, the Belgian art critic Jean Dypréau, Bogart settled in Brussels in 1960. His work underwent considerable change. He abandoned his expressionist tendencies, focusing instead on other, radical, aspects of his work. He increased the size of his canvases, used brighter, denser colours and ever thicker paint. He resorted to working on the floor and developed a process in which he combined linseed oil, stand oil, dry pigments and whiting to produce larger, more heavily impastoed paintings. He called this period of evolution in his work the 'Bodenbroek period', after the name of the street in which he lived.

In 1964 Bogart moved to Ohain, south of Brussels. There, with his wife Leni and their three young children, he experienced a *joie de vivre* in the Belgian countryside as well as in his family life. The new environment confirmed him in his approach to his work. He was more productive, his work became bolder, his colour even brighter; the signs, symbols and shapes of his early work reappeared, but now took up the entire canvas, in monumental, formal arrangements of lozenges, diamonds and circles.

In the following decade, he applied thick pastes of paint playfully, extending them over the edges of the canvas, emphasizing the extravagant materiality and somewhat baroque appearance of his work. Bogart modified the stretchers for his paintings, reinforcing them with metal, and in turn modified their presentation. His paintings began to look like giant reliefs.

In 1987 Bogart moved to an old paper factory in the heart of Brussels, but was forced to leave after a fire broke out in his studio during some building works. In 1988 he moved to his current home in Kortenbos, a town in northern Belgium. Since then he has created very large works, with reinforced frames that he makes himself in order to support their extreme weight. Some of them weigh upwards of 250 to 300 kilograms. The intense saturation of colour in his paintings remains a feature. He also continues to make paintings that are uncompromisingly monochromatic, wholly white and/or black.

Throughout his long life, Bogart has travelled extensively and exhibited around the world. The interest in his work has grown considerably since his first exhibitions in the Netherlands, Germany and France in the 1950s. Since then he has exhibited successfully across Europe and in New York and London. His work was included in the Guggenheim International Award exhibition in 1964 in Pinacoteca do Estado, São Paulo, and in Bangkok, Thailand. He has also participated in international fairs in Paris, Frankfurt, Cologne, Cannes and Basel. Several films have been made about him and his work, pieces of music composed for him and substantial monographs published. Major retrospectives have been organized at the Boijmans van Beuningen Museum, Rotterdam, in 1984, the PMMK Museum voor Moderne Kunst, Oostend, in Belgium, in 1995 and most recently in 2005 at the Kunsthalle, Recklinghausen, in Germany.

Bogart works on each painting from start to finish without break. He spends up to 24 hours a day in his studio labouring over each work, carrying his materials and heavy frames, combining his paint and mortar-like mixture and manipulating it onto his canvas supports with improvised tools which include spatulas, various brushes and brooms. After a life-time spent working bent over his paintings on the studio floor, he developed a painful back problem and had to stop work for several months in 2003, but after regaining his strength, he returned to his work with renewed vigour and continues to exhibit internationally, including most recently in London and New York.

bram bogart
20 untitled 1951
Private collection

16 stilleven iv, vlakken, masker en kannen, delft (still life iv, marks, mask and jugs, delft) 1951
Private collection

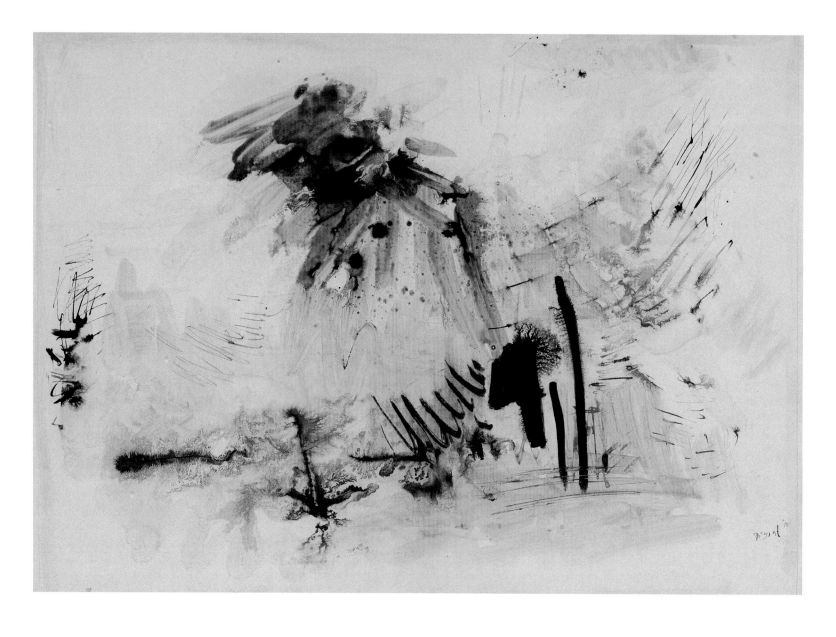

bram bogart

21 untitled 1956

Museum van Bommel van Dam, Venlo

17 dansante larmoyante (dancing whimpering) 1959

National Gallery of Victoria, Melbourne

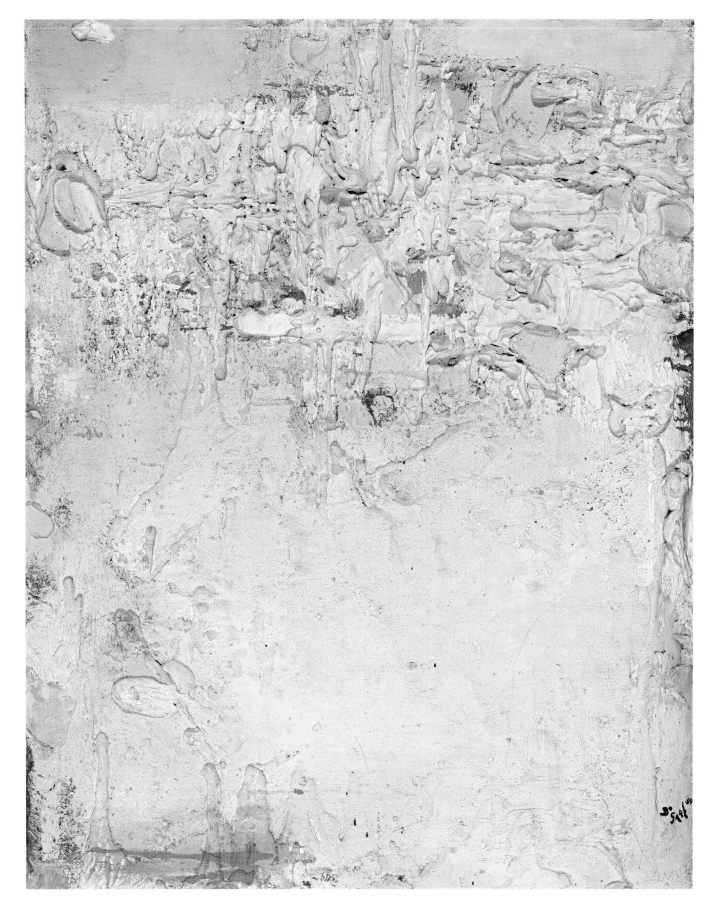

Many terms have been used to describe my work: *peinture relief, peinture mixed, peinture sculpture, peinture baroque, peinture matière*. More important to me than terminology, however, is the ever-returning problem of how to make good paintings.

Artists using only a pen and a pot with India ink can obtain excellent results using these simple materials. Think of Rembrandt's drawings for example: a pen, water and ink. For my own work I buy 25–40 kg of powdered pigment, in all colours, which I then mix in big barrels with poppy-seed oil (for white), linseed oil, boiled oil and quick-drying oil. After thoroughly mixing and rubbing them, I leave the mixtures alone for some time so that the oils can blend well.

When I start working on a painting, I mix equal amounts of the colouring matter (the colour I intend to use for my painting) with water or oil. The two, the oil paint and the watercolour, constitute the main part of my material. I then add mixing varnish, a quick drying agent, and whiting for thickening. I may also add any of these materials to the surface of the painting, depending on whether I want it to be rough or smooth.

The first step is to make the panel itself which provides an essential support for the jute canvas. Because of the weight and liquidity of my materials, I work flat on the floor. Without the panel, the canvas would collapse under the weight of the paint. Because the thickness of the paint layers varies from 5 to 10 or 15 cm, a large painting can easily weigh up to 300 kg.

Bram Bogart in Francine-Claire Legrand, *Bram Bogart*, 1988, pp 99, 102

bram bogart
18 3x rouge (3x red) 1976
Private collection

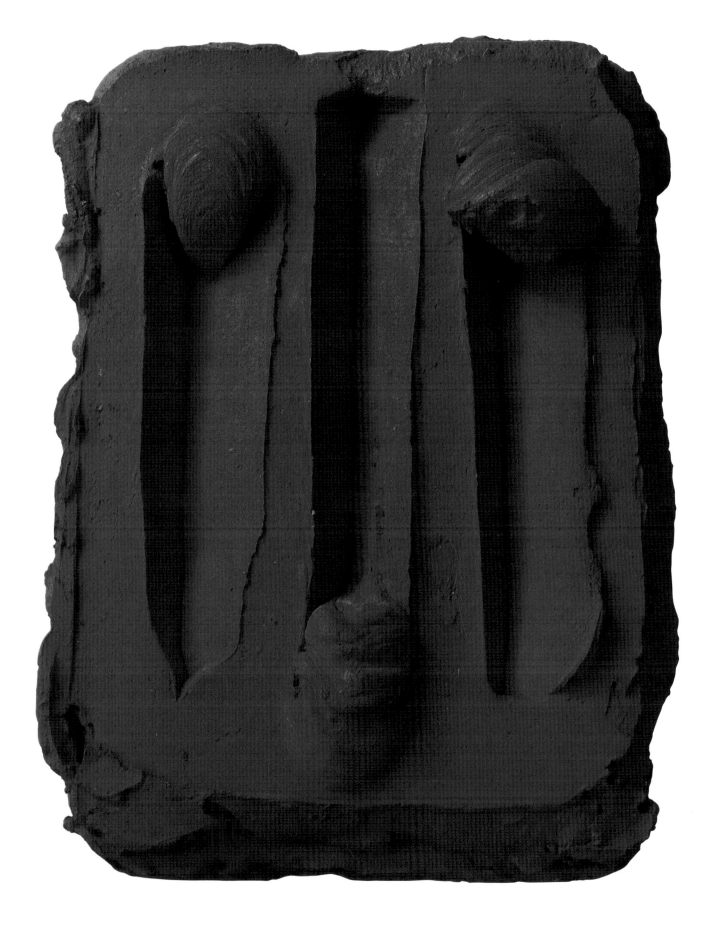

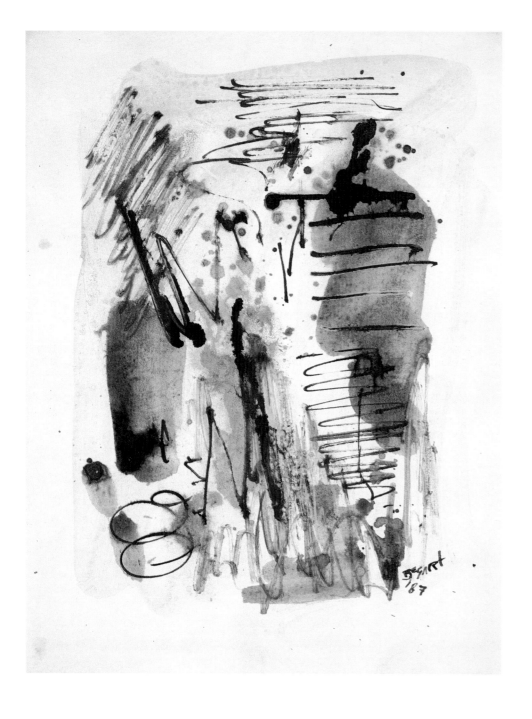

bram bogart

22 untitled 1987

Private collection

19 daybreak 1997

Private collection

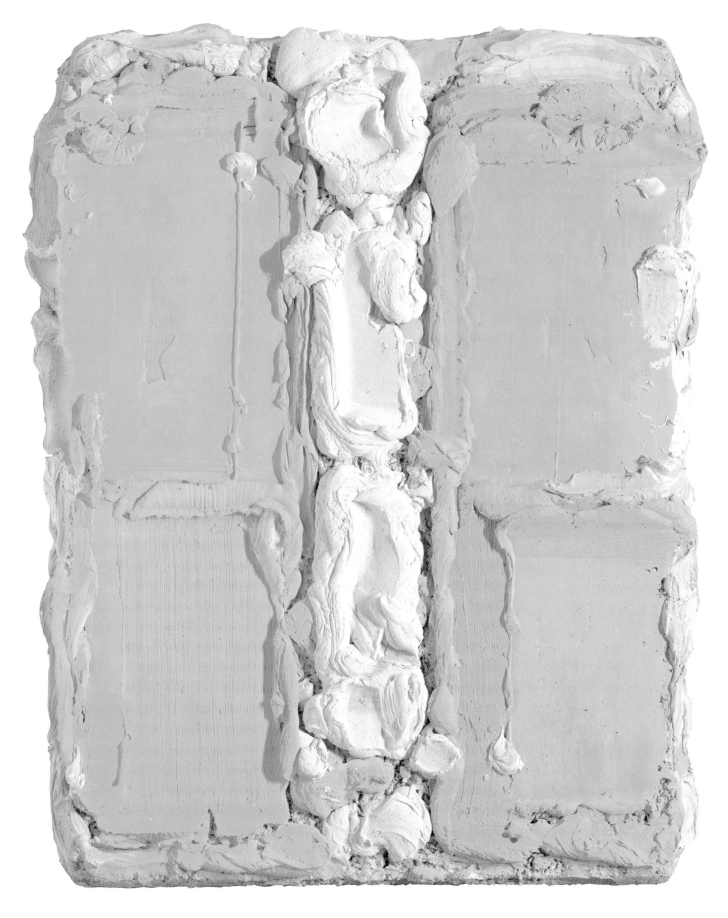

jan riske

Jan Hendrik Riske was born on the Voorstraat in Dordrecht on 21 June 1932, the second of eight children, to Hendrik and Francine Riske. His father was a lead-light glazier who wanted to become an artist but had been discouraged by his staunchly Protestant family. Jan attended a private Montessori school in Dordrecht and was encouraged to draw by his father. From the age of fourteen he began to draw seriously and visited the Dordrecht Museum frequently. There he attracted the interest of its Director Dr Laurens J Bol, who assisted him to gain financial support from the Schefferfonds (Ary Scheffer Fund) to study at the Academie van Beeldende Kunsten (Academy of Fine Arts) in Rotterdam.

In 1952, after completing his studies at the Academy, Riske decided to follow his elder brother, Theo, to Australia, foregoing an opportunity to study art further in Munich. He settled in Hobart, Tasmania, but initially worked in mining towns on the west coast. Most of his family also migrated to Australia, but his parents eventually returned to the Netherlands. For a time he travelled around rural Queensland drawing portraits for a living. On his return to Hobart, he found studio space so that he could concentrate on his art. Visiting Melbourne, he introduced himself to Eric Westbroek, Director of the National Gallery of Victoria, who purchased an early abstract painting *Autumn* 1954 for the collection. Stan de Teliga, artist and Curator of Art at the Tasmanian Museum and Art Gallery in Hobart, and Riske became friends and subsequently exhibited together at the Queen Victoria Museum and Art Gallery in Launceston. Riske's first solo exhibition at OBM Gallery, Hobart, followed in 1958.

In 1960 Riske met and married Cynthia McAulay, daughter of the Professor of Physics at the University of Tasmania and they moved to Melbourne, where he began to experiment with heavily textured paintings. He exhibited frequently – in Melbourne at the Victorian Artists Society and John Reed's Museum of Modern Art, in Sydney at Clune Gallery and Blaxland Gallery (with Shay Docking) and in Adelaide at the Royal Society of Arts – establishing himself as a leading exponent of abstract expressionism. His work attracted considerable critical attention, including that of the art historian Bernard Smith and artist/critic Elwyn Lynn.

In 1962 Riske and his family (Cynthia, two sons and a daughter) returned to the Netherlands where he rented a large studio space on the Warmoesstraat in Amsterdam. He shared the space with the painter Hans Nahuijs and sculptor Jan de Baat and began working on a monumental cycle of paintings measuring some fifteen metres in length, collectively named *Apocalypse*. The three artists exhibited their work together in Amsterdam and in the open air at Slotpark, Zeist, and produced a catalogue *Barokke abstractie* (Baroque abstraction), which included poems by Eldert Willems. Their work attracted widespread interest, including that of Willem Sandberg and Edy de Wilde of the Stedelijk Museum, Amsterdam.

Riske returned to Hobart in 1965, before settling in Sydney and exhibiting regularly in Melbourne, Sydney and Brisbane. He continued to paint on a large scale and began making drawings in pen and black ink. In 1967, in order to make a living, he and his wife set up a successful fabric screenprinting business in Paddington, but after about eighteen months they abandoned their business venture and Riske returned to painting and drawing. He shared a studio with the sculptor Ron Robertson-Swann for a time. Meanwhile his gestural abstract expressionism evolved into a more reflective and controlled approach to painting, influenced by his pen and ink drawings and an interest in Christian Science.

 In 1973 Riske and his family returned to Europe and settled in Cassis, near Marseille, where he drew intensively in pen and black ink on a large scale, exhibiting his drawings in the Netherlands at Pictura, Dordrecht, and Galerie Asselijn, Amsterdam. They returned to Australia in 1975 when his association with Robert Ypes of the Art of Man Gallery, Sydney, began. Riske's *Atomic*, *Coding*, *Terrain*, *Alignment*, *Spectrum* and *Expressions of time* series followed, underscoring his interest in scientific and technological discoveries. Since the mid 1970s he has been painting in intricately constructed layers of paint, on a small and large scale, using fine brushes and, at times, a magnifying glass. His drawings are equally refined, occasionally resorting to myriads of dots rather than short pen strokes. Gouache is also a favourite medium and he is a masterful colourist. Art critics Nancy Borlase, Arthur McIntyre and Terence Maloon have written enthusiastically about his work, as has Sandra McGrath, who effectively described his process:

Using a single-haired brush, Riske creates colour fields of paint built from minute brush strokes which swirl subtly into optical movement … to create some painterly equivalent of the physics that govern the universe.[1]

Riske taught at the Willoughby Arts Centre, Sydney, 1978–79. In 1982 he was one of three Australian artists (with Colin Lanceley and Michael Shannon) to have works included in the Carnegie International at the Museum of Art, Carnegie Institute, Pittsburgh. He exhibited with Ypes in New York, where he befriended the Australian artist Margery Edwards, and in London and Amsterdam. Baron Von Thyssen-Bornemisza took an interest in his work in London and purchased two paintings. He continued to exhibit in Australia and moved to Ulmarra near Grafton, with his wife, in 1983. There he had a large studio on an extensive property alongside the Clarence River. When Riske and his wife separated in 1993, he left Grafton and moved back to Sydney, where he still continues to paint, draw and exhibit. The artist's model, Margaret Weatherall, has been a support to him since his return to Sydney.

Riske was included in an exhibition of Dutch-Australian artists *The second landing* at the National Gallery of Victoria in 1993, as well as several exhibitions of finalists of the Dobell Drawing Prize, drawing exhibitions from the collection of the Art Gallery of New South Wales and in the 1997 exhibition of the Amcor Paper Award.

1. Sandra McGrath, 'Space-aged without being spaced out', *The Australian*, 12 November 1983

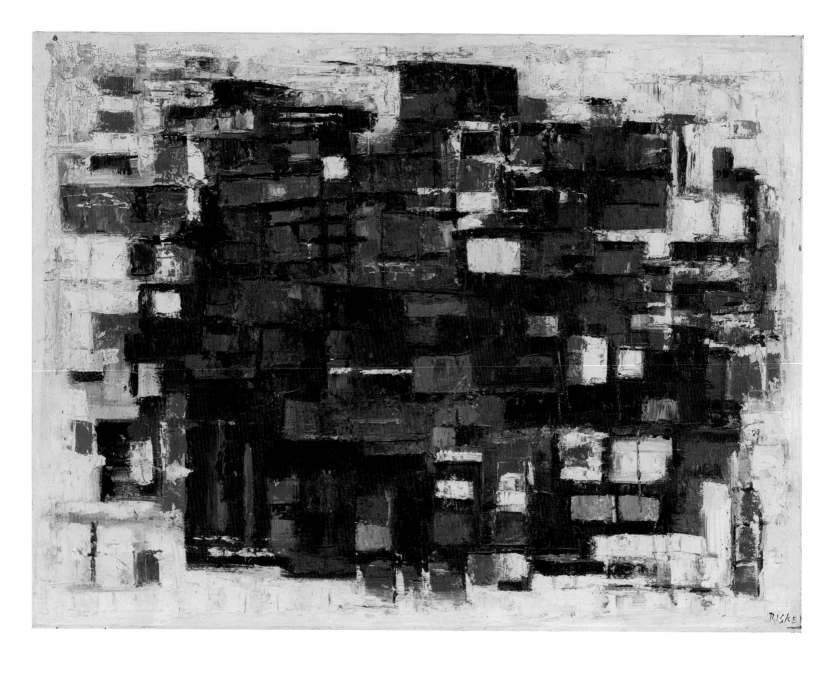

jan riske

82 dawn c1955

Private collection

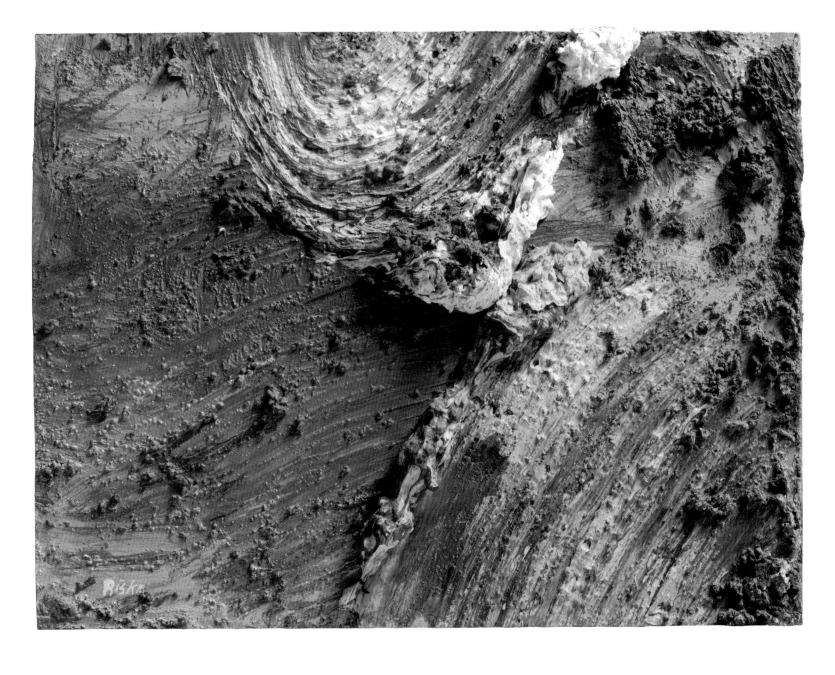

83 untitled c1963
Private collection

jan riske
87 altar of thought 1965–66
Museum of Modern Art at Heide, Melbourne

88 the structure of joy 1967
Art Gallery of New South Wales, Sydney

jan riske
89 untitled 1972
Robert Ypes

90 coding graph i 1990
Art Gallery of New South Wales, Sydney

jan riske
84 sound trails 1987–88
Private collection

85 expressions in time 20 1988
Robert Ypes

86 yellow command 1989
National Gallery of Australia, Canberra

theo kuijpers

Theodorus Gerardus Wouterus Kuijpers was born on 1 January 1939 in Helmond near Eindhoven in the province of Brabant, to Wout and Dora Kuijpers. He is the second of four children. His parents were farmers and he grew up on the family farm at Mierlo (between Helmond and Eindhoven), within a strict conservative Catholic agrarian community. He began drawing and painting seriously at high school and was initially attracted to the work of Vincent van Gogh and Pablo Picasso.

After finishing high school, in 1956, and encouraged by his art teacher, Kuijpers enrolled at the Academie voor Industriële Vormgeving (School of Industrial Design), Eindhoven, where he learnt the rudiments of painting and drawing. His teachers, Jan Gregoor and Lambert Tegenbosch, introduced him to CoBrA (Karel Appel, Asger Jorn, Pierre Alechinsky), *art informel* and post-war French abstract expressionism (Jean Bazaine, Roger Bissière, Alfred Manessier). He remains indebted to both teachers for their advice, encouragement and the example of disciplined work. Kuijpers began to travel, study and experiment; he spent time in Dutch museums, including the Van Abbemuseum in Eindhoven and the Kröller-Müller Museum near Otterlo, and was attracted to Vincent van Gogh, Amedeo Modigliani and Chaïm Soutine. Kuijpers had a studio in one of the buildings on the family farm and, as an art student aged nineteen, staged his first exhibition in Mierlo, which was favourably reviewed. He was described as having 'a potentially powerful talent for painting [with] a strong capacity for plastic synthesis and expression'.[1]

His next exhibition was held three years later, after he had completed his studies, received his diploma and was called-up for compulsory military service. Kuijpers applied to serve in Suriname (Dutch West Indies) and subsequently travelled about the region, including to South America. However, he rarely put anything on paper, allowing his experiences to gestate. Later, he described this time as, 'his most beautiful and richest to date'.[2]

Between 1963 and 1977 Kuijpers taught handcrafts at the Technical School in Bladel, south west of Eindhoven, and worked on his art on weekends and during holidays. He began to articulate his West Indies experiences on paper, board and canvas, establishing a pattern of delay and reflection following travel experiences, before turning to art-making. As he later stated:

I can't paint what I see. So that's why I don't have to travel often. What I paint, it always seems to me and more so, is memory. It is memory which creates images. And it is travelling, leaving and returning that creates memory.[3]

He exhibited the works that resulted from his time in the Dutch West Indies at exhibitions in Helmond and Reusel in 1965. Included was *Grote Watutsi* from 1964, revealing how successfully he had absorbed the example of CoBrA and French post-war abstract expressionism.

In 1966 he spent more time in South America and travelled to Morocco in North Africa, visiting the Atlas Mountains and the old cities of Fez and Marrakech. Afterwards his work became more allied to the *materieschilders* (matter painters), especially Jaap Wagemaker in the Netherlands, Alberto Burri in Italy and Antoni Tàpies in Spain. Doorways, walls and windows feature as subjects. He mixed sand and chalk with his paint and began to add collage. By the late 1960s, he incorporated whole doors and windows, reflecting his local farming environment and the influence of American pop artists such as Robert Rauschenberg, Jasper Johns and Claus Oldenburg. The work of major European modernists such as Arman, Christo, Daniel Spoerri and Jean Tinguely were also important to him. In the 1970s he began using sticks, string, paper, cardboard, pig skin, wire and lead.

After Kuijpers stopped teaching in Bladel in 1977, he taught part-time at art schools in Tilburg and 's-Hertogenbosch, giving him greater freedom to pursue his own art. In 1978 the Dutch lithographic printer Fred Genis, who had printed for Rauschenberg, De Kooning and Mark Tobey in the USA, approached him about producing some lithographs. Reluctant at first, he soon produced a startling series of lithographs that effectively summarized his work to that time, including the compelling large upright *Teken* 1978. Genis left the Netherlands for Australia soon after, prompting Kuijpers to follow.

In Australia he met the Australian artists for whom Fred Genis had begun to print lithographs, including Lloyd Rees, John Olsen, Brett Whiteley, John Firth-Smith and Tim Storrier. He spent two months travelling through the country by car, especially in Arnhem Land and the Northern Territory. He saw traditional Aboriginal cave paintings and spent time in Aboriginal communities. Back in his studio in the Netherlands he made numerous drawings and some of his biggest collages to date. In 1981 he travelled to New York and sought out the work of an earlier generation of abstract expressionists he admired including Arshile Gorky, Willem de Kooning, Franz Kline and Robert Motherwell.

In his studio in the Netherlands, he again returned to his Australian motifs before taking up an offer in 1984 to move to IJmuiden, a fishing village on the northern Dutch coast, where a group of like-minded artists, including the painter Lei Molin, had studios. They became known as the IJmuider Kring (IJmuiden Circle). Kuijpers returned to his natural impulses as an abstract painter, producing some of his most vigorously gestural works to date, many inspired by Australia. He revisited Australia in 1985, where he produced another lively sequence of colour lithographs with Fred Genis.

In 1988 there was a major survey of Kuijpers' work at the Noordbrabants Museum 's-Hertogenbosch. Travelling continues to stimulate him. Since the late 1980s he has travelled to Italy (including Sicily), France, Eygpt, Greece, Iceland and Indonesia. The great French cathedrals in Chartres, Amiens and Reims inspired a series of architectonic paintings and works on paper with dramatic contrasts of light and dark. He revisited Morocco, and between 1999 and 2006 made annual visits to Le Beausset, Provence, where he had the use of a studio.

In 2006 a monograph by Rick Vercauteren was published. Kuijpers lives in Nuenen with his partner, the painter Ellen Jess, and has occupied his current studio in Eindhoven since the mid 1980s. He continues to exhibit regularly in the Netherlands and his work is increasingly in demand with collectors and museums.

1. Frans Babylon in Rick Vercauteren (ed), *Theo Kuijpers,* Noordbrabants Museum, 's-Hertogenbosch 1988, p 15

2. Theo Kuijpers in Rick Vercauteren, 1988, p 17

3. Theo Kuijpers in *Herinnering Marokko,* Galerie Tegenbosch, Heusden aan de Maas, 1995

hand aan de ploeg slaan
een gat in de lucht
ruik je bloemen en stront

komt terug en verwijdert
zich de horizon vult vore
na vore de ogen en

openen zich vergezichten
vallen de coulissen om
in de hand van de smid

die het hoefijzer smeedt
en roodgloeiend slaat
in de hoef van het snuivende paard

Bert Schierbeek for Theo Kuijpers

your hand to the plough
knocks a hole in the sky
and you smell flowers and dung

it comes back and withdraws
the horizon that fills the eyes
furrow after furrow and

vast vistas open out as
the side-scenes tumble
in the hands of the blacksmith

who forges the horseshoe
and beats it to red heat
in the hoof of the snorting horse

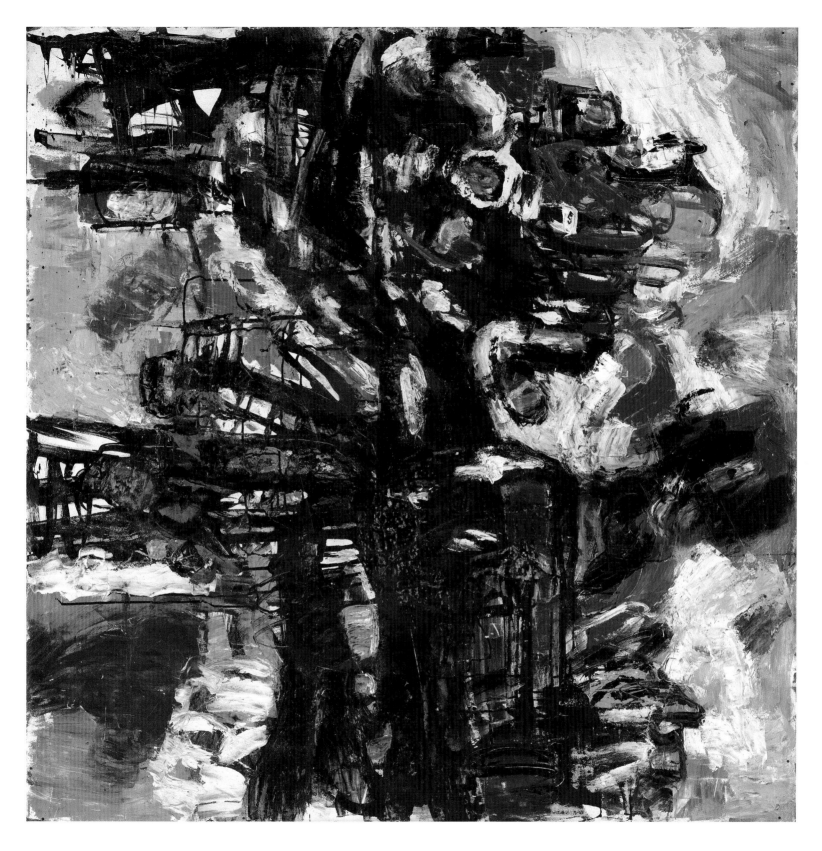

theo kuijpers
53 grote watutsi (big watutsi) 1964
Private collection

24/40 Theo Kuijpers '78

theo kuijpers

57 teken (sign) 1978

Private collection

54 ruit (window) 1976–77

Private collection

theo kuijpers

58 untitled vi 1985

Private collection

55 ijmuiden noord wester
(ijmuiden north-wester) 1984

Private collection

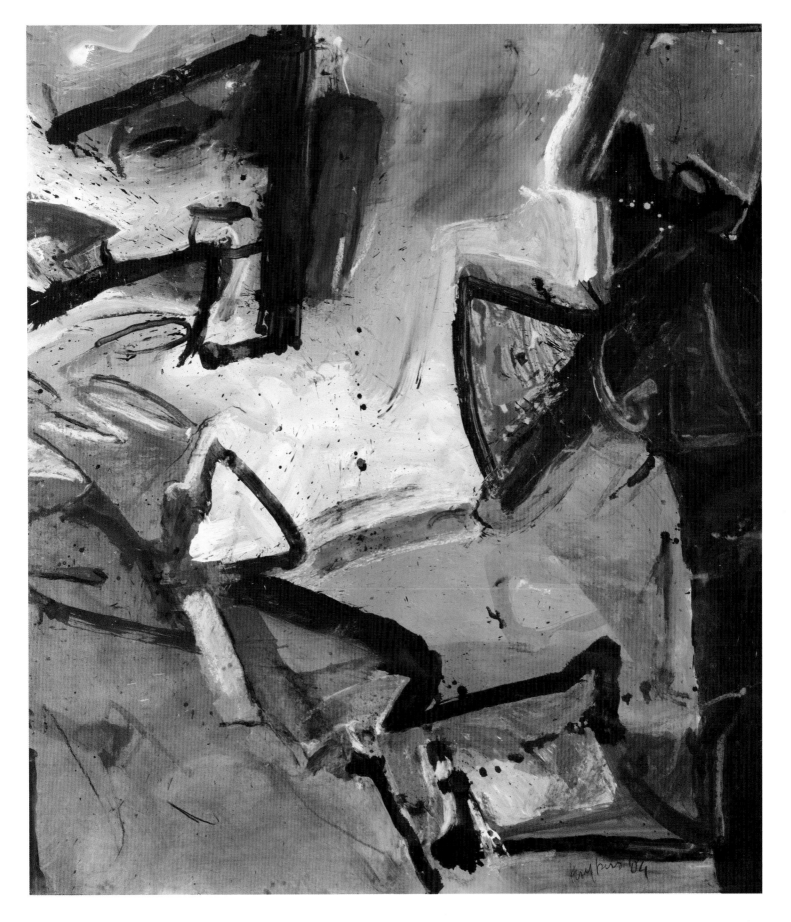

theo kuijpers
59 untitled vii 1985
Private collection

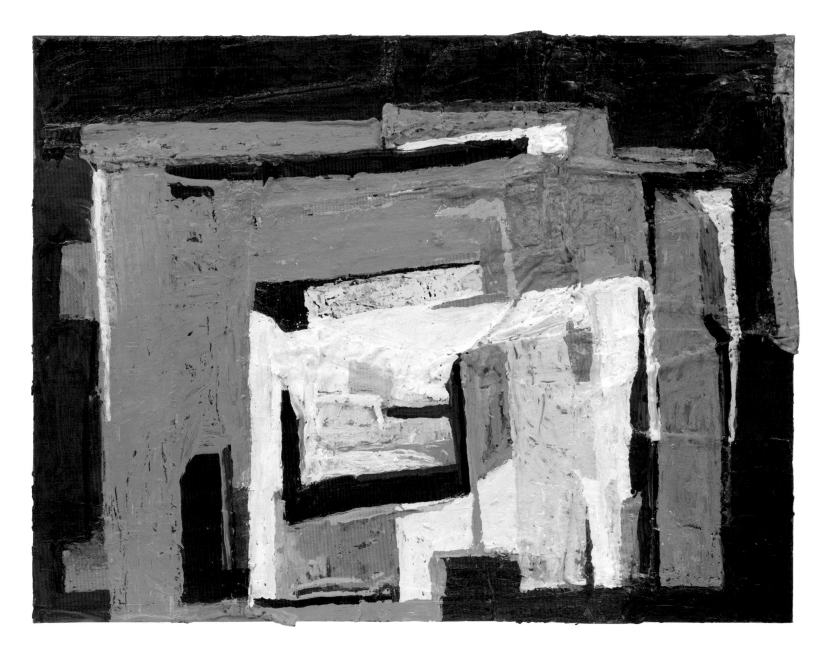

56 wit huis op blauwe zondag (white house on blue sunday) 2007
Private collection

freedom and innovation
willem sandberg and present-day art
in post-war netherlands

LUDO VAN HALEM

During the Second World War, in many respects the Netherlands was cut off from the outside world as a consequence of German occupation (1940–45). The cultural isolation in which the Netherlands had gradually fallen in the crisis years prior to the war became almost total, and artistic development slowly ebbed away. The repression inherent in occupation obstructed everything that flourishes in freedom.

Many cherished the hope that the liberation of the Netherlands would bring a definitive break with the past. They nurtured the prospect that regained freedom would also mean 'innovation' – not only a farewell to war but also to the deep crisis that had preceded it and the economic and political system that had caused it. However, to a large extent, the Netherlands emerged from the War just as segregated as it had entered it,[1] and, in political and social terms, it soon witnessed the emergence of forces advocating the restoration of pre-war power structures and moral values because these were regarded as essential to post-war reconstruction.

The immediate post-war years brought to the fore a number of artists who deliberately sought innovation and a break with the past, even if this entailed derision and occasionally smears. Some of these artists were from an older generation and seemed to want to begin all over again, while others had missed out on an academic education due to the War and pursued new impulses in an unrestrained manner. This urge for innovation went hand in hand with a renewed international orientation from the late 1940s onwards, and eventually led to the emergence of a remarkably large number of talented artists who also began to appear on international platforms. Nevertheless, as mentioned, the urge for artistic innovation initially aroused great scepticism and political insinuation and occurred against a background of occasionally irreconcilable differences in which self-interest, morality, politics, life principles and nationalism were intertwined.

An important and perhaps even key role in the ideological turmoil was reserved for Willem Sandberg (1897–1984), curator of the Stedelijk Museum in Amsterdam since 1937 and director from 1945. He had been active in the resistance during the Second World War, and was a prominent champion of artists' interests. His left-wing persuasion, which he shared with many people in the resistance, was often a source of irritation to his opponents but his status as a resistance fighter assigned him an almost unassailable position, certainly in left-wing Amsterdam. Accordingly, he was able to make a

unique mark on post-war art in the Netherlands and became the leading advocate for contemporary art, which he considered both international in its origins and trailblazing in its significance. In 'present-day art', he sought a spirit of freedom and innovation that he regarded as representative of the post-war reconstruction years. He seized every opportunity to display this present-day art in the Stedelijk, eventually ushering the Dutch art to which his policy had given such a strong impulse onto an international stage by the end of his directorship in 1962. Many of the artists who, in his view, had made a substantial contribution to international developments are now on show in the *Intensely Dutch* exhibition.

'The entire North German army has laid down its weapons and surrendered to Field Marshal Montgomery.' With these words, an extra bulletin of the popular resistance newspaper *Het Parool* announced the liberation of the Netherlands early on Saturday 5 May 1945. 'The capitulation will take effect at eight o'clock this morning; at that time the Canadian tanks will commence their victory procession along the Dutch Water Line and the Grebbe Line toward the coast.[2] We can expect the first allied soldiers in the capital within a few hours. We are free! Long live the Netherlands!' When the Canadian tanks rolled into the villages and towns north of the major rivers, the celebrations burst loose, but the contours of a dislocated and shattered country were clearly visible as background to the euphoria of liberation.

The Netherlands, even if liberated, was impoverished and destitute. While the economic catastrophe could be repaired astonishingly quickly thanks to support from the United Nations (1946) and American Marshall Plan (from 1947), so that prosperity was again at pre-war levels by 1949–50, the moral damage caused by the War was more difficult to mend. Social renewal, which many people cherished as an ideal during the German occupation, turned out to have only very limited support and, in many cases, there was more of a restoration of pre-war structures than a break with them.[3]

In commemorations of the War, the prevailing theme was not people's experience of hardship and loss, but rather the spirit of resistance, thus concealing the personal dramas under a blanket of heroism. Dealing with all the traumas, including all the personal and political issues involving collaboration, would eventually take many decades and would continue to dominate not only the lives of many but also the public debate on the War. Parallel to hope and yearning for change there were traumas and disappointments, parallel to decisive reconstruction there were questions of right and wrong, blame and responsibility.

In this dislocated Netherlands, which celebrated the arrival of the Canadian tanks in a most un-Dutch way, but was also willing to work hard, there turned out to be an enormous longing for art and culture. 'During the war the art public […] had been denied any contact with the visual arts', wrote Sandberg in a report to the Amsterdam City Council in 1950: 'Right after the liberation, there consequently was a very clearly felt "hunger" for the visual arts. The Dutch art public had lost touch with the art world abroad and was very eager to learn what had happened elsewhere during the five years of the war'.[4]

To artists, the occupation had also meant a serious obstacle to the free practice of their profession. In this, a crucial role was played by the *Nederlandse Kultuurkamer* (Netherlands Chamber for Culture) which, authorized by *Rijkscommissaris* (Government Commissioner) Seyss-Inquart on 1 April 1942, officially adopted a directive similar to its counterpart in Germany. Only artists who were members of the *Kultuurkamer* were permitted to practise their profession and display their work in public. In addition, the so-called 'alignment' with German publishers, newspapers and magazines meant a stringent restriction of literature and journalism, and therefore also of art criticism. In all possible ways, the artists and the general public had become estranged from one another and cut off from artistic developments elsewhere.

According to Sandberg, he had continually asked himself during the War: 'how will artists react to this war?'[5] Later he denounced the prevailing situation in the arts: 'Immediately after the war I looked everywhere to see how artists could possibly react to the years gone by and to the years ahead. I must remark, in all fairness, that I did become somewhat impatient when I saw so little movement from established names. People simply went back to their easels, tried to manipulate their dried-out paints, and continued with the still life they had been painting a couple of years previously'.[6]

The exhibition policy that Sandberg developed after his appointment as director of the Stedelijk Museum turned out to be of exceptional significance for the development of modern art in the Netherlands. The idea behind the exhibitions was not to be 'retrospective or historical but instead contemporary, and presented in such a way as to give the viewer a panorama of twentieth century art in its totality (thus also the possibility of comparing and evaluating the work)'.[7] One of the most conspicuous aspects was Sandberg's vigorous international orientation. Right from the outset he worked on generating a foreign network, and attempted to organize exhibitions that gave a good picture of what was going on in Europe and America. Accordingly, Sandberg wished to recoup what the Dutch public had been forced to do without in those five lean years, and to present the artists whom he found to be genuinely relevant to the times in which they were living.

By the end of 1945 he exhibited *7 Belgian painters*, soon followed by *British painters of the 20th century* and *Modern French graphic art*. In 1948, he presented exhibitions such as *13 sculptors from Paris*. With the exhibition *America paints* in 1950, the Netherlands could become acquainted with modern art from the USA for the first time. In retrospect, the series of exhibitions of the work of artists who were regarded even then as modern masters is most impressive: Georges Braque in 1945, the dual exhibition *Picasso Matisse*, and a memorial exhibition for Piet Mondriaan in 1946, while 1947 was an extraordinary year with Le Corbusier, Constant Permeke, a dual exhibition of Alexander Calder and Fernand Léger, Oskar Kokoschka, Marc Chagall and Wassily Kandinsky. In the following year, Picasso was again on show, this time with graphic art, as well as Ossip Zadkine and Paul Klee. In 1950, Joan Miró, Calder once again, and Alvar Aalto were noteworthy names on the exhibition list.[8] Sandberg's achievement is even more formidable when viewed in the light of social and economic circumstances. As a result of the serious material destruction, much of the initial war-damage repair had to be done with the 'shovel and wheelbarrow', and despite the encouraging recovery of the Netherlands, the 'administrative restrictions and the general economic situation made travel abroad virtually impossible, especially in the first years after the liberation'.[9]

The significance of Sandberg's efforts for the development of post-war art in the Netherlands can hardly be overestimated. Driven by the 'hunger' for what had happened abroad during the war years, the exhibitions he organized attracted many visitors as well as the necessary attention in the press. But this interest was not always sympathetic: various groups expressed resentment and exerted opposition to his policy, and his explicit preferences were questioned. Picasso, above all, caused the most fuss and many discussions focused on whether he was a 'genius' or a 'charlatan'. In the wake of the discussion, an intense paper war took place concerning whether or not the Dutch artists who had manifested themselves as 'experimentalists' or otherwise as progressive (and mostly abstract) weren't simply 'bunglers' and 'bamboozlers, swindlers'. In particular, the 'experimental' CoBrA artist Karel Appel had to bear the brunt of much criticism. And as the Cold War chilled the political climate of the fifties, the more conservative critics tended to furnish the work of progressive artists with a 'questionable' odium; even terms such as 'subversive' and 'a danger to the state' were articulated. J M Prange, the increasingly conservative critic of *Het Parool*, became particularly notorious with his defamatory pamphlet *De God*

Hai-Hai en rabarber (The God Hai-Hai and rhubarb), in which he suggested a parallel between the way modern art was being championed and the strategies of Fascism and Nazism: 'Modern art! When this slogan is continually chanted by the masses, as the cries of "Duce, Duce, Duce!" and "Sieg Heil, Sieg Heil, Sieg Heil!" once were, it begins to appear meaningful and becomes charged with an effect that gives it some magical power'.[10]

The post-war acquaintance of Dutch artists with the work of Picasso, Paul Klee, Joan Miró, Ossip Zadkine, Wassily Kandinsky, Henry Moore etc. had a major influence. Various elements from their visual language, handwriting, colouring and material use are recognizable in the work of Dutch artists; they had to take their new tutors into account in one way or another. A hasty and agitated letter that Karel Appel wrote to his friend Corneille on 2 December 1947 is illustrative of this: 'I'm just writing that I am working day and night I have just started to paint **suddenly I had it (at night)** now I produce powerful primitive work more powerful than negro art and Picasso **Why** because I continue on the 20th century originate from a Picasso **Bright colours**'.[11]

This evident influence, which can be discerned in the work of many artists, again became a point of discussion and turned out to be grist to the mill for those who rejected an artistic approach directed toward experiment and innovation. In 1947, the Amsterdam Artists' Association protested against Sandberg's internationally oriented policy which, in their view, was implemented at the cost of their own exhibition possibilities. Picasso in particular was the target of their objection. His influence was regarded as being so dominant that there was even mention of many 'Dutch disciples who began "to do Picasso" like kindergarten flocks'.[12] According to the writer W F Hermans, Karel Appel was one of them. In his essay entitled *De lange broek als mijlpaal in de cultuur* (Long trousers as a milestone in culture) 1951, in which he fulminates against Appel and Piet Ouborg[13] in particular, he makes a direct link between the rapid museum-ization of 'experimental' art and Picasso: 'The museum director cannot judge a thing in any other way than in comparison to what *has already occurred*. […] Is there anything in my museum that looks like an Appel? they ask in 1950. Yes, certainly! There we have Picasso and Masson. So come on in, Appel!'[14] In the opinion of Prange, 'Picassism' spread like the plague: in *De God Hai-Hai en rabarber* he wrote that he had seen no fewer than 'thousands and thousands of sous-Picassos' around him.[15]

Just before retiring, Sandberg accepted the prestigious invitation to compile an overview of ten years of non-American 'present-day art' for the Seattle World Fair, 1962. Independently of one another, various American advisors to the organization had proposed him as *the* expert in the domain of modern international art. Although Sandberg himself believed that several experts were necessary to cope with such a wide-ranging exhibition, the organization adhered to its view that one curator was best and that he would give the exhibition a clear signature.[16]

Sandberg presented the Seattle exhibition, called *Art since 1950*, under the theme of *vitality*, explicitly writing 'it is predominant in this exhibition'.[17] A couple of years previously, in 1959, he had already included many of the 55 artists he selected for Seattle in the large-scale touring exhibition called *Vitality in art*, which brought together diverse tendencies such as *art informel*, *art brut*, abstract expressionism and CoBrA.[18] With the concept of *vitality*, he signified the capacity for renewal that is always present in nature, art and society. On the one hand, it had universal, primitivist-tinted connotations by referring to a deep-rooted and irresistible vital urge, and on the other, there were social connotations – reasonably unimpeachable – due to the fact that Sandberg combined it with a rejection of repression and indifference.[19]

Looking back, it is undeniable that Sandberg seized this opportunity in Seattle to promote Dutch art. Six of the 55 artists were Dutch, a relatively large number. And while the exhibition was still running, he organized an exhibition entitled *The Dutch contribution to the international development of art since 1945* in his own house in the summer of 1962. For this occasion, the group of Dutch artists represented at *Art since 1950* – Karel Appel, Wessel Couzijn, Ger Lataster, Lucebert, Bram van Velde and Carel Visser – was extended with the painters Gerrit Benner, Corneille, Willem de Kooning and Jaap Wagemaker, and the sculptors Constant and André Volten. After Amsterdam, the exhibition went on a brief tour to Montreal and Ottawa, accompanied by an unusually large catalogue. Once again, Sandberg emphasized vitality as a unifying factor, but this time with a nationalist undertone: 'we are proud / of the Dutch contribution / to the vitality / of the present day' he wrote in his characteristic quasi-poetic language. In his opinion, the seeds of this development had been planted by the small group of artists who had made their appearance internationally under the name CoBrA, of which Appel, Constant and Corneille had been the Dutch co-founders. In the period from 1949–51 'they made a resolute start / experimenting / with a brand-new way of expression / seething and vital'.[20] Their pioneering work heralded a wave of vitalism that manifested itself everywhere in the fifties.

The concept of vitalism brought Sandberg a new round of criticism. Realists and artists working in an abstract-geometric style – who often imagined themselves to be the legitimate heirs to Mondriaan and De Stijl – felt slighted. But the most important fact is that, in one fell swoop, he united and summarized many expressions, gave them meaning, and largely neutralized them in political terms. Vital art was free art, and no one could dispute the importance of freedom. To many people, the heroism he assigned to the new post-war tendencies made them acceptable as the inevitable manifestation of a turbulent time. In the meantime, new developments presented themselves, as they always do, and Sandberg's concept of 'vitality' as the only true expression of the 'present day' was almost antiquated at its birth and marked, in fact, the end of an era. A new generation, also formed by the war but in a different way, ensured the ascendancy of 'imagination'.

Ludo van Halem is curator of 20th-century art at the Rijksmuseum, Amsterdam. Formerly editor of *Jong Holland* and senior curator of the Stedelijk Museum, Schiedam, he is also the editor of the recently reprinted *CoBrA the colour of freedom, the Schiedam collection*.

Translated from the Dutch by George Hall.

1. The societal structure of pre-war Netherlands was largely based on a strict segregation along socio-political and religious lines, also known as 'pillarization'.

2. The Dutch Water Line (*Hollandse Waterlinie*) and Grebbe Line (*Grebbelinie*) were military defense lines in the west of the Netherlands and in the Central Netherlands respectively that originated in the 17th century. The defense was based on the shallow and controlled inundation of land as the enemy approached, combined with strategic fortifications. In early May 1940, the Dutch army was only able to stop invading German troops for a few days at the Grebbe Line.

3. J C H Blom, De Tweede Wereldoorlog en de Nederlandse samenleving: Continuïteit en Verandering, in *Vaderlands Verleden in Veelvoud*, C B Wels et al. (eds), Martinus Nijhoff, The Hague 1982, pp 336–57

4. Ad Petersen & Pieter Brattinga, *Sandberg, Een documentaire/A documentary*, Kosmos, Amsterdam 1975, p 41

5. Petersen & Brattinga 1975, p 8

6. Ank Leeuw-Marcar, *Willem Sandberg, Portret van een kunstenaar*, Meulenhoff, Amsterdam 1981, p 101

7. Petersen & Brattinga 1975, p 41

8. Petersen & Brattinga 1975, p 153 ff.

9. Petersen & Brattinga 1975, p 41

10. J M Prange, *De God Hai-Hai en rabarber. Met het kapmes door de jungle van de moderne kunst*, J Heijnis, Zaandijk 1957, p 45

11. Willemijn Stokvis, *Cobra. Geschiedenis, voorspel en betekenis van een beweging in de kunst van na de tweede wereldoorlog*, De Bezige Bij, Amsterdam 1985, p 56

12. Jan van Adrichem, *De ontvangst van de moderne kunst in Nederland 1910–2000. Picasso als pars pro toto*, Prometheus, Amsterdam 2001, p 241

13. In 1950, Piet Ouborg was awarded the Jacob Maris Prize for *Vader en zoon* (Father and Son), which caused much protest in the press because many people thought it was too much like a child's drawing.

14. Carel Willink, *De schilderkunst in een kritiek stadium*, Van der Velden, Amsterdam 1981; first edition Meulenhoff, Amsterdam 1950, quoted on p 83

15. Prange 1957, p 74

16. Petersen & Brattinga 1975, pp 92–3

17. Caroline Roodenburg-Schadd, *Expressie en ordening. Het verzamelbeleid van Willem Sandberg voor het Stedelijk Museum 1945–1962*, Stedelijk Museum, Amsterdam/NAi Uitgevers, Rotterdam, no date [2004]), p 682

18. *Vitalità nell arte* was originally organized for the Centro Internazionale delle Arti et de Costume in the Palazzo Grassi in Venice (Italy), and travelled via the Kunsthalle in Recklinghausen (Germany) to the Stedelijk Museum, Amsterdam, where it was shown at the end of 1959/beginning of 1960.

19. See Roodenburg-Schadd [2004], pp 612–19

20. *Nederlands bijdrage tot de internationale ontwikkeling sedert 1945 / La contribution hollandaise au développement international de l'art depuis 1945 / The Dutch contribution to the international development of art since 1945* (exh cat), Stedelijk Museum, Amsterdam / Museum of Fine Arts, Montréal / The National Gallery of Canada, Ottawa 1962, unpaginated.

more than cobra
painting in the netherlands after 1945

LIES NETEL

When the International CoBrA exhibition in the Stedelijk Museum was opened to the public early in November 1949, the newspaper headlines screamed 'Experimental exhibition: blot, twaddle and daub in Stedelijk Museum' and 'Rather nothing than this worthless art'.[1] Still, it was the art of the painters from the Dutch Experimental Group participating in the exhibition, that would later become recognised as the most important innovative trend in post-war Dutch art. The experimental paintings and drawings by Karel Appel, Constant and Corneille, influenced by children's art and the creative outpourings of the mentally handicapped, written off in the press as 'worthless art', were highly praised by many art lovers. So highly, that other trends and artistic endeavours faded from Dutch art history. Since the 1990s this has started to change. Since then more attention has been paid to art in the Netherlands during the '50s and the image of the central role of CoBrA in post-war Dutch art is being adjusted.

In fact the CoBrA movement lasted no more than three years. The international group formed in Paris in 1948 fell apart after the third exhibition held in Luik (Liège) in 1951, and CoBrA artists went their own ways. Corneille continued his experimental art and was influenced by the African landscape. Appel combined his painting with other art forms. He worked with ceramics and completed a number of commissions for monumental murals. Constant ceased painting in the '50s and occupied himself with possibilities for shaping a new society. He started experimenting with lines and planes in space; and with wire and perspex sheets he built constructions for a contemporary, playful living space for the liberated modern man. Up to the mid 1970s Constant worked on his *New Babylon*: models for a utopian city for *Homo ludens*. Constant predicted that man, as a result of the large scale automation of society, would be redeemed from labour and thus have more leisure time. After these spatial projects Constant once again took up his brushes and combined his earlier experimental art with insights and themes from the classic European art tradition.

The Museum Henriette Polak in Zutphen has the two extremities of Constant's oeuvre in its collection: a still life from 1946 and a watercolour portrait from 1985. The still life was painted before the formation of CoBrA, before there was any thought of a collective experimental art. Constant, like so many other Dutch painters, was looking for a contemporary style based on pre-war French modern art. The watercolour of Mathilde Visser, which Constant painted in the mid 1980s, shows clearly how the experimental artist, at a mature age, combined abstraction and figuration.

Joop Sjollema (1900–91)
Familiekring (Family circle) c1970
collection: Museum Henriette Polak, Zutphen

During the 1950s and '60s a combination of figurative and experimental elements was unthinkable. The polarisation between practitioners of non-figurative or abstract art and the 'figuratives' reached an unbridgeable impasse in the '60s, with the result that many artists in the figurative tradition are unjustly under-represented in the collections of Dutch museums. In the 1970s the Henriette Polak Museum in Zutphen was established by artists wanting to redress this imbalance. The painter Joop Sjollema and his friends, painter Otto de Kat and sculptors Han Wezelaar and Bertus Sondaar, collected classic modern art. Their acquisitions were financed by Henriette Polak and held by a foundation with the aim of setting up a new museum. This became the present Museum Henriette Polak. The collection of this museum includes many works by artists who neither worked experimentally in the '50s, nor belonged to the Dutch avant-garde, but who forged their own paths outside the museums: in the reconstruction projects after the destruction of the war. Sjollema and his friends also bought works by outsiders on the Dutch art scene after 1945. Therefore the Museum Henriette Polak also has works by individualist artists such as Gerrit Benner and Wim Oepts. Their paintings and works on paper cannot be considered part of the avant-garde movements. Instead, their art bears witness to a personal experimentation with colour and composition.

In the Netherlands, immediately following the Second World War, the restoration of spiritual values and co-operation was given top priority. All activity was directed towards the community and the restoration and renovation of the liberated nation. In this context, art and culture were seen as unifying factors. The inclusion of artworks in new government buildings was recognised as having an educational value. Visual artists were invited to decorate sombre buildings, schools, dwellings, office blocks and government buildings. The inter-connection of art forms was eagerly sought by both visual artists and architects. More than this, it was stimulated by the so-called percentage-ruling introduced in 1951. Cabinet decided in that year 'that for really important buildings the Ministry could propose a sum of, say, 1.5% of the construction costs be set aside for decorative elements'.[2] And even though this resolution was extremely vague, throughout the whole country, art was applied to renovation and rebuilding projects. Concrete reliefs, mosaics, etched glass, murals and tapestries were included in buildings even in the remotest corners of the Netherlands. This application of works of art was seen as symbolic of new community feeling and regained freedom.

Many of the artists available for the commissioning of these art projects on buildings had studied at the Rijksakademie for Fine Arts in Amsterdam. Richard Roland Holst was, from 1918, head teacher in monumental mural art at this institution. From 1926 he was also director and subsequently the Rijksakademie developed the leading course in monumental art in the Netherlands. Artists who wanted to place their work at the disposal of society sought instruction there. One of Roland Holst's favourite students was Joop Sjollema. Already before the outbreak of the War, Sjollema had completed several commisions. He created posters and designed postage stamps. During the reconstruction he developed numerous monumental wall-decorations for schools and other public buildings. Like those of his contemporaries his murals portrayed themes from the daily lives of the building's occupants. Figures were built up in planes and the compositions were strengthened by a rhythmical use of line. The painting *Familiekring* (Family circle) 1970 from the collection of the Museum Henriette Polak is a continuation on a theme Sjollema developed for a mural on the facade of a De Gruyter supermarket in a post-war redevelopment in Amsterdam West. In the painting several family members sit at a round table. Noticeably each family member is in his own world. The circle of the table forms the link between the individual members. The way Sjollema joined the family members within the circle was also the way he saw the role of the visual arts, as a binding force between the various social groups within society.[3]

During the 1930s Richard Roland Holst was succeeded by the German artist Heinrich Campendonk. His appointment at that time caused quite a commotion. The National Socialist ideas of the German dictator had repercussions throughout Western Europe and there was some doubt whether the appointment of a German professor to such an important position at the leading art academy in the Netherlands was the correct decision.[4] Heinrich Campendonk had built his reputation on his monumental art projects. He had fled Germany and was living in Belgium, when his appointment at the Rijksakademie was ratified in 1935. Campendonk was greatly valued by his students, and his ideas can be traced in many of the commissions for reconstruction, because many of his students undertook these projects after the War. Campendonk never let go of the figurative. His wall designs always show a recognisable theme. He did simplify the figurative elements to colourful planes and graceful forms. He accentuated the expressive power of colour, but also gave weight to the expressive possibilities of the materials he used. He often worked in stained glass. With this method he could strengthen the expressiveness of colour, because glass offers the possibility of allowing light to shine through colour. Campendonk created relatively few works in the Netherlands but one of them is the impressive leadlight window in Amsterdam's Muiderpoort station, which he made in 1939. It is a circular window, to which he applied a structure of horizontal lines in lead, within which he designed flying birds as a symbol of travel and progress.

Heinrich Campendonk (1889–1957)
Vogelzug (Migrating birds) 1939
lead-glass window, Muiderpoortstation, Amsterdam

The experimental artists Constant and Karel Appel took lessons at the Rijksakademie Amsterdam around 1940 and it is known that they attended classes by Heinrich Campendonk. In 1949, during the CoBrA period, Karel Appel was commissioned by the Amsterdam City Council to create a mural for the canteen of the Town Hall. Appel developed his CoBrA theme 'Vragende kinderen' on a large scale. Similar to Campendonk's method he created figures on the wall with simple monumental lines and planes. But these figures or beings have no obvious arms and legs or recognisable faces. The title *Vragende kinderen* (Enquiring children), therefore, gave rise to more questions than answers among the employees. The 'abstract' scene caused so much unrest to these employees that the mural had to be hidden behind white panelling. When the building became a hotel in the '90s, Appel's mural was restored and is now even visible from the street.

Central to the Rijksakademie's educational philosophy was the idea that the visual arts held as important a place as architecture. Visual artist and architect worked together as equal partners. The first wave of art projects within the reconstruction period were approached from this standpoint. This ideal held for those artists working in a modern classical tradition such as Joop Sjollema, and in projects realised by experimental artists such as Karel Appel. In the course of the 1950s this ideal came under pressure. A number of artists sought a total re-creation of spaces. Constant made an important contribution to these developments with his *New Babylon* models. In his experimental spatial constructions he broke down the borders between art and architecture: the two disciplines were integrated. By the end of the '60s more and more artists completed commissions for monumental art as total creations within space. Spatial composition became a new art discipline. At the Art Academy in Arnhem a department of Monumental New Style was inaugurated in 1966. This department was led by Berend Hendriks who had been taught by Campendonk at the Rijksakademie. Together with teacher Peter Struyken, he gave direction to the newly integrated form of spatial composition.[5]

By the 1960s, the artistic ideals of the Rijksakademie were seen as old-fashioned. New commissions rarely went to ex-students of the academy. This trend affected not only the monumental muralists in the classical tradition, but also painters and sculptors who had remained true to that tradition and craftsmanship, and who saw their position in the Dutch art world shift to the margin. Their work was rarely, if ever, acquired by the museums and the sculptors from this modern classic tradition, such as

Han Wezelaar and Mari Andriessen, rarely received commissions. Now, forty years later, the polarisation between figuration and abstraction has been overtaken by post-modernism and the history of Dutch art in the 1950s can be re-examined. It becomes obvious that there was more than CoBrA, and gradually it is becoming clear that the discrepancy between experimental art and the ideals of the 'classic moderns' was far less than was previously believed.

Lies Netel, art historian, is curator of the Museum Henriette Polak, Zutphen, and author of a series of monographs on Dutch artists including Wim Oepts. Her most recent book is *Het hart van de collectie, Museum Henriette Polak*.

Translated from the Dutch by Cornelis Vleeskens.

1. Willemijn Stokvis (ed), *De doorbraak van de moderne kunst in Nederland de jaren 1945–1951*, Meulenhoff, Amsterdam 1984, p 100

2. Wilma Jansen, *Kunstopdrachten van de Rijksgebouwendienst na 1945*, 010, Rotterdam 1995, p 15

3. Lies Netel, *Joop Sjollema, een overzicht van zijn werk 1900–1990*, Museum Henriette Polak, Zutphen 2005, p 42

4. Kitty Zijlmans, 'Ein unerwijnschterAusländer. Heinrich Campendonk' in *Heinrich Campendonk, die zweite Lebenshelfte eines Blauen Reiters*, Astrid Schunck (ed), Waanders, Zwolle 2001, pp 232–45

5. Ineke Middag & Marion Fritz-Jobse, *De Arnhemse school, 25 jaar monumentale kunst praktijk*, Hogeschool voor de kunsten Arnhem, Arnhem 1994

everything is permitted
dutch poetry in the post-war years

CORNELIS VLEESKENS

In the first years after the Liberation it seemed that the drive for renewal in literature, as well as in the wider society, was no more than a scramble to re-establish the status quo as it had been in the years leading up to the Second World War. Poetry was firmly under the control of an elite group of competent but unexciting versifiers who, through their position on editorial boards, were able to censor publication of texts which may question their values.

A rare but welcome exception to this was the magazine *Het woord* (The word), published by De Bezige Bij, a co-operative publishing house originally set up by the Resistance during the War. Here, Koos Schuur [1] and others wanted to rid literature of the rhyming doggerel that had passed for poetry during the Occupation. The fact that these propaganda verses were often close to the thoughts and appreciation of the general public and were, therefore, a possible healing between literature and the wider society, was sadly left unnoticed. So, while wanting a new literature, the editors often missed the chance of realising the progress that would sweep them aside in a few years.

General editor Gerard Diels, whose theoretical writings advocated an emancipation of word and style, did not reach his own high expectations and appeared almost reluctant to allow others that honour. Schuur's friend Jan G Elburg worked closely with the magazine, and was later joined by Bert Schierbeek and Gerrit Kouwenaar, both of whom originally published fairly conservative novels based on their war-time experiences. These writers would soon develop widely divergent, but equally experimental styles which placed them at the centre of the Fiftiers poetry revolution, a poetics that would influence Dutch literature for several decades.

After the demise of *Het woord* in 1948 (Lucebert made an appearance with some drawings but no poetry in the final issue), the poets joined forces with the painters Constant, Corneille, Karel Appel, Anton Rooskens, Eugène Brands and Theo Wolvecamp in the Dutch Experimentele Groep (Experimental Group), and published in their periodical *Reflex*. By the end of the year, this group would amalgamate with the Danes and Belgians to form CoBrA.

A DIVERGENCE OF STYLES

The *Reflex* poets, Elburg, Kouwenaar, Schierbeek and Lucebert, form the core of the Fiftiers yet differ greatly in approach and style. Elburg in his poetry from the early '50s maintains a Marxist view, but one which is greatly tempered by a desire for peace.

I should like to make a man from resentment
and broken splinters: a winterman
with a face all elbows.
And the trees would thump at his passing
and if he had one minute to live,
he would be red the red of children's tears
and red.
('Willen' from *Laag Tibet* 1952)

His language, though sometimes appearing impenetrable at a first reading, becomes easier and easier to follow as one becomes familiar with his voice. On the other hand, Lucebert's obscurity is part and parcel of his playful experiments:

childfragrant she came at evening
into the room of chinese speaking plants
we smoked blind 3 cigarettes
on the naked mattress 2 cheeks lamps
light entered the dark room
(from *Triangel in de jungle* 1951)

Both poets developed and refined their style over the ensuing decades, and, despite Elburg's break with the overtly political, have built impressively consistent œuvres.

And while Gerrit Kouwenaar pared back his poems by eliminating everything he felt was unnecessary, he often left a sparse framework of paradox where ambiguity is rife:

A poem as a thing

a glass revolvingdoor and the chinese waiter
returning again and again with different dishes

a parkranger paring his fingernails
among siberian children from maine

a prehistoric venus together with
a spider on the freeway

('Als een ding' from *Zonder namen* 1962)

whereas Bert Schierbeek's lengthy, unpunctuated word-chains sometimes leave us reeling between foreign phrases and neologisms:

noblesse oblige
pauplesse souplige
no I have never taken braketests, he said later
we wish to live in the light, I think

ultimamotummovies which are subsidised play

the perpetuum mobile my heart didn't comprehend

and what did it have to understand namely that

there is an avoidance at the right moment …

(from *De andere namen* 1952)

THE WIDER CIRCLE

Events surrounding the CoBrA exhibition at the Stedelijk Museum in Amsterdam in November 1949 brought both artists and poets broad, if not favourable, attention. The accompanying 4th issue of the magazine *Cobra* drew the ire of the censors and was banned because of a 'lewd' photomontage by Elburg who, with the other experimentalists, occupied the 'poets' cage' during the exhibition. Here they declaimed their poetry and declared the death of the old lyrical tradition. Then, to top it off, a riot broke out during the public readings when French-speaking Belgian poet Christian Dotremont delivered a monotonous tirade in which only words relating to communism could be discerned by a shocked and confronted audience.

The papers and periodicals were full of it! The establishment attacked the young experimentalists. Others wrote in their defence. And from attics all over the country, new voices joined the poetry revolution. Small magazines blossomed, most notably *Braak*, edited by Remco Campert and Rudy Kousbroek, and *Blurb* from Simon Vinkenoog who was working for UNESCO in Paris. Vinkenoog's first collection *Wondkoorts* (Wound-fever) was published in November 1950, quickly followed by volumes from Lucebert, Remco Campert, Hans Andreus and others. A number of anthologies followed: *Atonaal,* edited by Vinkenoog in 1951, *Nieuwe griffels, schone leien,* edited by Paul Rodenko in 1954, and *Vijf 5 tigers,* from Kouwenaar in 1955.

The Fiftiers had arrived. And they would remain the most influential generation of Dutch poets for many decades to come.

ARTISTIC COLLABORATIONS

The importance of the Fiftiers does not, however, lie solely in their individual collections, anthologies and magazine publications. They freed up the language and subject matter for poetry but many of them were also active in the visual arts, most notably Lucebert, whose output and quality in both fields make him perhaps the only true double-talent.

The Flemish poet Hugo Claus also painted, as well as writing for stage and screen and turning his hand to film directing. Elburg worked extensively with collage and photo-montage as well as producing some impressive gouaches, and in more recent times Vinkenoog has held a number of successful exhibitions.

The CoBrA period also saw the birth of many artistic collaborations. The driving force behind this initiative was the Belgian Dotremont, who worked extensively on canvases with most of the artists, adding texts to their paintings or accompanying them with his calligraphic logograms. The many works he did with fellow Belgian Pierre Alechinsky are the best known of these, and their collaboration lasted many years.

On the literary side, most collective works were produced as limited editions which are now eagerly sought collector's items. Even a 1970s facsimile reprint will cost you a pretty penny. There were small books by Karel Appel with Claus and later with Hans Andreus. Corneille also worked with Claus and with Vinkenoog, the latter pairing reprising their collaboration with two lithographs in 1990.

And Constant produced *Het uitzicht van de duif* (The prospect of the dove) with Elburg and *Goede morgen haan* (Good morning cock) with Kouwenaar. As we noted earlier, Elburg retreated somewhat from his political outspokenness in later years, and though he did not reprint *Het uitzicht van de duif* in full, about half of it appears under the title *Wie biedt* (Who is offering) in the collection *Laag Tibet* (Low Tibet) and is also taken up in the 1982 selected poems *Lets van dat alles* (Something of everything).

Often the critics dismiss these collective works as being lightweight or even childish. Anyone who takes the time to give the text of *Goede morgen haan* more than a cursory glance will see that it is anything but childish. It is a revolutionary text written in a language that is accessible: we all know the cock of the French Revolution and the New Testament, we all grew up in a society that segregated the classes and the religions, we all watched the cowboy films with their black and white moral code. We all recognise the need for a radical change.

Good morning cock!

You have crowed thrice / We heard you. / You have crowed thrice / loud and on high
before the singing and clawing / harpy-green-evil-now forced us / to put up our honest bedstead.

Leave the Eiffel tower aside, / steel skeleton-shadow- / bullet-forgotten – on the scrapheap

that's / how we / hang,

And that's how we hang, / hanging in the ears of the / UPRISING. / Our uprising shall be a / testimonial.

Under Apollo's armpits / the barnowl slumbers, / at night he may have called
at ungodly hours, the lie / of sweetness, – nevertheless / morning fell from night's den,
pedestal / of the / 3 x / crowing COCK!

Cornelis Vleeskens, poet, editor and publisher, arrived in Australia from the Netherlands in 1958 aged ten. He has translated the poetry of Simon Vinkenoog and other post-war Dutch poets into English; books of his own poetry include *The day the river*, *Treefrog dreaming* and *The wider canvas*.

1. Koos Schuur, who was influential in the early days of the new poetry, migrated to Australia in 1951. He soon left the formal rhyming of his early poems and developed an easy fluency, most noticeable in his collection *Fata morgana voor Nederlanders* (Mirage for Netherlanders) 1956, as well as in the many letters he wrote home to the literary friends he had left behind. A selection of these was published in 1953 under the title *De kookaburra lacht* (The kookaburra laughs). After his return to Holland in 1963, a second expanded edition of the letters was published. Schuur continued to write, but only published one further collection *Waar het was* (Where it was) in 1980. In 1990 a selection from his œuvre, *Signalen*, appeared. Also refer to p 197.

catalogue of works

Comprises paintings and works on paper. Measurements are in centimetres, height before width. Only inscriptions by the artist are given. Titles are in their original Dutch with English translations in brackets (some titles are, as they were originally, in French, German or English). Only abbreviated selected main references to the works in the exhibition are given (books, exhibition catalogues etc) – see the *Selected bibliography* for full details.

KAREL APPEL 1921–2006

paintings

1
Ontmoeting (Encounter) 1951
oil on canvas 130 x 97.5 cm
signed, dated 'CK. AppeL 51' lower left
collection: Netherlands Institute for Cultural
Heritage (on loan to Centraal Museum,
Utrecht)

Stokvis, *Cobra 1948/51,* 1966 pp 55,
102 (43); Schneede & Wehr, *Cobra
1948–51,* 1982 p 71 (19); Stokvis, *Cobra,
geschiedenis, voorspel en betekenis,* 1985
p 324 (122); Stokvis, *Cobra, an international
movement in art,* 1987 p 75 (73); Blok,
Nederlandse kunst vanaf 1900, 1994 p 107;
Bosma, *Beeldende kunst 1850–2001,
Centraal Museum,* 2001 pp 182, 538 – see
Ragon, *Karel Appel, peinture 1937–1957,*
1988 p 21 for a related drawing

2
De wilde jongen (The wild boy) 1954
oil on canvas 195.3 x 113.7 cm
signed, dated 'CK. AppeL/'54' upper left
collection: Stedelijk Museum, Schiedam

Bellew, *Karel Appel, le grandi monografie,*
1968 (97); Fuchs, *Karel Appel, dipinti,
scultura e collages,* 1987; Ragon, *Karel
Appel, peinture 1937–1957,* 1988 p 453
(752); Fuchs, *Karel Appel, ik wou dat ik een
vogel was,* 1990 p 24; Van Halem, *CoBrA,
de kleur van vrijheid,* 2003 pp 22, 67, 307,
310; Fuchs, *Karel Appel, onderweg,* 2004
p 53; Van Halem, *Picasso, Klee, Miró en de
moderne kunst in Nederland 1946–1958,*
2006 p 105

3
Paysage à la tête noire (landscape with
a black head) 1959
oil on canvas 130 x 194 cm
signed, dated 'AppeL 59' lower left
collection: Jan and Ellen Nieuwenhuizen
Segaar

Christie's Amsterdam, *Twentieth century
art,* 30 May 2006 pp 108–109 (186); Vrieze
& Sassen, *Karel Appel, Jazz 1958–1962,*
Amstelveen 2008 p 8

4
Horizon of Tuscany #36 1995
oil on canvas 200 x 260 cm
signed, dated '95/AppeL' lower right
collection: ING, Amsterdam

Fuchs, *Karel Appel, pastorale chiaroscuro,*
2001 p 92; Brugger & Steininger, *Karel
Appel,* 2002 p 85 (45); Meulensteen &
Steininger, *Karel Appel, retrospective
1945–2005,* 2005 p 109

works on paper

5
Dier (Animal) 1950
brush and black ink 33.3 x 43.9 cm
signed, dated 'ck AppeL '50' lower left
collection: Boijmans van Beuningen
Museum, Rotterdam

6
untitled 1950
red and green crayon 23.8 x 37.2 cm
signed, dated 'CK.Appel 50' lower centre
collection: Gemeentemuseum, The Hague

Ragon, *Karel Appel, peinture 1937–1957,*
1988 p 293 (592)

7
Optocht (Procession) 1950
black conté, gouache 80 x 46 cm
signed, dated 'CK Appel 50' lower left
collection: Netherlands Institute for Cultural
Heritage (on loan to Stedelijk Museum,
Schiedam)

Van Halem, *Picasso, Klee, Miró en de
moderne kunst in Nederland 1946–1958,*
2006 p 97 – see Brugger & Steininger, *Karel
Appel,* 2002 p 54 (23) for a related painting
Tragic carnival 1954

8
Karel Appel & Bert Schierbeek
*A beast drawn man / Het dier heeft een
mens getekend* 1963
poem by Bert Schierbeek (1918–1996)
and 7 colour lithographs by Karel Appel,
51.9 x 42.8 cm
signed 'Appel' lower right; signed, inscribed
with edition on colophon '59CKAppel Bert
Schierbeek' lower corner
edition 59/75 in English, lithographs printed
by Jean Pons, Paris
collection: Boijmans van Beuningen
Museum, Rotterdam

See pp 195–96 for the full text as it appears
in this English translation of the poem by
John Vandenbergh

GERRIT BENNER 1897–1981

paintings

9
Wind, water, wolken (Wind, water, clouds)
1954
oil on canvas 60.3 x 80.2 cm
collection: Van Abbemuseum, Eindhoven

Benner, *tekeningen, gouaches, schilderijen,*
1959 (10); *Nederlands bijdrage, tot de
internationale ontwikkeling sedert 1945,*
1962; Tegenbosch, *Gerrit Benner,* 1970 (21);
De Wilde, *Modern Dutch painting,* 1983
p 80; Tegenbosch, *Gerrit Benner,* 1986 p 33

10
Bomen (Trees) 1955
oil on canvas 100 x 80 cm
signed 'Bnr' on verso
collection: Groninger Museum, Groningen

Benner, *tekeningen, gouaches, schilderijen,*
1959 (22)

11
Fries landschap (Frisian landscape) 1970
oil on canvas 80 x 100 cm
signed 'Bnr' on verso
collection: Groninger Museum, Groningen

Tegenbosch, *Gerrit Benner,* 1970 (89); De
Wilde, *Gerrit Benner, werk uit de jaren*

1965–1971, 1971 (8); De Wilde, *Modern
Dutch painting,* 1983 p 81; Brons, *In de
ban van Benner,* 1989 (50); Fuchs & Hoet,
Flemish and Dutch painting, 1997 p 228
(124); Westenberg, *Gerrit Benner,* 2005 p 99

works on paper

12
Plantsoen (Park) 1952
gouache 56.5 x 75.7 cm
signed 'Bnr' lower right
collection: Groninger Museum, Groningen

13
Koeien (Cows) 1956–57
black gouache 48.5 x 61 cm
collection: Boijmans van Beuningen
Museum, Rotterdam

Benner, *tekeningen, gouaches, schilderijen,*
1959 (75); Brons, *In de ban van Benner,*
1989 p 13

14
Zomer (Summer) 1970
gouache 48 x 62.5 cm
signed 'Bnr' lower right
collection: Museum Henriette Polak, Zutphen

15
untitled 1977
lithograph 56.7 x 76.5 cm
signed in image 'Bnr' lower right
from edition of 40; printed by Fred Genis,
Oudkerk
private collection

Dean, *The artist and the printer, lithographs
1966–1981,* 1982 p 9 (3); Kolenberg, *From
the studio of master lithographer Fred
Genis,* 1997 (49); Kolenberg, *Tintra, piedra y
papel las impresiones de Fred Genis,* 1998
p 41 (35) – see Tegenbosch, *Gerrit Benner,*
1986 p 15 for a related drawing

BRAM BOGART BORN 1921

paintings

16
Stilleven IV, vlakken, masker en kannen, Delft
(Still life IV, marks, mask and jugs, Delft) 1951
oil on canvas 69.5 x 80.5 cm
signed 'BOOGAART' lower right; signed,
dated 'Bram vd Boogaart/Mei 51' on verso
and inscribed 'NO IV STILLLEVEN B v d
BOOGAART' and 'VLAKKEN MASKER EN
KANNEN DELFT' on top and left stretcher
arms
private collection

17
Dansante larmoyante (Dancing whimpering)
1959
oil on canvas 130.3 x 102.4 cm
signed, dated '59/BoGARt' lower right;
inscribed 'DANSANTE LARMOYANTE/Juin
'59(72)/BogARt Juin 59' on verso
collection: National Gallery of Victoria,
Melbourne

18
3x rouge (3x red) 1976
pigment, oil, whiting on jute 70 x 57 cm
signed, dated 'BOGART '76' lower right

edge; signed, dated, inscribed with title
'Bram Bogart/Nov.1976/3°ROUGE' on verso
private collection

19
Daybreak 1997
pigment, oil, whiting on jute 238 x 190 cm
private collection (the artist)

Paquet, *Bram Bogart,* 1998 p 326; Lemesre,
Bram Bogart, feest van de materie, 1999 p 71

works on paper

20
untitled 1951
pen and black ink, wash 20.6 x 29.2 cm
signed, dated 'v/d BOOGART '51' vertically,
'Bv/d Boogaart/51' horizontally, faintly
in pencil 'Bogart' lower right, and 'Bram
Bogart/1951/(54)'on verso
private collection

21
untitled 1956
ink, watercolour 49 x 69 cm
signed, dated 'BogaRt '56' lower right
collection: Museum van Bommel van Dam,
Venlo

Voragen, *Een keuze uit de verzameling van
Museum van Bommel van Dam,* 1985

22
untitled 1987
black ink, brown ink wash 27.7 x 21.4 cm
signed, dated 'Bogart/87' lower right and
'Bram Bogart/Aug.1987/(21)' on verso
private collection

CONSTANT 1920–2005

paintings

23
untitled, Copenhagen 1949
oil on canvas 55 x 60 cm
signed, dated, inscribed 'Constant '49/
Kbhvn' upper right
collection: Jan and Ellen Nieuwenhuizen
Segaar

Flomenhaft, *The roots and development of
Cobra art,* 1985 p 148 (193); Shield, *Cobra,
Copenhagen, Brussels, Amsterdam,* 2003
p 56 (56); Durozoi, *Dada et les arts rebelles,*
2005 p 176; Adriaens-Pannier & Draguet
Cobra Paris 2008 p 181 (M56)

24
L'animal sorcier (The animal sorcerer) 1949
oil on canvas 110 x 85 cm
signed, dated 'Constant '49' lower right
collection: Centre Georges Pompidou,
Musée national d'art moderne, Paris

Stokvis, *Cobra 1948/51,* 1966 pp 62, 108
(73); Locher & Jitta, *Constant, schilderijen
1940–1980,* 1980 p 50 (27); Contensou,
Cobra 1948–1951, 1982 p 132 (49); Lambert,
Cobra, un art libre, 1983 p 71; Hummelink,
Constant, schilderijen/paintings 1948–1995,
1995 p 17 (8); Wingen, *De A van Cobra
in woord en beeld,* [199?] pp 64, 137;
Fréchuret, *Constant, une rétrospective,*
2001 p 81 (16), p 136 (19); Shield, *Cobra,*

Copenhagen, Brussels, Amsterdam, 2003
p 31; Van der Horst, Constant, de late
periode, Nijmegen 2008 p 61 (71)

25
Gevallen fietser (Fallen cyclist) 1950
oil on canvas 75 x 80 cm
signed, dated 'Constant '50' lower left
collection: Groninger Museum, Groningen

Van Haaren, Constant, 1966 (7b); Locher
& Jitta, Constant, schilderijen 1940–
1980, 1980 p 63 (40); Stokvis, Cobra,
geschiedenis, voorspel en betekenis,
1985 p 276 (44); Lambert, Constant, les
trois espaces, 1992 p 46 (27); Fréchuret,
Constant, une rétrospective, 2001 p 84 (20);
Van der Horst, Constant, de late periode,
Nijmegen 2008 p 76 (89)

26
Groeten uit New Babylon (Greetings from
New Babylon) 1963
oil on canvas 159.5 x 184.8 cm
signed, dated 'Constant/'63' lower centre
collection: Netherlands Institute for Cultural
Heritage (on loan to Stedelijk Museum,
Schiedam)

Van Haaren, Constant, 1966 (III); Locher
& Jitta, Constant, schilderijen 1940–1980,
1980 p 96 (73); Lambert, Constant, les trois
espaces, 1992 p 87 (61)

works on paper

27
Tekening II (Drawing II) 1949
pencil, pen and black ink, pastel 45 x 58 cm
signed, dated 'Constant/'49' lower left
collection: Netherlands Institute for Cultural
Heritage (on loan to Stedelijk Museum,
Schiedam)

Van Halem, CoBrA, de kleur van vrijheid,
2003 p 111

28
Vogels (Birds) 1949
charcoal, black ink, gouache 53.5 x 51.8 cm
signed, dated 'Constant /'49' upper right
collection: Stedelijk Museum, Schiedam

Van Halem, CoBrA, de kleur van vrijheid,
2003 p 107

29
Constant & Jan G Elburg
Het uitzicht van de duif (The prospect
of the dove) 1952
poem by Jan G Elburg (1919–92)
and 9 colour woodcuts by Constant,
34 x 54 cm
signed, inscribed with edition '101/Constant
on inside back cover
edition 101/125; woodcuts printed by
Goos Verweij, Schiedam
collection: Gemeentemuseum, The Hague

Van der Heijden, Cobra, 40 jaar later/40
years after, 1988 p 13; Stokvis, De taal van
Cobra, 2004 (179); Van Halem, Het uitzicht
van de duif (een documentaire), 1997;
Wingen, De A van Cobra in woord en beeld,
[199?] p 181; Van Halem, CoBrA de kleur
van vrijheid, 2003 pp 117–119; Dagen,
Constant graveur, 2004 pp 35–44 (16–25);
Van Halem, Picasso, Klee, Miró en de

moderne kunst in Nederland 1946–1958,
2006 p 85; Crowley & Pavitt, Cold War
modern, design 1945–1970, 2008 p 108 (4.12)

See pp 193–94 for English translation of
the poem

30
Constant & Simon Vinkenoog
New Babylon 1963
10 colour lithographs by Constant,
and Preambuul bij een nieuwe wereld
(Preamble for a new world)
by Simon Vinkenoog (born 1928)
40 x 76 cm
signed, inscribed with edition on colophon
'VII/X/Constant/Vinkenoog' lower left
artist's proof VII/X for edition of 50 in Dutch;
lithographs printed at Atelier Piet Clement,
Amsterdam (accompanying drawing New
Babylon pen and black ink 15.5 x 20.2 cm,
signed, dated 'Constant '62' lower right)
collection: Boijmans van Beuningen
Museum, Rotterdam

Locher, Constant, New Babylon, 1974 p 113
(74); Van der Heijden, Cobra, 40 jaar later/40
years after, 1988 p 188; Stokvis, De taal
van Cobra, 2001 (187); Lambert, Constant,
New Babylon, art et utopie, 1997 pp 56–57;
Wigley, Constant's New Babylon, the hyper-
architecture of desire, 1998 pp 148–149;
Van Halem, CoBrA de kleur van vrijheid,
2003 pp 132–133; Dagen, Constant graveur,
2004 pp 54–63 (33–42)

See pp 194–95 for English translation of
the text

31
Mathilde Visser 1985
pen and brown ink, watercolour 60 x 46 cm
signed 'Constant' centre right
collection: Museum Henriette Polak,
Zutphen

Locher, Constant, aquarellen/watercolors
1975–1995, 1995 p 29 (38); Netel, Het hart
van de collectie Museum Henriette Polak,
2008 pp 24, 60

CORNEILLE BORN 1922

paintings

32
Espace animé (Animated space) 1952
oil on canvas 69 x 102.5 cm
signed, dated 'Corneille 52' upper left
collection: Stedelijk Museum, Schiedam

Van Halem, CoBrA, de kleur van vrijheid,
2003 p 149

33
Après la tempête (After the storm) 1954
oil on canvas 65 x 80.9 cm
signed, dated 'Corneille 54' upper left
collection: Van Abbemuseum, Eindhoven

34
Aux abords de la grande cité
(On the outskirts of the big city) 1960
oil on canvas 89.2 x 116.2 cm
signed, dated 'Corneille 60' lower left
collection: Van Abbemuseum, Eindhoven

Gribling, Corneille, 1972 (22); Van den
Bussche, Cobra post Cobra, 1991 p 132

35
Le voyage du grand soleil rouge
(The big red sun's voyage) 1963
oil on canvas 114.5 x 162.5 cm
signed, dated 'Corneille 63' lower right
collection: Netherlands Institute for Cultural
Heritage (on loan to Stedelijk Museum,
Schiedam)

Van Halem, CoBrA, de kleur van vrijheid,
2003 p 155

works on paper

36
Le port en tête (The port overhead) 1949
pen and black ink, watercolour, collage with
newspaper 48 x 37 cm
signed, dated 'Corneille 49' lower centre;
signed, dated, inscribed with title 'Corneille
'49-/Le port en tête' on front of backing
board lower left
collection: Stedelijk Museum, Schiedam

Choisez, Cobra, 1975 p 27 (74); Schneede
& Wehr, Cobra 1948–51, 1982 p 117 (56);
Stokvis, Cobra, an international movement
in art, 1987 p 88; Van Halem, CoBrA, de
kleur van vrijheid, 2003 p 141; Van Halem,
Picasso, Klee, Miró en de moderne kunst in
Nederland 1946–1958, 2006 p 48

37
Zon (Sun) 1953
watercolour, gouache 30.5 x 43 cm
signed, dated 'Corneille 53' lower left
collection: Stedelijk Museum, Schiedam

Van Halem, CoBrA, de kleur van vrijheid,
2003 p 151

38
Compositie/Paysage du sud
(Composition/Southern landscape) 1959
gouache 36 x 33 cm
signed, dated 'Corneille '59' lower centre
collection: Boijmans van Beuningen
Museum, Rotterdam

see Donkersloot-Van den Berghe, Corneille,
het complete grafische werk 1948–1975,
1992 for a related lithograph p 95 (76)

39
Bretagne II (Brittany II) 1960
pen and black ink, white gouache
24.5 x 31.8 cm
signed, dated 'Corneille 60' lower left
collection: Gemeentemuseum, The Hague

40
Corneille & Jean-Clarence Lambert
Jardin errant (Meandering garden) 1963
poem by Jean-Clarence Lambert (born 1930)
and 10 colour lithographs by Corneille,
33.7 x 25.5 cm

signed, dated 'Corneille '63' lower left or
right; signed, dated, inscribed with edition
on colophon '79/Jean-Clarence Lambert
Corneille '63' lower centre
edition 79/100; lithographs printed by
Michel Cassé, Paris
private collection

Donkersloot-Van den Berghe, Corneille, het
complete grafische werk 1948–1975, 1992
pp 128–132 (127–136); Restany, Corneille,
2003 p 99 (73)

41
Omaggio a Leopold Sedar Sengor (In
homage to Léopold Sédar Senghor) 1977
10 colour screenprints 50.3 x 35.8 cm
signed, dated 'Corneille '77' lower right;
inscribed with edition '66/99' lower left
private collection

EDGAR FERNHOUT 1912–74

paintings

42
Zelf portret (Self portrait) 1953–54
oil on canvas 100 x 70 cm
signed, dated 'Fernhout 54' lower right
collection: Netherlands Institute for
Cultural Heritage (on loan to Boijmans van
Beuningen Museum, Rotterdam)

Edgar Fernhout, 1955 (24); Gans,
Edgar Fernhout 1944–1963, [1963] (9);
Cammelbeeck, Edgar Fernhout, 1969 (7);
Fuchs, Edgar Fernhout, 1976 p 4 (8); Van
den Berk, Moerbeek & Steen, Fernhout,
schilder/painter, 1990 p 48 (27), p 219 (216);
Nelissen, Edgar Fernhout, 1995 p 29

43
Zonnepitten en berkenschors (Dried
sunflower heads and beech bark) 1957
oil on canvas 60 x 55 cm
signed, dated 'Fernhout '57' lower right
collection: Museum van Bommel van Dam,
Venlo

Gans, Edgar Fernhout 1944–1963, [1963]
(12); Cammelbeeck, Edgar Fernhout, 1969
(9); Fuchs, Edgar Fernhout, 1976 p 20 (11);
Voragen, Een keuze uit de verzameling van
Museum van Bommel van Dam, 1985; Van
den Berk, Moerbeek & Steen, Fernhout,
schilder/painter, 1990 p 62 (44), p 131 (245)

44
Mistig bos (Misty bush) 1959
oil on canvas 46 x 99 cm
signed, dated 'Fernhout '59' lower right
collection: Museum van Bommel van Dam,
Venlo

Gans, Edgar Fernhout 1944–1963, 1963
(17); Van den Berk, Moerbeek & Steen,
Fernhout, schilder/painter, 1990 p 99 (78),
p 132 (266); Nelissen, Edgar Fernhout, 1995
p 37; Vercauteren, Collectiecatalogus 2005,
Museum van Bommel van Dam, 2005 p 74

45
Herfst (Autumn) 1962
oil on canvas 80 x 114.8 cm
signed, dated 'Fernhout/'62' lower right
collection: Van Abbemuseum, Eindhoven

Gans, *Edgar Fernhout 1944–1963,* 1963 (31); Cammelbeeck, *Edgar Fernhout,* 1969 (14); Fuchs, 'Seven Dutch artists', *Studio international,* 1973 p 222; Van den Berk, Moerbeek & Steen, *Fernhout, schilder painter,* 1990 p 134 (289)

46
In voorjaar (Spring) 1973
oil on canvas 85 x 85 cm
signed with initials, dated 'F 73' lower right
collection: Netherlands Institute for Cultural Heritage

Fuchs, *Dutch painting,* 1978 p 203 (192); De Wilde, *Modern Dutch painting,* 1983 p 126; Van den Berk, Moerbeek & Steen, *Fernhout, schilder/painter,* 1990 p 85 (65), p 138 (350)

WILLEM de KOONING 1904–97

paintings

47
July 4th 1957
oil on paper, collage 68.6 x 56 cm
signed, dated 'de Kooning '57' lower left
collection: National Gallery of Australia, Canberra

Drudi, *Willem de Kooning,* 1972 p 102; Rosenberg, *De Kooning,* [1974] (124); Hess, 'Four pictures by de Kooning at Canberra', *Art and Australia,* 1977 p 290; Mollison, *Australian National Gallery: an introduction* 1982 p 109; Lloyd & Desmond, *European and American paintings and sculptures 1870–1970 in the Australian National Gallery,* 1992 p 261; Prather, *Willem de Kooning, paintings,* 1994 p 158; Ward, 'A dame, some clams and the broad', *Artonview,* 1999 p 26

48
The cliff of the Palisade with Hudson River, Weehawken, New Jersey 1963
oil on cardboard 73.7 x 58.4 cm
signed, dated, inscribed 'S/S SHELLY HAMPTON ROAD 1926' lower centre and 'Leo Cohan/To my dearest friend/remember dear Leo/I love you!/de Kooning/1963' lower right
collection: Boijmans van Beuningen Museum, Rotterdam

Steininger, *Willem de Kooning,* 2005 p 75 (25)

49
Two trees on Mary Street … Amen! 1975
oil on canvas 203.8 x 177.8 cm
collection: Queensland Art Gallery, Brisbane

Ratcliff, 'Willem de Kooning', *Art International,* 1975 p 16; Goldin, 'Abstract expressionism, no man's landscape', *Art in America,* 1976 p 78; D'Offay, *Willem de Kooning, paintings and sculpture 1971–1983,* 1984 (5) and cover; Hogan, *Queensland Art Gallery collection, souvenir,* 1996 p 124

works on paper

50
untitled figure 1965–80
charcoal 31.7 x 20.3 cm
collection: Art Gallery of New South Wales, Sydney

Nuttall, *Willem de Kooning, drawings 1965–80,* 1997 (8)

51
Minnie Mouse 1971
lithograph 69.8 x 53.3 cm, image
signed, dated 'de Kooning 71' lower right; inscribed 'T P' lower left, workshop and printer's blind stamp lower right
proof for edition of 60; printed by Fred Genis, Hollanders Workshop, New York
collection: Art Gallery of New South Wales, Sydney

Waldman, *Willem de Kooning, obras recientes,* 1978 (36); Fourcade, *De Kooning lithographs,* 1985; Graham, *The prints of Willem de Kooning, a catalogue raisonné 1957–1971/1,* 1991 pp 64, 76 (25); Dean, *The artist and the printer, lithographs 1966–1981,* 1982 pp 26, 30 (29)

52
Landscape at Stanton Street 1971
lithograph 64.9 x 48.5 cm, image
signed, dated 'de Kooning 71' lower right; inscribed 'T P' lower left, workshop and printer's blind stamp lower right
proof for edition of 60; printed by Fred Genis, Hollanders Workshop, New York
collection: Art Gallery of New South Wales, Sydney

Waldman, *Willem de Kooning, obras recientes,* 1978 (37); Fourcade, *De Kooning lithographs,* 1985; Graham, *The prints of Willem de Kooning, a catalogue raisonné 1957–1971/1,* 1991 pp 65, 76 (26); Dean, *The artist and the printer, lithographs 1966–1981,* 1982 pp 26, 29 (28); Kolenberg, *From the studio of master lithographer Fred Genis,* 1997 p 8 (33); Kolenberg, *Tinta, piedra y papel las impresiones de Fred Genis,* 1998 pp 17, 39 (18)

THEO KUIJPERS BORN 1939

paintings

53
Grote Watutsi (Big Watutsi) 1964
oil on hardboard 122 x 122 cm
signed, dated 'Th. Kuijpers 65' on verso
private collection

Vercauteren, *Theo Kuijpers, een bezield constructivist,* 2005 pp 8, 104

54
Ruit (Window) 1976–77
pencil, acrylic on paper, collage of canvas, lead, pig's bladder, tacks 82.5 x 98 cm
signed, dated 'Theo Kuijpers/76/77' lower left
private collection

Vercauteren, *Theo Kuijpers, een bezield constructivist,* 2005 pp 12, 47, 105

55
IJmuiden Noord Wester (IJmuiden northwester) 1984
acrylic on paper 200 x 160 cm
signed, dated 'kuijpers 84' lower right
private collection

Vercauteren, *Theo Kuijpers, terugblik op twintig jaar kunstenaarschap,* 1988 p 70 (42)

56
Wit huis op blauwe Zondag (White house on blue Sunday) 2007
oil on canvas 80 x 100 cm
signed, dated 'Theo Kuijpers 07' on verso
private collection

lithographs

57
Teken (Sign) 1978
colour lithograph 106 x 75 cm
signed, dated, inscribed with edition '24/40 theo kuijpers 78' lower left and printer's blind stamp lower right
edition 24/40; printed by Fred Genis, Oudkerk
private collection

Fernhout, *Zeven litho's door Theo Kuijpers in samenwerking met steendrukker Fred Genis,* 1979; Vercauteren, *Theo Kuijpers, terugblik op twintig jaar kunstenaarschap,* 1988 p 26 (18)

58
untitled VI 1985
(from a set of 7 untitled lithographs)
colour lithograph 56.5 x 76 cm
signed, dated, inscribed 'Bon a tirer theo kuijpers/VI/Sydney 85' and printer's blind stamp lower right
printer's proof for edition of 25; printed by Fred Genis, Sydney
private collection

Vercauteren, *Theo Kuijpers, terugblik op twintig jaar kunstenaarschap,* 1988 p 79 (47b)

59
untitled VII 1985
(from a set of 7 untitled lithographs)
colour lithograph 76.2 x 57 cm
signed, dated 'kuijpers 85' upper right; inscribed 'III/IV AP' upper left and printer's blind stamp lower right
artist's proof III/IV for edition of 25; printed by Fred Genis, Sydney
private collection

LUCEBERT 1924–94

paintings

60
Dierentemmer (Animal tamer) 1959
oil on canvas 88 x 128.5 cm
signed, dated ' lucebeRt/VIII '59' lower left
collection: Stedelijk Museum, Schiedam

Van Halem, *CoBrA, de kleur van vrijheid,* 2003 p 219; Wind, *Lucebert, schilder, dichter, fotograaf,* 2007 p 67

61
Schilderij/Compositie (Painting/Composition) 1961
oil on canvas 100 x 80 cm
signed, dated 'lucebeRt 61' lower right
collection: Gemeentemuseum, The Hague

62
Het dorpsfeest (The village fair) 1974
oil on canvas 100.5 x 150 cm
signed 'lucebert' lower right
collection: Netherlands Institute for Cultural Heritage

Kuyvenhoven, *De staat koopt kunst,* 2007 p 258

63
I can't dance, I've got ants in my pants 1984
oil on canvas 115.5 x 145.5 cm
signed, dated 'lucebert/84' lower right
collection: Netherlands Institute for Cultural Heritage

works on paper

64
Oerolifant (Ancient elephant) 1959
pen and black ink, wash 27.9 x 21.7 cm
signed, dated, inscribed with title 'OeRolifant/lucebeRt/21viii '59' lower right
collection: Boijmans van Beuningen Museum, Rotterdam

65
De verzoeking van de heilige Antonius III (The temptation of St Anthony III) 1961
etching, drypoint, aquatint 45 x 43.7 cm
signed, dated, inscribed with edition 'e.d.10/50 lucebeRt 61' lower right
edition 10/50; printed by the artist
collection: Gemeentemuseum, The Hague

Petersen, *Lucebert in het Stedelijk,* 1987 p 142 (640-G)

66
Hintergedanke (Ulterior motive) 1962
pen and black ink 15.5 x 20.2 cm
signed, dated 'lucebeRt/30okt.'62'/ hinteRgedanke' lower right
collection: Boijmans van Beuningen Museum, Rotterdam

67
Macchiavelli 1974
lithograph 56.5 x 76.2 cm
signed, dated 'lucebert 74' lower right; inscribed with edition '2/25' lower left and printer's blind stamp lower right
edition 2/25; printed by Fred Genis, Oudkerk
private collection

Petersen, *Lucebert in het Stedelijk,* 1987 p 154 (833-G); Kolenberg, *Tinta, piedra y papel las impresiones de Fred Genis,* 1998 pp 24, 40 (28)

JAAP NANNINGA 1904–62

paintings

68
Koning (King) 1953
oil on hardboard 64.8 x 52 cm
signed, dated 'JNanninga 53' on verso
collection: Stedelijk Museum, Schiedam

Doelman, *Nanninga*, [1962] (10); Lampe, *Jaap Nanninga*, 1964 (4); *Jaap Nanninga*, 1964 (4); *Nanninga, schilderijen, gouaches*, 1966 (3); Slagter, *Nanninga, schilder/painter/peintre*, 1987 p 41 (I), p 73 (148)

69
Uganda 1958
oil on canvas 82 x 92 cm
signed 'JNanninga' lower right
collection: Gemeentemuseum, The Hague

Doelman, *Nanninga*, [1962] (26); Lampe, *Jaap Nanninga*, 1964 (IV); *Nanninga, schilderijen, gouaches*, 1966 (7); Slagter, *Nanninga, schilder/painter/peintre*, 1987 p 43 (IV), p 77 (239)

70
Figura 1960
oil on canvas 80.2 x 90.1 cm
signed, dated 'JNanninga 60' lower right
collection: Van Abbemuseum, Eindhoven

Penning, 'Jaap Nanninga (1904) Compositie met figuur', *Openbaar Kunstbezit*, 1962 (jaargang 6) 19 a,b; Doelman, *Nanninga*, [1962] (50); *Jaap Nanninga*, 1964 (33); Slagter, *Nanninga, schilder/painter/peintre*, 1987 p 47 (X), p 82 (343)

71
Bagdad 1961
oil on canvas 80 x 90 cm
collection: Boijmans van Beuningen Museum, Rotterdam

Doelman, *Nanninga*, [1962] (62); *Nanninga, schilderijen, gouaches*, 1966 (48); Slagter, *Nanninga, schilder/painter/peintre*, 1987 p 44 (VI), p 80 (295)

works on paper

72
Stilleven (Still life) 1953
pastel, gouache 46.5 x 63.5 cm
signed, dated 'JNanninga/53' lower right
collection: Van Abbemuseum, Eindhoven

Slagter, *Nanninga, schilder/painter/peintre*, 1987 p 36 (25), p 73 (145)

73
Compositie (Composition) 1959
pastel, gouache 50.4 x 35.3 cm
signed, dated 'JNanninga/59' lower right
collection: Gemeentemuseum, The Hague

Slagter, *Nanninga, schilder/painter/peintre*, 1987 p 79 (290)

74
Compositie op wit fond (Composition on white background) 1959
charcoal, pastel, gouache 49 x 69 cm
signed, dated 'JNanninga/59' lower right
collection: Dordrechtsmuseum, Dordrecht

Doelman, *Nanninga*, [1962] (47); Lampe, *Jaap Nanninga*, 1964 (11); Slagter, *Nanninga, schilder/painter/peintre*, 1987 p 81 (319)

75
Compositie in kleuren (Composition in colours) 1961
pastel, gouache 46.5 x 63.5 cm
signed, dated 'JNanninga/61' lower right; signed, inscribed 'No 2/Comp H 1250/JNanninga/Clingendael 11/Post den Haag' on backing board
collection: Boijmans van Beuningen Museum, Rotterdam

Doelman, *Nanninga*, [1962] (65); Slagter, *Nanninga, schilder/painter/peintre*, 1987 p 84 (397)

WIM OEPTS 1904–88

paintings

76
Dorpscafé (Village café) 1954
oil on canvas 48 x 60 cm
signed, dated 'Oepts/54' lower right
collection: Netherlands Institute for Cultural Heritage (on loan to Museum Henriette Polak, Zutphen)

De Kat, *W Oepts*, 1965 (3); Netel, *Wim Oepts 'peinture, c'est le principal' 1904–1988*, 2006 p 53; Netel, *Het hart van de collectie Museum Henriette Polak*, 2008 p 118

77
Het blauwe huis (The blue house) 1958
oil on canvas 44.5 x 59.5 cm
signed, dated 'Oepts-58' lower right
collection: Museum van Bommel van Dam, Venlo

Voragen, *Een keuze uit de verzameling van Museum van Bommel van Dam*, 1985; Welling, *Wim Oepts, schilder van het zonnige zuiden*, 1991 p 56; Netel, *Wim Oepts 'peinture, c'est le principal' 1904–1988*, 2006 p 57

78
Het rode huis (The red house) 1959
oil on canvas 49.5 x 61 cm
signed, dated 'Oepts/59' lower right
collection: Museum Henriette Polak, Zutphen

Reinders, *Wim Oepts, overzichtstentoonstelling*, 1987 (19); Welling, *Wim Oepts, schilder van het zonnige zuiden*, 1991 p 56; Netel, *Wim Oepts 'peinture, c'est le principal' 1904–1988*, 2006 p 82–87; Netel, *Het hart van de collectie Museum Henriette Polak*, 2008 pp 8, 119

79
Route nationale (Highway) 1960
oil on canvas 36.8 x 53 cm
signed, dated 'Oepts-60' lower right
collection: Museum van Bommel van Dam, Venlo

Netel, *Wim Oepts 'peinture, c'est le principal' 1904–1988*, 2006 p 58

80
Village 1972
oil on canvas 54 x 65 cm
signed, dated '72/Oepts' lower right
collection: ING, Amsterdam

81
Provence 1973
oil on canvas 54 x 65 cm
signed, dated 'Oepts 73' lower right
collection: ING, Amsterdam

JAN RISKE BORN 1932

paintings

82
Dawn c1955
oil on hardboard 61.6 x 82 cm
signed 'RISKE' lower right; inscribed with title, price, artist's name and address on verso
private collection

83
untitled c1963
oil, white cement, wood fibre on composition board 46 x 61 cm
signed 'RISKE' lower left
private collection

84
Sound trails 1987–88
oil on canvas 35 x 35 cm
signed, dated and inscribed with title 'Riske 1987–88 SOUND TRAILS' on verso
private collection

85
Expressions in time 20 1988
oil on canvas 35 x 35 cm
signed, dated, inscribed with title 'expressions in time 20/Riske 1988' on verso
collection: Robert Ypes

86
Yellow command 1989
oil on canvas 195.5 x 195.5 cm
signed, dated 'RISKE 89' lower right edge of canvas
collection: National Gallery of Australia, Canberra

works on paper

87
Altar of thought 1965–66
gouache 110.5 x 86 cm
signed 'Riske' lower left
collection: Museum of Modern Art at Heide, Melbourne

88
The structure of joy 1967
pen and black ink 111 x 86 cm
signed 'Riske' lower right
collection: Art Gallery of New South Wales, Sydney

Kolenberg, *Contemporary Australian drawings*, 1992 (51)

89
untitled 1972
pen and black/white ink, gouache 110 x 125 cm
signed 'RISKE' lower right
collection: Robert Ypes

90
Coding graph I 1990
pencil, pen and black ink 69.7 x 69.7 cm
signed, dated 'RISKE 90' lower right
collection: Art Gallery of New South Wales, Sydney

Kolenberg, *Australian drawings*, 1997 p 138 (135)

JAN J SCHOONHOVEN 1914–94

reliefs

91
Vegetation 1959
cardboard, papier mâché, grey and white acrylic 98 x 31.5 cm
signed, dated 'JJ Schoonhoven 1959' on verso
collection: Museum van Bommel van Dam, Venlo

Voragen, *Een keuze uit de verzameling van Museum van Bommel van Dam*, 1985; Wesseling, *Schoonhoven, beeldend kunstenaar/visual artist*, 1990 p 31 (17), p 126; Finckh, *Jan J Schoonhoven, retrospektiv*, 1995 p 84 (84); Vercauteren, *Collectiecatalogus 2005, Museum van Bommel van Dam*, 2005 p 126

92
R60-6 1960
cardboard, papier mâché, dark grey acrylic 49 x 33 cm
signed, dated 'JJ Schoonhoven 1960' on verso
collection: Museum van Bommel van Dam, Venlo

Wesseling, *Schoonhoven, beeldend kunstenaar/visual artist*, 1990 p 126

93
Cercle dish relief (Circular dish relief) 1966
cardboard, papier mâché, plaster, white acrylic paint 100 x 100 cm
signed 'JJ Schoonhoven 1966' on verso
collection: Gemeentemuseum, The Hague

Wesseling, *Schoonhoven, beeldend kunstenaar/visual artist*, 1990 p 118

94
Gerythmeerd quadratenreliëf (Rythmical grid relief) 1968
cardboard, papier mâché, white acrylic 104 x 102 cm
signed, dated 'JJ Schoonhoven 1968' on verso
collection: Gemeentemuseum, The Hague

Bool & Develing, *Jan Schoonhoven, retrospectief*, 1984 p 121; Lemoine, *Jan Schoonhoven, rétrospective*, 1988 p 10; Wesseling, *Schoonhoven, beeldend kunstenaar/visual artist*, 1990 p 118

works on paper

95
Lonesome lover, hommage à Charlie Parker
1955
gouache 52 x 63.5 cm
signed with initials, dated 'JJS '55' upper
right
collection: Museum van Bommel van Dam,
Venlo

Wesseling, *Schoonhoven, beeldend
kunstenaar/visual artist,* 1990 p 23 (11),
p 126; Finckh, *Jan J Schoonhoven,
retrospektiv,* 1995 p 74 (74)

96
Compositie/T82-45 (Composition) 1982
brush and black ink 50.2 x 32.7 cm
signed, dated 'Schoonhoven 1982' lower
right, inscribed 'T82-45' lower left
collection: Gemeentemuseum, The Hague

Bool & Develing, *Jan Schoonhoven,
retrospectief,* 1984 p 77; Wesseling,
*Schoonhoven, beeldend kunstenaar/visual
artist,* 1990 p 105 (88), p 120

97
T88-32 1988
pen, brush and black ink 50.2 x 32.6 cm
signed, dated 'Schoonhoven 1988' lower
right, inscribed 'T88-32' lower left
collection: Museum van Bommel van Dam,
Venlo

BRAM van VELDE 1895–1981

paintings, gouaches

98
Compositie (Composition) 1950
oil on canvas 92 x 73 cm
collection: Gemeentemuseum, The Hague

Putman, *Bram van Velde,* 1961 (41, 164);
Stokvis, *De doorbraak van de moderne
kunst in Nederland de jaren 1945–1951,*
1984 p 61 (56); Blok, *Nederlandse kunst
vanaf 1900,* 1994 p 110

99
untitled 1961
gouache 121.1 x 126.7 cm
collection: Van Abbemuseum, Eindhoven

Bram van Velde, 1971 (63); Leering, *Bram
van Velde,* 1971 (58); Slagter, *Bram van
Velde 1895–1981, de kracht van kleur,* 2006
p 119 (74)

100
Compositie (Composition) 1971
brush and black ink, white gouache
71 x 55 cm
signed 'Bram van Velde' lower right
collection: Netherlands Institute for Cultural
Heritage (on loan to Dordrechtsmuseum,
Dordrecht)

Slagter, *Bram van Velde 1895–1981,
de kracht van kleur,* 2006 p 137 (84)

lithographs

101
Compositie (Composition) 1955
colour lithograph 53 x 25 cm
signed 'Bram van Velde' lower right
edition 142/150; printed at Imprimerie
Mourlot, Paris
collection: Boijmans van Beuningen
Museum, Rotterdam

Rief, *Bram van Velde, das graphische Werk,*
1969 (9); Mason & Putman, *Bram van Velde,
les lithographies [I], 1923–1973,* 1974 p 34
(9); Slagter, *Bram van Velde, een hommage,*
1994 p 106 – see Putman, Duthuit &
Beckett, *Bram van Velde,* 1958 p 39 for a
related gouache

102
untitled 1974
colour lithograph 96.8 x 64.7 cm
signed with initials, inscribed 'e.a. 6/15 vV'
lower centre
artist's proof 6/15; printed by Pierre Badey,
Paris
collection: Boijmans van Beuningen
Museum, Rotterdam

Mason & Putman, *Bram van Velde, les
lithographies II, 1974–1978,* 1979 p 30 (153)

103
untitled 1975
colour lithograph 98 x 63 cm
signed with initials, inscribed with edition
'63/100 vV' lower left
edition 63/100; printed by Pierre Badey, Paris
collection: National Gallery of Victoria,
Melbourne

Mason & Putman, *Bram van Velde, les
lithographies II, 1974–1978,* 1979 p 33 (164)
– see Mason, *Bram van Velde 1895–1981,
rétrospective du centenaire,* 1996 p 160 (94)
for a related gouache 1959–60

104
untitled 1975
colour lithograph 75 x 45 cm
signed 'Bram van Velde' lower right;
inscribed with edition '88/100' lower left
edition 88/100; printed by Pierre Badey,
Paris
collection: Stedelijk Museum, Schiedam

Mason & Putman, *Bram van Velde, les
lithographies II, 1974–1978,* 1979 p 36
(172bis); Slagter, *Bram van Velde, een
hommage,* 1994 p 68 – see Putman, *Bram
van Velde,* 1961, 83 (228) for a related
gouache

105
untitled 1977
colour lithograph 32.6 x 56 cm
signed 'Bram van Velde' lower right;
inscribed with edition '9/100' lower left
edition 9/100; printed by Pierre Badey, Paris
private collection

Mason & Putman, *Bram van Velde, les
lithographies II, 1974–1978,* 1979 p 67 (257)

JAAP WAGEMAKER 1906–1972

paintings

106
Verschrikte dieren or *Het gevecht*
(Frightened animals or The fight) 1955
oil on canvas 125.2 x 144.5 cm
signed, dated 'Wagemaker 55' lower centre
collection: Centraal Museum, Utrecht

Doelman, *Jaap Wagemaker, schilderijen,
gouaches,* 1970 (7); Den Heijer & Van der
Knaap, *Jaap Wagemaker, schilder van het
elementaire,* 1995 pp 47, 64, 143 (S55.001)

107
Verdigris or *Oxyde de cuivre* (Verdigris or
Copper oxide) 1958
oil, burlap, collage 104 x 82 cm
signed, dated 'Wagemaker 58' lower right
collection: Newcastle Region Art Gallery

Schuurman, *Trends in Dutch painting since
Van Gogh,* [1961] (57); Wagemaker-Van
der Meer & Hammacher, *Jaap Wagemaker,*
[1976] pp 14, 39 (10); Den Heijer & Van der
Knaap, *Jaap Wagemaker, schilder van het
elementaire,* 1995 p 153 (S58.017)

108
Les traces (Traces) 1962
oil, copper, wood 128 x 164 cm
signed, dated 'Wagemaker 62' lower right
collection: Netherlands Institute for Cultural
Heritage

Doelman, *Jaap Wagemaker's informal art,*
[1962] (IV); Schulze Vellinghausen, *Jaap
Wagemaker, Bilder,* 1966 (31); Doelman,
Jaap Wagemaker, schilderijen, gouaches,
1970 (43); Busch, *Jaap Wagemaker, Bilder-
Materialbilder,* 1972 (27a); Wagemaker-Van
der Meer & Hammacher, *Jaap Wagemaker,*
[1976] p 93 (75); Den Heijer & Van der
Knaap, *Jaap Wagemaker, schilder van het
elementaire,* 1995 p 171 (S62.023)

works on paper

109
Compositie (Composition) 1959
brush and black ink 44.9 x 34.8 cm
signed, dated 'Wagemaker '59' lower right
collection: Groninger Museum, Groningen

Den Heijer & Van der Knaap, *Jaap
Wagemaker, schilder van het elementaire,*
1995 p 211 (T59.006)

110
Compositie/Geel, zwart met zand
(Composition/Yellow, black with sand) 1961
gouache 49.6 x 40.5 cm
signed, dated 'Wagemaker '61' lower right
collection: Boijmans van Beuningen
Museum, Rotterdam

Den Heijer & Van der Knaap, *Jaap
Wagemaker, schilder van het elementaire,*
1995 p 200 (G61.019)

111
Compositie (Composition) 1964
brush and black ink 70.7 x 54.7 cm
signed, dated 'Wagemaker '64' lower right
collection: Groninger Museum, Groningen

Den Heijer & Van der Knaap, *Jaap
Wagemaker, schilder van het elementaire,*
1995 p 212 (T64.001)

selected bibliography

Comprises mainly references for the works in the exhibition and those used in research, principally books and exhibition catalogues (exh cat), available in Australian libraries and in the author's collection, arranged chronologically.

GENERAL

Hans Konigsberger, *Modern Dutch painting, an introduction,* Netherlands Information Service, New York [195?] ENGLISH

Cornelis Doelman, 'Seekers after a new creativity, three Dutch painters', *delta,* autumn 1958, vol 1, no 3, pp 23–30 ENGLISH

Charles Wentinck, *De Nederlandse schilderkunst sinds Van Gogh,* Het Spectrum, Utrecht/Antwerp 1959 DUTCH

Kees E Schuurman, *Trends in Dutch painting since Van Gogh* (exh cat, Australia), [Gemeentemuseum, The Hague 1961] ENGLISH

Nederlands bijdrage, tot de internationale ontwikkeling sedert 1945 / The Dutch contribution to the international development of art since 1945 / La contribution hollandaise au développement international de l'art depuis 1945 (exh cat), [Stedelijk Museum, Amsterdam] 1962 DUTCH / ENGLISH / FRENCH

Pieter A Scheen, *Lexicon Nederlandse beeldende kunstenaars 1750–1950* (2 vols), Pieter A Scheen, The Hague 1969 DUTCH

Sadi de Gorter, *L'atelier de Piet Clement* (exh cat), Institut Néerlandais, Paris 1976 FRENCH

Rudi H Fuchs, *Dutch painting,* Thames & Hudson, London 1978 ENGLISH

Karel J Gierlandt & Gijs van Tuyl (eds), *België Nederland, knooppunten en parallellen in de kunst na 1945* (exh cat), [Paleis voor Schoone Kunsten, Brussel/ Museum Boijmans van Beuningen, Rotterdam] 1980 DUTCH

Ank Leeuw-Marcar, *Willem Sandberg, portret van een kunstenaar,* Meulenhoff, Amsterdam 1981 DUTCH

Adriaan H Venema, *G H Breitner, 1857–1923,* Het Wereldvenster, Bussum 1981 DUTCH

Carel Willink, *De schilderkunst in een kritiek stadium,* Van der Velden, Amsterdam 1981 DUTCH

Sonia Dean, *The artist and the printer: lithographs, 1966–1981, a collection of printer's proofs* (exh cat), National Gallery of Victoria, Melbourne 1982 ENGLISH

Henk Peeters & Mariëtte Josephus Jitta, *Informele kunst in België en Nederland 1955–1960, parallellen in de Nederlandstalige literatuur* (exh cat), Gemeentemuseum, The Hague/Vlaamse Gemeenschap, Brussels 1983 DUTCH

Edy de Wilde (ed), *Modern Dutch painting, realistic tendencies, expressionistic modes, abstraction in Dutch painting since Mondrian* (exh cat), National Gallery and Alexander Soutzos Museum, Athens / Ministry of Cultural Affairs, Amsterdam 1983 ENGLISH / GREEK

Geurt Imanse (ed), *De Nederlandse identiteit in de kunst na 1945,* Meulenhoff, Amsterdam 1984, 2nd edition Unipers, Abcoude 1995 DUTCH

Willemijn Stokvis (ed), *De doorbraak van de moderne kunst in Nederland de jaren 1945–1951* Meulenhoff, Amsterdam 1984 DUTCH

Thei Voragen, *Een keuze uit de verzameling van Museum van Bommel van Dam,* Museum van Bommel van Dam, Venlo 1985 DUTCH

Leonie ten Duis & Annelies Haase, *Ouborg schilder/painter,* Openbaar Kunstbezit, Amsterdam/SDU, The Hague 1990 DUTCH / ENGLISH

Marike van der Knaap (ed), *Meesters der materie, materieschilderkunst in een international perspectief* (exh cat), Waanders, Zwolle/Noordbrabants Museum, 's-Hertogenbosch 1993 DUTCH

Hendrik Kolenberg, *From the lithographer's workshop, lithographs by Australian artists printed in Sydney by Fred Genis* (exh cat), Art Gallery of New South Wales, Sydney 1993 ENGLISH

Cor Blok (ed), *Nederlandse kunst vanaf 1900,* Teleac, Utrecht 1994 DUTCH

Ineke Middag & Marion Fritz-Jobse, *De Arnhemse School, 25 jaar monumentale kunst praktijk,* Hogeschool voor de Kunsten Arnhem, Arnhem 1994 DUTCH

Wilma Jansen, *Kunstopdrachten van de Rijksgebouwendienst na 1945,* 010, Rotterdam 1995 DUTCH

Rudi H Fuchs & Jan Hoet (eds), *Flemish and Dutch painting, from Van Gogh, Ensor, Magritte and Mondrian to contemporary artists* (exh cat), Rizzoli, New York 1997 ENGLISH

Julianna Kolenberg, *From the studio of master lithographer Fred Genis, a retrospective exhibition, 1966–1995* (exh cat), Victorian Arts Centre, Melbourne 1997 ENGLISH

Julianna Kolenberg, *Tinta, piedra y papel las impresiones de Fred Genis* (exh cat), Instituto de Artes Gráficas, Oaxaca 1998 SPANISH

Rik Leeflang & Sacha Tanja, *The ING collection, a selection,* ING, Amstelveen 1998 ENGLISH

Astrid Schunck (ed), *Heinrich Campendonk, die zweite Lebenshälfte eines Blauen Reiters,* Waanders, Zwolle 2001 GERMAN

Marja Bosma (ed), *Beeldende kunst 1850–2001, de verzamelingen van het Centraal Museum Utrecht 6* (2 volumes including a CD Rom), Centraal Museum, Utrecht 2001–2002 DUTCH

Rudi H Fuchs, *Tussen kunstenaars, een romance,* De Bezige Bij, Amsterdam 2002, 2nd edition 2003 DUTCH

Hans Ebbink, Alied Ottevanger, Peter de Ruiter & Kriszti Vákár (eds), *Zelfportret als zeepaardje, memoires van W Jos de Gruyter,* Thoth, Bussum 2004 DUTCH

Alston W Purvis, *H N Werkman,* Yale University Press, New Haven 2004 ENGLISH

Ad Petersen, *Sandberg, vormgever van het Stedelijk,* 010, Rotterdam 2004 DUTCH also published as *Sandberg, designer and director of the Stedelijk* ENGLISH

Lies Netel, *Joop Sjollema, een overzicht van zijn werk 1900–1990,* Museum Henriette Polak, Zutphen 2005 DUTCH

Rick Vercauteren, *Collectiecatalogus 2005, Museum van Bommel van Dam Venlo, een selectie uit vijfentwintig jaar aanwinsten,* Museum van Bommel van Dam, Venlo 2005 DUTCH / ENGLISH / GERMAN

Aat van Yperen, Frank Eerhart & Truus Gubbels (eds), *Onmetelijk optimisme, kunstenaars en hun bemiddelaars in de jaren 1945–1970,* Stichting Visioen en Visie, Amsterdam/Waanders, Zwolle 2006 DUTCH

Ludo van Halem (ed), *Picasso, Klee, Miró en de moderne kunst in Nederland 1946–1958* (exh cat), Stedelijk Museum, Schiedam/NAi, Rotterdam 2006 DUTCH

Nonja Peters (ed), *The Dutch down under, 1606–2006,* Wolters Kluwer, Sydney 2006 ENGLISH

Annabelle Birnie (ed), *Art in the office, ING art collection, a universal language,* Waanders, Zwolle / ING, Amsterdam 2006 ENGLISH

Fransje Kuyvenhoven, *De staat koopt kunst, de geschiedenis van de collectie 20ste-eeuwse kunst van het ministerie van OCW 1932–1992,* Instituut Collectie Nederland, Amsterdam / Primavera Pers, Leiden 2007 DUTCH

Lies Netel, *Het hart van de collectie, Museum Henriette Polak,* Museum Henriette Polak, Zutphen 2008 DUTCH

Dieuwertje Dekkers, Jikke van der Spek & Anneke de Vries, *H N Werkman, het complete œuvre,* NAi, Rotterdam 2008 DUTCH

COBRA

Bert Schierbeek, *The experimentalists* (Art in the Netherlands), Meulenhoff, Amsterdam [196?] ENGLISH

Willemijn Stokvis, *Cobra 1948/51* (exh cat), Boijmans van Beuningen Museum, Rotterdam 1966 DUTCH

Erik Slagter, 'Art after the liberation: experiments in words and images', *delta,* summer 1971, vol 14, no 2, pp 87–104 ENGLISH

Willemijn Stokvis, *Cobra, geschiedenis, voorspel en betekenis van een beweging in de kunst van na de tweede wereldoorlog,*

De Bezige Bij, Amsterdam 1974, 2nd revised and expanded edition 1979, 3rd 1985, 4th 1990, 5th 2001 as *Cobra de weg naar spontaniteit* V+K Publishing, Blaricum, 6th 2003 DUTCH

Ellen Sharp (ed), *Cobra and contrasts, the Winston-Malbin collection* (exh cat), Detroit Institute of Arts, Detroit 1974 ENGLISH

Anne Choisez, *Cobra* (exh cat), [Stedelijk Museum, Sint-Niklaas/Maison de la Culture, Namur] 1975 DUTCH / FRENCH

Cobra 1948–1951, Jean-Michel Place, Paris 1980 reproduction of the issues *Cobra, Petit Cobra* and *Tout petit Cobra* FRENCH

Uwe M Schneede & Peter Wehr, *Cobra 1948–51* (exh cat), Kunstverein, Hamburg 1982 GERMAN

Bernadette Contensou (ed), *Cobra 1948–1951* (exh cat), Association Française d'Action Artistique, Paris 1982 FRENCH

Jean-Clarence Lambert, *Cobra, un art libre,* Éditions du Chêne, Paris 1983 FRENCH also published Abbeville Press, New York as *Cobra* DUTCH / ENGLISH / GERMAN

Eleanor Flomenhaft, *The roots and development of Cobra art,* Fine Arts Museum of Long Island, New York 1985 ENGLISH

Erik Slagter, *Tekst en beeld, Cobra en vijftig, een bibliografie,* Lannoo, Tielt 1986 DUTCH

Willemijn Stokvis, *Cobra, an international movement in art after the Second World War,* Poligrafa, Barcelona 1987, 2nd edition Rizzoli, New York 1988 ENGLISH

Chris van der Heijden (ed), *Cobra, 40 jaar later/40 years after, collectie J Karel P van Stuijvenberg* (exh cat), SDU, The Hague 1988 DUTCH / ENGLISH

Ed Wingen, *Ooggetuige van CoBrA, foto's van Henny Riemens,* Jaski Art Gallery, Amsterdam/Van Spijk, Venlo 1988 DUTCH

Ed Wingen (ed), *De A van Cobra in woord en beeld, 50 jaar Cobra*, Jaski Art Gallery, Amsterdam, [1998] DUTCH

Willy van den Bussche, *Cobra post Cobra* (exh cat), Provinciaal Museum voor Moderne Kunst, Oostende 1991 DUTCH / FRENCH

Willemijn Stokvis, *Cobra 3 dimensionaal, werk in hout, klei, metaal, steen, gips, afval, polyester, brood, keramiek* (exh cat), V+K Publishing, Blaricum/Cobra Museum voor Moderne Kunst, Amstelveen 1998 DUTCH also published Lund Humphries, London 1999 as *Cobra 3 dimensions, work in wood, clay, metal, stone, plaster, waste, polyester, bread, ceramics* ENGLISH

Shu-ling Chen (ed), *The Cobra movement, fifty years* (exh cat), Taipei Fine Arts Museum, Taipei 1999 CHINESE / ENGLISH

Willemijn Stokvis, *De taal van Cobra* (exh cat), Uniepers, Abcoude 2001, 2nd edition 2004 DUTCH

Peter Shield (ed), *Cobra, Copenhagen, Brussels, Amsterdam* (exh cat), Hayward Gallery, London 2003 ENGLISH

Ludo van Halem (ed), *Cobra, de kleur van vrijheid, de Schiedamse collectie,* NAi, Rotterdam/Stedelijk Museum, Schiedam 2003 2nd edition 2006 DUTCH also published as *CoBrA, the colour of freedom, the Schiedam collection* ENGLISH

Willemijn Stokvis, *Cobra, the last avant-garde movement of the twentieth century,* Lund Humphries, Hampshire 2004 Condensed English version of *Cobra, de weg naar spontaniteit* 2001

Willemijn Stokvis, *Cobra 1948–1951,* Waanders, Zwolle 2008 DUTCH

Anne Adriaens-Pannier & Michel Draguet, *Cobra* (exh cat), Lannoo, Tielt 2008 ENGLISH also published in DUTCH / FRENCH

DUTCH POETRY

Simon Vinkenoog (ed), *Atonaal,* Stols, The Hague 1951, 2nd edition 1952, 3rd 1956 DUTCH

Cor Stutvoet [Jaap Nanninga], *Gedichten,* De Windroos, Amsterdam 1955 DUTCH

Koos Schuur, *Fata Morgana voor Nederlanders en andere gedichten*, De Bezige Bij, Amsterdam 1956 DUTCH

Bert Schierbeek, *De gestalte der stem,* De Bezige Bij, Amsterdam [1957] DUTCH

Simon Vinkenoog, *Blurb, een tot en met negen,* De Beuk, [Amsterdam] 1962 DUTCH

Koos Schuur, *Gedichten 1940–1960*, De Bezige Bij, Amsterdam 1963 DUTCH

Gerrit Borgers (ed), *De beweging van vijftig,* Nederlands Letterkundig Museum, The Hague 1965 DUTCH

Koos Schuur, *De kookaburra lacht (Brieven van een emigrant),* De Bezige Bij, Amsterdam 1966 DUTCH

Simon Vinkenoog & Olivier Boelen, *Poëzie in Carré,* De Bezige Bij, Amsterdam 1966 DUTCH

Bert Schierbeek, *Weerwerk,* De Bezige Bij, Amsterdam 1977 DUTCH

Bert Schierbeek, *Betrekkingen,* De Bezige Bij, Amsterdam 1979 DUTCH also published Katydid Books, Rochester 1988 as *Cross roads* ENGLISH

Gerrit Komrij (ed), *De Nederlandse poëzie van de negentiende en twintigste eeuw in duizend en enige gedichten,* Bert Bakker, Amsterdam 1979, 10th edition 1996 DUTCH

Koos Schuur, *Waar het was*, De Bezige Bij, Amsterdam 1980 DUTCH

Karel Appel, *Gewonde oceaan / Wounded ocean / Océan blessé journal intime, poèmes et dessins,* Galilée, Paris 1982 DUTCH / ENGLISH / FRENCH

Hans Dütting (ed), *Archief de Vijftigers,* De Prom, Baarn 1983 DUTCH

Jan G Elburg, *Geen letterheren, uit de voorgeschiedenis van de vijftigers,* Meulenhoff, Amsterdam 1987 DUTCH

Cornelis Vleeskens (trans), *Naked dreams, Dutch poetry in translation,* Post Neo publications, Melbourne 1988 ENGLISH

Koos Schuur, *Signalen, een keuze uit de gedichten*, De Bezige Bij, Amsterdam 1990 DUTCH

Cornelis Vleeskens (trans), *Simon Vinkenoog and the eye became a rainbow,* Fling Poetry, Melbourne 1990 ENGLISH

Karel Appel, *Ode aan het rood, gedichten,* Contact, Amsterdam 1996 DUTCH / ENGLISH / FRENCH

Hans Groenewegen (ed), *Licht is de wind der duisternis, over Lucebert,* Historische Uitgeverij, Groningen 1999 DUTCH

Lucebert, *Verzamelde gedichten,* De Bezige Bij, Amsterdam 2002, 3rd edition 2004 DUTCH

J M Coetzee (trans), *Landscape with rowers, poetry from the Netherlands,* Princeton University Press, Princeton 2004 ENGLISH

Peter Glassgold (ed), *Living space, poems of the Dutch fifties* (PIP anthology of world poetry of the 20th century, volume 6), Green Integer, Copenhagen/Los Angeles 2005 ENGLISH

Jan G Elburg, *Gedichten 1950–1975,* Athenaeum Boekhandel/De Bezige Bij, Amsterdam 2006 DUTCH

Ton den Boon (ed), *'Wie wil stralen die moet branden': citaten en aforismen van Lucebert,* BnM, Nijmegen 2007 DUTCH

KAREL APPEL

Hugo Claus, *Karel Appel, schilder,* A J G Strengholt, Amsterdam 1962, 2nd edition 1964 DUTCH also published as *Karel Appel, painter* ENGLISH

The reality of Karel Appel, 35mm film, Eastmancolor 1961, Director Jan Vrijman, music *Lyrics for Appel* by Dizzy Gillespie and *Musique barbare* by Karel Appel

Jan Vrijman (ed), *De werkelijkheid van Karel Appel,* De Bezige Bij, Amsterdam 1962 DUTCH

Simon Vinkenoog, *Het verhaal van Karel Appel, een proeve van waarneming,* A W Bruna & Zoon, Utrecht 1963 DUTCH

Peter Bellew, *Karel Appel, le grandi monografie, pittori d'oggi,* Fratelli Fabri, Milan 1968 ITALIAN

Simon Vinkenoog, *Appel's oogappels & het verhaal van Karel Appel* (exh cat), Centraal Museum, Utrecht 1970 DUTCH

Alfred Frankenstein, *Karel Appel,* Harry N Abrams, New York 1980 ENGLISH

Jean-Clarence Lambert, *Karel Appel, works on paper,* Abbeville Press, New York 1980 ENGLISH also published in SPANISH

Wim Beeren (ed), *Het nieuwe werk van Karel Appel 1979–1981/The new work of Karel Appel, paintings 1979–1981* (exh cat), Boijmans van Beuningen Museum, Rotterdam 1982 DUTCH / ENGLISH

Mariëtte Josephus Jitta, *Karel Appel, werk op papier,* Gemeentemuseum, The Hague 1982 DUTCH also published 1984 as *Karel Appel, work on paper* ENGLISH

Rupert Martin, *Karel Appel, paintings 1980–85* (exh cat), Arnolfini Gallery, Bristol 1986 ENGLISH

Rudi H Fuchs, Johannes Gachnang & Alessandra Santerini (eds), *Karel Appel, dipinti, scultura e collages* (exh cat), Castello di Rivoli, Torino 1987 ENGLISH / ITALIAN

Michel Ragon, *Karel Appel, peinture 1937–1957,* Galilée, Paris 1988 FRENCH also published as *Karel Appel, the early years, 1937–1957* DUTCH / ENGLISH

Roland Hagenberg (ed), *Karel Appel, dupe of being,* Lafayette, New York 1989 ENGLISH

Rudi H Fuchs (ed), *Karel Appel, ik wou dat ik een vogel was, berichten uit het atelier*, Meulenhoff, Amsterdam/Gemeentemuseum, The Hague 1990 DUTCH

Donald Kuspit, *Karel Appel, sculpture, a catalogue raisonné,* Harry N Abrams, New York 1994 ENGLISH

Donald Kuspit, Rudi H Fuchs & Johannes Gachnang, *Karel Appel, Psychopathologisches Notizbuch, Zeichnungen und Gouachen 1948–1950,* Gachnang & Springer, Bern/Berlin 1997 GERMAN also published 1999 as *Karel Appel, psychopathological notebook, drawings and gouaches 1948–1950* ENGLISH / FRENCH

Cathérine van Houts, *Karel Appel, de biografie,* Contact, Amsterdam 2000 2nd edition Olympus, Amsterdam 2003 DUTCH

Rudi H Fuchs (ed), *Karel Appel, pastorale chiaroscuro* (exh cat), Stedelijk Museum, Amsterdam/NAi, Rotterdam 2001 DUTCH / ENGLISH

Ingried Brugger & Florian Steininger, *Karel Appel* (exh cat), Kunstforum, Vienna 2002 GERMAN

Rudi H Fuchs (ed), *Karel Appel, onderweg, reis van Rudi Fuchs langs de kunst der Lage Landen* (exh cat), Mercatorfonds, Antwerp 2004 DUTCH

Gerard H Meulensteen & Florian Steininger (eds), *Karel Appel, retrospective 1945–2005* (exh cat), Danubiana Meulensteen Art Museum, Bratislava 2005 ENGLISH

John Vrieze & Jan Hein Sassen, *Karel Appel, Jazz 1958–1962* (exh cat), Cobra Museum voor Moderne Kunst, Amstelveen 2008 DUTCH / ENGLISH

www.karelappelfoundation.com

GERRIT BENNER

Benner, tekeningen, gouaches, schilderijen (exh cat), Cultureel Centrum De Beyerd, Breda 1959 DUTCH

Hans Redeker, *Gerrit Benner* (Art and architecture in the Netherlands), Meulenhoff, Amsterdam 1967 ENGLISH

Lambert Tegenbosch, *Gerrit Benner* (exh cat), Van Speijk, Venlo 1970 DUTCH

Edy de Wilde (ed), *Gerrit Benner* (exh cat), Stedelijk Museum, Amsterdam 1971 DUTCH

[Lambert Tegenbosch] *Gerrit Benner* (exh cat), Galerie Tegenbosch, Eindhoven 1986 DUTCH

Loek Brons, *In de ban van Benner, overzichtstentoonstelling van schilderijen, gouaches en tekeningen van Gerrit Benner 1897–1981* (exh cat), Singer Museum, Laren 1989 DUTCH

Erik Slagter, *Gerrit Benner, werken uit de periode 1944–1948, samengesteld uit de collectie Rie Gubitz-Vellinga,* De Drijvende Dobber, Franeker 1991 DUTCH

Geke Westenberg (ed), *Gerrit Benner,* Galerie de Vis, Harlingen 2005 DUTCH / ENGLISH

BRAM BOGART

Manfred de la Motte, *Bram Bogart,* Galerie Hennemann, Bonn 1977 DUTCH / FRENCH / GERMAN

Wim Beeren (ed), *Bram Bogart, schilderijen 1950–1983* (exh cat), Boijmans van Beuningen Museum, Rotterdam 1984 DUTCH

Francine-Claire Legrand, *Bram Bogart,* Lannoo, Tielt 1988 DUTCH / ENGLISH / FRENCH

Marcel Paquet, *Bram Bogart,* Éditions de la Différence, Paris 1990, 2nd revised and expanded edition 1998 FRENCH

Willy van den Bussche, *Bram Bogart, retrospectief, Paris-Roma-Brussel-Ohain-Kortenbos* (exh cat), Stichting Kunstboek, Brugge/PMMK Museum voor Moderne Kunst, Oostende 1995 DUTCH / ENGLISH / FRENCH

Franck Gribling, *Bram Bogart, tekens van bestaan, marks of existence* (exh cat), Galerie Willy Schoots, Eindhoven 1999 DUTCH / ENGLISH

Marion Lemesre (ed), *Bram Bogart, feest van de materie* (exh cat), Stadhuis, Brussels 1999 DUTCH also published in FRENCH

Matthew Collings, *Bram Bogart, paintings 1951–2006* (exh cat), The Fine Art Society, London 2006 ENGLISH

Saul Ostrow, *Bram Bogart* (exh cat), Bernard Jacobson Gallery, London 2007 ENGLISH

[Bram Bogart] *Bram Bogart* (exh cat), Jacobson Howard Gallery, New York 2008 ENGLISH

http://brambogart.nexenservices.com

CONSTANT

Hein van Haaren, *Constant* (Art and architecture in the Netherlands), Meulenhoff, Amsterdam 1966 ENGLISH

Constant, *Opstand van de Homo ludens, een bundel voordrachten en artikelen,* Paul Brand, Bussum 1969 DUTCH

Fanny Kelk, *Constant, een illustratie van vrijheid/Tekeningen van Constant 1946–1974* (exh cat), Stedelijk Museum, Amsterdam 1974 DUTCH

John L Locher, *Constant, New Babylon* (exh cat), [Gemeentemuseum, The Hague] 1974 DUTCH

Edy de Wilde & Fanny Kelk, *Constant, schilderijen 1969–77* (exh cat), Stedelijk Museum, Amsterdam 1978 DUTCH / ENGLISH

Fanny Kelk, *Constant* (exh cat), Galeries Nouvelles Images, The Hague 1979 DUTCH

John L Locher & Mariëtte Josephus Jitta, *Constant, schilderijen 1940–1980* (exh cat), Gemeentemuseum, The Hague 1980 DUTCH

Klaus Honnef, *Constant 1945–1983* (exh cat), Rheinland-Verlag, Köln 1986 DUTCH

Jean-Clarence Lambert, *Constant, les trois espaces (écrits théoriques de Constant),* Cercle d'Art, Paris 1992 FRENCH

Jean-Clarence Lambert, *Constant, les aquarelles,* Cercle d'Art, Paris 1994 FRENCH

John L Locher, *Constant, aquarellen/ watercolors 1975–1995* (exh cat), Gemeentemuseum, The Hague 1995 DUTCH / ENGLISH

Marcel Hummelink, *Constant, schilderijen/ paintings 1948–1995* (exh cat), Stedelijk Museum, Amsterdam 1995 DUTCH / ENGLISH

Jean-Clarence Lambert, *Constant, New Babylon, art et utopie (textes situationnistes),* Cercle d'Art, Paris 1997 FRENCH

Ludo van Halem, *Het uitzicht van de duif, Jan Elburg en Constant (een documentaire)* (exh cat), Stedelijk Museum, Schiedam 1997 DUTCH

Mark Wigley, *Constant's New Babylon, the hyper-architecture of desire,* Witte de With center for contemporary art 010, Rotterdam 1998 ENGLISH

Jean-Clarence Lambert, *Constant, l'atelier d'Amsterdam,* Cercle d'Art, Paris 2000 FRENCH

Maurice Fréchuret (ed), *Constant, une rétrospective* (exh cat), Musée Picasso, Antibes/Réunion des musées nationaux, Paris 2001 FRENCH

Philippe Dagen & Trudy van der Horst, *Constant graveur,* Cercle d'Art, Paris 2004 FRENCH also published in DUTCH

Gérard Durozoi, *Dada et les arts rebelles,* Hazan, Paris 2005 FRENCH

Maarten Schmidt & Thomas Doebele, *Constant, avant le départ,* VPRO 2005 (first played on Dutch television, Nederland 3, 21 December 2005) DUTCH with subtitles in ENGLISH

David Crowley & Jane Pavitt (eds), *Cold War modern: design 1945–1970* (exh cat), V&A Publishing, London 2008 ENGLISH

Trudy van der Horst, *Constant, de late periode, tegen de stroom in naar essentie, une peinture nouvelle,* BnM, Nijmegen 2008 DUTCH

CORNEILLE

Jean-Clarence Lambert, *Corneille* (Le Musée de Poche), Georges Fall, Paris 1960 FRENCH

Tekeningen van Corneille (exh cat), [Stedelijk Museum, Amsterdam] 1960 DUTCH / FRENCH

Franck T Gribling, *Corneille* (Art and architecture in the Netherlands), Meulenhoff, Amsterdam 1972 ENGLISH

André Laude, *Corneille, le roi-image,* SMI, Paris 1973 FRENCH

Hugo Claus, *Ontmoetingen met Corneille en Karel Appel,* Elsevier, Antwerpen/Manteau, Amsterdam 1980 DUTCH

Marcel Paquet, *Corneille, la sensualité du sensible,* Francis Delille, Paris 1988 FRENCH also published in DUTCH

Marcel Paquet, *Corneille, peintures et gouaches,* Éditions de la Différence, Paris 1989 FRENCH also published in DUTCH

Graham Birtwistle & Patricia Donkersloot-Van den Berghe, *Corneille, het complete grafische werk 1948–1975,* Meulenhoff, Amsterdam 1992 DUTCH

Jean-Clarence Lambert, *Corneille, het oog van de zomer,* Van Spijk, Venlo 1992 DUTCH

Marjet den Bieman, *Corneille, een vroege vogel, zijn onbekende werken (1943–1948)/ Corneille, un oiseau précoce, ses œuvres inconnues (1943–1948)/Corneille, an early bird, his unknown works (1943–1948)* (exh cat), Galerie Elisabeth den Bieman de Haas, Amsterdam 1997, 2nd edition 1998 DUTCH / ENGLISH / FRENCH

Erik Slagter, *Corneille's weergaloze werkelijkheid* (exh cat), Cobra Museum voor Moderne Kunst, Amstelveen 1997 2nd edition Uniepers, Abcoude 2002 DUTCH with summary in ENGLISH

Wim Koesen, *Corneille, verborgen vogel, aantekeningen uit een schildersleven,* Uniepers, Abcoude 2002 DUTCH

Claudia Küssel & Willemijn Stokvis, *Corneille, het Hongaarse avontuur, 1947* (exh cat), Galerie Elisabeth den Bieman de Haas, Amsterdam 2002 DUTCH

Pierre Restany, *Corneille,* Cercle d'Art, Paris 2003 FRENCH

Erik Slagter, *Corneille, some of these days* (exh cat), Cobra Museum voor Moderne Kunst, Amstelveen 2007 DUTCH / ENGLISH

EDGAR FERNHOUT

Edgar Fernhout (exh cat), De Waag, Nijmegen 1955 DUTCH

L Gans, *Edgar Fernhout 1944–1963* (exh cat), [Van Abbemuseum, Eindhoven/ Stedelijk Museum, Amsterdam 1963] DUTCH

G J P Cammelbeeck, *Edgar Fernhout* (Art and architecture in the Netherlands), Meulenhoff, Amsterdam 1969 ENGLISH

Rudi H Fuchs, 'Seven Dutch artists', *Studio international,* vol 185, no 955, May 1973 p 222 ENGLISH

Rudi H Fuchs (ed), *Edgar Fernhout* (exh cat), Van Abbemuseum, Eindhoven 1976 DUTCH

Aloys van den Berk, Jozien Moerbeek & John Steen (eds), *Fernhout, schilder/painter,* Openbaar Kunstbezit, Amsterdam/SDU, The Hague 1990 DUTCH / ENGLISH

Jeske Nelissen, *Edgar Fernhout,* SDU, Nijmegen 1995 DUTCH

Marja Bosma (ed), *Vier generaties, een eeuw lang de kunstenaarsfamilie Toorop/Fernhout* (exh cat), Centraal Museum, Utrecht 2001 DUTCH

Mieke Rijnders & Aloys van den Berk (eds), *In het licht van Alassio, Edgar Fernhout neo-realist* (exh cat), Ludion, Amsterdam/ Museum voor Moderne Kunst, Arnhem 2002 DUTCH

WILLEM de KOONING

Thomas B Hess, *Willem de Kooning,* Museum of Modern Art, New York 1968 ENGLISH

Gabriella Drudi, *Willem de Kooning,* Fratelli Fabbri, Milan 1972 ITALIAN

Harold Rosenberg, *De Kooning,* Harry N Abrams, New York [1974] ENGLISH

Carter Ratcliff, 'Willem de Kooning', *Art international,* vol XIX/10 December 1975, pp 14–19, 73 ENGLISH

Amy Goldin, 'Abstract expressionism, no man's landscape', *Art in America,* January/ February 1976, pp 77–79 ENGLISH

Thomas B Hess, 'Four pictures by de Kooning at Canberra', *Art and Australia,* vol 14, no 3/4, January/April 1977, pp 289–296 ENGLISH

Diane Waldman, *Willem de Kooning, obras recientes, enero-marzo 1979* (exh cat), Fundación Juan March, Madrid 1978 SPANISH

James Mollison, *Australian National Gallery: an introduction,* Australian National Gallery, Canberra, 1982 ENGLISH

Harry F Gaugh, *Willem de Kooning,* Abbeville Press, New York 1983 ENGLISH

Edy de Wilde (ed), *Willem de Kooning, het Noordatlantisch licht 1960–1983/the North Atlantic light 1960–1983* (exh cat), Stedelijk Museum, Amsterdam 1983 DUTCH / ENGLISH

Paul Cummings, Jörn Merkert & Claire Stoullig, *Willem de Kooning, drawings, paintings, sculpture, New York, Berlin, Paris* (exh cat), Whitney Museum of American Art, New York 1983 ENGLISH

Anthony d'Offay, *Willem de Kooning, paintings and sculpture 1971–1983* (exh cat), Anthony d'Offay Gallery, London 1984 ENGLISH

Xavier Fourcade, *De Kooning lithographs* (exh cat), Gunnar Olsson Konsthandel, Stockholm 1985 ENGLISH

Diane Waldman, *Willem de Kooning,* Thames & Hudson, London 1988 ENGLISH

Lanier Graham, *The prints of Willem de Kooning, a catalogue raisonné 1957–1971/I* Baudoin Lebon, Paris 1991 ENGLISH / FRENCH / GERMAN

Michael Lloyd & Michael Desmond, *European and American paintings and sculptures 1870–1970 in the Australian National Gallery,* Australian National Gallery, Canberra 1992 ENGLISH

Marla Prather (ed), *Willem de Kooning, paintings* (exh cat), National Gallery of Art, Washington/Yale University Press, New Haven 1994 ENGLISH

Janet Hogan, *Queensland Art Gallery collection, souvenir,* Queensland Art Gallery, Brisbane 1996 ENGLISH

William Nuttall, *Willem de Kooning, drawings 1965–80* (exh cat), Niagara Galleries, Melbourne 1997 ENGLISH

Klaus Kertess, *Willem de Kooning, drawing seeing/seeing drawing,* Arena Editions, Santa Fe 1998 ENGLISH

Lucina Ward, 'A dame, some clams and the broad', *Artonview,* autumn 1999, pp 26–28 ENGLISH

David Acton (ed), *The stamp of impulse, abstract expressionist prints* (exh cat), Worcester Art Museum, Worcester 2001 ENGLISH

Cornelia H Butler & Paul Shimmel (eds), *Willem de Kooning, tracing the figure* (exh cat), Princeton University Press, Princeton/ Museum of Contemporary Art, Los Angeles 2002 ENGLISH

Mark Stevens & Annalyn Swan, *De Kooning, an American master,* Alfred A Knopf, New York 2004 ENGLISH

Florian Steininger (ed), *Willem de Kooning* (exh cat), Waanders, Zwolle/Minerva, Wolfratshausen 2005 DUTCH

Bernhard Mendes Bürgi (ed), *De Kooning, paintings 1960–1980* (exh cat), Hatje Cantz, Ostfildern-Ruit 2005 ENGLISH / GERMAN

Robert Long, *De Kooning's bicycle, artists and writers in the Hamptons,* Farrar, Straus and Giroux, New York 2005 ENGLISH

Sally Yard, *Willem de Kooning, works, writings, interviews,* Polígrafa, Barcelona 2007 ENGLISH also published FRENCH / SPANISH

THEO KUIJPERS

Meine Fernhout, *Zeven litho's door Theo Kuijpers in samenwerking met steendrukker Fred Genis* (exh cat), Wetering Galerie, Amsterdam 1979 DUTCH

Karel Schampers, *Theo Kuijpers, Australië 1979* (exh cat), Wetering Galerie, Amsterdam 1980 DUTCH

Bert Schierbeek & Reyer Kras, *IJmuider kring* (exh cat), Reflex, Utrecht 1984 DUTCH / ENGLISH

Karel Schampers, *Theo Kuijpers, tussen IJmuiden en Steenbokskeerkring* (exh cat), Galerie Tegenbosch, Eindhoven 1986 DUTCH

Rick Vercauteren (ed), *Theo Kuijpers, terugblik op twintig jaar kunstenaarschap* (exh cat), Noordbrabants Museum, 's-Hertogenbosch 1988 DUTCH

Lambert Tegenbosch, *Theo Kuijpers, la Sicilia Nera* (exh cat), Galerie Tegenbosch, Heusden aan de Maas 1991 DUTCH

Theo Kuijpers, *Theo Kuijpers, herinnering Marokko* (exh cat), Galerie Tegenbosch, Heusden aan de Maas 1995 DUTCH

Lambert Tegenbosch & Peter van Vlerken, *Theo Kuijpers schilderijen, Arie Berkulin beelden* (exh cat), Museum van Bommel van Dam, Venlo 1999 DUTCH

Theo Kuijpers, evenos, herinnering aan de Provence (exh cat), Galerie Wansink, Roermond 2002 DUTCH

Frank Eerhart, *Theo Kuijpers, arcades* (exh cat), De Krabbedans, Eindhoven 2003 DUTCH

Rick Vercauteren, *Theo Kuijpers, een bezield constructivist/ein beseelter konstruktivist* (exh cat), Galerie Willy Schoots, Eindhoven 2005 DUTCH / GERMAN

LUCEBERT

Lucebert edited by Lucebert (exh cat), Marlborough Fine Art, London 1963 ENGLISH

Jan Eijkelboom, *Lucebert* (Art and architecture in the Netherlands), Meulenhoff, Amsterdam 1964 ENGLISH

Jan Martinet, Ad Petersen & Gijs van Tuyl, *Lucebert, schilderijen, gouaches, tekeningen en grafiek* (exh cat), Stedelijk Museum, Amsterdam 1969 DUTCH

Ad Petersen (ed), *Lucebert in het Stedelijk/ Lucebert in the Stedelijk,* Stedelijk Museum, Amsterdam 1987 DUTCH / ENGLISH

Jens C Jensen (ed), *Der junge Lucebert, Gemälde, Gouachen, Aquarelle, Zeichnungen, Radierungen 1947 bis 1965* (exh cat), Kunsthalle, Kiel 1989 GERMAN

Mabel Hoogendonk (ed), *Lucebert, schilder-dichter* (exh cat), Meulenhoff, Amsterdam 1991 DUTCH

Ad Petersen (ed), *Lucebert, la tiranía de la libertad, dibujos, poemas, pinturas* (exh cat), IVAM Centre Julio González, Valencia 2000 ENGLISH / SPANISH

Jens C Jensen (ed), *Lucebert, schilder, wording en analyse van zijn schilderkunst,* SUN, Nijmegen 2001 DUTCH

Peter Hofman, *Lichtschikkend en zingend, de jonge Lucebert,* De Bezige Bij, Amsterdam 2004 DUTCH

Jens C Jensen, *Lucebert, Schilder, Dichter* (exh cat), Die Galerie, Frankfurt 2005 ENGLISH / GERMAN

Diana A Wind (ed), *Lucebert, schilder, dichter, fotograaf/Maler, Lyriker, Fotograf* (exh cat), BnM, Nijmegen 2007 DUTCH / GERMAN

Lies Netel, Evert Rodrigo & Simone Vermaat, *Schenking Lucebert, schilderijen en werken op papier uit de collectie van het Instituut Collectie Nederland,* Museum Henriette Polak, Zutphen/Instituut Collectie Nederland, Rijswijk 2007 DUTCH

JAAP NANNINGA

R A Penning, 'Jaap Nanninga (1904) Compositie met figuur', *Openbaar Kunstbezit* 1962 (Jaargang 6) 19 a,b DUTCH

Cees Doelman, *Nanninga* (exh cat), [Boijmans van Beuningen Museum, Rotterdam/Gemeentemuseum, The Hague 1962] DUTCH

Jaap Nanninga (exh cat), Stedelijk Museum, Amsterdam 1964 DUTCH

George Lampe, *Jaap Nanninga* (Art in the Netherlands), Meulenhoff, Amsterdam 1964 ENGLISH

Nanninga, schilderijen, gouaches (exh cat), Vishal, Haarlem 1966 DUTCH

Goos Verweij, *Jaap Nanninga 1904–1962* (exh cat), Raadhuis, Heerlen 1977 DUTCH

Dolf Welling, *Nanninga* (exh cat), Librije, Zwolle 1977 DUTCH

Erik Slagter, *Nanninga, schilder/painter/peintre* (exh cat), Openbaar Kunstbezit, Amsterdam 1987 DUTCH with summaries in ENGLISH/FRENCH

Marike van der Knaap, *Geer van Velde, Jaap Nanninga, Jaap Wagemaker* (exh cat), Borzo Kunsthandel, 's-Hertogenbosch 1994 DUTCH

WIM OEPTS

Otto B de Kat, *W Oepts* (exh cat), Rijksakademie van Beeldende Kunsten, Amsterdam 1965 DUTCH

Hans L C Jaffé, *Wim Oepts, tableaux, gravures* (exh cat), Institut Néerlandais, Paris 1984 FRENCH

Carin Reinders, *Wim Oepts, overzichtstentoonstelling* (exh cat), Museum Henriette Polak, Zutphen 1987 DUTCH

Dolf Welling, *Wim Oepts, schilder van het zonnige zuiden* Waanders, Zwolle 1991, 2nd edition 1994 DUTCH

Lies Netel, *Wim Oepts 'peinture, c'est le principal' 1904–1988,* Museum Henriette Polak, Zutphen 2006 DUTCH

JAN RISKE

Barokke abstractie – Jan Riske schilder, Hans Nahuijs schilder, Jan de Baat beeldhouwer, ideeën – Eldert Willems dichter [self-published, Amsterdam 1963] DUTCH

Elizabeth Cross Phillips, *Crosscurrents* (exh cat), Heide Park and Art Gallery, Melbourne 1986 ENGLISH

Hendrik Kolenberg, *Contemporary Australian drawings from the collection* (exh cat), Art Gallery of New South Wales, Sydney 1992 ENGLISH

Dirk Eijsbertse (ed), *The second landing, Dutch migrant artists in Australia* (exh cat), Erasmus Foundation, Melbourne 1993 ENGLISH

Hendrik Kolenberg, *Time series, particle paintings and drawings by the abstract artist Jan Riske* (exh cat), Regional Gallery, Grafton 1995 ENGLISH

Jacqueline Taylor & Lesley Harding (eds), *Amcor paper awards 1997* (exh cat), Victorian Arts Centre, Melbourne 1997 ENGLISH

Hendrik Kolenberg, *Australian drawings from the gallery's collection* (exh cat), Art Gallery of New South Wales, Sydney 1997 ENGLISH

www.janriske.com

JAN J SCHOONHOVEN

Rudi H Fuchs, 'Seven Dutch artists', *Studio international,* vol 185, no 955, May 1973, p 223 ENGLISH

John Hallmark Neff (ed), *Contemporary art from the Netherlands* (exh cat), Ministry for Cultural Affairs, Amsterdam 1982 ENGLISH

Flip Bool & Enno Develing (eds), *Jan Schoonhoven, retrospectief, tekeningen en reliëfs/Jan Schoonhoven, Retrospektiv, Zeichnungen und Reliefs* (exh cat), Gemeentemuseum, The Hague/Openbaar Kunstbezit, Weesp 1984 DUTCH/GERMAN

David W Courtney, *Jan Schoonhoven, a retrospective* (exh cat), Ritter Art Gallery/Florida Atlantic University, Boca Raton 1987 ENGLISH

Serge Lemoine, *Jan Schoonhoven, rétrospective* (exh cat), Institut Néerlandais, Paris/Musée de Grenoble, Grenoble 1988 FRENCH

John L Locher, *Jan Schoonhoven, drawings 1962–1987* (exh cat), Chinati Foundation, Marfa, Texas/Gemeentemuseum, The Hague 1989 ENGLISH

Janneke Wesseling (ed), *Schoonhoven, beeldend kunstenaar/visual artist,* Openbaar Kunstbezit, Amsterdam/SDU, The Hague 1990 DUTCH/ENGLISH

Gerhard Finckh (ed), *Jan J Schoonhoven, retrospektiv* (exh cat), Richter, Düsseldorf 1995 ENGLISH/GERMAN

Rudi H Fuchs, *Jan Schoonhoven* (exh cat), Paula Cooper Gallery, New York 1999 ENGLISH

BRAM van VELDE

Samuel Beckett, 'La peinture des Van Velde ou le monde et le pantalon', *Cahiers d'art,* Paris 1945–1946, pp 349–356 FRENCH

Samuel Beckett, 'The New Object', *Bram and Geer van Velde* (exh cat), Samuel M Kootz Gallery, New York March 1948, pp 2–3 ENGLISH

Samuel Beckett, 'Les peintres de l'empêchement', *Derrière le miroir,* no 11–12, Galerie Maeght, Paris June 1948, pp 3–4, 7 FRENCH

Samuel Beckett, 'Three dialogues', *Transition,* no 5, Paris 1949, pp 100–103 ENGLISH

Georges Duthuit, 'Bram van Velde ou aux colonnes d'Hercule', *Derrière le miroir,* no 43, Galerie Maeght, Paris February 1952, pp 2–4, 8 FRENCH

Jacques Putman, Georges Duthuit & Samuel Beckett, *Bram van Velde,* Georges Fall, Paris 1958 FRENCH also published Grove Press, New York 1960 ENGLISH

Jacques Putman (ed), *Bram van Velde, catalogue général de l'œuvre peint 1907–1960,* Guy Le Prat, Paris/Fratelli Pozzo, Turin 1961 FRENCH also published Harry N Abrams, New York 1962 as *Bram van Velde* ENGLISH

Bram van Velde, paintings 1957–1969 (exh cat), Knoedler Gallery, New York/Albright Knox Art Gallery, Buffalo 1968 ENGLISH

Hans-Herman Rief, *Bram van Velde, das graphische Werk,* Worpsweder Kunsthalle, Worpswede 1969 GERMAN

Bram van Velde (exh cat), Kunsthalle, Basel 1971 GERMAN

Jean Leering, *Bram van Velde* (exh cat), Van Abbemuseum, Eindhoven 1971 DUTCH

Hans-Herman Rief, *Bram van Velde, das graphische Werk, teil II,* Worpsweder Kunsthalle, Worpswede 1972 GERMAN

Rainer Michael Mason & Jacques Putman, *Bram van Velde, les lithographies [I], 1923–1973,* Yves Rivière, Paris 1973 FRENCH

André du Bouchet, *Bram van Velde* (exh cat), Fondation Maeght, Saint-Paul de Vence 1973 FRENCH

Charles Juliet, *Rencontres avec Bram van Velde,* Fata Morgana, [Montpellier] 1973 2nd expanded edition 1978, 3rd 1985, 4th Fata Morgana, [Saint-Clément-de-Rivière] 1995, 5th POL, Paris 1998 FRENCH also published Academic Press, Leiden 1995 as *Conversations with Samuel Beckett and Bram van Velde* ENGLISH

Jacques Putman & Charles Juliet, *Bram van Velde,* Maeght, Paris 1975 FRENCH also published Leon Amiel Publisher, New York ENGLISH/GERMAN

Rainer Michael Mason & Jacques Putman, *Bram van Velde, les lithographies II, 1974–1978,* Yves Rivière/Maeght, Paris/Cabinet des estampes du Musée d'art et d'histoire, Genève 1979 FRENCH

Jacob Marius de Groot (ed), *Bram van Velde, retrospectieve 1907–1978* (exh cat), Dordrechtsmuseum, Dordrecht 1979 DUTCH

Rainer Michael Mason, *Bram van Velde, lithographies, donation de l'artiste à la Bibliothèque Nationale* (exh cat), Musée de la Seita, Paris 1982 FRENCH

Rainer Michael Mason & Jacques Putman, *Bram van Velde, les lithographies III, 1979–1981,* Yves Rivière/Daniel Lelong, Paris/Cabinet des estampes du Musée d'art et d'histoire, Genève 1984 FRENCH

Jacques Putman, *Bram van Velde* (exh cat), Musée d'art et d'industrie, Saint-Etienne 1985 FRENCH

Claire Stoullig (ed), *Bram van Velde* (exh cat), Centre Georges Pompidou, Paris 1989 FRENCH

Hans Janssen (ed), *Bram van Velde 1895–1981* (exh cat), SDU, The Hague 1989 DUTCH/FRENCH

Arnold Heumakers & Erik Slagter, *De onmogelijkheid van de kunst, Samuel Beckett en Bram van Velde,* Algemeen Burgerlijk Pensioenfonds, Heerlen 1993 DUTCH

Erik Slagter (ed), *Bram van Velde, een hommage* (exh cat), Stedelijk Museum De Lakenhal, Leiden 1994 DUTCH

Rainer Michael Mason (ed), *Bram van Velde, peintures noires 1895–1981* (exh cat), Cabinet des estampes du Musée d'art et d'histoire, Genève 1995 FRENCH

Rainer Michael Mason (ed), *Bram van Velde 1895–1981, rétrospective du centenaire* (exh cat), Musée Rath, Genève 1996 FRENCH

Anita Hopmans & Erik Slagter, 'Het ritme van de kunst': brieven van Bram van Velde aan zijn mecenas 1922–1935, (RKD Bronnenreeks, deel 4) Thoth, Bussum 2006 DUTCH

Erik Slagter (ed), *Bram van Velde 1895–1981, de kracht van kleur* (exh cat), Thoth, Bussum 2006 DUTCH with summaries in ENGLISH/FRENCH

Jacques Putman, *L'oeil et la plume,* L'échoppe, Paris 2007 FRENCH

JAAP WAGEMAKER

Cees Doelman, *Jaap Wagemaker's informal art,* Meulenhoff, Amsterdam [1962] ENGLISH

W Jos de Gruyter, *Wagemaker* (exh cat), Gemeentemuseum, The Hague 1965 DUTCH

Albert Schulze Vellinghausen, *Jaap Wagemaker, Bilder* (exh cat), Städtische Kunstgalerie, Bochum 1966 GERMAN

Cees Doelman, *Jaap Wagemaker, schilderijen, gouaches* (exh cat), Cultureel Centrum/Van Speijk, Venlo 1970 DUTCH

Günter Busch (ed), *Jaap Wagemaker, Bilder-Materialbilder und ausgewählte Beispiele exotischer Plastik aus der Sammlung Wagemaker* (exh cat), Kunsthalle, Bremen 1972 GERMAN

Didi Wagemaker-Van der Meer & A M Hammacher, *Jaap Wagemaker,* [subscribers, Vlaardingen, 1976] DUTCH/ENGLISH/GERMAN

Simon den Heijer & Marike van der Knaap, *Jaap Wagemaker, schilder van het elementaire,* Waanders, Zwolle 1995 DUTCH with summaries in ENGLISH/GERMAN

Translations by Cornelis Vleeskens unless
otherwise indicated.

The prospect of the dove
(Het uitzicht van de duif)

Cold as the fish, as the gaze of crawling animals,
as undercooled sunlight under ice;
plants are mute and the animals silent.
I have my own displaced existence
to know how the others fare
in this inflated painted paradise.

What the workers pay with the backs of their kids
and the skin of their hands,
I also pay: a ransom of injustice
with the battered language of my blind
dissatisfaction, but always I pay too little:
only with the passing beat of my heart;
not with the cuckoo clock of my blood.

With damaged protestations about a liberty
to protect against sunburn and rain
and hunger and the scorn of windbags,
I also pay off the never-ending mortgage
our ancestors were talked into
along with the prints of heroes and statesmen,
with an arithmetic from a to b
and the never-ending conformist language lessons.

Only from ideas like potplants
dusted by twilight, do cities die;
only from terraces with snappy women,
only from our domestic despair and the gregorian
school chant through gaping windows
do factories and warehouses fade.
Only from hate does the heart shut down,
a signlanguage with signifiers of smoke;
only from lies does the word die,
from slogans and lessons the blind faith
of wind and water and wading birds.

We, who regard the world with poems
on our tongues as a jeering scorn,
we carry concealed in our cheeks
a copper skull that is angered:
battered and blue from hammers within;
and in the spotlight startled to a grin:
the laughter of cynical cashing in.

That's what the alleys and attics make of us.
We are, because the streets made us
with a foot and a foot and a hand
and a handy selfrighteousness,
rough and injured, because we are who we are:
with hands and feet and mouths escaped
from this inhuman mentality:
to pay lipservice to a class structure.

But the eyes smarting from sweat and tears
but the provocative shedding of calendar pages:
that's what the days do to him, what do the days do?
What do we do? We scour the walls
with a graffito of children's crayons,
with a knife and a rasp of ordinary wishes,
for once and for all to see an end to
the wretched stooping, turning and giving in
to the excuses of injustice and grief
of the worker's child and the unfair

promotions far beyond us.
Forwards, and never forget.

What bids, gentlemen? What use a stash
of uniforms and machine guns? Who'll bid more,
offer me a place without promises
of the moon, mogul or moloch or mammon,
a spot in the sun, without a "golden age"?
Magnate, magistrate, devil's advocate,
who'll bid? And no haggling.

They have a patent on ramshackle houses
and rent garments, the sole right to exhibit
my rain, and on the straight road
levy a toll when I pay my dues,
and their unfair share of my crops:
rapeseed and grain and sweet sweet roots.

I must: be sweet and pay the soldiers,
dutch courage, demand innocent blood
and approve inflicted pain, provide alibis
and consort with the yes-men and clowns,
steal the bread from our mouths.

I should know better, not read Marx,
be fastidious, not choose the side
of blue-collars covered in coaldust
from the backshed, the shabby backblocks
and workingclass slums, no, be refined
and dine with the immaculate,
point to heaven and manifest God
(that is: labour on a quay of decay).
And the H-bombs slam the door.
Who'll offer a simpler prospect,
without begging-bowls, without townsquares
of fear?

This is the choice: unkind slogans,
the delicate speech of fingertips
on a keyboard with a kabala alphabet,
or standing and falling in the rollercoaster
battle for bread and justice and a new world,
with the multitudinous multilingual masses:
children, housewives, hardfisted guys:
a unanimous delegation for peace.

Comrades, he who voices an honest resolution
in song and stands with his class,
will be chased and hunted by bailiffs,
hounds and hardened cronies, hated
as the pest. But it will be a long time
before he will cease his admonishments.

Always the eye has preferred down to blood
that down grows on Picasso's doves:
that's what the shrapnel slashes as knives,
that's what the incendiary devices burn,
that's what our detractors poke fun at,
that's where the past blows a fanfare
for dead oppressors.

Our peace has been born, a normal desire
for a safe cradle and a small voice,
a friendly word and a slice of wholesome bread:
that's what death gnaws at, that's what
the yellow rooster attacks with flaming wings,
that's what they touch with hands of fire.

Personally we want a fatherland,
where the cows browse and graze,
with wheat and sunny ways, even in the rain:
this they scar with barbed wire,
there they build up volcanos,
there a crazed crisscross of cart tracks fights
through the ripened grain, that will burn.

In reality we are with many,
a reality with bare hands:
that's what they get their teeth into,
that's where they shove the weapons of profit,
that's where they extract the last penny,
that's where they want to read the lines
of how it will be.

It is proven that their dominion has passed:
we are doomed to courage, a faithful rabble,
that shall sally forth, cultivate the land,
work as free men in the factories.
No Hail Marys can stop it,
no God in his holy house,
no divining rod, no moon,
no mousetraps that snap shut,
no wailing, no policestate:
the future lies in the fists
of the proletariat.

Jan G Elburg
refer to pages 32, 33 (29)

Preamble to a new world
(Preambuul bij een nieuwe wereld)

Bricks speak. Cities speak. Ruin and skylines: a
tale of people. Tradition speaks. The city is a voice,
spoken language.

Names reach us: of sacred cities, where possession
lapsed into power and man became his own slave,
his own master, without gods. Books of words, the
oral and written tradition of the cities record the
existence of one generation, or tens – conquered
or subjugated, destroyed and rebuilt. Buried in the
depths of time, or still controlling an endless space,
Angkor and Tughlakabad speak of man, and Cuzco
still whispers of the might of the Incas. A crocodile
shuffles through the temples of Thebe, it rains
mushrooms over Hiroshima, a flourish of trumpets
echoes in Jericho, the Trojan war takes place again.
Zion speaks of prayer and work, and Babylon is still
offered to us by the serpent as a forbidden fruit.
Names stay alive. To us the memory and the
knowledge. Ours is the present: Chandrigarh and
Brasilia, reflective words of glass and concrete.
Wood and water. The name of a builder, names of
continents, a time on its way to a new oblivion.

We are witnesses to other constructions.

CONSTANT is constructing a new world and we
are his witnesses. With the right to speak: everyone
is welcome on his stage. As tribute we give him
the right to build us a cityscape, and he takes this
right, with both hands, with head and heart, with the
senses and imagination of the possessed. He is not
a peculiarity, no, not that. A singularity at the most,
who converts his imagination into vision converts it
to form and shape converts it to world converts it to
sacred right converts it to NEW-BABYLON.
A creation in words, models, photos, drawings,
games, theories.

Cities write life. Vanished eyewitnesses leave behind
the tales of war and peace, of world rulers. Constant
creates the new stories, not science fiction, he
chronicles his own world, which he gives the name
of a symbol, which becomes a sign on the wall of
this world. A sign that speaks to us, who know of
civil engineering, and can spell the names of the
moment. The builders and the wreckers with their
conglomerates of problems, the technicians of light,
the wreckers of open space, the builders in air and
earth, with their materials of now and before: brick,
glass, concrete, wood, metal.

From the earth come their ores, and from her
inhabitants the calculations and drawings, the
interest and the meaning. A world language of
figures and signs has developed: of land-use
restrictions and universal rules, of urbane theories
and mathematical solutions.
Possession plays tricks. We dispossess. Limited
insight. Growing prosperity. Impoverishment.
Unlimited possibilities. Public property institutes
doubts. Housing, transport, fast traffic and
industrialisation undermine human principles. Space

breaks laws. Laws tie us down. Life becomes
estranged. Each his square metre (m^2), each his
climate, surroundings and statistical value.

Nothing is determined, except change.
The sun still shines, the same sun, over the same
seas and continents. Towering buildings arise
where once the jungles grew, mountain ranges
are penetrated by tunnels and freeways, climates
change through the smoke from factory chimneys,
man has learnt to fly and lifts himself into space.
The mines sink always deeper, the derricks spread
further and further out to sea, and into the depths
of Africa powerstations deliver electricity from
hydro-dams and lakes. More than twenty countries
are building an atomic future. Incurable diseases
disappear. Sea water will be drunk and eaten, the
sun shines and gives warmth even when it doesn't
shine. We are living precariously on the edge of
knowledge, power and possibilities, experiment with
people's insides and outsides, and accept hunger,
over-population, war and ignorance.
New-Babylon exists. Constant builds on. Only the
idea of this new Babylon exists. Before a forum
of non-believers, Constant exhibits his belief. It is
not a belief – but a truth. In a world of paper laws
and uniforms he mocks the present, which is not
immutable; which he utilizes. For the last time he
wipes the sweat from his brow, for man no longer
has to justify this untruthful existence. He no longer
has to pray and work, no longer be engulfed by the
masses, for his productive freedom places him in a
position to demand his place in nature.
Man has outgrown his imposed climate, and in
his hands he holds the energy for a thousand
years; between his fingers lies the future, in the
innumerable cells that make him live and die.
Man has the possibility to live in an earthly
paradise, in an unsurpassed New-Babylon; the
city of the automated era, no longer just an
economic organisation, a political concentration,
a geographical presence and a civil engineering
construct.

Constant: "The modern city is dead; she has fallen
victim to the cult of profit. New-Babylon is the
project for a city in which people can live. Because
living means being creative. New-Babylon is the
product of mass creativity, based on the activation
of the enormous creative potential, which at this
time still slumbers unrealised in the masses. New-
Babylon rests on the proposition that as a result of
automation non-creative labour will disappear, rests
on a metamorphosis of morals and thinking, rests on
a new society."

In a cityscape, in a world where the inhabitants only
have to come to terms with themselves, a new order
reigns – woe the word – one of self-fulfilment. The
new citizen no longer harbours ideals or illusions;
he lives his ideals and makes his illusions come
true. He will have time and opportunity to know
himself, and he will better understand his fellow-
man. Unencumbered he can be himself, understand
his own language and that of others, he will be able
to devote himself to living, because in New-Babylon
everything is possible, everything will be realised,
everything is true.

Is everything possible? Can man create his own life, 'and nothing else?' Can he give his life a unique form and content? Can man still live, playing, not as an escape from reality, but experiencing life itself as a game?

Yes, this man can do everything, because

because
man with his so-many-hours working week,
because
his collective bargaining, pension schemes
because
and other refuges is an adolescent, dependent
because
on a traumatic past.
because
In New-Babylon, man is liberated from burdens,
because
he makes his own life.

This man will be able to play, because

because
he will learn from his children,
because
no 'being different' has to hide its secrets
because
from him, he won't have to look up to his
because
betters, won't be able to laugh at a lesser.

This man, who has not yet found his face, and only uses half his brain
This man who feels empty and is empty, who still has not mastered his senses and sleeps away a third of his life
This man is not yet born.

The New-Babylonian is different, because

because
everything will be different, everything
because
will be possible
because
everything is different everything is possible
because
it is still to happen
because
it is happening, soon, now
because
it *has* happened.
(It has happened to you, and the people, here in New-Babylon, founded by Constant, 1958 – now.)

Guidelines for now

See with your hands
Feel with your eyes
Hear with your nose
Smell with your tongue and
Taste with your ears

Think with your guts
Live with your body
Know with your all

Put yourself in the now

Now. Experience, do the business, don't look back, live to the full. Make way for all knowing, all doing, all the millions of suns whose energy is not yet used, the immeasurable powers that lie within you, not yet exploited.

You live in life

Now you can choose: psychology surpassed, space conquered, an untainted heritage, between nil and nothing, godself, the first generation, man, city, reality.

There is only one reality

Dream and deed co-incide, all differences removed, active belongs with passive, positive with negative, giving with taking. Night as dusky as day, light as blinding as blindness, cold as suffocating as heat.

There is only one world: This one

Erotic – brainwashing – hypnosis – intoxication – science – isolation – rest – nature – radiocommunication – telepathy – cinerama – nomadism – kaleidoscope – a sphere of everything and nothing – chance – tension and relaxation – the labyrinth the labyrinth the labyrinth – a world without fear – life a game

without is with

Living is playing. Building is living

Miracles are discovered, worlds become real, inventions unmade, the rules of the game forgotten, nothing is fixed not even that. A new balance is growing, new limbs, new senses, functional machines without machinery, equipment without an obvious function, good without nicety, true without certainty.

with and without are one

Death conquered

Wear and tear – battles – catastrophes – religious disputes – nationalistic feuds - colourbars – language barriers – incidents and accidents – lung diseases – organ failure

Tasks

Give a definition of life – submit to the game – play tricks – allow now to happen – prepare yourself.

Simon Vinkenoog
for Constant's *New Babylon* 1963
refer to page 36 (30)

A beast drawn man
(Het dier heeft een mens getekend)

for here I lie in the sussurus of a shell
a nightshade –
an empty beast breathing on earth
I enter upon the world with the wind and lo
the secretary bird of my hands traces a firefly
then what is hunger but the end of a lonely voice

o russet I was born
and follow the writing of the sword bearer
a magic virgin
I am the water form for simple swimmers
and erect the flagstone
a landmark!
with the tail of my eye I measure
the thirst of sacred birds
I sneak round the stalking-place
o russet
a column of sound is
the throat of my belly
virgin of graven shade
I say black; wheedling-point
I hear, I swoop
and see
the perimeter is measured differently
o russet I am
I pour boiling oil into a donkey's ear
at once it sings the ghost of a bird
a throbbing threnody

who killed my king
where shall he rise again
that I may walk in loco motion
a stranger to the foot impelling me
who
that breath my virgin may ride me
and speak to her king in my ear
so I may say yes, stoop, and eat thorns

for this in an odd old story of a bear caught by folks
and for three weeks fattened and kept warm in his cage and daily spoken to till they thought the time had come and they took him out of his cage and addressed him as follows:
listen, we aren't going to hurt you, we'll just kill you in a hurry and no roaring, mind, we've kept you warm and fed you well and looked after you better than after our children and now we are going to sacrifice you, nice and fast, you won't feel it and it is your duty by us 'cause we've done what we could and now we cannot any longer 'cause we're waiting for heaven to open and you the one to open it with your soul and then we shall eat your flesh and sell your skin and nail your head to the wall and we shall be happy and celebrate and you will join us and thus you open heaven to us and we'll bring sacrifices to your head and again you'll have the best of everything
and better than what our children get and so heaven will open to you as well and now, just stand here and we'll chop off your head at one blow and you'll be wanting in nothing any more …

O self
in me the whispering tower of death rears up
and grows towards human stature
myself
open here on earth
catching the sound
bending the spiky stems of my words
I form the flowing crest for the steps of man
my guest who goes
and went
sounding the grapevine of my memory
my grassgreen gecko
hidden in the jars of my ears
turning my skin into a flag
a house of wind fluttering over the strange land
I carried round in me
and did not know
my guest the speaking mouth
that spoke my self
he said among other things
by midnight my señora broke off a flower
with which to douse the candle
I was a 1926 russian
my wife caressed the flower and enjoyed its scent
It's a walk in the woods said she
I enjoy the scent
I am the mouth waiting for you said she
a decanting vessel
my lips two oilstones
they take you straight to god I read
I enjoy the scent
and you don't see me
the flower I broke off
that was when she wore round her neck a lace
my eyes the pearls
multiplied around her neck
when I was laid out blind in the night
I used to wake up with a start
and cry turn over
give me back my eyes
bloodred in the night
but she smiled
turned over and took off the pearls
so I woke up blind
blind I now speak in sound-script
bloodred
on the tongue of the day
the pearl
I broke

o poisonous mollifier
from the night-language of this body
the word is made
that forms its shadow
the old man walking with the child
newborn
under his coat
he calls himself 'the beaut'
greets nobody
one hand above his eyes
he runs behind the blind walls
of the park
ten girls on each finger he cries
for 42 years in the same garden
on his deathbed
tacks he says
a hundred times

Bird I say
and its wings are singed in the flame of this myth
nobody knows what these forms hide
the jungle makes us reticent

so I went to the stable, said the man, with a knife,
in the darkest corner breathed down upon by the
live
stock I laid her down on the straw and then knew
her and destroyed her even the tiniest parts of her
existing body but I spared her eyes that looked at
me so big and melting and urgent and when she lay
there completely undone I pushed her into the oven
with the bread and see here is the sieve with her
remains all that is left and dead and matter but her
eyes are before me night and day large melting
mirrors of devotion in which I see myself and hear her
voice her more than rustling voice

Passes at times along the children's cavern in the
solitude of the night a white and pensive horse
following
the procession of blind umbrapeds that inhabit his
body the speaking stones of his gait and on its back a
shriveled saint planted with three wavering candles
two for his eyes one on his chin and the horse
follows
the procession which is to set up the saint at the
edge of the space conceded by the mountains once
they have been climbed
and partake of the light say the umbrapeds
once we are there we shall throw him away they say
but the horse slowly followed them through the night
and spoke with his weary body which was his soul
to him
in his ignorance said the umbrapeds
the horse thinks I shall carry him till my breath fails
me for years I have carried him through the
borrowed
light of their eyes I shall not leave now since it will
happen that presently we shall be consumed by the
flaming space beyond the mountains the saint and
I he the stone writer and I the stone thus we shall be
preserved till we are found and deciphered
a premature death like the children they carried to
their graves say the umbrapeds
and if I drop down the horse thinks and they forget
me they will take up their abode in me to get me
on my legs again and batten on me like at present
with
a saint on my back and I must have none of that
Arrived at the edge of the space the umbrapeds
looked
round to see if the horse was there but they did not
see it though they heard the sound of his hoofs and
years later in the mountains a stone writer was
found
who had scribed a horse

and so it happens that late at night we come home
after standing the livelong day at the face of the rock
where to draw the animal that has regularly haunted
our sleep in our lifetime and as we thought had
clearly
engraved its bulk and movement in our memory and
equally the demand to drive an echo of its
appearance
in the dust so as to know for ever …

what happened though?
under our hands groping for the shape of the
animal as
it lived in our eyes and wishing to imitate it as we had
seen it its bulk and contours grew to such an extent
that
the face of the rock which we had chosen to register
its appearance on dwindled rather than that the
shape of the animal grew more complete in the
process
what did we do?
were we portraying an animal bigger than the one we
had seen or was the animal from our eyes
deceptively
bigger than the face of the rock which we knew to be
the largest of our region?
for try as we might to reduce the animal
to such proportions that the whole could
be carved in the face of the wall we did not succeed
we then have been singing for days on end
days and nights
one song for the early morning
since morning begins and man does not
one for the late afternoon
since the afternoon passes and man does not
one for the early afternight
when the animal lives and takes shape
what did we find after seven days and nights?
what we had never seen or known before
we did not know the animal as we thought
it was against the face of the rock in the last night of
our singing when a lucid bright intoxication of fatigue
had opened our eyes wide like tiny cool sickles
we saw it move against the face of the wall in sharp
outline and it was smaller and its contours were bright
as if aflame but with a blue light
its huge tail resembled the poisonous tongue of
a viper
and its mouth snorted white lines that stuck
to the face of the wall
our singing muted into a stifled cry
the animal draws itself
many of us fled
we never saw them back
but those of us who silently watched the night out
have seen that the animal kept moving its jaws till the
advent of light and that as it grew lighter its
movements became more languid and its eyes paler
that its powerful legs strained as though was being
pulled to a place where it knew it would die for it was
a ghost of anguish for so long as we could
distinguish it
a dying animal that seemed to take unto itself the
face of the wall without a trace of its frightening
life…
till some of us had the courage to go up to the face
of the wall and as we stood there the way we had
been
standing there for days on end with chisels,
pickaxes
and scrapers we saw:
the animal has drawn a human

Bert Schierbeek
translated by John Vandenbergh
refer to page 46 (8)

Tantrum in the attic and Enquiring children (Drift op zolder en Vragende kinderen)

the gold T-shirt cost millions
and the bronze despot's head robbed even
 God of his beckoning bell
but all this is over now
a wig is just as expensive as real hair

and it is evening, you shut up shop, lower
the shutters and stare a moment in a puddle
on the footpath: 'what a magnificent white animal'
and then you turn off the lights,
 not that above the mirror
and above the fruitbowl,
 fruit which has lain there for centuries
the apple of Paris,
 the grapes of Bacchus, the hard nuts
 of Loki and you scrape the fur from your tongue,
think of tomorrow, knock on unpainted wood
and finally remove the iron in your head from the fire

the clock travels round
centuries completed themselves, dog after dog
soiled the booted foot of the cross
the mouse bore the stone tail of the mountain
and everyone went to live in a teacosy
 between lukewarm radiovalves

but you moved to the attic,
 nice and close to the sun
and the light there just not quite regulated
by the 1001 national still life painters
you built a tree of soapwhisks
for a lovely din previously
only spread by those visionary seabirds
the Irish love to see
and you built yourself a road of garbage
the road the children take
at the hands of ragged fairies

so:
between boxes of enough paperclips
to merge all the shares of Montgomery Ward
with those of Bethlehem Steel
between sackfuls of mouthorgans on which to play
everything from bustle to bother
between loads of pocketmirrors soapbubbles
bakingpowder
corks skimmers umbrellas crayons knives
toycars gardensprinklers pipecleaners newtonrings
academic busts prepared intestines lemonadestraws
you extract from life all the entertwined
and all the clashing colours

and now you know what red does
red loves to walk in the green grass
now you know what yellow knows
that the sun shines because no-one really wants to die
and of blue: that skyblue looks black
to a child given nothing

Lucebert for Karel Appel
refer to note 8, page 14

Part 9 of Mirage for Netherlanders (Fata Morgana voor Nederlanders)

OFFICIAL BULLETIN TO MY FRIENDS TO INFORM
them that I departed without the slightest notion
of what lay ahead of me (as all emigrants) and that
I have accepted this as the cast of the die (as all
emigrants must) and that I build on the gains and
not on the losses (as all emigrants should) and that
I rebel

 After the woes of the 13th month
 a world upsidedown
 living on the breadline
 I build from a pair of damaged hands
 a way
 a distance
 a cross-stitch pattern for love

I AM BUSY
houses have I painted
and carpentered
I have mixed my sweat with the grey primer
of corrugated iron roofs
from seven in the morning to seven at night
seven days a week
I wanted to paint the heavens skyblue
but couldn't find the owner
and no estate agent knows him

I am busy
newspapers have I set
and laid out
I have set booklets for freemasons' lodges
so that the president should be named
and the secretary
and the worshipful brothers
and the brethren
brotherly
one
by
one
under
the other
I wanted to set a poem that would change the world
but was left no time to write

I am busy
I have learnt english
in word and deed
and spoken dutch with the lost
argued with Raymond Glass
about the uselessness of canvaspainting
and art as a loner's path against the world
I still have to learn to buy a car
for business and the kids

listen
I am busy
I still have to be european amidst the barbarians
I must still think
europe
europe
I must defend my loner's europe
as a refuge for all

and I must still write papers letters
to jan g elburg and gerard diels
to salvador hertog and to my mother
to anton bigot to hugh jans
and to bert schierbeek my schizofrater
and I still have to tell willem schouten:
 I have taken my lot in my hands
 and this is what has become of it

I ride past mona vale warriewood narrabeen
collaroy dee why brookvale
through the clear australian morning
musing on a book by andre breton
through a landscape of treed hills and rocks
and fertile soil of the valleys
under a year round sun
to one day start work with head and hand
to one day start work for tomorrow's bread
to one day start work on myself
to one day farther
and then and there the world is created anew
in yellow blue and green

in a morning of riches
I spell a word
 a clarity
 a farther reason

Koos Schuur
refer to note 14, page 15

index